G000162646

The Organic Chemistry of Museum Objects

Butterworth-Heinemann Series in Conservation and Museology

Series Editors: *Arts and Archaeology*

Andrew Oddy
British Museum, London

Architecture

Derek Linstrum
Institute of Advanced Architectural Studies, University of York

US Executive Editor: **Norbert S Baer**
New York University, Conservation Center of the Institute of Fine Arts

Consultants: **Sir Bernard Feilden**

David Bomford
National Gallery, London

C V Horie
Manchester Museum, University of Manchester

Colin Pearson
Canberra College of Advanced Education

Sarah Staniforth
National Trust, London

Published titles: Artists' Pigments c. 1600–1835, 2nd Edition (Harley)
Care and Conservation of Geological Material (Howie)
Conservation and Exhibitions (Stolow)
Conservation and Restoration of Ceramics (Buys, Oakley)
Conservation and Restoration of Works of Art and Antiquities (Kühn)
Conservation of Building and Decorative Stone, Volumes 1 and 2 (Ashurst, Dimes)
Conservation of Glass (Newton, Davison)
Conservation of Historic Buildings (Feilden)
Conservation of Library and Archive Materials and the Graphic Arts (Petherbridge)
Conservation of Manuscripts and Paintings of South-east Asia (Agrawal)
Conservation of Marine Archaeological Objects (Pearson)
Conservation of Wall Paintings (Mora, Mora, Philippot)
The Museum Environment, 2nd Edition (Thomson)
The Organic Chemistry of Museum Objects, 2nd Edition (Mills, White)
The Textile Conservator's Manual, 2nd Edition (Landi)

Related titles: Manual of Curatorship, 2nd Edition
Materials for Conservation
Museum Documentation Systems

The Organic Chemistry of Museum Objects

Second edition

John S. Mills
Formerly Scientific Adviser

and

Raymond White
Principal Scientific Officer

Scientific Department, The National Gallery, London

OXFORD AMSTERDAM BOSTON LONDON NEW YORK PARIS
SAN DIEGO SAN FRANCISCO SINGAPORE SYDNEY TOKYO

Butterworth-Heinemann
An imprint of Elsevier Science
Linacre House, Jordan Hill, Oxford OX2 8DP
200 Wheeler Road, Burlington, MA 01803

First published 1987
Second edition 1994
Reprinted 1996
Paperback edition 1999
Reprinted 2003

Copyright © 1987, 1994, Elsevier Science Ltd. All rights reserved

No part of this publication may be reproduced in any material form (including
photocopying or storing in any medium by electronic means and whether
or not transiently or incidentally to some other use of this publication) without
the written permission of the copyright holder except in accordance with the
provisions of the Copyright, Designs and Patents Act 1988 or under the terms of
a licence issued by the Copyright Licensing Agency Ltd, 90 Tottenham Court Road,
London, England W1T 4LP. Applications for the copyright holder's written
permission to reproduce any part of this publication should be addressed
to the publisher. Permissions may be sought directly from Elsevier's Science and
Technology Rights Department in Oxford, UK: phone: (+44) (0) 1865 843830;
fax: (+44) (0) 1865 853333; e-mail: permissions@elsevier.co.uk . You may also
complete your request on-line via the Elsevier Science homepage
(http://www.elsevier.com), by selecting 'Customer Support' and then 'Obtaining
Permissions'.

British Library Cataloguing in Publication Data
Mills, John S.
 Organic Chemistry of Museum Objects. –
 2 Rev. ed. – (Butterworth-Heinemann Series
 in Conservation & Museology)
 I. Title II. White, Raymond III. Series
 069.53

Library of Congress Cataloguing in Publication Data
Mills, John S. (John Stuart)
 The organic chemistry of museum objects/John S. Mills and
 Raymond White. – 2nd ed.
 p. cm.
 Includes bibliographical references and index.
 1. Museum conservation methods. 2. Artists' materials.
 3. Chemistry, Organic. I. White Raymond. II. Title III. Series:
 Butterworth series in conservation and museology
 AM145.M55 1994 93-32082
 069'.53-dc20 CIP

ISBN 0 7506 4693 4

For information on all Butterworth-Heinemann publications
visit our website at www.bh.com

Composition by Genesis Typesetting, Laser Quay, Rochester, Kent
Printed and bound in Great Britain by St Edmundsbury Press Limited,
Bury St Edmunds, Suffolk

Contents

Series editors' preface

The conservation of artefacts and buildings has a long history, but the positive emergence of conservation as a profession can be said to date from the foundation of the International Institute for the Conservation of Museum Objects (IIC) in 1950 (the last two words of the title being later changed to Historic and Artistic Works) and the appearance soon after in 1952 of its journal *Studies in Conservation*. The role of the conservator as distinct from those of the restorer and the scientist had been emerging during the 1930s with a focal point in the Fogg Art Museum, Harvard University, which published the precursor to *Studies in Conservation, Technical Studies in the Field of the Fine Arts* (1932–42).

UNESCO, through its Cultural Heritage Division and its publications, had always taken a positive role in conservation and the foundation, under its auspices, of the International Centre for the Study of the Preservation and the Restoration of Cultural Property (ICCROM), in Rome, was a further advance. The Centre was established in 1959 with the aims of advising internationally on conservation problems, co-ordinating conservation activators and establishing standards of training courses.

A significant confirmation of professional progress was the transformation at New York in 1966 of the two committees of the International Council of Museums (ICOM), one curatorial on the Care of Paintings (founded in 1949) and the other mainly scientific (founded in the mid-1950s), into the ICOM Committee for Conservation.

Following the Second International Congress of Architects in Venice in 1964 when the Venice Charter was promulgated, the International Council of Monuments and Sites (ICOMOS) was set up in 1965 to deal with archaeological, architectural and town planning questions, to schedule monuments and sites and to monitor relevant legislation. From the early 1960s onwards, international congresses (and the literature emerging from them) held by IIC, ICOM, ICOMOS and ICCROM not only advanced the subject in its various technical specializations but also emphasized the cohesion of conservators and their subject as an interdisciplinary profession.

The use of the term *Conservation* in the title of this series refers to the whole subject of the care and treatment of valuable artefacts, both movable and immovable, but within the discipline conservation has a meaning which is distinct from that of restoration. *Conservation* used in this specialized sense has two aspects: first, the control of the environment to minimize the decay of artefacts and materials; and, second, their treatment to arrest decay and to stabilize them where possible against further deterioration. Restoration is the continuation of the latter process, when conservation treatment is thought to be insufficient, to the extent of reinstating an object, without falsification, to a condition in which it can be exhibited.

In the field of conservation conflicts of values on aesthetic, historical, or technical grounds are often inevitable. Rival attitudes and methods inevitably arise in a subject which is still developing and at the core of these differences there is often a deficiency of technical knowledge. That is one of the principle *raisons d'être* of this series. In most of these matters ethical principles are the subject of much discussion, and generalizations cannot easily cover (say) buildings, furniture, easel paintings and waterlogged wooden objects.

A rigid, universally agreed principle is that all treatment should be adequately documented. There is also general agreement that structural and decorative falsification should be avoided. In addition there are three other principles which, unless there are overriding objections, it is generally agreed should be followed.

The first is the principle of the reversibility of processes, which states that a treatment should normally be such that the artefact can, if desired, be returned to its pre-treatment condition even after a long lapse of time. This principle is impossible to apply in some cases, for example where the survival of an artefact may depend upon an irreversible process. The second, intrinsic to the whole subject, is that as far as possible decayed parts of an artefact should be conserved and not replaced. The third is that the consequences of the ageing of the original materials (for example 'patina') should not normally be disguised or removed. This includes a secondary proviso that later accretions should not be retained under the false guise of natural patina.

The authors of the volumes in this series give their views on these matters, where relevant, with reference to the types of material within their scope. They take into account the differences in approach to artefacts of essentially artistic significance and to those in which the interest is primarily historical, archaeological or scientific.

The volumes are unified by a systematic and balanced presentation of theoretical and practical material with, where necessary, an objective comparison of different methods and approaches. A balance has also been maintained between the fine (and decorative) arts, archaeology and architecture in those cases where the respective branches of the subject have common ground, for example in the treatment of stone and glass and in the control of the museum environment. Since the publication of the first volume it has been decided to include within the series related monographs and technical studies. To reflect this enlargement of its scope the series has been renamed the Butterworth-Heinemann Series in Conservation and Museology.

Though necessarily different in details of organization and treatment (to fit the particular requirements of the subject) each volume has the same general standard, which is that of such training courses as those of the University of London Institute of Archaeology, The Victoria and Albert Museum, the Conservation Center, New York University, the Institute of Advanced Architectural Studies, York, and ICCROM.

The authors have been chosen from among the acknowledged experts in each field, but as a result of the wide areas of knowledge and technique covered even by the specialized volumes in this series, in many instances multi-authorship has been necessary.

With the existence of IIC, ICOM, ICOMOS and ICCROM, the principles and practice of conservation have become as internationalized as the problems. The collaboration of Consultant Editors will help to ensure that the practices discussed in this series will be applicable throughout the world.

Preface to the first edition

The aim of this book is to provide, in one volume, an account of the composition, chemistry and analysis of the organic materials which enter into the structures of objects in museum collections. This was embarked on in the belief that there is a need for such a compendium, both on the museum side and on that of the academic chemist, and in the hope that it may bring the two closer together. The literature of conservation and that of chemistry overlap only to a small extent, and while most conservators and other technical museum personnel are at least aware (through the medium of *Art and Archaeology Technical Abstracts*) of the existence of much of the relevant chemical literature, those in academic positions often do not come across the more practical or *ad hoc* research scattered through the conservation journals.

A book intended for both chemists and non-chemists must involve some compromise, and not all of this one will be of interest to both parties. The chemists will not need the introductory chemistry of Chapter 1 while conservators and curators, perhaps even students, may not feel the need to inform themselves fully on, say, the chemistry of shellac. However, the book is intended to be read: it has not been compiled primarily as a reference handbook of materials though it may partly serve this function for the natural products.

A word should be said regarding our policy both on coverage and on referencing. Both of these are generally fuller, with topics for which there exist no adequate books or review articles – resins and lacquers are a case in point – and in consequence there is no necessary correlation between length of a chapter and the practical importance of its subject. A correlation between length and chemical complexity is more likely but even in the fuller chapters no attempt is made at completeness. Despite their practical importance, the major structural materials, such as wood or skin products, are relatively simple chemically. They are included here so as to be seen in their chemical context but they really need the individual treatment which, it is hoped, they will receive in this Series. As concerns references, later ones are always preferred to earlier; before 1960 they are mainly confined to those of historical interest.

We thank our colleagues in the Scientific Department of The National Gallery for their help with our enquiries and their patience when practical investigations have sometimes been delayed by our preoccupation with this book. Our thanks are also due to the Series Editors, Professor Norbert S. Baer and Mr Stephen Rees Jones, for reading the manuscript and making many suggestions for improvements.

John Mills
Raymond White

Preface to the second edition

Since the text for the first edition of this book (which went out of print in 1991) was completed at the end of 1985, a great deal of relevant new material has appeared in the conservation literature, especially in connection with analytical methods and findings. This has been the stimulus for preparing a new and revised edition, which is also desirable to enable us to correct a number of errors that unfortunately crept into the first.

The same general layout has been retained. Although the arrangement by chemical class means that discussion of some topics – paint, varnish, archaeological residues – is distributed through more than one chapter, alternative approaches are attended by even greater difficulties. Significant advances have been made in some fields – the red insect dyestuffs, synthetic varnish resins, and the use of antioxidants, for example – and these are given more extended discussion, while some other topics, such as the synthetic resin parylene, are newly introduced.

March 1993

Introduction

Organic chemistry is the chemistry of compounds of carbon. Life on this planet is a function associated only with carbon-based materials. Conversely carbon compounds were originally thought of as necessarily produced in living things – plants or animals – by some kind of 'life force', and as incapable of being synthesized in the laboratory. In the nineteenth century this idea was found to be erroneous and was discarded. It is none the less true that biochemical processes still far exceed in complexity the usual methods of organic chemical synthesis and often give rise to materials and molecular structures which have yet to be duplicated by work in the laboratory. The scope of biosynthetic methods constantly expands however.

The manipulation of organic compounds to yield new useful products started in the nineteenth century but became really large-scale and all-pervasive only in the present one. However the organic materials incorporated into the objects to be found in museums and art galleries, or which are collected by ethnographers or excavated by archaeologists, will be very largely of natural origin and some of them, such as wood and some animal and plant fibres, will often have been used quite unmodified by any treatment which alters their chemical nature. Others, such as leather or vulcanized rubber, involve a treatment of the raw material which does significantly modify chemical structure. Still others again, such as seed oils or plant dyestuffs, require a considerable amount of technological development to obtain or utilize them. Such operations will of course have been devised quite empirically without any conception of the chemistry involved, and the same is true of the utilization of the complex phenomena of the drying of oils or oriental lacquer.

How does one achieve some unity of understanding of such diverse properties and behaviour as: the colour of dyes; the drying of oils; the elasticity of rubber; the insolubility of some materials and the varying solubilities of others; the stability of beeswax and the impermanence of coloured textiles or watercolours? The answer is: by a knowledge of the chemical structures of the materials, because structures determine physical properties, reactions with other components of the biosphere, and responses to the various sources of energy.

The study of natural products was the primary aim of organic chemistry and has always remained an important aspect of it. As already implied, natural materials can be very complex in structure and much was attempted before the development of adequate methods, and an adequate theoretical framework, rendered a solution possible. Natural resins, for example, were studied chemically from the early nineteenth century yet it was not until near the middle of the twentieth that new separation methods enabled isolation of pure compounds, and new spectrometric methods made the determination of their structures easier. An incentive to any research – which is inevitably expensive – is the development of useful products or the understanding of useful processes. With the expansion of the synthetic chemicals industry, based largely on coal, natural gas, and petroleum, there has been a decline in the use of many other natural products, and less research is now carried out on them both in industry and by the universities. Increasingly, museums and galleries have to carry out needful research themselves. Often much information is available but results of relevance to objects of art and archaeology are scattered through the literature of many disciplines in several languages. Furthermore

the absence of commercial or technological importance for many of these results means that they often do not find their way into even recently published books on relevant topics, such as coatings technology.

There exist already a number of excellent handbooks on the materials and techniques of art and conservation. This book is not intended to duplicate the information available in these but rather to convey the present state of knowledge of the chemical composition of such materials and thereby provide a framework for a general understanding of their properties. While the viewpoint will be that of the organic chemist, the subject matter covered will necessarily be selective and dictated by relevance to museum materials. Whole areas of organic chemistry – heterocyclic chemistry for example – have little such relevance and hence are largely omitted.

The fascinating and vexed questions of the history of techniques and materials in art can only be touched on incidentally, and thus incompletely. Many of the books on these topics were, in the past, based on searches of the early literature, with very little in the way of experimental verification – entirely understandable at a time when analytical methods were inadequate to the task. Yet often such books remain extremely valuable, for their scholarship would be hard to duplicate today. Lucas on Egyptian materials; Church and Laurie on artists' techniques; the nineteenth-century explications of early manuscripts and printed works by Merrifield and by Eastlake; original sources themselves such as Cennini and Theophilus; these are valuable guides as to what organic materials might be expected to be found in museum objects. In the field of Oriental art, or the art of the New World, there is less in the way of source material, or it is less accessible, but even here there are the great encyclopaedias of raw materials compiled in the nineteenth and twentieth centuries such as Watt's *Dictionary of the Economic Products of India* or Tschirsche and Stock on the natural resins.

One task of the chemist working in this field is to try to test actual practice, as against precept, by analysis. Before he can do that he must assess the feasibility of such analysis and devise methods. This in turn requires a knowledge of the chemistry of the materials themselves – the main subject of this book.

A word must be said regarding nomenclature, units etc. In an ideal world chemical compounds would be universally known by unique and consistent names which would immediately convey to the listener or reader the chemical structure of each compound. Systems for naming organic compounds in such a way have indeed been formulated, that adopted by the International Union of Pure and Applied Chemistry (IUPAC) being one such system. Such nomenclature permits the naming of all compounds, both known and foreseeable, but unfortunately the names which result for the more complex compounds can be long and cumbersome, and they only convey the structure of the compound to the reader after long and careful thought.

While they are essential for indexing and databases, they often prove unsuitable for everyday use, especially in the case of common or familiar compounds, and inevitably most such compounds have shorter so-called trivial names by which they are generally known. The multivolume annual compound-name indexes of *Chemical Abstracts* mercifully recognize the problem and cross-index systematic and trivial names. We shall here confine use of the systematic names to our first chapter on Basic Chemistry, while also giving there the more familiar names.

In the case of units, while generally using those which are internationally recognized (SI units) we feel obliged to continue to present certain values in the non-standard units commonly encountered in the chemical literature; thus bond strengths are given in $kcal\,mol^{-1}$ rather than in $J\,mol^{-1}$.

Bibliography

ALEXANDER, S. M., 'Towards a History of Art Materials – A Survey of Published Technical Literature in the Arts. Part I From Antiquity to 1599', *Art and Archaeology Technical Abstracts*, 7(1969), No. 3, 123–61; Part II From 1600 to 1750, *ibid*, 7(1969), No. 4, 201–16; Part III 1751 – Late 19th Century, *ibid*, 8(1970), No. 1, 155–73

BERGER, E., *Beiträge zur Entwickelungs-Geschichte der Maltechnik*, 4 vols, Callwey, Munich (1901–4)

BOMFORD, D., BROWN, C. and ROY, A., *Art in the Making: Rembrandt*, National Gallery, London (1988)

BOMFORD, D., DUNKERTON, J., GORDON, D., ROY, A. and KIRBY, J., *Art in the Making: Italian Painting before 1400*, National Gallery, London (1989)

BOMFORD, D., KIRBY, J., LEIGHTON, J. and ROY, A., *Art in the Making: Impressionism*, National Gallery, London and Yale University Press (1990)

CENNINI, C., *Il Libro dell'Arte*. Several editions and translations including those by D. V. Thompson, Yale University Press, New Haven (1932 and 1933). Reprinted by Dover Publications, New York (1954)

CHURCH, A. H. *The Chemistry of Paints and Paintings*, 4th edition, Seeley and Co., London (1915)

EASTLAKE, C. L., *Materials for a History of Oil Painting*, 2 vols, Longman, London (1847 and 1869). Reprinted by Dover Publications, New York (1967)

EIBNER, A., *Entwickelung und Werkstoffe der Wandmalerei*, Heller, Munich, (1926)

GETTENS, R. B. and STOUT, G. L., *Painting Materials, A Short Encyclopedia*, Van Nostrand, New York (1942). Reprinted Dover Publications, New York (1966)

KÜHN, H., *Erhaltung und Pflege von Kunstwerken und Antiquitäten*, 2 vols, Keyser, Munich (1974 and 1981)

KÜHN, H., ROOSEN-RUNGE, H., STAUB, R. E. and KOLLER, M., *Reclams Handbuch der Künstlerischen Techniken. Bd. 1. Farbmittel, Buchmalerei, Tafel- und Leimvandmalerei*, Philip Reclam jun., Stuttgart (1984)

LAURIE, A. P. *Materials of the Painters' Craft*, T. N. Foulis, London and Edinburgh (1910)

LUCAS, A., *Ancient Egyptian Materials and Industries*, 3rd edition, revised, Edward Arnold, London (1948)

MAYER, R., *The Artist's Handbook of Materials and Techniques*, Viking Press, New York (1982)

MERRIFIELD, M. P., *Original Treatises Dating from the XIIth to XVIIIth Centuries on the Arts of Painting . . .*, 2 vols, J. Murray, London (1849). Reprinted Dover Publications, New York (1967)

THEOPHILUS, *An Essay upon various Arts*, trans. by R. HENDRIE, J. Murray, London (1847). Also trans. by C. R. Dodwell, Thomas Nelson and Sons, Oxford, New York and London (1961); and trans. by J. G. Hawthorne and C. S. Smith, University of Chicago Press (1963), reprinted Dover Publications, New York (1979)

TSCHIRSCHE, A. and STOCK, E., *Die Harze*, 4 vols, Borntraeger, Berlin (1933–5)

WATT, G., *Dictionary of the Economic Products of India*, 6 vols plus index, London (1889–96)

WEHLTE, K., *Werkstoffe und Techniken der Malerei*, Otto Maier Verlag, Ravensburg (1967)

1

Basic organic chemistry

Atoms of carbon form strong bonds with other carbon atoms and with those of hydrogen, oxygen, and nitrogen, and the majority of the materials dealt with in this book are made up of compounds formed from these elements. Carbon also combines with the halogens (fluorine, chlorine, bromine and iodine, in diminishing order of the strength of the carbon–halogen bond); with sulphur and phosphorus; and with many other elements including some of the metals, though compounds of this last type are often unstable or very reactive.

Enormous numbers of individual organic compounds are known and there is no theoretical limit to how many could, or may in fact, exist. Part of the reason for this is that carbon is *tetravalent*, i.e. each carbon atom can form bonds with up to four other atoms. Rather than attempt a formal presentation of the theory of chemical bonding (which is to be found in all organic chemistry textbooks), only some aspects of it will be touched on in this book. Initially it suffices to say that organic compounds can be represented on paper, and by models, as if they were made up of particulate atoms linked by single or multiple bonds of specific length (represented by lines in structural formulae on paper, by wires or rods in models), arranged in three-dimensional space.

While simplistic and naive-seeming, such a representation of the structures of compounds is nevertheless of extraordinary value in explaining *and predicting* properties and chemical behaviour. Most of the great achievements of synthetic organic chemistry are the result of visualizing molecular structure in such a way, alongside a concomitant understanding of the properties and reactions of

functional groups: the hydroxyl group ($-OH$), the carboxyl group ($-COOH$), the amino group ($-NH_2$) etc.

The basic composition of a compound is expressed as its *empirical formula*. This simply indicates the elements present and their proportions; thus C_2H_6O (two carbons, six hydrogens, one oxygen). The *molecular formula* indicates the actual numbers of each atom in each molecule and so may be the same as the empirical formula or it may be a multiple of it. The empirical or molecular formulae give no indication of chemical structure. The example above, taken as a molecular formula, in fact applies to two possible compounds whose structures would be conveyed more completely by the formulae C_2H_5OH (ethanol; ethyl alcohol) and CH_3OCH_3 (methoxymethane; dimethyl ether). These formulae still give no indication of the arrangement of the atoms in space. To explain that we must start at the beginning.

1.1 Hydrocarbons

1.1.1 Saturated hydrocarbons: alkanes

Compounds consisting only of carbon and hydrogen are called hydrocarbons. As carbon is tetravalent and hydrogen is monovalent it follows that the simplest possible hydrocarbon containing a single carbon atom per molecule, methane, contains four hydrogen atoms – CH_4. It is indispensable to say here that what the carbon–hydrogen bonds actually represent in terms of atomic structure is a sharing of a pair of electrons between the atoms concerned. One electron of the pair comes from each atom, and

this equal contribution is indicated in the name of this type of bond: the covalent bond. Because of the equal sharing of the electrons the atoms remain electrically neutral; there is no separation of charges. A partial structure of the molecule in terms of electrons is therefore expressed by:

$$H : \overset{\displaystyle H}{\underset{\displaystyle H}{\overset{\cdot\cdot}{C}}} : H$$

each electron being represented by a dot. The hydrogen atoms have each completed a stable valence shell of two electrons; the carbon has completed a stable shell of eight electrons.

As one might expect, these hydrogen atoms are spaced around the carbon atom in a completely symmetrical way, as if at the four corners of a regular tetrahedron with the carbon atom at its centre.

methane

In such an arrangement the angle between the bonds is 109° 28' and this is, for unstrained compounds, the normal bond angle for saturated carbon whether to hydrogen, other carbon atoms or other elements. By unstrained is meant compounds in which the bond angles are not distorted for any reason, such as large size of substituents or formation of small rings (see below). The compound with two carbon atoms, ethane, has molecular formula C_2H_6 and is arranged in space thus:

ethane

Nothing prevents the molecule from rotating about the bond connecting carbon to carbon and consequently the hydrogen atoms on one carbon atom are not in a fixed position relative to those on the other. The various arrangements that the two halves of the molecule can adopt relative to one another are known as *conformations*. They are of no significance in this case but become so when considering more complex molecules such as those with larger substituents than hydrogen and those involving ring structures, for here the physical interactions and

space limitations often lead to the adoption of a particular preferred conformation for a molecule.

The next compound of the *homologous series*, as a series of compounds differing one from another only by a CH_2 (methylene) group is known, is propane, C_3H_8 of structure:

propane

Here the thing to notice is that the two carbon–carbon bonds of the chain are not in a straight line. Despite this the continuing series of compounds in which all the carbon atoms, except those at the ends, are linked to two other carbon atoms is known as the series of straight chain hydrocarbons to distinguish its members from the branched chain hydrocarbons. No branched chain compound is possible with only three carbon atoms but with the next member of the series, butane, C_4H_{10}, a branched chain is possible, thus:

methylpropane (*iso*butane)

Here we see that one of the carbon atoms is linked with three other carbon atoms. Such a carbon is described as a tertiary carbon atom while those linked only to two or one other carbon are described as secondary and primary respectively. Whether a carbon atom is primary, secondary or tertiary has important consequences for the reactivity of the functional groups (including hydrogen) attached to it. The formula of butane may be written in text in several ways; as C_4H_{10}, $CH_3(CH_2)_2CH_3$, or $CH_3CH_2CH_2CH_3$. Methylpropane would be written as $C_2H_4(CH_3)_2$ or $CH_3CH(CH_3)_2$.

The two compounds butane and methylpropane, which have the same molecular formula and different structural formulae, are *isomers* of one another. *Isomerism*, as this phenomenon is known, can take several different forms which will be met with in due course. One however, known as *stereoisomerism*, will be introduced at this point.

If we consider the structure of methane, given above, it is clear that in theory the hydrogen atoms can be substituted by an endless number of other groups, be these hydrocarbon chains or the numerous functional groups yet to be described. Such groups may be conveniently indicated by such expressions as R^1, R^2 etc. (the customary use of R comes from the now obsolete use of the term *radical* for a group). If all the groups are different then it is found that two (and only two) different ways are possible of drawing their spatial arrangement round the carbon atom:

$$
\begin{array}{ccc}
R^1 & \qquad & R^1 \\
| & & | \\
C-R^3 & & C-R^2 \\
R^2 \quad R^4 & & R^3 \quad R^4
\end{array}
$$

These two structures are, in fact, mirror images of one another. However they are twisted about, one cannot be superimposed on the other.

This theoretical idea reflects reality for in such a case two compounds are indeed found to exist which have identical chemical properties and identical physical properties except for one known as *optical rotation*. Since this property is one which is without any practical significance in the field of museum materials a simple definition of it must suffice here. It is the extent to which the compound rotates the plane of polarized light passing through it, and it is expressed in angular degrees.

This property yields the alternative name for stereoisomers, namely *optical isomers*, and such isomers show rotations which are equal in degree but opposite in sign. The direction of the rotation (positive or negative) is also expressed in another way, by adding to the name the prefixes *d-* (for *dextro-*; to the right) and *l-* (for *laevo-*; to the left) to distinguish the two isomers.

The carbon bearing the four different groups is known as an *asymmetric*, or *chiral*, centre. A molecule may, of course, have more than one such centre and it is only when two compounds have the opposite configurations at all their asymmetric centres that they have equal and opposite rotations. Such pairs of isomers are given the name *enantiomers*.

When compounds differ in configuration only at one or more of their asymmetric centres (rather than all of them) they are known as *diastereoisomers*, and are said to be *epimeric* at those centres. It is an interesting fact that natural products incorporating asymmetric centres are commonly found only as one of the possible optical isomers. In other words

their biosynthesis is *stereospecific*. This is true, for example, of the sugars and the amino acids and also, very largely, of the terpenoids.

To return to our theme of the saturated hydrocarbons; there is no need to indicate the structures of higher members of the series for they are obvious. It is also obvious that scope for variety of branching of the chain will increase as the number of carbon atoms increases, though the extent to which this is so may be surprising. Decane (10 carbons) has 75 isomers while eicosane (20 carbons) has a theoretical 366,319. In practice we will here be more concerned with the straight chain hydrocarbons and other straight chain compounds resulting from the substitution of hydrogen by functional groups.

1.1.2 Unsaturated hydrocarbons

Not all four of the valencies of carbon need be taken up by substituents linked by single bonds. If the substituent is more than monovalent then there is the possibility of multiple bonds. Multiple bonds are possible therefore between carbon atoms, the simplest such compound being that with two carbon atoms and a double bond, ethene (ethylene) $CH_2=CH_2$. Compounds with triple bonds are also possible, the simplest being ethyne (acetylene), $CH\equiv CH$. Triple bonds are rather reactive and consequently are found relatively rarely in nature. Recently however compounds containing them have been found to be the polymerizable components of a certain type of natural lacquer (8.7.3).

The presence of a double bond in a chain allows the existence of another form of isomerism, known as positional isomerism, for different compounds will result depending on its position in the chain. There may also, of course, be as many double bonds in a chain as there is space for but it should be noted that compounds with double bonds on adjacent carbon atoms such as $CH_2=C=CH_2$, which do exist and are known as allenes or cumulative dienes, are unstable and tend to rearrange to acetylenes. When the double bonds are separated by one single bond then they are known as conjugated double bonds. Thus butadiene, $CH_2=CH-CH=CH_2$, is the simplest conjugated diene. Pentadiene has two possible positional isomers, one of which will be a conjugated diene, the other not, viz. $CH_2=CH-CH=CH-CH_3$ and $CH_2=CH-CH_2-CH=CH_2$. Conjugated and isolated double bonds confer different reactivities on a molecule, as will be seen in the case of drying oils (3.4).

There cannot be rotation around double bonds and this leads to the possibility of yet another type of isomerism. Consider the compound $R_1CH=CHR_2$. This can have two possible structures:

The structures are known as *cis* and *trans* isomers according to whether the substituents are on the same side or opposite sides of the double bond respectively. When the carbons are fully substituted, the hydrogens being replaced by other groups, then deciding which isomer is to be called *cis* and which *trans* becomes more tricky but the rules for this need not be given here. An alternative nomenclature uses *Z* for *cis* and *S* for *trans*.

Reactivity of functional groups, including double bonds, is discussed later but it should be said here that double bonds are quite mobile under the influence of certain reagents and can consequently change their positions on a chain. Generally a compound with two bonds in conjugation is more stable than one with the two bonds more widely separated and so unconjugated, and so the latter, given a chance, will move into conjugation. The reverse does not happen. Chains with several double bonds which can behave in this way are to be found among the fatty acids (3.1.1).

1.1.3 Cyclic compounds

It is easy to conceive that if a hydrocarbon chain is long enough one end could be linked to the other by a carbon–carbon bond to form a cyclic, or ring, compound. Such compounds are indeed well known and are highly important in natural product chemistry. There are, of course, constraints put upon the formation of such rings by the bond angle mentioned above.

The highly strained compounds with three and four carbon atoms in the ring (cyclopropane and cyclobutane) do exist but are relatively unimportant. The compound with five carbon atoms in the ring, cyclopentane, is almost unstrained (the angles of a regular pentagon being 108°) and is stable and easily made. Compounds with the five-membered ring are common throughout nature.

Even more abundant though are compounds involving the six-membered ring of cyclohexane and this we will give a little more attention.

Cyclohexane consists of a ring of six CH_2 groups, but it is most conveniently represented simply as a hexagon without letters and numbers:

The normal unstrained bond angle of 109° 28' can be attained only if the molecule is not flat, since this would result in angles of 120°. There are in fact two possible conformations of the ring which are strainless, known as the chair and boat forms:

The conformations can flip quite readily from one to the other but there is another factor which decisively determines which is preferred. In the boat form two of the hydrogen atoms at the 'ends' of the ring which are turned up are quite close to each other and undergo mutual repulsion. This is sufficient to ensure that at least 99% of the molecules of cyclohexane are in the chair form at any one time. Another point can be made concerning the chair form. It can be seen that the bonds linking the carbons to the hydrogens are of two types. Six of the bonds point out radially from the ring, the other six point, three up three down, from the plane of the ring. These two types of bonds are known as equatorial and axial, respectively. They are not important in single ring compounds since they are interconvertible by ring-flipping, but they are in the so-called condensed ring systems common in the di- and triterpenoids where conformational changes cannot readily occur. A condensed ring system is one in which a pair of rings has two carbon atoms in common as in, for example, bicyclodecane (decalin):

bicyclodecane (decalin)

It is necessary to explain here some points concerning the stereochemistry of condensed, or fused, ring

systems. The two carbon atoms of decalin common to the two rings each have one hydrogen atom attached to them. These may both project on the same side of the rings (both up or both down) or on opposite sides (one up one down). This then gives rise to another form of *cis–trans*-isomerism, the two compounds being known in this case as *cis-* and *trans*-decalin. They are written as follows:

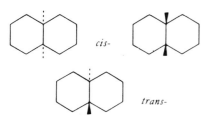

The dotted lines indicate that the groups go below the plane of the paper, the thickened lines that they come above. The *cis* compound has been drawn in two different ways but it is easily seen that they are in fact identical compounds and not optical isomers: by simply turning one over it can be superimposed on the other. This would not be the case, however, if one of the rings carried a substituent: several optical isomers would now be possible since both the common carbon atoms and the carbon to which the substituent was attached would become asymmetric centres. Both the *cis* and *trans*-isomers can adopt all-chair conformations:

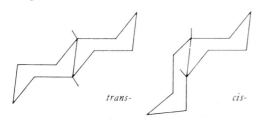

1.1.4 Unsaturated cyclic compounds

Cyclic compounds may have isolated or conjugated double bonds in the same way as chain compounds. Thus cyclohexene and two possible cyclohexadienes exist:

In accordance with what was said earlier, the conjugated diene readily forms from the non-conjugated one. It can be seen that there is room in the ring for one more double bond, yielding a compound with molecular formula C_6H_6. The presence of this third unit of unsaturation results in a dramatic change of chemical properties, the compound – benzene – behaving unlike a conjugated triene but as if all six of the bonds were equal and of a hybrid character. In structural formulae it is represented as follows:

The compounds containing the unsaturated system of benzene are known, for historical reasons, as aromatic compounds, also as benzenoid compounds, and the special character of the bonding as aromaticity or aromatic character. The formation of benzene (and the aromatic system) from cyclohexadiene is an exothermic process (one giving out energy) and it follows that any reaction which destroys the aromaticity of the molecule will require a correspondingly high energy input (will be endothermic).

Looked at another way, this means that the carbon–carbon bond strength in aromatic compounds is very high and reactions involving rupture of the ring or loss of aromaticity become correspondingly less likely. Generally, then, aromatic compounds are rather stable, and most of their reactions involve substitution reactions of the constituent hydrogen atoms rather than the carbon–carbon bonds.

The study of aromatic compounds is one of the most important sections of organic chemistry both from the theoretical and technological points of view. Benzene, along with other aromatic compounds, is a major product of the destructive distillation of coal and it was one of the principal raw materials for the development of the synthetic organic chemicals industry in the nineteenth century, notably that devoted to dyestuffs (10.3). It is a good solvent but insidiously poisonous; that is to say it can have serious long-term toxic effects even when producing no immediate symptoms. Its use has to be carefully controlled and in fact is best avoided. Its homologues, toluene (methylbenzene) and the xylenes (dimethylbenzenes), which are somewhat higher boiling (110°C and between 138

and 144°C respectively), are also useful solvents and much less poisonous.

Xylene consists normally of a mixture of the three possible isomers, ortho-, meta-, and para-xylene (also known as 1,2-, 1,3-, and 1,4-dimethylbenzenes):

ortho (1,2-) meta (1,3-)

para (1,4-)

Table 1.1 Straight chain paraffin hydrocarbons

Name	Formula	M.W.	m.p. (°C)	b.p. (°C)
Methane	CH_4	16	−182	−161
Ethane	C_2H_4	30	−183	−88
Propane	C_3H_8	44	−190	−44
Butane	C_4H_{10}	58	−138	−0.5
Pentane	C_5H_{12}	72	−13	36
Hexane	C_6H_{14}	86	−95	69
Heptane	C_7H_{16}	100	−91	98
Octane	C_8H_{18}	114	−56	125
Nonane	C_9H_{20}	128	−51	151
Decane	$C_{10}H_{22}$	142	−30	174
Pentadecane	$C_{15}H_{32}$	212	10	270
Eicosane	$C_{20}H_{42}$	282	37	343

Compounds containing the benzene ring are also common as natural products and will be encountered later, in the sections on dyestuffs and bituminous materials in particular. The enhanced stability of aromatic compounds over corresponding compounds containing only one or two double bonds in the ring means that oxidation (dehydrogenation) of cyclic dienes to form an aromatic ring will readily occur, as will rearrangement of conjugated trienes to an aromatic system, when that can take place without the breaking of carbon–carbon bonds. The reverse reactions are difficult and will never occur spontaneously.

Condensed ring systems are equally found with aromatic compounds. The simplest, with two rings, is naphthalene, $C_{10}H_8$:

naphthalene

1.1.5 Properties and reactions of hydrocarbons

Table 1.1 shows selected physical properties of the first ten, and some higher, members of the homologous series of saturated straight chain hydrocarbons. The lowest members up to butane are gases at normal temperatures, then follow liquids of increasing boiling point until by about C_{20} the compounds are solids. Introduction of a double bond into the chain has the effect of lowering the melting and boiling points a few degrees from those of the corresponding saturated compound.

The saturated hydrocarbons are chemically very unreactive compounds. Both carbon–carbon and carbon–hydrogen bonds are strong and not easily broken. To understand this we must consider again the electronic nature of bonds as shared pairs of valence electrons, mentioned earlier. An individual bond may be broken, in theory, in three different ways: with one electron of the pair remaining with each of the atoms in question (known as *homolysis*; equal splitting) or with both electrons remaining with one or the other of the two atoms (*heterolysis*; unequal splitting). In the first case each fragment will be electrically neutral and carry a single, unpaired electron. Such entities are known as *free radicals*. In the second case each fragment will be positively or negatively charged according to whether it has lost or retained the originally shared pair of electrons. These charged fragments are known as ions. The possibility of two modes of heterolysis is in practice only theoretical since one mode is always preferred over the other (i.e. has overwhelming energy advantages).

$$AB \longrightarrow \begin{cases} A^{\cdot} + B^{\cdot} \\ A^{+} + B^{-} \\ A^{-} + B^{+} \end{cases}$$

In saturated hydrocarbons each of these ways of splitting the carbon–carbon or the carbon–hydrogen bond produces fragments which are unstable and of high energy. Consequently they can only be effected (if at all) under energetic conditions, such as at high temperatures. Now not all, or even most, chemical reactions proceed first by the splitting of

bonds followed by reaction of the fragments so formed; more common is the abstraction of an atom by some reactive species, or the displacement of a group from carbon by an attacking reactive species.

In other words bond making accompanies bond breaking and the overall energy needed to effect the splitting of the original bond is correspondingly reduced. Displacement reactions usually involve attack by, and displacement of, negatively charged ions (nucleophilic substitution) but since the negatively charged hydrogen ion is of such high energy as not to be able to exist in the free state, and the departure of a negatively charged hydrocarbon fragment is also unfavourable, such displacements do not occur with saturated hydrocarbons.

This only leaves the possibility of *free radical reactions* resulting from the homolysis of bonds or abstraction of atoms by reactive radical species and indeed these are the sorts of reaction most encountered with saturated hydrocarbons. But again they only take place at high temperatures or under special conditions. Radical reactions involving hydrocarbons, or the hydrocarbon chains of other compounds, including those with double bonds, will be discussed in more detail later in this book, particularly when considering the drying of drying oils.

The presence of a double bond in a hydrocarbon makes it more chemically reactive. In addition to facilitating free radical reactions, double bonds are electron-rich and consequently attack positively charged species (or positively charged species attack them: it is immaterial which way one thinks of it). The proton, H^+, is a common such species and the immediate product is a carbonium ion or carbon cation:

$$R^1CH = CHR^2 + H^+ \rightarrow R^1CH_2 - C^+HR^2$$

This intermediate ion is itself reactive and can behave in several ways. Thus it may again lose a proton, re-forming a double bond which can be in a different position to the original one. This is the mechanism by which double bonds are isomerized (shifted) by acids. It may attack another double bond, in the same or another molecule, forming another carbon–carbon bond. Most typically it will combine with an anion, a negatively charged species, and most probably that which was associated with the proton originally:

$$R^1CH_2 - C^+R^2 + X^- \rightarrow R^1CH_2CHXR^2$$

Thus the overall effect is an addition to the double bond and the reaction is known as an electrophilic

addition reaction. In the presence of suitable metallic catalysts, and especially under pressure, hydrogen gas itself will react with double bonds to give the saturated compound. The process is known as hydrogenation.

1.1.6 Occurrence of hydrocarbons

Enormous quantities of hydrocarbons occur naturally in the form of petroleum deposits and natural gas, which is mostly methane. A gas chromatogram of crude petroleum reveals the presence of hundreds of individual compounds. The major components of this mixture are the straight chain saturated hydrocarbons but minor components include many branched chain and unsaturated compounds also. Aromatic compounds are also present in great variety.

The petroleum industry is based primarily on the provision of fuel for transport, heating, and electricity generation, and to supplying raw materials for the synthetic chemicals industry. More relevant here is that petroleum is the source of hydrocarbon solvents.

In many petroleum producing areas the crude oil comes to the surface and so has always been available for collection and use. This is so, for example, at La Brea, Los Angeles and in the region of Baku, on the Caspian, and for centuries before the development of the petroleum industry people resorted to these areas to collect the oil for use as fuel for lighting or heating and even for medicinal purposes. The properties of the material can vary widely and sometimes it exudes as quite a light oil, possibly a natural distillate, which can be used as a solvent.

A series of arbitrary fractions boiling over different ranges is obtained by the distillation of crude petroleum. Light petroleum or gasoline, used for motor car fuel, now has added materials to alter its properties but basically it is the fraction boiling between about 70 and 175°C. Thus its main components are heptane and octane (see *Table 1.1*). The lower boiling range solvents are known as petroleum spirit, while these and other fractions also go by a confusing variety of other names. Thus they may be called naphtha, ligroin and benzine (not benzene).

Kerosene usually refers to the fraction of boiling range about 175–290°C and it contains the hydrocarbons between C_{10} and C_{16}. A fraction intermediate between light petroleum and kerosene, of which about 80% boils between 155 and 195°C, is known in the paint and varnish context, as

turpentine substitute. A similar fraction is known as Stoddard solvent while several manufacturers produce their own branded solvents of a like nature but perhaps differing boiling ranges. All these solvents contain a proportion of unsaturated and aromatic hydrocarbons in addition to the saturated ones and this materially affects the solvent properties.

Hydrocarbons are important as solvents for both natural and synthetic resins in the preparation of varnishes, and their ability to dissolve these materials and keep them in solution once dissolved is very dependent on the aromatics content. Since this is liable to vary from batch to batch, problems of insolubility sometimes arise. Unfortunately an analysis of the solvent is rarely provided by the supplier and is difficult for the user so the problem is hard to control.

Further materials are obtained by continuation of the distillation above the kerosene range. Liquid paraffin or Nujol comes next followed by the so-called petroleum jelly (Vaseline). Then follows paraffin wax with hydrocarbons ranging from C_{22} to C_{27} which is dealt with later among the other waxes (4.3.3). The undistillable residue is equivalent to asphalt or bitumen (5.1).

1.2 Compounds with functional groups

At the beginning of this chapter it was stated that other elements, and particularly oxygen and nitrogen, enter into the composition of many organic compounds. These elements, those bonded to them, and the type of bonds involved form centres having particular chemical properties within the molecule which often largely determine the properties and reactions of the molecule as a whole. Such groupings are known as functional groups. Oxygen is bivalent and nitrogen trivalent which means that several different types of groups can be formed from each of them. The halogens – fluorine, chlorine, bromine, and iodine – are monovalent and consequently tend simply to substitute for hydrogen linked to carbon.

1.2.1 Halogenated compounds: alkyl halides

In principle any or all of the hydrogen atoms directly linked to carbon may be replaced by any of the four halogens. This may be illustrated by reference to methane and chlorine. Successive replacement of the four hydrogens leads to chloromethane (methyl chloride) CH_3Cl, b.p. $-24°C$,

dichloromethane (methylene chloride) CH_2Cl_2, b.p. $40°C$, trichloromethane (chloroform) $CHCl_3$, b.p. $61°C$, and tetrachloromethane (carbon tetrachloride) CCl_4, b.p. $76.5°C$. The last three of these are important solvents having the advantage that they are not inflammable. Both carbon tetrachloride and chloroform are, however, rather poisonous and the latter is now no longer used as an anaesthetic, but alkyl halides find a variety of other uses.

The mixed fluorochloromethanes, CCl_3F, CCl_2F_2, and $CClF_3$, are used under the name 'Freon' as refrigerants and propellants in aerosol cans, but this is being increasingly phased out on account of their seemingly being responsible for damage to the ozone layer in the stratosphere. Methyl bromide, CH_3Br, a gas at normal temperatures, is an important fumigant for destroying woodworm etc. but unfortunately it appears that it too is a danger to the ozone layer and will no doubt also be eventually phased out. Carbon tetrachloride was at one time used for dry-cleaning but its place was long ago taken by other halogenated solvents. There is now, however, a general suspicion of these too on health and environmental grounds and there has been some return to the use of petroleum solvents despite their inflammability.

1.2.2 Oxygenated compounds

The most highly oxidized state of carbon is to be found in carbon dioxide, CO_2, which may be considered to have structure $O=C=O$. Such a compound evidently cannot be the first of a homologous series since it has no replaceable hydrogens to be substituted by a CH_3 group; it stands alone. Other oxidation states of the carbon atom are indicated by the following formulae:

$$HCH_2-OH \qquad HC\!\!\nearrow^{\!O}_{\!\searrow H} \qquad HC\!\!\nearrow^{\!O}_{\!\searrow OH}$$

methanol methanal methanoic acid
 (formaldehyde) (formic acid)

These represent compounds with a hydroxyl group, a carbonyl group, and a carboxyl group respectively. Each is the lowest member of a homologous series.

1.2.2.1 Alcohols

Compounds with a hydroxyl group are known as alcohols, after the common name of the best known

member of the group, ethyl alcohol or ethanol. The boiling points of the lower members of the series are given in *Table 1.2*. It is at once observable that introduction of the hydroxyl group results in a very marked raising of the boiling point. Methanol, for example, boils at 64°C whereas methane is a gas with boiling point −182°C. This is due to a phenomenon known as hydrogen bonding which is most easily explained in terms of the water molecule, H_2O. The $O-H$ bond is slightly polarized so that there is a partial charge on the oxygen and hydrogen atoms:

$$\overset{\delta^+}{H} - \overset{\delta^-}{O} - \overset{\delta^+}{H}$$

The oxygen atom has two unshared pairs of electrons in its valency shell and these associate themselves with the partial charge on the hydrogen atoms of other water molecules forming a weak bond, represented by a dotted line:

etc

The molecules being thus weakly linked together, the vapour pressure is diminished and the boiling point raised. This is why water has such a very much higher boiling point than, say, hydrogen sulphide, H_2S, or hydrogen chloride, HCl, despite the higher molecular weights of these compounds. The same effect occurs with alcohols to result in their higher than expected boiling points. It is also the reason for the ready miscibility of the lower alcohols with water: hydrogen bonds can be formed between them.

As the homologous series is ascended the effects of hydrogen bonding become less observable, outweighed as they are by the effects of the longer hydrocarbon chain. Butanol (C_4) is only partially soluble in water while above C_6 the alcohols are virtually insoluble. Alcohols are described as primary, secondary, or tertiary according to whether the hydroxyl group is on a primary, secondary or tertiary carbon atom.

A word should be said here regarding *polar* and *non-polar* solvents. The terms are loose ones but in effect refer to whether the solvent is miscible or immiscible with water — hydrophilic or hydrophobic in yet other terms. As well as determining miscibility with other solvents, position on the polar−non-polar scale (which might be thought of as running from water to saturated hydrocarbons) also determines what compounds will dissolve (or swell, in the case of cross-linked polymers) in the solvent in question. The situation is summed up by the simple idea of like dissolves (or mixes with) like.

A more sophisticated treatment of solubilities is provided by consideration of the *solubility parameter*, an experimentally determined index of solvent power[1−5], but discussion of this belongs in the realm of thermodynamics rather than organic chemistry.

The *ethers* are formed by replacing the hydrogen atom of the hydroxyl group by an alkyl group. Ethoxyethane (diethyl ether; also known simply as ether), $(C_2H_5)_2O$, is a liquid boiling well below ethanol itself despite its higher molecular weight. This is because it has lost the ability to form hydrogen bonds. Ethers are chemically rather unreactive compounds though when the ether group is part of a composite grouping, as in the hemiketals and ketals found in the sugars (6.1), it reacts more readily.

Table 1.2 Some lower alcohols

Common name	Systematic name	Formula	M.W.	b.p. (°C)
Methanol	methanol	CH_3OH	32	64.5
Ethanol	ethanol	C_2H_5OH	46	78
Propanol	propan-1-ol	C_3H_7OH	60	97
*iso*propanol	propan-2-ol	$(CH_3)_2CHOH$	60	82.5
Butanol	butan-1-ol	C_4H_9OH	74	118
*iso*butanol	3-methylbutan-1-ol	$(CH_3)_2CHCH_2OH$	74	107
sec-butanol	butan-2-ol	$C_2H_5CH(CH_3)OH$	74	99.5
tert-butanol	2-methylpropan-2-ol	$(CH_3)_3COH$	74	83
Pentanol	pentanol	$C_5H_{11}OH$	90	138
Decanol	decanol	$C_{10}H_{21}OH$	158	229
Eicosanol	eicosanol	$C_{20}H_{41}OH$	298	369 (m.p. 65.5)

1.2.2.2 Carbonyl compounds

These can be made from the corresponding alcohols by oxidation and are of two kinds. Oxidation of a primary hydroxyl group gives an aldehyde while oxidation of a secondary hydroxyl gives a ketone. The former has a hydrogen atom on the same carbon atom as the carbonyl group while the latter does not. A tertiary alcohol cannot be oxidized without rupture of carbon–carbon bonds.

Ketones are useful solvents, the lower molecular weight compounds being miscible with water. Propanone (acetone), $(CH_3)_2CO$, is the most familiar such compound. Aldehydes find little use as solvents as they are rather reactive chemically and easily oxidized and autoxidized (i.e. spontaneously oxidized by the oxygen of the air) to the corresponding carboxylic acids. Ketones, on the other hand, cannot be further oxidized without breaking carbon–carbon bonds.

Aldehydes and ketones undergo numerous interesting types of chemical reaction, very important in synthetic organic chemistry but less so in the present context. Such reactions are mainly a consequence of the fact that the carbonyl bond is partially polarized: the oxygen atom abrogates to itself more than its share of the valence electrons and consequently carries a slight negative charge, the carbon atom being correspondingly positive:

$$R^1 - \overset{\overset{\textstyle O^{\delta-}}{\|}}{\underset{\delta+}{C}} - R^2$$

1.2.2.3 Carboxylic acids

These form an important class of organic compounds both in their own right and for their ability to form compounds with alcohols called esters, and salts with many metals. As mentioned above they are formed by the further oxidation of aldehydes. Since oxidation cannot proceed still further without rupture of carbon–carbon bonds (which needs powerful reagents or energetic conditions) the carboxyl group is a stable one, and acids often constitute the stable end products of natural autoxidation reactions.

The properties of some of the lower acids are shown in *Table 1.3*. As can be seen they have still higher boiling points than their corresponding alcohols. This is because hydrogen bonding is even stronger with carboxylic acids which form a sort of dimer with an eight-membered ring structure:

$$R - C \underset{\textstyle O - H \cdots O}{\overset{\textstyle O \cdots H - O}{<}} C - R$$

The most familiar of the lower fatty acids, as the series is sometimes called, is ethanoic acid (acetic acid), the acid in vinegar, in which it has been formed by the oxidative transformation of ethanol by a yeast. The higher acids, lauric, myristic, palmitic, and stearic, are important components of oils and fats and so are discussed more fully in Chapter 3, devoted to them. The nature of acidity must now be explained. As mentioned above, the carbonyl group is slightly polarized resulting in a small negative charge on the oxygen atom and an electron deficiency on the carbon. This deficiency can, however, be supplied by donation from the hydroxyl oxygen, especially if its hydrogen atom is given up as a hydrogen ion:

$$RCOOH \longrightarrow R - C \overset{\textstyle O}{\underset{\textstyle O^-}{<}} + H^+$$

Table 1.3 Some carboxylic acids

Common name	Systematic name	Formula	M.W.	m.p. (°C)	b.p. (°C)
Formic	Methanoic	HCOOH	46	8.5	100.5
Acetic	Ethanoic	CH_3COOH	60	17	118
Propionic	Propanoic	CH_3CH_2COOH	74	−22	141
Butyric	Butanoic	$CH_3(CH_2)_2COOH$	88	−5	163
Valeric	Pentanoic	$CH_3(CH_2)_3COOH$	102	−35	187
Capric	Decanoic	$CH_3(CH_2)_8COOH$	172	32	268
Lauric	Dodecanoic	$CH_3(CH_2)_{10}COOH$	200	48	—
Myristic	Tetradecanoic	$CH_3(CH_2)_{12}COOH$	228	58	—
Palmitic	Hexadecanoic	$CH_3(CH_2)_{14}COOH$	256	64	—
Stearic	Octadecanoic	$CH_3(CH_2)_{16}COOH$	284	69	—

The overall effect is ionization of the hydroxyl group to yield a proton and the carboxylate anion: the extent to which this ionization takes place (i.e. the proportion of molecules ionized and thus the hydrogen ion concentration) determines the strength of the acid. In carboxylic acids the tendency to ionization is somewhat diminished by the electron-donating capacity of the hydrocarbon chain on the carboxyl group, and consequently they are not very strong acids. The lowest member of the family, methanoic acid (formic acid), which has no hydrocarbon group but only a hydrogen atom, is a much stronger acid than the others.

It should be noted that the carboxylate anion can exist in so-called *resonance forms* (also known as *canonical forms*), that is to say forms which result simply from a shift of electrons. In fact the ion is a sort of half-way form between these two with the negative charge distributed over both oxygens:

$$RC\underset{O^-}{\overset{O}{\Big\langle}} \rightleftharpoons RC\underset{O}{\overset{O}{\Big\langle}}{}^- \rightleftharpoons RC\underset{O}{\overset{O^-}{\Big\langle}}$$

This spreading of the charge means lower energy of formation and greater stability. The concept of resonance is an important one and will be met with again later.

As already indicated in connection with hydrogen bonding, even the hydroxyl group on its own, as in alcohols, has a very small tendency to ionize and so has some acid character. When a hydroxyl group is attached to a benzene ring the resulting compound, known as a phenol, is distinctly more acidic than an alcohol because the charge resulting from ionization can be distributed by resonance:

Carboxylic acids, in common with the strong 'mineral' acids such as hydrochloric, sulphuric acid etc., form salts with metals; that is to say the hydrogen ions are replaced by metal ions. Salts of the longer chain acids are commonly known as soaps and they are formed during the saponification of esters with alkali, which again will be discussed later.

Carboxylic acids react with alcohols under suitable conditions to form compounds known as esters:

$$R^1OH + R^2COOH \longrightarrow R^1-O-\overset{\overset{\textstyle O}{\|}}{C}-R^2 + H_2O$$

Esters are stable compounds and important to us as major constituents of the fats and some of the waxes, under which heads they will be discussed at more length.

Esters are also of importance as convenient *derivatives* for handling both acids and alcohols under particular circumstances. Thus alcohols are very readily converted to their acetates: this group is unaffected by oxidizing agents yet the alcohol can readily be regenerated by treatment with alkali. Again acids are rather high-boiling and for certain analytical applications, such as gas chromatography, a lower boiling derivative is needed. This is provided by the methyl esters which are easily made using any one of several simple methods. The need to derivatize functional groups in some way will be often encountered in the following pages.

A number of esters of the lower carboxylic acids with the lower alcohols, for example ethyl ethanoate (ethyl acetate) and pentyl ethanoate (amyl acetate), are important as solvents for particular applications. Such esters have characteristic fruity smells and are indeed the compounds responsible for the flavours of many fruits.

1.2.3 Compounds containing nitrogen

Nitrogen is trivalent, as observable in its most familiar compound ammonia, NH_3. The simplest organic compounds of nitrogen can be thought of as compounds in which one or more of the three hydrogen atoms of ammonia are replaced by alkyl groups, such compounds being known as amines, thus: aminomethane (methylamine), CH_3NH_2; methylaminomethane (dimethylamine), $(CH_3)_2NH$; and dimethylaminomethane (trimethylamine), $(CH_3)_3N$.

These amines are bases, as is ammonia itself. The nitrogen atom in them has a pair of unbonded electrons in its outermost valency shell which it very readily shares with an electrophile such as the proton, thus taking on the positive charge itself. This happens even in water solution so ammonia and the amines are present in such a solution partially as the hydroxides, NH_4OH, RNH_3OH etc. Stable salts are formed with the strong acids, e.g. CH_3NH_3Cl, methylamine hydrochloride.

It is probably this basic character, which allows ready dissolution of acidic materials, that renders amines, including ammonia, useful as solvents and

cleaning agents. However there are other ways also in which amino compounds have a place in the field of detergents. Even the hydrogen atom of the salts of tertiary amines, $(R)_3N^+HX^-$, can be substituted by an alkyl group to yield the quaternary salt, $(R)_4N^+X^-$. When one or more of the four alkyl groups, R, is a long (say C_{16} or C_{18}) hydrocarbon chain then the compound forms one of the cationic surfactants, important as components of laundry detergents and fabric conditioners[6] though not so far much used in conservation.

Quaternary amine salts, with a range of different substituents including aromatic and substituted aromatic groups, are important biocides, i.e. compounds with bactericidal and fungicidal properties. In addition to medicinal use they find applications in preventing mildew and as preservatives[7].

The range of possible substituent hydrocarbons naturally also includes cycloalkanes and aromatic compounds, for example:

aminocyclohexane
(cyclohexylamine)

aminobenzene
(aniline)

Nitrogen atoms can also form an integral part of a ring system as in the important compound pyridine (whose systematic name azine is rarely encountered):

The formal resemblance to benzene is evident and indeed pyridine does behave like an aromatic compound. Like the amines it is also a base, forms salts, and is a powerful solvent. Compounds such as pyridine, containing an element other than carbon in the ring system, are known as heterocyclic compounds. There are many different kinds of such ring systems, which can include oxygen and sulphur atoms as well as nitrogen, and some will be encountered in the section on dyestuffs.

The amino group can also replace the hydroxyl group in a carboxylic acid, the resulting compound being known as an amide, for example:

The basic character of the amino group is here reduced by the electron-attracting carbonyl group but not enough to render it significantly acid like a carboxylic acid. Thus amides do not form stable salts either as cation or anion but one or both hydrogens can none the less be replaced by alkyl groups to give a sort of ester-equivalent:

$HCONH_2$
methanamide
(formamide)

$HCONHCH_3$
methylmethanamide
(methylformamide)

$HCON(CH_3)_2$
dimethylmethanamide
(dimethylformamide)

The last of these is an important solvent which has its uses even in picture conservation.

Monosubstituted amides can be thought of formally either as products of reaction of an amine with a carboxylic acid or of an amide with an alcohol, both with elimination of water. In fact they cannot be made directly by either of these methods but when subjected to acid hydrolysis they yield the amine and carboxylic acid.

Proteins are polyamides, made up from amino acids. These have both amino and carboxylic acid groups on each molecule and consequently are able to combine together to form long chains (Chapter 7).

References

1 FELLER, R. L. , STOLOW, N. and JONES, E. H., *On Picture Varnishes and their Solvents*, Case Western Reserve University Press, Cleveland and London (1971)

2 BURRELL, H., 'The challenge of the solubility parameter concept', *J. Paint Technology*, 40 (1968), 197–208

3 GARDON, J. L., 'The influence of polarity upon the solubility parameter concept', *J. Paint Technology*, 38 (1966), 43–57

4 HEDLEY, G., 'Solubility parameters and varnish removal: a survey', *The Conservator*, 4 (1980), 12–18

5 VARIOUS AUTHORS (OIL AND COLOUR CHEMISTS' ASSOCIATION, AUSTRALIA), *Surface Coatings. Vol. I – Raw Materials and their Usage*, 2nd edition, Chapman and Hall, London, (1983), 262–7

6 PUCHTA, R., 'Cationic surfactants in laundry detergents and laundry after treatments', *J. Amer. Oil Chem. Soc.*, 61 (1984), 367–76

7 SCHAUEFELE, P. J., 'Advances in quaternary ammonium biocides', *J. Amer. Oil Chem. Soc.*, 61 (1984), 387–9

Bibliography

ASHLEY-SMITH, J. (Editor), *Science for Conservators. Book 1 An Introduction to Materials; Book 2 Cleaning; Book 3 Adhesives and Coatings*, Crafts Council, London (1982–3)

FELLER, R. L., STOLOW, N. and JONES, E. H., *On Picture Varnishes and Their Solvents*, revised and enlarged edition, Case Western Reserve University Press, Cleveland, (1971)

INGOLD, C. K., *Structure and Mechanism in Organic Chemistry*, 2nd edition, G. Bell and Sons, London (1969)

MORRISON, R. T. and BOYD, R. N., *Organic Chemistry*, 3rd edition, Allyn and Bacon, Boston (1973)

NOLLER, C. R., *Chemistry of Organic Compounds*, 3rd edition, W. B. Saunders Co., Philadelphia and London (1965)

NONHEBEL, D. C. and WALTON, J. C., *Free-radical Chemistry*, Cambridge University Press, Cambridge (1974)

PINE, S. H., HENDRICKSON, J. B., CRAM, D. J. and HAMMOND, G. S., *Organic Chemistry*, 2nd edition, McGraw-Hill International Book Co., New York (1981)

ROBERTS, J. D., STEWART, R. and CASERIO, M. C., *Organic Chemistry: Methane to Macromolecules*, W. A. Benjamin, Menlo Park, CA (1971)

STREITWIESER Jr., A. and HEATHCOCK, C. H., *Introduction to Organic Chemistry*, Macmillan Pub. Co., 2nd edition, New York (1981)

WALLING, C., *Free Radicals in Solution*, Wiley, New York (1957)

2

Analytical methods

Analysis is a broad term covering a number of different objectives. For organic chemists in industry or the universities the various methods of instrumental analysis are often directed towards the study of the chemical structure of newly made or newly isolated compounds. In the field of museum studies, however, the aim is primarily to identify particular raw materials or detect their presence in what may be complex and degraded mixtures such as paint media. It follows that some methods which are of great value in revealing details of chemical structure may have little relevance to the problems of analysis in the museum.

Analytical approaches fall into two broad classes: spectrometric and separation methods, the latter having come to mean almost exclusively the various forms of chromatography.

Spectrometric methods are at their most powerful when dealing with chemically homogeneous materials, i.e. single compounds, whereas chromatography in its various forms is designed for separating mixtures into their components, either as a first step towards their individual study or simply in order to produce a pattern of some kind which is characteristic for the raw material. The following descriptions of methods concentrates more on those which have proved of value for museum materials.

2.1 Separation methods – chromatography

2.1.1 Column chromatography

The name chromatography was introduced by the Russian botanist Tswett who was the first to observe the separation of coloured plant pigments adsorbed on a column of powdered solid (calcium carbonate) contained in a glass tube, when a solvent (petroleum) was passed through it (a brief history of this and other aspects of chromatography is given by Heftman[1]).

Tswett developed the process as an efficient separation method for such pigments and although his work was virtually forgotten for twenty-five years it was revived in the 1930s to become a standard method for separating the components of mixtures of organic compounds (colourless as well as coloured) on a preparative scale. The method – column chromatography – exemplifies the approach of chromatography in general: partition between two phases, a stationary and a moving one. Here the stationary phase is a solid and the moving one a liquid.

Tswett listed many possible solid adsorbents but in practice the preferred materials have been reduced to two: alumina (aluminium oxide) and silica gel (hydrated silicon dioxide). The liquid moving phase, known as the eluent, is usually a series of organic solvents and intermediate mixtures of these, starting with the non-polar alkanes (petroleum ether or hexane) and going on to aromatic solvents, ethers and alcohols.

The theory of adsorption on solids need not be entered into here; intuitively it can be appreciated that more polar compounds, for example those with hydroxyl or carboxyl groups, will be more strongly adsorbed on polar substrates such as alumina than will non-polar hydrocarbons. The non-polar compounds will therefore be more readily displaced by adsorption of solvent than will the polar compounds and so will move faster than these down the column

14

of adsorbent, in a state of dynamic equilibrium between the adsorbed and dissolved states. So the components of the original mixture are separated out and can, if wished, be washed off (eluted) one by one from the end of the column.

Another commonly used adsorbent is silica gel. With this material it is uncertain whether one is getting a true solid/liquid partition or rather a partition between two liquids – the moving phase, and water permanently adsorbed on the silica gel. More certain liquid/liquid partition is observed in so-called reverse phase methods. A non-polar liquid phase is held in position by an inactive support such as kieselguhr (often treated with silylating agents to render it hydrophobic) while a polar moving phase such as methanol/water acts as eluent. In such systems the order of elution is, of course, reversed; the more polar compounds eluting before the non-polar. While such an arrangement is now little used in preparative chromatography it still holds its own for the analytical technique of high performance liquid chromatography, discussed below.

Another type of liquid–solid chromatography involves the use of ion-exchange resins as the stationary phase. These materials are high polymers incorporating anionic or cationic groups or sometimes both which, being immobilized on a resin, cannot react together and neutralize one another. Such resins absorb bases or acids by forming salts with them and this absorption may be reversed by treatment with aqueous solutions of suitable pH. The method has found most application to the analysis of amino acids from protein hydrolysates, the so-called 'amino acid analyser' having been developed to meet the frequent need for such analyses for medical purposes. A sulphonic acid resin (i.e. one carrying the group $-SO_3H$) is commonly employed and the amino acids are eluted sequentially by a gradient of pH from 2.875 to 5.00, being detected and estimated by the intensity of the colour reaction with ninhydrin, carried out automatically. The method is a useful one, limited only by the size of sample required (about 0.3 mg), and it has been applied to museum materials[2].

2.1.2 Paper and thin-layer chromatography

Column chromatography is not suited to handling small quantities of materials and so is not useful as an analytical method. A great advance from this viewpoint was the discovery and development, in the 1940s, of paper chromatography[3]. Here the stationary phase is paper, or more correctly a cellulose/adsorbed water phase, and the mobile phase is a water-saturated solvent mixture. The sample is applied, in solution, as a small spot a short way in from one end of the paper strip or sheet. This end is then dipped into a trough of solvent which moves along the paper by capillary action. The components of the mixture are more or less completely separated into a series of individual spots which may be revealed (in the case of colourless compounds) by spraying the dried paper chromatogram with a suitable colour reagent.

Useful as it was in its day, paper chromatography was progressively replaced by the more convenient thin-layer chromatography (TLC) after about 1960. Paper chromatograms took several hours to develop with solvent and the colour reagents which could be used were limited by the vulnerability of the paper support. In TLC a solid adsorbent, commonly silica or alumina, is spread as a thin film on glass plates and the chromatography carried out essentially as for paper, the rigidity of the plates making for easier handling and greater permanence. Furthermore the solvent moves much more quickly – the chromatography is usually finished within half an hour – while the finer grain of the adsorbent, as compared with paper, gives better separations and less diffusion of spots. Originally most workers spread the adsorbent on glass plates themselves; nowadays it is more common to buy plates ready prepared as these often give better results.

Thin-layer chromatography is a simple and inexpensive analytical method which is sensitive and can be useful for certain classes of materials but it also has some drawbacks. Separations can be incomplete and spots may tend to be blurred by streaking in the presence of significant amounts of polymerized or highly oxidized materials – a common state of affairs with old natural materials. It is, moreover, not well adapted to giving quantitative results and so is unable to distinguish between materials which only differ by having different proportions of the same constituents.

2.1.3 Gas–liquid chromatography

The technique of gas–liquid chromatography (GLC) was developed from the early 1950s[4,5]. Here the partioning of the mixture takes place between a stationary liquid phase and a moving gas phase. Although initially designed for the separation of relatively volatile compounds, improvements in the various components of the system now permit separation of compounds of quite high molecular

weight. Because of its great usefulness it will be described in rather more detail than the preceding methods.

The essential parts of the system comprise:

A long narrow tube or 'column' containing the stationary phase;

A temperature-controlled oven in which the column is mounted;

A supply of suitable inert gas and pressure controls to force it through the column at the required rate;

A detection device at the exit from the column which responds to compounds as they are eluted;

A chart recorder to record the response of the detector or, increasingly nowadays, a computer to receive the data and process them for printing out in whatever form is required.

The system is shown diagrammatically in *Figure 2.1*.

The column can take several forms. The original system of *packed columns*, still often used, consisted of a glass or metal tube a metre or two in length and a few millimetres in diameter, bent or coiled to fit conveniently in the oven and packed with uniformly graded inert material (kieselguhr, a diatomaceous earth, or something similar) coated with the stationary liquid phase. A later development was the use of *capillary columns*, in which the internal diameter was only between 0.2 and 2 mm and the length might be up to 100 m. These might be *open tubular*, in which the stationary phase simply coated the internal wall, or *support coated*, in which the walls also had a coating of solid support. Although sometimes made of metal, these columns were originally usually of glass and were consequently very fragile.

More recently columns of flexible quartz have been perfected which are much easier to use. The separation efficiency of capillary columns is very much greater than that of packed columns but as the amount of stationary phase is so small they can only handle very small quantities of material. However, since detectors can now be very sensitive, this is no disadvantage and, indeed, renders them particularly suited to the small sample sizes available from art works.

The *stationary phase* must necessarily be a high-boiling liquid if it is not to volatilize significantly into the carrier gas stream. Hundreds of different materials have been used in the past and they have usually been roughly divided into 'polar' and 'non-polar' types. The 'polar' materials have generally been polyesters of high molecular weight while silicone polymers have most commonly provided the 'non-polar' phases.

Formerly much time and trouble was put into finding suitable phases for particular separations but with the increased efficiency of the newer capillary columns this is now less necessary and a silicone phase will commonly serve for many different chemical types. Volatility (or decomposition) of the stationary phase is the factor which normally limits the upper temperature at which gas chromatography may be conducted and thus also the range of compounds which may be examined by it. A development which has reduced this problem is that of *bonded phases* in which the stationary phase is chemically bonded (commonly through oxygen links) to the glass or silica of the columns.

Column ovens were initially designed to maintain the column at a fixed temperature within a possible range. This has the advantage that, provided other factors such as gas flow rate are also kept constant, the time of elution of a particular compound (the retention time), or the elution time relative to a known compound (the relative retention time), is

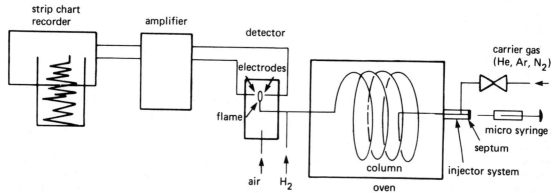

Figure 2.1 Schematic diagram of a gas chromatograph.

also a constant and so aids identification. The disadvantages are that it is not always easy to find an optimum temperature for a mixture of compounds of widely differing volatilities: either the early-eluting compounds are too compressed together or the later ones are too delayed and emerge as broad, low peaks after an inconveniently long time.

A solution is provided by *temperature programming*, in which the oven temperature is progressively raised at a suitable rate during the run so as to speed up the emergence of the later peaks. In this case retention times become unreliable indicators of identity and a more sophisticated measure, known as the Kovats retention index (which relates the retention time to that of the closest straight chain hydrocarbon), is commonly utilized.

Gases used as the mobile phase are quite few in number, usually being selected from among nitrogen, argon, or helium. It used to be thought that hydrogen, being inflammable, was too dangerous for use as a carrier gas but recently it has been increasingly used, particularly for capillary columns where flow rates are very low. The gas used does influence the separations though usually little consideration is given to this.

Another important factor is that it should not be too viscous at high temperatures. Viscosity of gases increases with temperature, with consequent decline of flow rate at constant pressure. Most chromatographs now incorporate flow controllers which give constant flow rate (by increasing the pressure).

Detectors may be of several types. Early kinds were based on gas density measurement or detection of thermal conductivity changes in the emerging gas stream but these were not very sensitive. The most generally employed for many years now is the hydrogen flame detector. The gas from the column is mixed with hydrogen and burned at a jet in a supply of air. A potential is maintained across this flame by means of suitable electrodes and the current which flows is amplified and recorded on the strip chart recorder.

The conductivity of a hydrogen flame is normally extremely low but as organic compounds emerge from the column and are burnt, ions are formed and the conductivity, and hence the current flowing, are greatly increased, resulting in a recorder response. When plotted, emerging compounds are therefore seen as peaks on a baseline and the areas of these are proportional to the amounts of the compounds concerned, so permitting their quantitative estimation.

Other detectors are also available but these are mostly for special groups of compounds. The electron capture detector, for instance, responds only to compounds containing halogens and is extremely sensitive to these, a property utilized in the detection of the minute traces of pesticides in the environment. Other detectors are specific for nitrogen- and phosphorus-containing compounds. In the combined technique of gas chromatography – mass spectrometry (see below) the mass spectrometer itself acts as the detector.

2.1.4 Treatment of samples

So far nothing has been said regarding the chemical form in which samples are subjected to the chromatographic methods described. It goes without saying that samples must be in solution, so that they can be applied to thin-layer plates or injected into a gas chromatograph, but this often has to involve rather more than simply dissolving in a solvent.

Natural polymeric materials have commonly to be broken down into their individual 'building blocks' – fatty acids, sugars, amino acids or whatever – before subjecting these to separation procedures. Furthermore these individual compounds are themselves not always suitable but need to be derivatized (1.2.2.3) in order to make separations feasible. This is particularly so in the case of gas chromatography.

Compounds of each of the three classes just mentioned are indeed insufficiently volatile to be analysed directly by this method and have to be converted to esters to permit them to be run. This added complication means that derivatization procedures must be fairly simple, especially when very small quantities are being handled. More will be said about this when specific materials and methods are presented.

2.1.5 Pyrolysis gas chromatography

In certain cases – synthetic polymers for example – there is no way in which a sample may be converted to volatile derivatives. Indeed a polymer does not consist of distinct components which can be separated. Decomposition of the material by heating – pyrolysis – sometimes yields characteristic low molecular weight products and the technique of pyrolysis gas chromatography effects this pyrolysis on a small scale, commonly in the gas stream at the start of the gas chromatograph column, and then

directly separates the resulting volatile products in the usual way. Such a technique is of particular utility in identifying synthetic polymers as these commonly 'unzip' on heating to give the monomer or monomers of which they were originally made, thus leading to ready identification. The method has been applied with success to the identification of the synthetic resin medium and varnishes of modern paintings[6]. Where the pigments involved were synthetic as well as the medium the pyrolysis chromatogram was found to represent a sum of those of the individual materials[7]. It has also been used very successfully in identifying the medium of the faked Vermeers as a phenol–formaldehyde resin[8].

The technique has also been applied to natural materials such as paint media[9] and resins[10] with some success. More recent work on these lines has sought optimum conditions for the pyrolysis and chromatography and has built up a 'reference library' of pyrograms of major organic art materials[11,12]. The use of the technique for identification of carbohydrate gums is described in Section 6.7.

2.1.6 High performance liquid chromatography

Liquid–liquid chromatography has already been alluded to above. It was used to some extent in the early days as a preparative technique, but its adoption as a reliable analytical tool has only come about recently with the development of new methodology, particularly the necessary high-pressure, pulse-free pumps; extremely fine and uniform particle size (3–10 μm) column packings, with bonded stationary phase; and the microbore columns.

It is to these newer techniques that the name high performance (or high pressure) liquid chromatography (HPLC) is applied. The strength of the method lies in its applicability to all soluble compounds, but it is used mainly for those which are too involatile, however derivatized, to be separated by GLC.

The general layout of an HPLC system is not dissimilar to that for gas chromatography except that, since nearly all separations are carried out at ambient temperature, no oven is called for. Columns are now always of metal and often very short. A wide variety of column packings is now available and these are not confined simply to liquid–liquid systems: there are liquid–solid and ion-exchange systems also.

With bonded phases it is possibly more realistic to consider these also as liquid–solid rather than liquid–liquid. Reversal of the phases, with the less polar as the stationary phase, is common and even preferred as it allows for greater flexibility in adjustment of the composition of the mobile phase (and hence retention times) which often consists of water-miscible solvents with water.

With so-called 'conventional' LC, columns may be 15–30 cm in length with solvent flow rates of 0.5–2 ml min^{-1}. 'Fast' LC uses very short columns 5–10 cm long and flow rates of 2–4 ml min^{-1}. In a microbore system columns are commonly 50–100 cm long, only 1 mm in internal diameter, and have flow rates of only 10–100 μl min^{-1}.

Detectors for eluted compounds have proved to be more difficult to develop than was the case with GLC and no really sensitive universal type has appeared. Detection is usually based on changes in refractive index (impracticable with gradient elution, i.e. when there is progressive change of solvent composition), or ultraviolet absorption. Most compounds have some ultraviolet absorption and can thus be detected but as the absorption coefficients differ from compound to compound, it is difficult to obtain quantitative results. The wavelength used for detection is commonly variable and visible light absorption detectors are also available though these are commonly less sensitive owing to the lower absorption coefficients in this region even with coloured compounds. In some newer instruments there are facilities for recording the ultraviolet/ visible spectra of peaks, so further aiding identification. A notable application of this combined technique has been the analysis of red insect dyestuffs from textiles[13].

2.2 Spectrometric methods

Visible light is but a very small part of the *electromagnetic spectrum* which ranges from long wavelength radio waves at one end, through the infrared, visible, and ultraviolet to X-rays and gamma and cosmic rays of very short wavelength at the other (*Figure 2.2*).

The extent to which these forms of radiation can be absorbed by matter is dependent on chemical structure. Their absorption, or selective absorption, has consequences both for the absorbing material and for the radiation. The material which absorbs the radiation is raised in energy content and may

Frequency (Hz) / Wavelength (m)

Figure 2.2 The electromagnetic spectrum.

consequently undergo chemical change. This is not our concern here but will be discussed in Chapter 11.

The radiation which has undergone selective absorption is changed in that it now lacks, or is diminished in, the absorbed wavelengths. It is this modified radiation, the *absorption spectrum* (actually, of course, the *transmission spectrum*: the two are reciprocal), which gives clues to the structure of the absorbing material and so forms the basis of spectrometric methods of examination.

The principal spectral regions which are selectively absorbed by organic compounds in revealing ways are those of visible light and the neighbouring infrared and ultraviolet bands. These bands, or rather that part of them for which measurements are

practicable (and useful), cover the wavelengths between 200 nm (2000 Å) in the ultraviolet through to about 25 μm in the infrared.

The various units of measurement which may be encountered are related to each other as follows:

$$\frac{1}{\text{wavelength}} = \text{wavenumber} = \frac{\text{frequency}}{\text{speed of light}}$$

or

$$\frac{1}{\lambda} = \bar{\nu} = \frac{\nu}{c}$$

When λ is in m (metres), $\bar{\nu}$ in m^{-1} (per metre), μ in Hz (cycles per second), and c in $m\,s^{-1}$ (metres per second) we have for example:

$$\frac{1}{5 \times 10^{-7}} = 2 \times 10^6 = \frac{5.996 \times 10^{14}}{2.998 \times 10^8}$$

for green light of wavelength 5×10^{-7} m.

In practice metres are not often used for wavelengths as the result is cumbersome. Ultraviolet and visible light wavelengths are now generally expressed as nanometres, nm (10^{-9} m). However other units have often been used in the past and will still be encountered. They are:

micrometre (μm) or micron (μ)	$= 10^3$ nm	$= 10^{-6}$ m
millimicron (mμ)	$= 1$ nm	$= 10^{-9}$ m
Ångstrom (Å)	$= 10^{-1}$ nm	$= 10^{-10}$ m

The wavelength of the green light of the above example is therefore usually given as 500 nm. Because the wavelength of infrared radiation is of the order of a few micrometres, infrared spectra are most commonly calibrated in these units rather than the less convenient nanometres.

The relationship between wavelength and energy of radiation[14] is a simple one namely:

$$\epsilon = h\nu = \frac{hc}{\lambda}$$

where h is Planck's constant (6.62×10^{-34} J s), c the velocity of light ($m\,s^{-1}$), ν the frequency (in Hz) and λ the wavelength (m). This gives the energy, ϵ, of a single quantum of light of the specified wavelength in joules, the official unit of energy of the SI system. However, just as bond energies are almost always given per mole (1 mole = gram molecular weight of substance), rather than per molecule, so energies of particular wavelengths are often similarly expressed, the concept of 'mole' here implying a number of quanta equal to the number of molecules in a mole

of substance, namely Avogadro's number N (= 6.02322×10^{23}).

$$E = Nh\nu = \frac{Nhc}{\lambda}$$

Inserting values for the constants this comes down to

$$E = \frac{1.196 \times 10^5}{\lambda} \; ((\text{kJ mol}^{-1})$$

where λ is expressed in nm.

Bond strengths are still commonly reported in the organic chemical literature in kcal mol^{-1}. Including the conversion factor for kJ to kcal the formula becomes

$$E = \frac{2.857 \times 10^4}{\lambda} \; (\text{kcal mol}^{-1})$$

2.2.1 Infrared spectrometry

Infrared radiation comprises the invisible, but sensible radiation which we can detect coming from hot objects and other heat sources. We feel it because the matter of which we are composed absorbs it, selectively, in the same way as organic materials undergoing examination by infrared spectrometry absorb it.

The total energy of a molecule is made up of the sum of its bond (i.e. electronic) energies plus the kinetic energies associated with vibrational or rotational motions of the various component parts of the molecule. Vibrational energy levels are of the same order as those of the easily measurable infrared radiation band between about 2.5 to 25 μm (readily calculated from the formula above as being from 11.4 to 1.14 kcal mol^{-1}) and they can therefore be excited by the absorption of such radiation.

Infrared spectrometers now available are of two types. The older and less expensive, still most generally used, are dispersive; the newer non-dispersive. The meaning of these terms will become clearer as they are briefly described.

Conventional dispersive instruments are set up as follows. Infrared radiation from a suitable glowing source is split into two beams by mirrors: the sample and reference beams. The sample, suitably prepared (see below), is placed in the sample beam path and the infrared radiation which passes through it is then dispersed according to its wavelength by means either of a prism of non-infrared absorbing material (sodium chloride is still commonly used) or a diffraction grating.

By rotating either the dispersal device or a

suitable mirror placed in the light path, together with use of a suitable slit, it can be arranged that only a very narrow band of the dispersed radiation reaches a detector at any one time, sequentially from one end of the spectrum to the other. This detector measures the intensity of this band (as compared with the same band in the reference beam) and records the result as a plot of percentage transmission (or absorbance) against wavelength/wavenumber.

In non-dispersive instruments, known as Fourier-transform infrared spectrometers, the infrared which has passed through the sample is not dispersed but caused to be changeably out of phase with the reference beam by reflecting it from a moving mirror. Recombined with the reference beam it produces a low frequency interference pattern, or interferogram, which contains full intensity/frequency information for the spectrum. This can be extracted and expressed in the familiar form of an infrared spectrum by a mathematical procedure, carried out rapidly by computer, known as Fourier transformation. This method is much quicker than the former and multiple spectra can be accumulated and averaged. This eliminates random noise so even very small samples can still be made to yield good spectra.

Samples for dispersive infrared can be prepared in several ways. Soluble materials can be examined in solution in suitably non- (or little-) absorbing solvents. Insoluble material can be ground up with dispersant, such as liquid paraffin, to form a mull which is then confined between rock salt plates. However the most common and convenient method is to grind the sample very finely in an agate mortar with dry potassium bromide and press the resulting homogeneous powder in a small hydraulic press to form a semi-transparent disc, commonly referred to as a KBr disc. With Fourier-transform infrared spectroscopy (FTIR) the sample needs very little preparation if any, even diffuse reflectance giving good results.

The great value of infrared spectra to the practising organic chemist is to give information on functional groups present when determining the structure of a new or unidentified compound. The absorption bands to be expected of particular groups are now well established and tables of these are to be found in the specialized literature of the subject. The reverse proceeding – attribution of every band in the spectrum to a functional group – cannot always be done because of spread and overlap of bands.

The infrared spectrum of a compound is unique to it though spectra of compounds of a homologous series will naturally differ only marginally one from another. In principle therefore, identifications may be made by comparing spectra with those of likely known compounds and this is the basis for attempting to identify organic raw materials in this way.

Unfortunately the infrared spectrum of a complex mixture gives so many absorption bands that these often overlap to the point of yielding only broad envelopes of absorption with few distinctive features. This is exemplified in *Figure 2.3* which shows infrared spectra of a pure compound, hydroxydammarenone I, a constituent of dammar; fresh dammar resin; and material from an old oxidized dammar varnish film.

Despite this limitation, infrared spectra of some classes of museum material are useful for analysis. Stable materials such as beeswax, for example, give a characteristic spectrum even when thousands of years old. But conventional infrared is probably at its most useful in identifying synthetic materials, such as those used in conservation, for these generally have characteristic spectra which often permit identification without further tests. Large catalogues of infrared spectra exist which makes the search for possible matches quite easy, while authentic materials are also freely available for running standard spectra for comparison.

The development of FTIR is a promising one for a number of reasons. Firstly because of the possibility of obtaining good spectra from very small samples, as mentioned above, and also for the ability to display or process the spectra in useful ways. One of these is the subtraction of one spectrum from another – that of pigment from whole paint to give that of the medium for example. Granted this though, the overall result is still an infrared spectrum with the limitations of these as outlined above, and yielding much less information that does GLC–MS. The great advance probably lies more in the development of the use of the infrared microscope in conjunction with FTIR. Now it is possible to obtain so-called *dimensionally resolved* analytical results: from different layers or from specific inclusions within a paint cross-section, for example. This

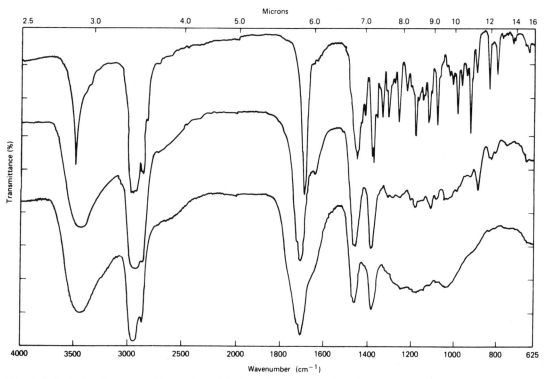

Figure 2.3 Infrared spectra of (*top* to *bottom*) hydroxydammarenone I (a dammar constituent); fresh dammar resin; dammar from a fifty year old film. While characteristic bands attributable to individual components can still be observed in the fresh resin, in the aged sample increased complexity of the mixture has lead to a general blurring.

means that possibilities begin to approach those for the analysis of the inorganic (pigment) components of paint, something which has been difficult to achieve by other techniques. Although characterization of the organic components will probably not get beyond the identification of broad categories – protein, oil etc. – the ability to do this within a single sample will be most useful.

The first edition of this book was able to refer to only one paper on the application of FTIR to conservation-related work[15]. Since then there has been quite an explosion of publications referring to use of the technique and some of these will be referred to in appropriate sections. A curious variation of FTIR, known as photothermal beam deflection, has been explored and used for *in situ* identification of the materials of an object[16].

A spectral technique which is related to infrared spectrometry, in that the spectrum results from laser-induced vibrations of the constituent groups of the sample, is use of the Raman spectrum obtained using the Raman laser microprobe. Since visible light is used as the exciting radiation, and the Raman-diffused radiation corresponds to the frequency of this plus or minus the vibrational frequencies, a conventional optical microscope only is needed. The Raman spectrum (infrared frequencies) is obtained after the requisite optical filtering and computer data processing. This method has been applied to the identification of very small samples of synthetic dyestuffs and pigments[17]. The Raman effect is however a very weak one and good spectra are not easy to obtain. It seems unlikely to be able to compete with FTIR and the infrared microscope.

2.2.2 Ultraviolet and visible spectrometry

The relatively low energies required to excite vibration and rotation in molecules correspond, as we have seen, to wavelengths in the infrared region. To break bonds within the molecule, or to excite the electrons involved in formation of those bonds to higher energy levels without necessarily breaking them, requires higher energies corresponding to the shorter wavelengths falling in the visible and ultraviolet regions.

Visible light is usually thought of as lying between roughly 380 and 700 nm (blue to red). Ultraviolet radiation lies between 10 and 380 nm but for purposes of studying absorption spectra only that part of this which is not absorbed by quartz (of which optical components of the spectrometer are

made) need be considered, namely from 200 to 380 nm, the near ultraviolet. It is easily calculated that absorption of light in the far ultraviolet region, say at 150 nm, involves energies of about 185 kcal mol^{-1}. This is well in excess of even the strongest bond energies in organic compounds (11.1.2) and can result in the emission of electrons and the rupture of the bonds. At the lowest end of the quartz ultraviolet, say at 200 nm, the energy is about 140 kcal mol^{-1} while at the beginning of the visible, at 400 nm, it is about 70 kcal mol^{-1}.

What kinds of electronic transitions do the energies of UV and visible wavelengths correspond to? The answer depends on the status of the electrons involved: non-bonding or bonding and, if the latter, then the kind of bonding. Single valence bonds are known as sigma (greek σ) bonds and the electrons involved as sigma electrons. Being of high energy such bonds absorb only in the far ultraviolet, and consequently compounds containing only sigma bonds show no measurable ultraviolet or visible spectra. The non-bonded electrons of hetero atoms – oxygen, nitrogen, halogens, and sulphur – are known as n-electrons. These are less firmly bound than sigma electrons and can be raised to an activated state by absorption of ultraviolet, in some cases in the near ultraviolet, but again these absorptions are weak and of little consequence.

The electrons involved in formation of a double bond are of two types: a pair of sigma electrons as in saturated compounds and a second pair which are known as π-electrons. A full discussion of π-bonding belongs to molecular orbital theory but from the point of view of electronic spectra it suffices to say that π-electrons are more loosely bound than sigma electrons, and progressively more so as the extent of conjugated unsaturation gets greater. This means that the energies required to excite these electrons to activated states (higher orbitals) becomes progressively less; consequently the region of light absorption moves into the near ultraviolet and, with highly unsaturated systems, into the visible.

Isolated double bonds have maximum absorption till just within the far ultraviolet at about 180 nm. This is very strong however and the peak slopes down into the near ultraviolet – the so-called 'end absorption' observed with all unsaturated compounds. Conjugated dienes absorb in the near ultraviolet: butadiene at 217 nm and cyclohexadiene at 256 nm. As is evident from these two examples, the actual position of the maximum is affected by structural factors such as configuration and the nature of substituents. It should also be said that the

absorptions due to electronic transitions actually occur at very specific wavelengths to give sharp bands. Unfortunately there are separate such absorptions for every vibrational and rotational level of the molecule, which results in so many bands that they merge to form a broad envelope.

With lengthening conjugated systems, absorption finally gets into the visible region and the compound is, in consequence, *coloured*. The polyene carotenoid pigments, for example, are bright yellow or orange due to their absorption maxima in the blue region. Thus β-carotene (Structure 2.1), with a total of eleven conjugated double bonds, has maxima at 483 and 452 nm (in light petroleum).

Coloured compounds result also from conjugation with other types of unsaturated groupings, such as ketones, and in other ways as will be seen in the discussion of pigments and dyestuffs in Chapter 10.

Ultraviolet spectra rather rarely prove of value in the examination of old museum materials since the spectra, broad from the start, become still less informative in admixture. Visible spectra do however find application to the study of coloured compounds: obviously for identification of dyestuffs on textiles but also for the difficult identification of those adsorbed on inert support and used for painting, known as lake pigments[18].

2.2.3 Fluorescence spectrometry

When electrons are excited to higher energy levels by the absorption of ultraviolet or visible light the enhanced energy may subsequently be dissipated in different ways. It may result in chemical change; it may simply be lost as heat; or it may be re-emitted as radiant energy of longer wavelength than the original exciting radiation. When this re-emitted radiation is in the visible region the result is known as luminescence or, more commonly, fluorescence. The fluorescence of many materials under an ultraviolet lamp is a well-known phenomenon and many attempts have been made to use it as a roughly

diagnostic method. More careful measurement of the actual visible spectrum of the emitted fluorescence of museum materials, both organic and inorganic, has also been made[19] though commonly these spectra tend to show rather broad and featureless bands with maxima which do not allow clear identification of the substrates by observing them. More recently, excitation of fluorescence using laser light of specific frequencies has been utilized and is claimed to have advantages over ultraviolet from a mercury lamp. The fluorescence spectra of both pigments and media in oil paintings have been recorded by this method and are said to permit their identification[20-22]. Likewise the fluorescence spectra of a number of Japanese dyestuffs on silk are reported to be sufficiently characteristic to permit their identification, being superior to their visible reflectance spectra in this respect[23,24]. Fluorescence and ultraviolet/visible spectra have been used to identify the yellow dyes on two third century Egyptian mummy cloths[25].

2.2.4 Nuclear magnetic resonance spectrometry (NMR)

This technique has yet to demonstrate great usefulness for the analysis of natural materials and so can be given only a brief description here. It involves the interaction of atomic nuclei with very high frequency radio waves. Certain nuclei, among them those of hydrogen and the carbon isotope of atomic weight 13 (^{13}C), have a charge which spins about the axis of the nucleus, generating a magnetic dipole. If subjected to a strong magnetic field this dipole will normally be aligned in a parallel (stable) orientation to this field but can be made to 'flip' to an antiparallel (high energy, unstable) orientation by the absorption of energy from radiation of suitable frequency. In practice radio frequencies in the 60–220 MHz region provide the energy required (which is directly proportional to the strength of the applied magnetic field).

β-carotene

Structure 2.1

The precise frequency (for a fixed magnetic field) at which the nucleus absorbs energy (or *resonates*) depends upon its molecular environment (i.e. the amount of 'shielding' by surrounding groups) but the differences are very small, protons in different positions ranging over about 1000 Hz (at 60 MHz). By scanning over this range (or, in practice, by leaving the frequency constant and scanning the magnetic field) a spectrum of resonances is obtained which provides information on the functionality and position of hydrogen atoms in a molecule, the information being particularly useful for those on, or adjacent to, double bonds.

As is readily appreciated, the method is of great help in determining molecular structures but it is of limited use with complex mixtures. However it has been successful in the identification of the more stable organic materials such as waxes[26-28], and also hydrolysed archaeological fat samples[29]. Another application has been to the identification of organic materials such as pitch from shipwrecks[30].

[13]C magnetic resonance using a special technique known as 'magic angle spinning', which allows examination of solid samples, has proved to be of value with intractable, highly polymeric materials, such as the insoluble bulk of ambers, both European[31,32] and that from the Dominican Republic[33].

2.2.5 Mass spectrometry

The method of mass spectrometry, especially when combined with a separation method such as gas chromatography, is probably the most powerful tool available to the analyst of organic materials. It is a method different in kind from those just described and the term spectrometry, as applied to it, is somewhat misleading.

In essence energy, in the form of a stream of electrons, is applied to the vaporized compound under examination which becomes ionized. This ion (the molecular ion) is usually unstable and undergoes partial breakdown into a pattern of fragment ions which, separated according to their masses and measured in intensity, form the so-called mass spectrum. Such a spectrum gives valuable clues to the structure of an unknown compound and can also be used as a fingerprint for the identification of compounds whose spectra are already known.

Although simple in concept, mass spectrometry in practice requires complex and expensive apparatus including a computer for control of instrumentation and for data storage and handling.

2.2.5.1 The spectrometer

A mass spectrometer of conventional double focusing type is shown diagrammatically in *Figure 2.4*. It consists of three regions: the source with its associated sample inlet system, the analyser region, and the electron-multiplier detector. A system of backing and diffusion pumps maintains a low pressure within the spectrometer.

Sample introduction may be either of solid sample via the direct insertion probe, the sample being then vaporized by heating or, more usefully, directly from the outlet of a gas chromatography column. In either case sample in the gas phase diffuses into the ionization chamber where it is bombarded by a highly collimated stream of electrons, the energy of which may be varied.

At a certain energy level the sample will become positively ionized (by loss of an electron), and at higher energy levels fragmentation as well as ionization will occur. The positive ion fragments are directed out of the chamber by means of a repeller electrode maintained at a positive potential and the ion beam is then focused and accelerated by a potential of several kilovolts into the analyser region where separation by mass occurs. A double focusing system employing both electrostatic and magnetic fields ensures that each ion mass in turn is brought to focus on the detector over a short period, typically at a rate of 1 second per decade (faster on some instruments), i.e. one second from mass 1000 to mass 100; another second for mass 100 to mass 10. With an interscan time of say one second, mass spectra can be obtained every three seconds or so, thus easily coping with compounds rapidly emerging from a gas chromatograph. The detector takes the form of an electron multiplier working on a cascade system with gain up to 10^6.

The above double focusing type of instrument is rather bulky and heavy. An alternative type of mass filter which has great advantages in terms of faster scanning rates and multiple ion monitoring (particularly advantageous for use with capillary GLC analysis), as well as greater compactness and ease of use, is the quadrupole mass filter (*Figure 2.5*). Here ions produced in the same way as above are extracted from the source into a high vacuum environment between two pairs of rod electrodes (the quadrupoles), each pair being maintained at opposite polarity by a DC supply. An oscillating field is generated within the region by application of radio frequency alternating voltages on each pair of rods, as a result of which the ions execute a 'dance'

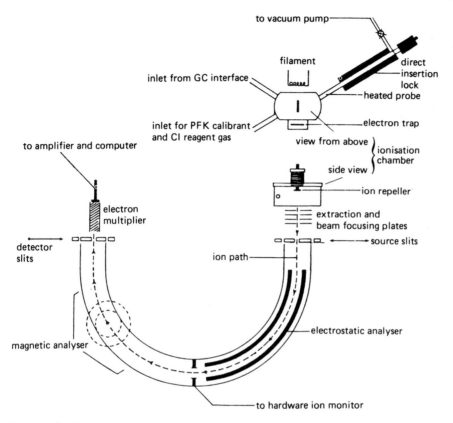

Figure 2.4 Diagram of a double focusing mass spectrometer.

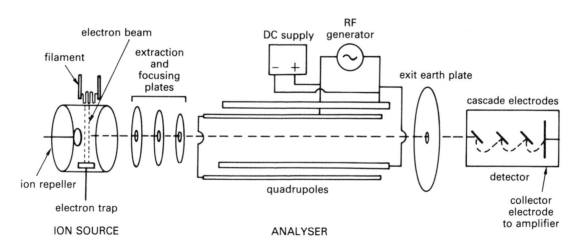

Figure 2.5 Diagram of a quadrupole mass spectrometer.

about an equilibrium position (the longitudinal axis of the quadrupole) and at any given frequency of excitation by the RF field only one particular ion mass maintains this equilibrium position. Other ions, above or below this mass value, strike the quadrupole and are filtered out of the ion plasma. Thus an isobaric ion stream will emerge from the outlet of the quadrupole filter to strike the ion detector. Scanning of the masses is effected by scanning over an appropriate RF range, and a spectrum can be recorded in as little as 0.3 s.

The spectra obtained by the above procedures are known as electron impact spectra. In another method, known as chemical ionization, ions are produced via the intermediacy of an ionized reagent gas, commonly methane, butane, ammonia etc. This is a more controlled and gentler method and fragmentation of the sample is normally less. In consequence a molecular ion (or rather pseudo-molecular ion resulting from addition of the ionized reagent gas) can commonly be obtained in cases when it might otherwise be entirely absent in the electron impact spectrum.

2.2.5.2 Output and data handling

It is not intended to describe here the method by which the ion masses are actually measured except that the instrument is first calibrated against a standard substance, the masses of whose spectrum, with their intensities, are exactly known. In the course of a single gas chromatographic run more than a thousand mass spectra may be obtained, each consisting of up to four or five hundred masses with their intensities.

To obtain, store and handle these data once seemed a formidable problem but has become trivial with the arrival of cheap personal computers with high capacity hard disc drives. Once recorded, the body of data may be handled in many ways. It may be examined spectrum by spectrum in a number of different formats; used to construct chromatograms out of total ion, or selected ion currents; subjected to library searching to attempt to match spectra to those of known compounds, and so on. Many examples of the application of mass spectrometry to art materials have now been published[34,35] and some appear in Chapter 12.

The great strength of GLC–MS is that it allows the detection of extremely small amounts of individual compounds in the presence of large quantities of other material, something usually impossible with other methods. This means that trace additives, or materials which have largely disappeared through oxidation, can still be detected, and originally complex mixtures of raw materials can be disentangled. Archaeological studies will surely rely increasingly on its use, as has already happened in investigations of wood tars[36], asphalts in Egyptian mummies[37], resins in amphorae in a shipwreck[38], and mixed materials from an ancient boat from the Sea of Galilee[39].

2.2.6 Electron spin resonance

The technique known as *electron spin resonance spectroscopy* (ESR; otherwise known as *electron paramagnetic resonance spectroscopy*) is of restricted applicability since it gives information on the presence, and chemical environment, of free radicals. It therefore finds applications in the study of radical polymerization, and of pyrolytic, oxidative and other radical degradative reactions occurring in organic materials. Despite their chemical reactivity, free radicals are often able to survive in polymers and ESR has been used to detect these in amber and also to show that the amounts increase some tenfold when amber is ground up finely[40,41].

Breaking of polymer bonds by mechanical forces is a well-known phenomenon and is, indeed, sometimes put to use as in the mastication of rubber to reduce its molecular weight. It should be noted that the ESR spectra in the papers just cited yielded no evidence of the structures of the radicals or of the polymers from which they were formed.

ESR has also been used in studies of the photodegradation of cellulose and in this case the results were rather more informative[42]. No free radicals were detected with light of wavelengths longer than 340 nm though they were formed when light sensitizers were present, for example traces of ferric salts which form a complex with cellulose absorbing at 360 nm. It proved possible to analyse the composite spectrum obtained in terms of known spectra of particular free radical types and to suggest degradation mechanisms. In another paper[43] the formation of radicals in different forms of cellulose was examined and it was concluded that chain scission occurred mainly in amorphous regions and probably largely on the surface. Yet another application has been in the study of jet (Chapter 5) and its distinction from related coal-like substances[44].

2.2.7 Thermal analysis

A number of other methods of examination and analysis are comprised under the general heading of thermal analysis. *Differential thermal analysis* (DTA), which observes the occurrence of phase, or other changes in a material as it is heated, has been applied to the study of oil paint samples[45-47]. The apparatus consists essentially of a very sensitive calorimeter capable of detecting endo- or exothermic responses in the sample as it is heated, and these are plotted against temperature. In the more sophisticated method of *differential scanning calorimetry* (DSC), quantitative heat exchanges are measured. In the earlier oil paint studies[45,46] samples of paint of between 0.2 and 0.9 mg were used. It was found that heating in nitrogen did not give a characteristic thermogram but that in an oxygen atmosphere a sharp exothermic reaction (presumably an oxidation) was observed at around 400°C with old (100 years) oil paint. With recent paint this maximum was weak, being largely replaced by one at around 300°C. A plot of the ratio of the heights of these two maxima against the logarithm of the age of the paint was essentially linear, allowing an estimate of age for unknown samples. The reliability of such an estimate was, however, wholly dependent on the sample's being *oil* paint free from ground layers and varnish.

In more recent studies using DSC[47,48] the study was extended to linseed oil and egg yolk, alone, mixed, and with different pigments present. The ability to detect protein and oil is claimed and a number of analyses on actual samples from Italian paintings were made.

Most recently a rather thorough study of the DSC (in the presence of oxygen) of a wide range of media has been published[49]. These embraced proteins, poppyseed oil, linseed oil, resins and waxes, as well as modifications and mixtures of these and the effects of pigments. The large number of samples studied (470) allowed a statistical treatment of the results. White pigments show only small, discountable effects, and results on a series of white-pigmented paint samples were subjected to statistical averaging with determination of standard deviation.

The resulting average curves for the above five groups showed that they were in principle distinguishable on the basis of the peak maxima observed. Waxes showed the most distinctive curve, proteins very weak effects. Resins as a whole were also distinct and even the two oils, rather surprisingly, showed different maxima.

Other pigments were not necessarily so innocuous as the white pigments. Several, especially the organic materials, showed strong DSC curves of their own. The advantages of using white-pigmented samples for this type of analysis is therefore emphasized.

A further statistical procedure, discriminant analysis, was carried out on the results from the same set of 152 samples used for the above averaging. Graphical plots of the four discriminant functions so obtained, one against another, showed satisfactory clustering, in some instances, of results for particular media.

The same method (DSC) has been used to study the drying process of the main drying oils in the presence of different pigments and to observe the effects of solvents on dried paint films[50]. This latter topic has also been studied using thermal mechanical analysis (TMA) and its variations[51]. Other fields in which DTA has been applied are the study of objects made of Japanese lacquer[52], the deterioration of paper[53], and the study of papyrus[54].

References

1. HEFTMAN, E., 'History of chromatography', in *Chromatography: a Laboratory Handbook of Chromatographic and Electrophoretic Methods*, 3rd edition, edited by E. Heftman, Van Nostrand Reinhold Co., New York (1975), 1–13

2. KECK, S. and PETERS, T., 'Identification of protein-containing paint media by quantitative amino acid analysis', *Stud. Conserv.*, 14(1969), 75–82

3. CONSDEN, R., GORDON, A. H. and MARTIN, A. J. P., 'Qualitative analysis of proteins: a partition chromatographic method using paper', *Biochem. J.*, 38(1944), 224–32

4. JAMES, A. T. and MARTIN, A. J. P., 'Gas – liquid partition chromatography. A technique for the analysis of volatile materials', *Analyst*, 77(1952), 915–31

5. JAMES, A. T. and MARTIN, A. J. P., 'Gas – liquid partition chromatography: the separation and micro-estimation of volatile fatty acids from formic acid to dodecanoic acid', *Biochem. J.*, 50(1952), 679–90

6. SONODA, N. and RIOUX, J.-P., 'Identification des matériaux synthétiques dans les peintures modernes. 1. Vernis et liants polymères', *Stud. Conserv.*, 35(1990), 189–204

7. SONODA, N., 'Analyse des peintures sythétiques pour artistes par pyrolyse couplée avec la chromatographie en phase gazeuse', *Journées sur la conservation, restauration des biens culturels: recherches et techniques actuelles: Paris, 15–16 Octobre 1987*, (1987), 104–9

8. BREEK, R. and FROENTJES, W., 'Application of pyrolysis gas chromatography on some of Van Mee-

geren's faked Vermeers and Pieter de Hooghs', *Stud. Conserv.*, 20(1975), 183–9

9. ROGERS, G. DEW., 'An improved pyrolytic technique for the quantitative characterization of the media of works of art', in *Conservation and Restoration of Works of Art*, edited by N. Brommelle and P. Smith, Butterworths, London (1976), 93–100

10. WHITE, R., 'A review, with illustrations, of methods applicable to the analysis of resin/oil varnish mixtures', *ICOM Committee for Conservation Report 81/16/2*, 6th Triennial Meeting, Ottawa (1981)

11. SHEDRINSKY, A. M., WAMPLER, T. P. and BAER, N. S., 'The identification of dammar, mastic, sandarac and copals by pyrolysis gas chromatography', *Wiener Berichte über Naturwissenschaft in der Kunst* 4/5(1987/88), 12–23

12. SHEDRINSKY, A. M., WAMPLER, T. P., INDICTOR, N. and BAER, N. S., 'Application of analytical pyrolysis to problems in art and archaeology: a review', *J. Anal. Appl. Pyrol.*, 15(1989), 393–412

13. WOUTERS, J. and VERHECKEN, A., 'The coccid insect dyes: HPLC and computerized diode-array analysis of dyed yarns', *Stud. Conserv.*, 34(1989), 189–200

14. RÅNBY, B. and RABEK, J. F., *Photodegradation, Photooxidation and Photostabilization of Polymers*, John Wiley and Sons, London and New York (1975)

15. LOW, M. J. D. and BAER, N. S., 'Application of infrared Fourier transform spectroscopy to problems in conservation. I. General principles', *Stud. Conserv.*, 22(1977), 116–28

16. LOW, M. J. D. and VARLASHKIN, P. G., 'Application of infrared Fourier transform spectroscopy to problems in conservation II. Photothermal beam deflection', *Stud. Conserv.*, 31(1986), 77–82

17. GUINEAU, R., 'Non-destructive analysis of organic pigments and dyes using Raman microprobe, microfluorometer or absorption microspectrophotometer', *Stud. Conserv.*, 34(1989), 38–44

18. KIRBY, J., 'A spectrometric method for the identification of lake pigment dyestuffs', *National Gallery Tech. Bull.*, 1(1977), 34–45

19. DE LA RIE E. R., 'Fluorescence of paint and varnish layers (Part I)', *Stud. Conserv.*, 27(1982), 1–7; Part II, *ibid*, 27(1982), 65–9; Part III, *ibid*, 27(1982), 102–8

20. MIYOSHI, T., 'Laser-induced fluorescence of oil colours and other materials for painting', *Scientific Papers on Japanese Antiques and Art Crafts*, 30(1985), 28–33

21. MIYOSHI, T., 'Fluorescence from oil colours, linseed oil and poppy oil under nitrogen laser excitation', *Japan J. Applied Physics, Part 1*, 24(1985), 371–2

22. LARSON, L. J., SHIN, K.-S. K. and ZINK, J. I., 'Laser spectroscopy of materials used in painting', in *Materials Issues in Art and Archaeology II: symposium held April 17–21, 1990, San Francisco, CA*. Materials Research Society symposia proceedings no. 185, edited by P. B. Vandiver, J. Druzik and G. S. Wheeler, (1991), 133–8

23. MIYOSHI, T. and MATSUDA, Y., 'Laser-induced fluores-cence and reflection spectra of red and purple natural dyes on silk cloths', *Kobunkazai no kagaku*, 32(1987), 47–55

24. MIYOSHI, T. and MATSUDA, Y., 'Laser-induced fluorescence of natural dyes on silk cloths', *Archaeology and Natural Science*, 17(1984/5), 51–60

25. WALLERT, A., 'Natural organic yellows: analysis and documentary evidence', in *Recent Advances in the Conservation and Analysis of Artifacts*, compiled by J. Black, Institute of Archaeology, London (1987), 297–302

26. CASSAR, M., ROBINS, G. V., FLETTON, R. A. and ALSTIN, A., 'Organic components in historical non-metallic seals identified using ^{13}C-NMR spectroscopy', *Nature*, 303(1983), 238–9

27. ROBINS, G. V., PENDLEBURY, D., FLETTON, R. A. and ELLIOTT, J., 'The application of ^{13}C Fourier transform nuclear magnetic resonance spectroscopy to the analysis of art objects and archaeological artifacts', in *Application of Science in Examination of Works of Art: proceedings of the Seminar, September 7–9, 1983*, edited by P. England and L. Van Zelst, Boston (1985), 126–31

28. ROBINS, D., ALSTIN, A. and FLETTON, D., 'The examination of organic components in historical non-metallic seals with C-13 Fourier transform nuclear magnetic resonance spectroscopy', in *ICOM Committee for Conservation: 8th Triennial Meeting, Sydney, Australia, 6–11 September 1987*, edited by G. Kirsten, (1987), 87–92

29. BECK, C. W., FELLOWS, C. A. and MACKENNAN, E., 'Nuclear magnetic resonance spectrometry in archaeology', in *Archaeological Chemistry*, ACS Advances in Chemistry Series no. 138, Washington D.C. (1974), 226–35

30. GHISALBERTI, E. L. and GODFREY, I., 'The application of nuclear magnetic resonance spectroscopy to the analysis of pitches and resins from marine archaeological sites', *Bulletin of the Australian Institute for Maritime Archaeology*, 14(1990), 1–8

31. LAMBERT, J. B. and FRYE, J. S., 'Carbon functionalities in amber', *Science*, 217(1982), 55–7

32. LAMBERT, J. B., BECK, C. W. and FRYE, J. S., 'Analysis of European amber by carbon-13 nuclear magnetic resonance spectroscopy', *Archaeometry*, 30(1988), 248–63

33. LAMBERT, J. B., FRYE, J. S. and POINAR JR, G. O., 'Amber from the Dominican Republic: Analysis by Nuclear Magnetic Resonance Spectroscopy', *Archaeometry*, 27(1985), 43–51

34. WEISS, N. and BIEMANN, K., 'Application of mass spectrometric techniques to the differentiation of paint media', in *Conservation and Restoration of Pictorial Art*, edited by N. Brommelle and P. Smith, Butterworths, London (1976), 88–92

35. MILLS, J. S. and WHITE, R., 'Organic mass-spectrometry of art materials: work in progress', *National Gallery Tech. Bull.*, 6(1982), 3–18

36. REUNANEN, M., EKMAN, R. and HEINONEN, M., 'Analysis of Finnish pine tar from the wreck of frigate St. Nikolai', *Holzforschung*, 43(1989), 33–9

37. RULLKOETER, J. and NISSENBAUM, A., 'Dead Sea asphalt in Egyptian mummies: molecular evidence', *Die Naturwissenschaften*, 75(1988), 618–21

38. MILLS, J. S. and WHITE, R., 'The identity of the resins from the late Bronze Age shipwreck at Ulu Burun (Kaş)', *Archaeometry*, 31(1989), 37–44

39. WHITE, R., 'Analysis of resinous materials', in *The Excavations of an Ancient Boat in the Sea of Galilee (Lake Kineret)*, Atiqot English series, no. 19 (1990), 81–8

40. URBANSKI, T., 'Formation of solid free radicals by mechanical action', *Nature*, 216(1967), 577–8

41. URBANSKI, T., 'Degradation of amber and formation of free radicals by mechanical action', *Proc. R. Soc. Lond.*, A325(1971), 377–81

42. HON, N.-S., 'Formation of free radicals in photo-irradiated cellulose. VIII. Mechanisms', *J. Polymer Sci. Polymer Chem. Edition*, 14(1976), 2497–512

43. HON, N.-S., 'Formation of free radicals in photo-irradiated cellulose and related compounds', *J. Polymer Sci. Polymer Chem. Edition*, 14(1976), 2513–25

44. SALES, K. D., ODUWOLE, A. D., CONVERT, J. and ROBBINS, G. V., 'Identification of jet and related black materials with ESR spectroscopy', *Archaeometry*, 29(1987), 103–9

45. PREUSSER, F., 'Study of works of art and culture by differential thermal analysis. I. Age determination of oil paint samples', *J. Thermal Analysis*, 16(1979), 277–83

46. PREUSSER, F., 'Differential thermal analysis of paint samples', *ICOM Committee for Conservation Report 78/20/2*, 5th Triennial Meeting, Zagreb, (1978)

47. ODLYHA, M. and BURMESTER, A., 'Preliminary investigations of the binding media of paintings by differential thermal analysis', *J. Thermal Analysis*, 33(1987), 1041–52

48. ODLYHA, M., 'A novel approach to the problem of characterizing the binding media in early Italian paintings (13th/16th century)', in *ICOM Committee for Conservation, 9th Triennial Meeting, Dresden, 26–31 August 1990*, edited by K. Grimstad, (1990), 57–61

49. BURMESTER, A., 'Investigation of paint media by differential scanning calorimetry (DSC)', *Stud. Conserv.*, 37(1992), 73–81

50. MCGLINCHEY, C. W., 'Thermal analysis of fresh and mature oil paint films: the effect of pigments as driers and the solvent leaching of mature paint films', in *Materials Issues in Art and Archaeology II: symposium held April 17–21, 1990, San Francisco California*. Materials Research Soc. Symposia proceedings no. 185 (Eds. P. B. Vandiver, J. Druzik and G. S. Wheeler), (1991), 93–103

51. HEDLEY, G., ODLYHA, M., BURNSTOCK, A., TILL-INGHAST, J. and HUSBAND, C., 'A study of the mechanical and surface properties of oil paint films treated with organic solvents and water', in *Cleaning, Retouching and Coatings. Preprints of the Brussels Congress, 1990*, IIC, London (1990), 98–105

52. TOSHIKO, K., 'Studies on analysis of Japanese lacquer (III). Application of differential thermal analysis' (in Japanese), *Science for Conservation*, (1980) no.19, 15–19

53. BLANK, M. G., FLYATE, D. M. and LOTSMANOVA, E. M., 'The forecasting of the longevity of paper, comparison of methods', *ICOM Committee for Conservation Report 81/14/5*, 6th Triennial Meeting, Ottawa (1981)

54. BAYER, G. and WIEDERMANN, H. G., 'Papyrus: the paper of Ancient Egypt', *Analyt. Chem.*, 55(1983), 1220A–30A

Bibliography

Separation methods

BLAU, K. and KING, G. (editors), *Handbook of Derivatives for Chromatography*, Heyden, London (1977)

KIRCHNER, J. G., *Thin-Layer Chromatography*, 2nd edition, Wiley Interscience, New York (1978)

LITTLEWOOD, A. B., *Gas Chromatography. Principles, Techniques, and Applications*, 2nd edition, Academic Press, New York and London (1970)

MCFADDEN, W. H., *Techniques of Combined Gas-chromatography/Mass-spectrometry: Applications in Organic Analysis*, Wiley Interscience, New York (1973)

PIERCE, A. E., *Silylation of Organic Compounds*, Pierce Chemical Co., Rockford, IL (1968)

STAHL, E., *Thin-Layer Chromatography. A Laboratory Handbook*, 2nd edition, Allen and Unwin, London (1969)

Spectrometric methods

BELLAMY, L. J., *The Infra-red Spectra of Complex Molecules*, 3rd edition, Chapman and Hall, London (1975)

BELLAMY, L. J., *The Infra-red Spectra of Complex Molecules. Volume Two, Advances in Infrared Group Frequencies*, 2nd edition, Chapman and Hall, London (1980)

GILLAM, A. E. and STERN, E. S., *An Introduction to Electronic Absorption Spectroscopy in Organic Chemistry*, 2nd edition, Edward Arnold, London (1957)

HAMMING, M. C. and FOSTER, N. G., *Interpretation of Mass Spectra of Organic Compounds*, Academic Press, New York and London (1972)

RÅNBY, B. and RABEK, J. F., *ESR Spectroscopy in Polymer Research*, Springer-Verlag, Berlin (1977)

ROBOZ, J., *Introduction to Mass Spectrometry*, Wiley Interscience, New York (1968)

SADTLER, *The Infrared Spectra Atlas of Monomers and Polymers*, Sadtler Research Laboratories, Philadelphia (1980)

SILVERSTEIN, R. M. and BASSLER, G. C., *Spectrometric Identification of Organic Compounds*, John Wiley and Sons, New York and London (1963).

SOCRATES, G., *Infrared Characteristic Group Frequencies*, John Wiley and Sons, Chichester, New York, Brisbane and Toronto (1980)

WALLER, G. R. and DERMER, O. C. (Editors), *Biochemical Applications of Mass Spectrometry – First Supplementary Volume*, John Wiley and Sons, New York (1980)

3

Oils and Fats

Oils and fats are familiar materials since they form an important part of the normal human diet. In addition to their use as food they have been used since antiquity as illuminants, as a base for perfumes, and in ointments for medical and cosmetic purposes. Materials for ritual and burial practices would also often incorporate fatty matter. As a consequence of these uses they are often encountered in an archaeological context as residues in vessels and on sherds. The subgroup formed by the *drying oils* is of basic importance to coatings technology in general and to western painting in particular. The chemistry of fats, while simple in essence, becomes more complicated and less precise when the question of 'drying', or polymerization is entered into.

3.1 Composition

There is no essential difference between oils and fats excepts that the former are usually liquid, the latter solid, at normal temperatures. It should be remembered though that the animal fats, which we think of as solids, will be liquid at the body temperature of the animal. Chemically, fats are defined as mixtures of mixed triglycerides, which are esters of the trihydric alcohol glycerol with a range of possible

long chain fatty acids. Fats form the major subgroup of the larger class of fatty acid esters known as *lipids*, the definition of which sometimes extends to include other fat-soluble compounds also. The physical and chemical properties of individual fats are determined by the kinds and proportions of fatty acids which enter into the triglyceride composition.

3.1.1 The fatty acids

While the range of fatty acids which can be found in fats is large, most triglycerides are made up from relatively few of them, more especially the straight chain acids with eighteen carbon atoms. The series of saturated straight chain acids has already been shown in *Table 1.3* (1.2.2.3). The more important ones are repeated in *Table 3.1* together with the unsaturated acids and a single hydroxy acid, ricinoleic acid, which is a major component of castor oil. The carbon atoms of a straight chain fatty acid are numbered starting with the carboxyl group carbon as number one, and in the systematic names of the unsaturated acids the position of each of the double bonds is indicated at the start of the name by giving the lower number of the two carbon atoms bearing them. Thus linoleic acid is 9,12-octadecadienoic acid and has Structure 3.1.

Structure 3.1

31

It is easily seen that the double bonds can have *cis* or *trans* configurations (see 1.1.2): in the structure above they are shown as *cis* which is the usual, though not invariable, configuration found in the natural acids and the one to be assumed if not specified in the name.

The introduction of unsaturation into the molecule lowers the melting point from that of the corresponding saturated acid. This property is communicated to the triglyceride and hence the fat incorporating it. This is the main reason for the liquidity of vegetable oils as opposed to animal fats: they contain higher proportions of the unsaturated triglycerides. An index of the total amount of unsaturation in a fat is the *iodine number*, a measure of the amount of iodine which will chemically react with it by addition across the double bonds. This used to be, and is still to a lesser extent, an important characterizing feature of oils and fats, particularly drying oils.

The doubly unsaturated linoleic acid and the triply unsaturated linolenic acid are the compounds principally responsible for the drying properties of drying oils. It should be noted that they are not, respectively, conjugated dienes and trienes (1.1.2) but they can easily become so by isomerization. This does occur in the early stages of the drying process, as observed by the development of ultra-violet absorption at a wavelength of 233 nm (conjugated diene) and 268 nm (conjugated triene).

The fatty acid compositions of a number of oils and fats are summarized in *Table 3.2*. Within the partly arbitrary groupings of fat, edible oil, semidrying, and drying oil, differences of composition are largely quantitative rather than qualitative. Only rarely is an oil uniquely distinguishable by the presence of particular fatty acids. An example of one which is typical, is castor oil, which contains large quantities of the hydroxyoleic acid, ricinoleic acid. The pattern as a whole however may be distinctive, as for example with coconut oil. This could probably be confused only with that of palm kernel oil, which has a similar composition.

It should not be supposed that the composition of a particular oil is perfectly constant. It can vary for a number of reasons, among them: strain or variety of plant[1-3], nature of the soil, and season of harvesting or variation in weather conditions[4,5]. Equally the determination of composition is subject to experimental error and variation due to the use of different measurement techniques.

The results in *Table 3.2* are all based on gas chromatography but many of the figures in the older texts were obtained using other, less accurate, methods. A number of valuable studies of linseed have served to show how composition varies from strain to strain and with season. The latter mainly affects the extent of unsaturation, but this in turn affects the ratios of palmitic and stearic acids since increased amounts of the unsaturated C_{18} acids diminish the amount of stearic acid.

3.1.2 Triglycerides

While the composition of oils and fats is usually discussed in terms of the percentages of the individual fatty acids entering into their composition, these are actually present combined with the trihydric alcohol glycerol to give esters known as triglycerides of the following general formula:

$$
\begin{array}{l}
\quad\quad\quad\quad\; O \\
H \quad\quad\quad\; \| \\
HC-O-C-R^1 \\
| \quad\quad\quad\quad O \\
| \quad\quad\quad\quad \| \\
HC-O-C-R^2 \\
| \quad\quad\quad\quad O \\
| \quad\quad\quad\quad \| \\
HC-O-C-R^3 \\
H
\end{array}
$$

Much work has been done and several theories formulated to predict the way in which fatty acids are distributed between the triglyceride molecules[6]. It was discovered at an early stage that they are not usually present as simple triglycerides – triolein, tripalmitin etc. – but theories of even distribution (each fatty acid distributed over as many triglyceride molecules as possible) and random distribution (fatty acids distributed randomly through the triglycerides) were equally found often not to fit experimentally determined triglyceride compositions. As can be seen, the hydroxyl groups of glycerol are not all equivalent for there are two primary hydroxyls and one secondary to each molecule.

Another theory of fatty acid distribution[7] is that the unsaturated acids are attached preferentially to the secondary position and any left over, together with the saturated acids, are distributed in a random manner between the primary positions. In fact this results in a calculated triglyceride composition not far removed from random and again does not agree

Table 3.1 Major fatty acids of oils and fats

Formula	Systematic name	Common name	m.p. °C
$C_{12}H_{24}O_2$	Dodecanoic	Lauric	44
$C_{14}H_{28}O_2$	Tetradecanoic	Myristic	54
$C_{16}H_{32}O_2$	Hexadecanoic	Palmitic	63
$C_{16}H_{30}O_2$	9-Hexadecenoic	Palmitoleic	0.5
$C_{18}H_{36}O_2$	Octadecanoic	Stearic	70
$C_{18}H_{34}O_2$	9-Octadecenoic	Oleic	16
$C_{18}H_{32}O_2$	9,12-Octadecadienoic	Linoleic	−5
$C_{18}H_{30}O_2$	9,12,15-Octadecatrienoic	Linolenic	−11
$C_{18}H_{30}O_2$	cis,trans,trans-9,11,13-Octadecatrienoic	α-Elaeostearic	49
$C_{18}H_{34}O_3$	12-Hydroxy-9-octadecenoic	Ricinoleic	

with that actually found for linseed oil, for example, for which a still further amended theory has been presented[8].

For present purposes however the important thing to remember is that the number of possible different triglycerides is very much greater than the number of component fatty acids. For example, with only three fatty acids fourteen different triglycerides can be made, assuming that the two primary hydroxyl groups are considered as chemically equivalent. With more fatty acids the number of possibilities goes up rapidly: with the five fatty acids of linseed oil there can be fifty-five different triglycerides.

The resulting complexity means that analysis of a fat for specific triglyceride composition is a much more difficult task than analysis for fatty acids and one which has been only incompletely effected for most of them. It is made still more difficult because the fairly high molecular weight of triglycerides, and their consequent low volatility, makes them difficult to analyse by gas chromatography. We shall therefore here consider fats largely in terms of their fatty acid make-up.

Table 3.2 Fatty acid compositions of some oils and fats

	8:0	10:0	12:0	14:0	16:0	18:0	18:1	18:2	18:3	Others
Olive				tr	8–18	2–5	56–82	4–19	0.3–1	
Sunflower seed				tr	5–6	4–6	17–51	38–74	tr	
Coconut	5–9	6–10	44–52	13–19	8–11	1–3	5–8	1–2		
Poppyseed					10	2	11	72	5	
Walnut					3–7	0.5–3	9–30	57–76	2–16	
Linseed				tr	6–7	3–6	14–24	14–19	48–60	
Hempseed					6–7	2–3	12–17	55–65	14–20	
Perilla					7	2	13	14	64	
Tung					3	2	11	15	3	elaeostearic 59%
Castor					1–2	1–2	3–6	4–7		ricinoleic 83–89%
Pig				1–2	20–28	13–16	42–45	8–10	0.5–2	
Beef tallow				2–3	23–30	14–29	40–50	1–3	0–1	
Mutton tallow				6	26	30	30	1.5	0.2	
Cows' milk	1–2.5	2–3	2–3	9–11	22–30	11–15	25–31	1–2.5	1–2.5	
Hens' eggs				tr	27	9	44	13.5	0.5	

The headings, 18:0, 18:1, etc. indicate chain lengths:number of double bonds. These data were all obtained by gas chromatography and are taken from several sources, notably T. P. Hilditch and P. N. Williams, *The Chemical Constitution of Natural Fats* and D. Swern (Editor), *Bailey's Industrial Oil and Fat Products* (see Bibliography). For several oils there are few reliable data and it is not possible to give a range of compositions.

3.2 Chemical properties of fats

The chemical properties of fats are determined by their principal structural features, namely the presence of the triple ester function in each molecule, and the possible presence of reactive double bonds. The presence of fatty acids containing two or more double bonds confers on the molecule the high susceptibility to oxidation characteristic of the drying oils, to be discussed below. Conversely, absence of double bonds results in relative stability to oxidation, and this is true of many purified saturated animal fats.

The presence of the ester groups means that the molecules may be broken down to the component glycerol and fatty acids by the processes of saponification or hydrolysis. The term saponification refers to treatment of the fat with aqueous alkali – caustic soda or potash (i.e. sodium hydroxide (NaOH) or potassium hydroxide (KOH)) – to yield the sodium or potassium salts of the fatty acids (soaps) and glycerol. Hydrolysis refers to the reaction whereby the splitting is carried out either with water alone, which requires much higher temperatures, or in the presence of catalytic amounts of mineral acid, both processes yielding free fatty acids. It can also come about as a result of enzymatic action initiated by bacteria or fungi, as discussed in the next section.

3.3 Changes in fats

3.3.1 Buried fats

Fatty materials found in vessels, in graves, and buried in the soil are usually found to have been completely converted to free fatty acids, all the glycerol resulting from hydrolysis having, presumably, been washed away by water. How this conversion takes place is not entirely settled. It might be expected that hydrolysis would be effected by water alone, given a sufficient length of time, but in fact it appears that the change comes about, or comes about much more quickly, through bacterial action.

The materials most studied have been those deriving from human fats, known as adipocere, and the material sometimes found buried in Scottish and Irish bogs, known as bog butter[9,10]. The latter has a composition high in saturated fatty acids, mostly C_{16} and C_{18}, with amounts of monounsaturated C_{18} acid (oleic) much reduced from that typical of two possible contenders for the original material, butter and mutton fat.

Disappearance of unsaturated acids might be expected, but less explicable is an apparent increased ratio of palmitic acid to stearic acid in the bog butter. Experiments have shown that butter and mutton fat, incubated with water containing small amounts of nutrient chemicals and soil microorganisms in a virtually anaerobic environment, rather quickly (a year or two) undergo the changes indicated above.

An extensive series of experiments was carried out by den Dooren de Jong[11] on the conversion of olive oil to an adipocere-like material by water and bacteria under eventually (though not initially) anaerobic conditions. He demonstrated that the proportion of palmitic acid in the resultant material had greatly increased and that this was, apparently, formed from oleic acid since it also resulted from the similar conversion of pure triolein (the triglyceride formed from glycerol and oleic acid only). A number of pure cultures, notably of *Staphylococcus* spp. and *Proteus* spp., were also able to effect the conversion which took place very rapidly, i.e. in a few weeks.

How this conversion of oleic to palmitic acid takes place, involving loss of two carbons and saturation of the double bond, is far from obvious. There is no simple chemical route but apparently such reactions are commonly encountered in lipid metabolism. The suggested route involves first hydrolysis to free acid by lipases associated with certain bacteria (oxygen seems to be necessary for this); dehydrogenation to give the αβ-unsaturated acid (the α-carbon is that to which the carboxylic acid group is attached; the β-carbon is the next along the chain etc.); oxidative scission at this double bond to give the acid with two fewer carbon atoms; hydrogenation of the original double bond. However, there are problems with this explanation. The oxidation at the position two carbons from the carboxyl group (β-oxidation) is well known as a part of the metabolism of fatty acids but it does not usually stop until the whole chain has been degraded[12]. Furthermore attack commonly takes place at a double bond when one is present, as here, and the apparent reduction of this here is without explanation. Clearly further investigation is called for.

These bacterial changes were temperature dependent, being slow at low temperatures. Recently it has been shown that 1000-year-old fat samples from a frozen midden in the Yukon had not undergone very extensive changes in the fatty acid composition, which still involved relatively large

proportions of oleic and other unsaturated acids[13,14]. Nonetheless the fatty acids were almost entirely free, indicating that simple hydrolysis does occur in time under wet conditions.

The adipocere from an Irish bog body of around AD 1570 has been carefully analysed by GLC–MS[15]. It was fully hydrolysed, consisting entirely of fatty acids, the pattern of which was much as usual, with a high proportion of palmitic acid. Hydroxy palmitic and stearic acids were also present in small amounts.

Some archaeological samples indicate that complete hydrolysis does not necessarily take place. The contents of two Roman glass bottles, which contained water as well as fat residues, consisted of mono- and diglycerides as well as free fatty acids[16], and a similar result was reported for an emulsified fat in another Roman bottle[17]. A significant amount of oleic acid was still present in the latter example and this was true also for remains of olive oil in the walls of amphorae recovered from the ground[18,19] though here it was not determined how far hydrolysis had proceeded. The contents of a broken Egyptian jar (sixth century BC) also contained free fatty acids[20], though in what proportion to glycerides was not determined. In this case shorter chain dicarboxylic acids such as azelaic acid (see below) were also found. A homologous series of dicarboxylic acids was also found in the lipids of a 4000-year-old Egyptian mummy[21], as well as hydroxy and oxo fatty acids, though whether in significant amounts relative to the saturated acids is not made clear.

Gas chromatography of fatty acids is being used more and more in an attempt to identify the plant or animal origins of archaeological fat residues[22,23]. Caution is needed though in view of the changes in proportions of saturated fatty acids which can occur, as mentioned above.

3.3.2 Fats in ethnographic and other objects

Objects are often treated or coated with oils or fats, both as part of their original make-up or as a supposed conservation measure. Chemical changes in the fat commonly have visual consequences which need looking into and there have been a number of analyses to this end. Wooden sculptures and domestic objects from Mali in West Africa often exhibit a whitish surface bloom, as a result of an original treatment with locally available fats such as shea nut fat (from *Butyrospermum parkii*) and others. A study of this bloom on a number of objects, using gas chromatography for some and infrared spec-

trometry for the remainder, confirmed its fatty nature[24]. GLC positively identified shea nut fat for one sample and palm oil for another and this latter finding served to confirm a re-attribution of the object to a different tribe and place. Unfortunately it was not clearly established to what extent the exudate consisted of free fatty acids rather than triglycerides. In the case of a sample from a restored area of a sculpture, infrared spectrometry identified the material as non-original carnauba wax (4.2.1).

Hawaiian *tapa* or bark cloth, prepared from the inner bark of certain plants, is often oiled to make it waterproof and more flexible. This leads, however, to considerable degradation probably due to the acidic nature of the oil's oxidation products. GLC was used to identify the oil, in six out of seven samples, as being kukui nut oil from *Aleurites moluccana* Wild[25].

An interesting study has appeared on the results of the treatment with fats (by collectors and museums) of Benin bronzes, as a supposed 'protective'[26]. GLC analysis showed that the fats had been almost fully hydrolysed to free fatty acids and that these had corroded the bronze to give copper and zinc salts. A test study showed that a coating of free fatty acids (oleic, palmitic and stearic) applied to copper was 50% converted to the copper salts in only four days, while after two months the conversion was complete. The effect is similar to that sometimes observed with western oil paintings on copper panels, where the oil ground has reacted with the metal to give green salts of copper.

Fatty blooms are sometimes observed also on the surfaces of paintings and this is discussed in a later section.

3.4 Drying oils and drying

An oil is able to 'dry', that is to say polymerize to a semi-solid, only if it has a sufficient content of di- or tri-unsaturated fatty acids in the make-up of its component triglycerides. There has to be an average of at least two reactive centres within each triglyceride molecule, which would be achieved in a theoretical oil which contained 66% of linoleic acid. In practice both linoleic and linolenic acids are found together and the sort of composition which results in satisfactory drying may be assessed from *Table 3.2*.

The extent to which the mono-unsaturated oleic acid takes part in the polymerization reactions is uncertain. It certainly is gradually oxidized but

probably does not get incorporated into the polymer network except perhaps occasionally as an end group.

Drying oils which have found most use in western European painting practice are linseed, walnut, and poppyseed. Others which have been mentioned in the early literature, but for which there is no certain evidence of use, are hempseed (from *Cannabis sativa*) and pinenut oil (from the edible seeds or 'nuts' of the umbrella pine, *Pinus pinea* L.). The evidence of analysis (12.1.4) suggests that linseed oil was used in northern Europe from the thirteenth century at latest; on its introduction into Italy in the fifteenth century oil painting seems mainly to have been effected using walnut oil but use of linseed became more general in the sixteenth century[27].

The time when oils were first used in painting is quite unknown. Linseed oil was well known to the ancient Egyptians, as flax was grown for spinning into linen, but according to Lucas[28] there is no evidence that the oil was ever used by them for painting. Equally, although walnut and poppyseed oils were known in the Greece and Rome of classical times, there is no mention of their use in painting.

The writings of Theophilus[29], in the twelfth century, are the first to refer to the use of oil for tempering colours but earlier still, in the sixth century, a medical writer named Aetius had mentioned drying oil as a varnish for finished paintings[30]. Eastlake[31] pointed to the evidence of the Close Rolls (records of royal expenditure) for the purchase of large quantities of 'painters' oil' to be used for the work on the decoration of St. Stephen's Chapel, a part of the Palace of Westminster, in the fourteenth century and the paintings have indeed been found to be in oil[32]. Many early Norwegian works of art, including altar frontals and polychrome sculpture, are also painted in oil, probably linseed[33-36].

Other drying oils are produced by trees and plants native to other parts of the world and some have a long history of local use. Thus perilla and hempseed oils are both mentioned in a Japanese document of AD 883[37]. Perilla oil was probably the kind used in an early (eighth century) technique of oil painting in Japan in which lead was incorporated as drier[38,39]. Chia oil from the seeds of *Salvia hispanica* was used as a paint medium in Mexico during the Spanish colonial period[40].

Some exotic oils, such as Tung ('China wood oil'), Perilla and Oiticica, have been produced on a large scale for commercial use in the twentieth century. Other oils, such as tobacco seed, are of recent introduction as is the use of modified natural oils such as dehydrated castor oil.

3.4.1 Mechanism of drying[41-43]

The gradual conversion of a liquid oil through a soft gel to a rubbery solid occurs as a result of a *free radical chain reaction*. Since oils are mixtures of compounds, their drying is not explicable in terms of a simple and uniform reaction scheme such as may be the polymerization of pure monomers such as vinyl acetate. What can be indicated are the types of reactions which may occur and the kinds of bonds formed; also the concurrent oxidation reactions which take place which are degradative in nature, leading to the production of small molecules. In practice there also exist factors which influence the course of the drying reaction, such as the influence of light, the presence of different metal ions from the pigments, the thickness of the film and hence the availability of oxygen, and the extent of prepolymerization of the oil.

The bonds between carbon and hydrogen are very strong and a high energy must be transmitted to the molecule in order to break them. The amount of energy required – the bond dissociation energy – is dependent upon the structure of the molecule as a whole but particularly on the immediate molecular environment of the bond in question. It becomes less, the more the carbon atom carrying the hydrogen has links to other carbon atoms rather than hydrogens; that is to say (see 1.1.1) when the hydrogen is at a tertiary rather than at a secondary or primary position. Thus for methane, CH_3-H, it is 102 kcal, for primary hydrogens as in ethane CH_3CH_2-H it is 98, for secondary hydrogens, as in isopropane $(CH_3)_2CH-H$, it is 94, and for tertiary hydrogens as in *tert*-butane $(CH_3)_3C-H$, it is 90. These are still high energies and mean that for these compounds bond breaking occurs only at very high temperatures.

Proximity to double bonds also results in lowering of bond dissociation energy: down to 77 kcal for propylene, $CH_2=CHCH_2-H$. Still lower values obtain for the hydrogen atoms situated on the methylene group between two unconjugated double bonds, though exact figures do not seem to be available. This is the case with the unsaturated fatty acids with which we are concerned – linoleic and linolenic acids – the former having one, the latter two such methylene groups.

The first step in the drying process is usually thought to be the abstraction of a hydrogen atom from such a position to yield a free radical:

$$-CH=CH-\overset{\cdot}{C}H-CH=CH-$$

How this abstraction occurs initially is still open to question; there are many possible ways. However, how it continues seems fairly clear for reactive radicals are formed which can effect it, as will be seen below. The radical above is stabilized by delocalization or resonance, behaving as if it were a mixture or hybrid of the above with the two rearranged radicals with conjugated double bonds:

$$-\overset{\cdot}{C}H-CH=CH-CH=CH-$$

and

$$-CH=CH-CH=CH-\overset{\cdot}{C}H-$$

These free radicals are very reactive and several reaction paths are open to them. Most favoured is the reaction with the oxygen of the air, if this is freely available, to yield the intermediate peroxy radicals:

$$-CH=CH-\underset{\underset{OO^{\cdot}}{|}}{CH}-CH=CH-$$

$$-\underset{\underset{OO^{\cdot}}{|}}{CH}-CH=CH-CH=CH-$$

$$-CH=CH-CH=CH-\underset{\underset{OO^{\cdot}}{|}}{CH}-$$

These in turn can abstract a hydrogen atom from another molecule of unsaturated acid (so propagating the reaction) to give the hydroperoxides:

$$-CH=CH-\underset{\underset{OOH}{|}}{CH}-CH=CH-$$

$$-\underset{\underset{OOH}{|}}{CH}-CH=CH-CH=CH-$$

$$-CH=CH-CH=CH-\underset{\underset{OOH}{|}}{CH}-$$

These reactions propagate the chain but without resulting in any linking together of the triglyceride units. This can occur in several ways. The peroxy radicals can, instead of abstracting hydrogen, add to double bond systems, especially conjugated double bonds:

$$R-OO^{\cdot} + -CH=CH-CH=CH-CH_2- \rightarrow$$

$$-CH-\overset{\cdot}{C}H-CH=CH-CH_2-$$
$$\underset{\underset{OOR}{|}}{}$$

to give a dimer linked by a peroxy group, the new radical being able to rearrange and/or react further in the various ways open to it. Likewise, similar addition to double bonds can occur with alkoxy radicals, produced by homolysis of hydroperoxides or peroxides, to yield dimer formed by single oxygen (ether) bridging links:

$$R^1OOR^2 \rightarrow R^1O^{\cdot} + R^2O^{\cdot}$$

$$R^1O^{\cdot} + -CH=CH-CH=CH-CH_2- \rightarrow$$

$$-CH-\overset{\cdot}{C}H-CH=CH-CH_2-$$
$$\underset{\underset{OR^1}{|}}{}$$

Vinyl polymerization can also take place since carbon radicals, formed as explained above, can add directly to double bonds in the same way as the alkylperoxy or alkyloxy radicals:

$$R^{\cdot} + -CH=CH-CH=CH-CH_2- \rightarrow$$

$$-CH-\overset{\cdot}{C}H-CH=CH-CH_2-$$
$$\underset{\underset{R}{|}}{}$$

The newly formed radical goes on to react in the same or other ways. It is not believed that any of these linking up reactions go on to produce the very long polymer chains which form in the regular polymerizations of vinyl monomers, but it is not necessary for the production of the three-dimensional polymer network that they should, as will be explained below. The chain reactions are terminated by formation of non-radical products, either by reaction between two radicals, thus:

$$R^{\cdot} + R^{\cdot} \rightarrow RR$$
$$R^{\cdot} + ROO^{\cdot} \rightarrow ROOR \text{ etc.}$$

or, occasionally, by oxidation of carbon radicals to carbonium ions by transition metal ions in the film, the ion then losing a proton to re-form a double bond:

$$M^{2+} + R-\overset{\cdot}{C}H-CH_2-R \rightarrow$$
$$M^+ + R-\overset{+}{C}H-CH_2-R \rightarrow$$
$$R-CH=CH-R + H^+.$$

The relative proportions of the three types of linkage produced – carbon–carbon, ether, and peroxy – is not known. It will vary with conditions and will not remain constant. The carbon–carbon and ether linkages are probably stable but the peroxy linkages can split to two alkoxy radicals and react further as explained above.

The above reactions have been discussed in terms of individual fatty acids and it has been said that linking together rarely proceeds beyond the point of forming dimers or possibly trimers. Clearly if individual acids were in fact involved this could never lead to a three-dimensional cross-linked network: but it is not individual acids but triglycerides which are involved and each triglyceride has two or three unsaturated fatty acids to each molecule. Thus, after formation of a triglyceride dimer using up one fatty acid chain from each molecule, the dimer will still retain from two to four remaining unsaturated fatty acid chains to continue the dimerization process.

If two of these dimers then link together to give a tetramer then this will have between two and six unsaturated fatty acid chains remaining, i.e. it is at least as well, and can be much better, equipped to continue the dimerization process. And this assumes only dimerization: if reaction chains are longer and go on for three or more stages then the result is even more favourable to the development of a highly cross-linked network.

3.4.2 Factors affecting the drying process

The foregoing account of the drying mechanism is a simplified one and leaves many possibilities out and much unexplained, the chain initiation mechanisms in particular remaining uncertain.

It is known that certain oils such as tung oil, which contain high proportions of acids with conjugated double bonds, dry very much more quickly than those such as linseed oil in which the double bonds are initially unconjugated. The reasons for this are uncertain. Does it mean that polymerization can be initiated by direct attack of oxygen on the conjugated double bonds; or that free radicals are more readily formed from them, mediated perhaps by transition metal ions; or can activated species be formed by light absorption? (conjugated dienes and trienes absorb in the near ultraviolet).

Such effects as these have all had their proponents. They cannot be considered in detail here but

the question of the effects of pigments must at least be touched on.

In the history of painting it was soon discovered that oils dry quicker in the presence of certain pigments rather than others. The effect may not be one simply of quicker drying rates for basic pigments also serve to 'mop up' low molecular weight acidic oxidation products whose presence can otherwise re-soften the dried film (an effect known as syneresis).

The speeding up of drying rate is found principally with compounds of the metals capable of existing in more than one valence state. Cobalt, manganese, and lead are considered to be the most active, in that order. Compounds of them which are oil-soluble such as their naphthenates, resinates, or their salts with the long chain fatty acids, are often added to commercial oil paints and varnishes to promote drying.

Traditional artists' pigments are not, of course, soluble in the oil paint medium to any great extent (with certain exceptions) and any promoting effect they may have on the drying must presumably start at the pigment/medium interface[44–46]. The reactions which can be occurring are exemplified by the following:

$$Co^{3+} + ROOH \rightarrow Co^{2+} + ROO^{\cdot} + H^{+}$$
$$Co^{2+} + O_2 \rightarrow Co^{3+} + OO^{\cdot-}$$
$$OO^{\cdot-} + H^{+} \rightarrow HOO^{\cdot}$$

The first equation shows a typical reaction with a hydroperoxide which occurs readily at room temperature. The cobaltic ion is reduced to cobaltous, splitting the hydroperoxide into a hydroperoxy radical and a proton. This system is often used in promoting the polymerization of certain monomers, the hydroperoxide being the so-called initiator, the cobalt or other metal salt solution the promoter.

In the second equation the cobaltous ion is re-oxidized back to cobaltic by atmospheric oxygen, an oxygen radical ion being produced. This in turn readily reacts with a hydrogen ion, as in the third equation, to give a hydroperoxy radical which can also initiate chain reactions. These are not the only possible reaction routes, for cobaltous ion can also promote hydroperoxide decomposition in a different way, thus:

$$Co^{2+} + ROOH \rightarrow Co^{3+} + RO^{\cdot} + OH^{-}$$

This reaction, together with the first of the three above, provides a redox (reduction–oxidation)

mechanism promoting polymerization in closed systems without the intervention of oxygen.

Another possibility is direct oxidation of the methylene groups adjacent to or between double bonds as follows:

$$Co^{3+} - CH = CH - CH_2 - CH = CH - \rightarrow$$
$$- CH = CH - \overset{\cdot}{C}H - CH = CH - + Co^{2+} + H^+$$

Such reactions as these have great energy requirement advantages over those involving homolysis into two radicals.

Certain metal ions can also act as chain stoppers. It has been observed often that paint films containing green copper pigments, particularly verdigris (basic copper acetate), retain larger amounts of unsaturated compounds such as oleic acid than do paint films of the same age containing other pigments[47,48]. The mechanism of chain stopping in this case is believed to be the single-electron oxidation of the carbon radical to a carbonium ion followed by loss of an adjacent proton from the chain to give back a double bond:

$$- CH_2 - \overset{\cdot}{C}H - CH_2 - + Cu^{2+} \rightarrow$$
$$- CH_2 - \overset{+}{C}H - CH_2 - + Cu^+$$

$$- CH_2 - \overset{+}{C}H - CH_2 - \rightarrow$$
$$- CH_2 - CH = CH - + H^+$$

At the same time these copper compounds seem in no way to delay the drying process. Clearly there are subtleties here which are not yet understood.

The red pigment vermilion (mercuric sulphide) has a marked accelerating effect on oxidative degradation of dried oil[46]. This probably accounts for the increased vulnerability to mild cleaning solvents often noticed with areas of vermilion paint in early paintings.

3.4.3 Antioxidants and inhibitors[49]

It is not only inorganic materials which can affect the course or speed of drying. Certain classes of chemical compounds, notably the phenols, are able to react with the peroxy or alkoxy radicals formed in the drying process, to give rather stable aryloxy radicals which end up by dimerizing or being further oxidized by oxygen to quinones. The free radical chain reactions leading to drying (or other autoxidation reactions) are therefore effectively stopped, at least until all the phenols present are used up.

Compounds of this type are known as inhibitors or antioxidants (further discussed in Section 11.2.1)

and are of great industrial importance, being added to many products to stop or slow down oxidative degradation. Various types of phenols are common minor components of natural products and they serve as natural antioxidants. The initial delay period in commencement of drying of drying oils is supposed to be due to the presence of these, and notably the group of compounds known as the tocopherols (vitamin E).

α-Tocopherol

Phenols are present in tars, and certain other materials which are products of pyrolysis, and this is the probable reason for the poor drying of paint films containing carbon black as pigment, as well as the bituminous earths such as Vandyck brown.

3.4.4 Oxidation processes leading to small molecules

Some of the reactions which take place during the drying lead not to cross-linking but to bond breaking and the formation of low molecular weight degradation products. A major way in which this can happen is through alternative reaction paths of the hydroperoxide intermediates. Alkoxy radicals, produced from the hydroperoxides in the ways described, can break down instead of adding to double bonds or abstracting hydrogen from other molecules:

$$R - \underset{\underset{O^{\cdot}}{|}}{CHR^1} \rightarrow R - CHO + {}^{\cdot}R^1$$

The products are an aldehyde and an alkyl radical. The radical can go on to react with oxygen or add to double bonds: the aldehyde usually gets further oxidized to a carboxylic acid. If R represents the glyceryl ester end of the fatty acid molecule then the resulting acid is still attached to this as the half ester of a dicarboxylic acid. If it represents the hydrocarbon end of the fatty acid chain then the product is a free monocarboxylic acid.

The chain length of these possible products depends on the exact position of the hydroperoxy group on the C_{18} fatty acid chain. Usually it is

somewhere more or less in the middle and consequently the major products are the half esters of the C_9 dicarboxylic acid, azelaic acid, and the C_8 and C_{10} compounds, with still smaller amounts of the shorter chain compounds.

The most abundant monocarboxylic acid product is also the C_9 compound though very much less of this and the other monocarboxylic acids is found in old oil films than the dicarboxylic acids[50].

3.4.5 Yellowing of oil films

Paint films formed from certain drying oils yellow more than others, especially when kept in the dark, and it is known that oils with a high linolenic acid content are particularly prone to undergo this. Several structures have been suggested as possibly contributing to this yellow colour, including diketones and metal salts of the enol forms of these:

$$\underset{R-C-C-CH_2-R^1}{\overset{O\quad O}{\underset{\|\quad\|}{}}} \qquad \underset{R-C-C=CH-R^1}{\overset{O\quad OM}{\underset{\|\quad|}{}}}$$

$$M = metal$$

It has however been pointed out that these are quite weakly chromophoric groups (a chromophore is a group absorbing in the visible or ultraviolet) and the compounds would need to be present in quantity to produce the observed intensity of colour[51].

The alternative suggestion was made that yellowing in the dark is a superficial reaction needing the presence of traces of ammonia, or perhaps other amines, in the atmosphere to give rise to the formation of yellow compounds containing the pyrrole nucleus. Pyrrole itself is colourless but readily gives dark autoxidation products of uncertain structure.

pyrrole

Other possible chromophores giving a yellow colour have also been suggested, for example quinoid structures[52] which could arise by condensation of two diketone molecules:

The yellowing reaction is a slow one while the subsequent bleaching, by re-exposure to light, occurs very quickly. The cycle of yellowing followed by bleaching can be repeated a number of times. Earlier studies[53,54] suggested that the extent of yellowing diminished each time but more recent work has indicated that darkening and susceptibility to bleaching is not a function of age of the paint film or its darkening–bleaching history[55]. Yellowing reactions also appear to result from the interaction of proteins (conceivably giving rise to amines) with autoxidizing drying oils, and consequently are particularly liable to occur with protein/oil emulsion media.

3.4.6 Prepolymerized, or stand oils

Drying oils can be processed in various ways to produce materials in which the linking together of the triglycerides is already partially effected before the oil is put to use. The product is naturally more viscous than the raw oils, giving rise to the name thickened or bodied oils. The nature of the reactions occurring depends on whether the bodying is carried out in the presence or absence of air. If the former then reactions much the same as those taking place in the drying of oil films may be expected, but when oils are bodied by heating in the absence of air – the usual method of preparing stand oils today – then other types of reaction must take place.

It was long ago proposed that dimerization by Diels-Alder type reactions occurs, and this seems to have been confirmed in recent years[56]. A Diels-Alder reaction is one between a conjugated diene and a compound with a single double bond to give a cyclic compound:

For this to occur with linolenic or linoleic acid, isomerization of the unconjugated double bonds to give some conjugated diene is a necessary preliminary to reaction. This does occur simply on heating the oil but it is a slow and probably rate-controlling step.

The formation of di- and some trimeric products greatly speeds up during the heating period: in

some experiments on the formation of stand oil by heating linseed oil at 300°C under nitrogen[57] it was found that after 6 h the oil contained some 49% of polymeric glycerides, after 6.5 h, 57%, and after 7 h, 84%. The corresponding viscosities were 33, 73, and 210 poises respectively.

As can be seen, the product of dimerization contains a single double bond and so could go on to react with further diene to give trimer, though in fact the evidence is that little of this is formed. It has long been known that, in addition to dimer formation, cyclized monomeric acids are formed in the heating of drying oils under various conditions.

While most of the experimental work on the formation of these has been conducted using conditions of alkali promoted isomerization they are also known to form with heat alone[57–64]. The precursor of the cyclic monomers is a conjugated trienoic acid, and in fact they were first noticed in heated tung oil, being formed from the conjugated elaeostearic acid. Reaction is by a so-called electro-cyclic reaction:

$$\text{structures: } -(CH_2)_X CH_3 \quad \longrightarrow \quad -(CH_2)_X CH_3$$
$$-(CH_2)_Y COOH \qquad\qquad -(CH_2)_Y COOH$$

or

$$(CH_2)_X CH_3$$
$$(CH_2)_Y COOH$$

where X + Y = 10. The position of the diene group in the products, which must initially be as shown, can shift. In about 55% of the product from linseed oil X is 2 and Y is 8.

The fate of these cyclized acids has not been specifically determined but almost certainly they go on to be incorporated into the polymer network, perhaps first through participation in the Diels-Alder dimerization reaction. Certainly they seem not to be detectable, after saponification, in well-dried oil films.

3.4.7 Drying of stand oils

Stand oils dry more slowly than raw oils and with the uptake of much less oxygen. Thus raw linseed oil may absorb some 10 or 12% of oxygen by weight compared with about 3% for heat bodied oils. The predominance of carbon–carbon links over carbon–oxygen links in the resulting polymer is probably responsible for the more durable qualities of the film formed.

Other advantages of stand oils accrue from the smaller volume changes on drying (resulting in less wrinkling) and the lowered tendency to yellow (due to the reduction in the linolenic acid content).

3.5 Minor components of oils and fats

In addition to the triglycerides, oils and fats usually contain a small proportion, usually less than 1%, of so-called non-saponifiables – neutral compounds which do not react with alkali to give water-soluble soaps. Considerable attention has been given to identifying these in recent years and they have also been proposed as a possible key to identifying different oils[65]. However, except in the case of egg fats they are present in such small amounts as to be of no particular significance, either as affecting the properties of the oil or as identifiers in analysis, at least in the case of small samples of dried oils[66].

β-sitosterol

cholesterol

The non-saponifiables of seed oils are usually very complex mixtures containing triterpene alcohols (8.3.1), methyl sterols, and sterols[67]. Invariably present, and usually in greatest amount, is β-sitosterol. The sterol cholesterol is usually found only in vanishingly small quantities, for this is the characteristic sterol of animals. It is present in large amounts in egg yolk, which makes this a convenient place to discuss the composition of this complex material.

The composition of eggs, in terms of broad chemical groupings, is shown in *Table 3.3*. The proteins will be discussed in the appropriate section. The lipids are made up of triglycerides (*c.* 65%), phospholipids (*c.* 29%) and cholesterol (*c.* 5.2%).

Table 3.3 Composition of hens' eggs (%)

Component	Egg white	Egg yolk	Whole egg
Water	88	49	75
Solids	12	51	25
Protein	10	16.5	12
Lipids	—	33	11
Carbohydrate	1	1	1
Inorganic	0.6	1.7	1

The cholesterol is thus present to the extent of some 0.5% of whole egg, 1.5% in egg yolk, or again some 2.5% of dried whole egg solids. This is a large amount compared with the content of any one sterol in a vegetable oil and its detection in dried paint has been attempted as a way of identifying the presence of egg[50].

The nature of the phospholipids must briefly be explained. They are in effect triglycerides in which one of the fatty acid ester groups is substituted by a phosphatide group, that is to say an ester with phosphoric acid. As phosphoric acid is tribasic it may, in turn, be further combined with various compounds. When so esterified with the strong nitrogenous base choline the resulting compound is one of the group of compounds called lecithins, the hydrous and anhydrous forms of the α-lecithins (with the phosphatide group at the primary glyceride position) are usually formulated as:

$$
\begin{array}{l}
\quad\quad\;\; O \\
H \quad\;\; \| \\
HC-OCR^1 \\
| \quad\quad\;\; O \\
| \quad\quad\;\; \| \\
HC-OCR^2 \\
| \quad\quad\quad\;\; O \\
| \quad\quad\quad\;\; \| \\
HC-O-P-OCH_2CH_2N(CH_3)_3 \\
H \quad\quad\quad \diagdown_O \diagup
\end{array}
$$

Compounds such as these are only very minor constituents of most vegetable oils and they are largely removed during washing or other refining procedures. The substantial amounts in egg yolk means, however, that this has a significant phosphorus content, about 0.5% by weight, equivalent to some 0.9% of dried whole egg. Because of this, tests for elementary phosphorus were made a basis for the detection of egg in paint media by some early workers[68] but this is not very reliable because of possible other (pigmentary) sources of the element.

The fatty acid composition of egg yolk (from the combined glycerides and phosphatides) is included in *Table 3.2*.

3.6 Products containing or derived from fats and fatty acids

3.6.1 Varnishes

Until the advent of synthetic materials in the 1940s and 50s, oil varnishes were the standard material for coating interior and exterior woodwork, and indeed objects made of other materials including metals. They will also have been used for varnishing paintings until the development of distillation, and the preparation of oil of turpentine (8.1.1), permitted the introduction of spirit varnishes containing little or no oil.

Very little evidence survives for the use of oil varnishes on early paintings, since most will long ago have been replaced during cleaning and conservation. However, a small area of varnish found on a fourteenth century Italian painting was shown to be compounded of boiled oil and a resin of the sandarac type, and was very possibly that originally applied[69]. The indicator found here for pre-polymerization by heating was the relative proportions of suberic to azelaic acids (i.e of the C_8 to C_9 dicarboxylic acids) in the dried oil. Much higher proportions of the former have been found for treated than for untreated oils[50].

Early recipes for oil varnishes are sometimes very, and probably impracticably, complex. Eventually, however, the recipes generally called for a combination of hard resin (by which was meant an African or kauri copal or similar material) with hot boiled oil and driers. The whole was then diluted with oil of turpentine. The following two recipes from Hurst's *Manual of Painters' Colours, Oils, and Varnishes* will exemplify later practice[70]. They have been converted to weight percentages from the original measures in pounds and gallons and ignore possible losses in weight from the 'running' of the resin and the 'boiling' of the oil. As can be seen, they contain a very high percentage of oil as compared with resin.

Elastic Carriage Varnish

Resin ('Animé' or copal)	10%
Linseed oil	29%
Zinc sulphate	0.15%
Litharge (lead monoxide, PbO)	0.3%
Lead acetate	0.15%
Oil of turpentine	60%

Pale oak varnish

Resin	9%
Oil	35%
Ferrous sulphate	0.3%
Lead acetate	0.3%
Litharge	0.3%
Oil of turpentine	55%

The procedure for making the varnish was first to melt, or 'run' the resin by heating it to about 330°C and maintain it at this temperature for half an hour or so. Meanwhile the oil was separately heated to about 260°C and then added to the melted resin with vigorous stirring. The driers were then added and the varnish 'boiled' for several hours until it 'stringed', i.e. when a little between two fingers drew out to a string as the fingers were drawn apart. After allowing to cool somewhat the mixture was diluted with the turpentine.

The expression 'boiling' refers to the gentle apparent ebullition which really was the escape of volatile decomposition products of the oil and resin produced both by oxidation processes and by pyrolysis. After its preparation the varnish was allowed to stand, or 'age', for a while when a certain amount of insoluble matter would sink to the bottom. This probably included some of the added driers which do not always dissolve completely. The above varnishes were said to be very quick drying; some five hours in Summer being claimed.

Although the use of hard resins was always said by nineteenth and early twentieth century authors such as Hurst[70] to be necessary for the best and most durable varnishes, they concede that the much cheaper pine resin (rosin or colophony) could be used with some success for varnishes for internal use. One may suspect that in practice the temptation to substitute it, in part at least, was often not resisted. In early recipes, such as those to be found in Hendrie's translation of Theophilus[29], pine resin is a common ingredient.

The extent to which oil varnishes were used as a painting medium is still a matter of some doubt, since the detection and estimation of resins, particularly the so-called 'hard' or polymerized resins, in a dried oil-resin varnish is a difficult task further discussed in Sections 8.3.6 and 12.1.5. There have however been a number of findings of traces of pine resin as part of the paint medium and when these are combined with indications that the oil component has been prepolymerized by heating (as discussed above) then it is reasonable to suspect an oil varnish medium[71].

3.6.2 Printing ink

The medium for printing inks has traditionally been 'lithographic varnish', which is really just another name for boiled oil. Linseed oil was almost the only one to be used up until this century. The preparation often involved the actual inflammation of the oil which was allowed to burn for some time. Naturally this gave a very dark product but this was of no consequence since carbon black in some form (usually lampblack) was in any case going to be added as pigment. Some resin was also usually incorporated, probably generally pine resin.

In the nineteenth century various pitches and tars also started to be added to inks for cheaper applications, as well as petroleum products as diluents. Present day printing inks, which include coloured inks, commonly incorporate components from the whole gamut of synthetic and semi-synthetic resins and other materials which are now available.

Inks used for newsprint on very absorbent paper often do not dry, in the sense of polymerize, but are simply absorbed into the fibrous texture of the paper and lose solvent by evaporation.

3.6.3 Linoleum and oil cloth[42]

The floor covering material named linoleum is, as its name implies, a product of linseed oil. The first linoleum factory was built in England in 1864 and the material became the dominant flexible floor covering until vinyl products displaced it in the 1950s and 1960s. Essentially it consists of three components: the organic binder; inorganic filler (pigments and ground limestone); and organic filler (ground cork and wood flour). The binder was made from dried boiled oil processed in certain ways and then fluxed with about a quarter of its weight of resin, usually rosin but sometimes more expensive resins such as kauri.

Oil cloths are of two types. In one the fabric is impregnated with unpigmented drying oil which is then allowed to dry. Such materials were much used until quite recently in making waterproof capes, umbrellas (especially in Japan) and the like. In the second type of oilcloth one side of a fabric is covered with a continuous coating of pigmented oil – paint essentially – to give a washable surface, and such materials were used as covers for tables, shelves etc.

The painted floorcloths of eighteenth and nineteenth century England and America (the precursors of linoleum) consisted of several layers of thick oil paint on a strong canvas backing (often sailcloth), and were both plain and patterned.

3.6.4 Putty and plasticine

Ordinary window putty is sometimes encountered in the museum, having been used to make moulded or cast objects. It is usually simply a mixture of whiting (calcium carbonate) with either raw or boiled linseed oil. Likewise the modelling material plasticine, which hardens only very slowly, is (or was originally) a mixture of 'sulphur with pure vegetable oils'[72].

3.6.5 Soaps[73]

Soaps are the salts of the long chain fatty acids. The material generally known as 'soap' is more particularly the sodium or potassium salts of these in the proportions in which they occur in the fat from which the soap is made. Treatment of fats with aqueous alkali gives the soluble soaps and glycerol:

$C_3H_5 (OOCR)_3$ + 3NaOH \rightarrow
triglyceride sodium
 hydroxide

3NaOOCR + $C_3H_5(OH)_3$
sodium glycerol
soap

Soaps, or at least soap solutions, have apparently been known since antiquity as the saponification process can be effected, though very slowly, with potassium carbonate leached from wood ashes. Manufacture of soap reached a high state of development by the eighteenth century but it was not until the early nineteenth century, with the production of cheap caustic soda by the LeBlanc process, that its use could become common.

Many metal soaps, such as those of calcium and magnesium, are insoluble in water and so precipitate out when soap is used in 'hard' water containing dissolved salts of these metals, with consequent loss of detergency. The detergent effect of soap, in common with that of other detergents, has many facets but is due basically to the fact that the molecule is both hydrophobic and hydrophilic.

Like all salts, sodium and potassium soaps are ionized in water solution. Consequently at any interface between water and immiscible non-polar material the molecules align themselves with the carboxylate ion in the water phase and the long hydrocarbon chain of the fatty acid in or towards the non-polar material. This forms a link between the two phases resulting in ready emulsification or suspension of one in the other.

3.6.6 Free fatty acids: stearin

Free fatty acids have been produced commercially since the early nineteenth century, for they have many uses. They are formed when soaps are acidified but a more economical process is the direct hydrolysis of fats with water[74]. This can be effected at atmospheric pressure in the presence of acid and certain other catalysts (Twitchell process) or, with different catalysts, at the elevated temperatures (260°C) which can be achieved under pressure. The product is, of course, a mixture of acids in the proportions in which they occur in the fat.

As mentioned earlier, the unsaturated C_{18} acids tend to be liquid at room temperature, and to obtain the mixed solid saturated acids (C_{16} and C_{18}) known as stearin or stearin wax the liquid, predominantly unsaturated, acids are squeezed out under pressure.

Stearin wax was, and to some extent still is, an important ingredient of certain types of candles, particularly those used in churches. It may therefore be encountered as an ingredient of wax sculptures and models, either added deliberately or because candles were used as a source of the wax.

Essentially identical with stearin wax, though having different proportions of components, are adipocere and bog butter, discussed above (3.3.1).

3.7 Analysis of oils and fats

Enough examples have already been given in this chapter to make it evident that the detection and identification of fatty materials relies heavily on the qualitative and quantitative analysis of the component fatty acids, and that the only practicable way of doing this is by means of gas chromatography. The application of this to paint media now goes back thirty years[75] and has more recently been widely discussed and adopted[76-78]. It is considered in practical detail in Chapter 12. GLC has also seen application to the study of the solvent-extractable components of oil paint films[79], which consist of unpolymerized triglycerides, free fatty acids and low molecular weight oxidation products.

Disfiguring blooms, analogous to those encountered on objects as discussed above, sometimes manifest themselves on paintings, particularly twentieth century ones, and these are commonly found to consist of free fatty acids. The works of artists who have compounded elaborate mixed media instead of using straight oil paint are particularly liable to such defects. The semi-crystalline white exudate on some paintings of Mark Rothko was found by GLC to consist of palmitic acid, stearic acid, and a plasticizer, bis-(2-ethylhexyl)adipate[80]. Apparently the artist used an *ad hoc* emulsion compounded of oil paint, eggs, and dammar varnish. The fatty acids clearly derived from the hydrolysis of the saturated triglycerides of the egg fats; the plasticizer from the acrylic polymer which had also been used as medium in places.

A similar phenomenon was noted with a number of paintings by Serge Poliakoff[81], the medium here being very high in free fatty acids and, in parts, fatty acid soaps. A clear explanation, in terms of the original composition of the medium, was not available in this case. Unpublished results on a similar case showed that this artist had used an egg-oil emulsion as medium, and this was supported by anecdotes concerning his painting practice[82].

These analyses all involved GLC of derivatives of fatty acids following saponification of the fatty material. It may well be that in future more attention will be given to the analysis of the unsaponified fats since it is now feasible to separate fatty acids, mono- and diglycerides as well as unchanged triglycerides all together in a single run at a suitably high temperature. Archaeological fat residues have been so analysed[83], the hydroxyl and carboxylic acid groups of the sample being first converted to trimethylsilyl (TMS) ether and ester derivatives by treating with N,O-bis(trimethylsilyl)trifluoroacetamide. Using a quartz capillary column with immobilized dimethyl polysiloxane coating (BP-1), programmed up to 350°C, all these groups of compounds were well separated, the triglycerides emerging during the final constant temperature period.

References

1 MCGREGOR, W. G. and CARSON, R.B., 'Fatty acid composition of flax varieties', *Canadian J. Plant Sci.*, 41(1961), 814–17

2 SEKHON, K. S., GILL, K. S., AHUJA, K. L. and SANDHU, R. S., 'Fatty Acid composition and correlation studies in linseed (*Linum usitatissimum* L.)', *Oléagineux*, 28(1973), 525–6

3 YERMANOS, D. M., 'Variability in seed oil composition of 43 *Linum* Species', *J. Amer. Oil Chem. Soc.*, 43(1966), 546–9

4 PRICE, M. J., 'Comparative fatty acid composition of linseed oil in Northern and Southern Queensland', *Queensland J. Agricultural and Animal Sciences*, 25(1968), 129–33

5 FORCHIERI, H., BERTONI, M. H., KARMAN de SUTTON, G. and CATTANEO, P., 'Aceites de semilla de lino oleaginoso. Composicion quimica: influencia de la epoca de siembra', *Anales Asoc. Quim. Argentina*, 53(1970), 313–27

6 SONNTAG, N. O. V., 'Structure and composition of fats and oils', in *Bailey's Industrial Oil and Fat Products* (Edited by D. Swern), 4th edition, vol.1(1979), 1–98

7 GUNSTONE, F. D., 'Distribution of fatty acids in natural triglycerides of vegetable origin', *Chem. Ind. (London)*, (1962), 1214–23

8 VERESHCHAGIN, A. G. and NOVITSKAYA, G. A., 'The triglyceride composition of linseed oil', *J. Amer. Oil Chem. Soc.*, 42(1965), 970–4

9 THORNTON, M. D., MORGAN, E. D. and CELORIA, F., 'The composition of bog butter', *Science and Archaeology*, 2–3(1970), 20–4

10 MORGAN, E. D., CORNFORD, C., POLLOCK, D. R. J. and ISAACSON, P., 'The transformation of fatty material buried in the soil', *Science and Archaeology*, 10(1973), 9–10

11 DEN DOOREN DE JONG, L. E., 'On the formation of adipocere from fats', *Antonie van Leewenhoek J. Microbiol. Serol.*, 27(1961), 337–61

12 RATLEDGE, C., 'Microbial conversion of alkanes and fatty acids', *J. Amer. Oil Chem. Soc.*, 61(1984), 447–53

13 MORGAN, E. D., TITUS, L., SMALL, R. J. and EDWARDS, C., 'Gas chromatographic analysis of fatty material from a Thule midden', *Archaeometry*, 26(1984), 43–8

14 MORGAN, E. D. and TITUS, L., 'The fate of buried fats and oils and the remains from a 1000-year old Eskimo dwelling', *Anal. Proceedings*, 22(1985), 77–8

15 EVERSHED, R. P., 'Chemical composition of a bog body adipocere', *Archaeometry*, 34(1992), 253–65

16 BASCH, A., 'Analysis of oil from two Roman glass bottles', *Israel Exploration J.*, 22(1972), 27–32

17 JAKY, M., PEREDI, J. and PALOS, L., 'Untersuchungen eines aus römischen Zeiten stammenden Fettproduktes', *Fette, Seifen Anstrichmittel*, 66(1964), 1012–17

18 CONDAMIN, J., FORMENTI, F., METAIS, M. O., MICHEL, M. and BLOND, P.,'The application of gas chromatography to the tracing of oil in ancient amphorae', *Archaeometry*, 18(1976), 195–201

19 CONDAMIN, J. and FORMENTI, F, 'Detection du contenu d'amphores antiques (huile, vin). Etude méthodologique', *Revue d'Archéometrie*, 2(1978), 43–57

20 SEHER, A., SCHILLER, H., KROHN, M. and WERNER, G., 'Untersuchungen von "Ölproben" aus archäologischen Funden' *Fette, Seifen Anstrichm.*, 82(1980), 395–9

21 GÜLAÇAR, F. O., BUCHS, A. and SUSINI, A., 'Capillary gas chromatography-mass spectrometry and identification of substituted carboxylic acids in lipids extracted from a 4000-year-old Nubian burial' *J. Chromatog.*, 479(1989), 61–72

22 ROTTLÄNDER, R. C. A., 'Detection and identification of archaeological fats'; *Fette, Seifen Anstrichm.*, 87(1985), 314–17

23 ROTTLÄNDER, R. C. A., 'A new method for investigating the content of archaeological vessels', *Chemie für Labor und Betrieb*, 40(1989), 237–8

24 PEARLSTEIN, E., 'Fatty bloom on wood sculpture from Mali', *Stud. Conserv.*, 31(1986), 83–91

25 ERHARDT, D and FIRNHABER, N., 'The analysis and identification of oils in Hawaiian oiled tapa', *Recent Advances in the Conservation and Analysis of Artifacts*, compiled by J. Black, Institute of Archaeology, London (1987), 223–8

26 SCHRENK, J. L., 'Corrosion and past "protection" treatments of the Benin "bronzes" in the National Museum of African Art', *Materials Issues in Art and Archaeology II: Symposium held April 17–21, 1990, San Francisco*, Materials Research Society proceedings no. 185, edited by P. B. Vandiver, J. Druzik and G. S. Wheeler (1991), 93–103

27 MILLS, J. S. and WHITE, R., 'Analyses of paint media', *National Gallery Technical Bulletin*, 4(1980), 65–7

28 LUCAS, A., *Ancient Egyptian Methods and Materials*, 3rd ed, Edward Arnold, London (1948), 385

29 THEOPHILUS, *An Essay upon Various Arts*, trans. with notes by R. Hendrie, London (1847)

30 AETIUS AMIDENUS, *De Re Medica*, 5th to 6th century. See LAURIE, A. P. *Materials of the Painters' Craft*, London and Edinburgh (1910), 65

31 EASTLAKE, C. L., *Materials for a History of Oil Painting*, 2 vols., T. N. Foulis, London, (1847 and 1869), vol.1, 48–61

32 MILLS, J., PLESTERS, J. and WHITE, R., 'The structure, pigments, and medium of some samples from the St. Stephen's Chapel wallpaintings in the British Museum', published as Appendix I in VAN GEERSDAELE, P. C. and GOLDSWORTHY, L. J., 'The restoration of wallpainting fragments from St. Stephen's Chapel, Westminster' *The Conservator*, 2(1978), 9–12

33 PLANTER, L. E., SKAUG, E. and PLAHTER, U., *Medieval art in Norway, Vol. I. Gothic painted Altar Frontals from the Church of Tingelstad: Materials, Technique, Restoration*, Universitetsforlaget, Oslo (1974)

34 WIIK, S. A. and PLAHTER, U., 'St Olav of Fresvik and St Paulus of Gausdal. Two polychrome wooden sculptures from the Middle Ages', *Universitetets Oldsaksamling Årbok* (1979), 213–27

35 PLAHTER, U., 'Norwegian easel paintings from the period 1250–1350', *La Pittura nel XIV e XV Secolo. Il Contribuito dell'Analisi Tecnica alla Storia dell'Arte* (Edited by H. W. van Os and J. R. J. van Asperen de Boer), Cooperativa Libraria Universitaria Editrice Bologna, Bologna (1983), 73–88

36 PLAHTER, U., 'The crucifix from Hemse: analysis of the painting technique', *Maltechnik Restauro*, (1984), 35–44

37 MATSUI, E., 'The appearance of Koshiabura in ancient documents' (in Japanese), *Sci. Papers on Japan. Antiques and Art Crafts.*, 26(1981), 15–23

38 UEMURA, R., KAMEDA, T., KIMURA, K., KITAMURA, D. and YAMASAKI, K., 'Studies on the Mitsuda-e, a kind of oil painting' (in Japanese), *Sci. Papers on Japan. Antiques and Art Crafts*, 9(1954), 15–21

39 HIROKAZU, A., 'Trays with flower-and-bird designs in litharge painting', *Museum* (Tokyo), no. 128 (1961), 19–21

40 CARILLO Y GARIEL, A., *Tecnica de la Pintura de Nueva España*, Imprenta Universitaria, Mexico (1946), 42–8

41 WEXLER, H., 'The polymerization of drying oils', *Chemical Reviews*, 64(1964), 591–611

42 FORMO, M. W., 'Paints, varnishes and related products' in *Bailey's Industrial Oil and Fat Products*, (Edited by D. Swern), 4th edition, vol. 1 (1979), 687–816.

43 INGOLD, K. U., 'Peroxy radicals', *Accounts of Chemical Research*, 2(1969), 1–9

44 NACHTIGAL, M. and ZELINGER, J., 'The influence of pigments on the polymerization of linseed oil' (in Czech), *PICT Scientific Papers*, S6(1981), 119–56

45 NACHTIGAL, M. and ZELINGER, J., 'Effects of various factors in the polymerization and degradation process of vegetable oils used in art' (in Czech), *Chemicke listy*, 74(1980), 1159–84

46 RASTI, F. and SCOTT, G., 'The effects of some common pigments on the photo-oxidation of linseed oil-based paint media', *Stud. Conserv.*, 25(1980), 145–56

47 PEKKARINEN, L., 'The effect of copper, manganese and cobalt acetates on the autoxidation of *trans*-9, *trans*-11-octadecadienoic acid in 90% v/v aqueous acetic acid', *J. Amer. Oil Chem. Soc.*, 49(1972), 354–6

48 MILLS, J., 'The gas-chromatographic examination of paint media part I. Fatty acid composition and identification of dried oil films', *Stud. Conserv.*, 11(1966), 92–106

49 SONNTAG, N. O. V., 'Structure and composition of fats and oils: Components affecting the stability of fats and oils' in *Bailey's Industrial Oil and Fat Products*, (Edited by D. Swern), 4th edition, vol. 1 (1979) 72–77

50 MILLS, J. S. and WHITE, R., 'Organic mass-spectrometry of art materials: work in progress', *The National Gallery Technical Bulletin* 6(1982), 3–18.

51 O'NEIL, L. A., 'Applications of infra-red spectroscopy to the study of the drying and yellowing of oil films', *Paint Technology*, 27(1963), 44–7

52 FORMO, M. W., 'Paints, varnishes and related products: Discoloration' in *Bailey's Industrial Oil and Fat Products*, (Edited by D. Swern), 4th edition, vol. 1

722–4

53 RAKOFF, H., THOMAS, F. L. and GAST, L. E., 'Yellowing and other film properties of linseed-derived paints influenced by linolenate content', *J. Coatings Technology*, 48(1976), 55–7

54 RAKOFF, H., THOMAS, F. L. and GAST, L. E., 'Reversibility of yellowing phenomenon in linseed-based paints', *J. Coatings Technology*, 51(1979), 25–8

55 LEVINSON, H. W., 'Yellowing and bleaching of paint films', *J. American Institute for Conservation*, 24(1985), 69–76

56 BOELHOUWER, C., KNEGTEL, J. TH. and TELS, M., 'On the mechanism of the thermal polymerization of linseed oil', *Fette, Seifen Anstrichm.*, 69(1967), 432–6

57 PASCHKE, R. F., PETERSON, L. E. and WHEELER, D. H., 'Dimer acid structures. The thermal dimer of methyl 10-*trans*, 12-*trans*, linoleate', *J. Amer. Oil Chem. Soc.*, 41(1964), 723–7

58 ARTMAN, N. R. and ALEXANDER, J. C., 'Characterization of some heated fat components', *J. Amer. Oil Chem. Soc.*, 45(1968), 643–8

59 GREAVES, J. H. and LAKER, B., 'Estimation of unreacted acids during polymerization of linseed oil', *Chem. Ind. (London)* (1961), 1709–10

60 ARTMAN, N. R., 'The chemical and biological properties of heated and oxidized fats', *Advances in Lipid Res.*, 7(1969), 245–330

61 MCINNES, A. G., COOPER, F. P. and MACDONALD, J. A., 'Further evidence for cyclic monomers in heated linseed oil', *Can. J. Chem.*, 39(1961), 1906–14

62 FRIEDERICH, J. P., 'C_{18}-saturated cyclic acids from linseed oil. A structural study, *J. Amer. Oil Chem. Soc.*, 44(1967), 244–8

63 SAGREDOS, A. N., 'Nachweiss und Bestimmung von cyclischen C_{18}- Fettsäuren in isomerisiertem Leinöl', *Fette, Seifen Anstrichm.*, 71(1969), 863–9

64 PERKINS, E. G. and IWAOKA, W. T., 'Purification of cyclic fatty acid esters: a GC-MS study', *J. Amer. Oil Chem. Soc.*, 50(1973), 44–9

65 JOHNSON, M. and PACKARD, E., 'Methods used for the identification of binding media in Italian paintings of the fifteenth and sixteenth centuries', *Stud. Conserv.*, 16(1971), 145–64

66 MILLS, J. S. and WHITE, R., 'The identification of paint media from their sterol composition – a critical view', *Stud. Conserv.*, 20(1975), 176–82

67 LERCKER, G., FREGA, N., CONTE, L. S. and CAPELLA, P., 'La gascromatografia su colonne capillari (HRGC) nello studio dell'insaponificabile degli olii vegetali', *Rivista Italiana delle Sostanze Grasse*, 58(1981), 324–30

68 EIBNER, A., 'L'examen microchimique des agglutinants', *Mousseion*, 20(1932), 5–22

69 DUNKERTON, J., KIRBY, J. and WHITE, R., 'Varnish and early Italian tempera paintings', *Cleaning, Retouching and Coatings*, IIC London (1990), 63–9

70 HURST, H. G., *A Manual of Painters' Colours, Oils, and Varnishes*, 5th edition revised by N. Heaton, London, 1913

71 MILLS, J. S. and WHITE, R., 'Analyses of paint media', *National Gallery Technical Bulletin*, 11(1987), 92–5

72 Brit. Pat. 19 211 (28.8.1914). This patent is not for plasticine itself but for a composition of it with fibrous material. An application by Harbutt for a British Patent (12 814, 5.6.1902) of a modelling material which was, presumably, plasticine was abandoned

73 JUNGERMANN, E., 'Soap' in *Bailey's Industrial Oil and Fat Products* (Edited by D. Swern), 4th edition, vol. 1, 511–85

74 SONNTAG, N. O. V., 'Fat splitting, esterification, and interesterification' in *Bailey's Industrial Oil and Fat Products* (Edited by D. Swern), 4th edition, vol.2, 97–173

75 MILLS, J. S., 'The identification of organic materials in art objects with particular reference to paintings', *ICOM Committee for Conservation, Report 63/18*, 1st Triennial Meeting, Leningrad and Moscow (1963)

76 ERHARDT, D., HOPWOOD, W., BAKER, M. and VON ENDT, D., 'A systematic approach to the instrumental analysis of natural finishes and binding media', *Preprints, 16th Annual Meeting of AIC, New Orleans* (1988), 67–84

77 KOPECKÁ, I., 'Determination of drying oils by means of gas chromatography' (in Czech), *Sbornik Restaurátorských Prací*, 1(1983), 91–8

78 BUCIFALOVÁ, J., 'Chromatographic methods to determine oils used in painting techniques' (in Czech), *Sbornik Restaurátorských Prací*, 2–3(1988), 64–77

79 ERHARDT, D. and TSANG, J. -S., 'The extractable components of oil paint films', *Cleaning, Retouching and Coatings*, IIC, London (1990), 93–7

80 MANCUSI-UNGARO, C., 'The Rothko Chapel: treatment of the black-form paintings', *Cleaning, Retouching and Coatings*, IIC, London (1990), 134–7

81 KOLLER, J. and BURMESTER, A., 'Blanching of unvarnished modern paintings: a case study on a painting by Serge Poliakoff', *Cleaning, Retouching and Coatings*, IIC, London (1990), 138–43

82 MILLS, J. S. and WHITE, R., unpublished results

83 EVERSHED, R. P., HERON, C. and GOAD, L. J., 'Analysis of organic residues of archaeological origin by high-temperature gas chromatography and gas chromatography-mass spectrometry', *Analyst*, 115(1990), 1339–42

Bibliography

BAER, N. S. and INDICTOR, N., 'Linseed oil and related materials: an annotated bibliography: Part I – from antiquity to 1940', *Art and Archaeology Technical Abstracts* (AATA), 9(1972) no.1, 153–240; 'Part II – from 1941–1960', AATA, 9(1972) no.2, 159–241; 'Part III – from 1961–1972', AATA, 10(1973) no.1, 155–256; 'Part IV – from 1973–75', *Lipids and Works of Art*.

Proceedings of the 13th International Society for Fat Research Congress, Marseille (1976), 17–31; 'Part V – from 1976–1977', *Lipids and Works of Art. Proceedings of the 14th International Society for Fat Research Congress, Brighton* (1978), 31–49

EMANUEL, N. M. and LYASKOVSKAYA, YU.N. (trans. ALLEN, K. A.), *The Inhibition of Fat Oxidation Processes*, Pergamon Press, Oxford, 1967

FIESER, L. F. and FIESER, M., *Steroids*, Reinhold, New York (1959)

GUNSTONE, F. D., HARWOOD, J. L. and PADLEY, F. B. (Editors), *The Lipid Handbook*, Chapman and Hall, London and New York (1986)

HILDITCH, T. P. and WILLIAMS, P. N., *The Chemical Constitution of Natural Fats*, 4th edition, Chapman and Hall, London (1964)

MILLS, J. S. and SMITH, P. (Editors), *Cleaning, Retouching and Coatings; preprints of the Brussels Congress, 3–7 September 1990*, IIC, London (1990)

MARKLEY, K. S. (Editor), *Fatty Acids: their Chemistry, Properties, Production and Uses*, 2nd edition revised in 5 parts, Interscience, New York (1960–68)

OIL AND COLOUR CHEMISTS' ASSOCIATION OF AUSTRALIA, *Surface Coatings*, 2 vols., Chapman and Hall, London and New York, 2nd edition (1983/4)

SWERN, D. (Editor), *Bailey's Industrial Oil and Fat Products*, 4th edition, 2 vols., John Wiley and Sons, New York (1979 and 1982)

4

Natural waxes

The term *wax* is a rather inexact one which has come popularly to mean a material with a 'waxy' character, that is to say resembling beeswax or paraffin wax in being a low-melting, translucent solid with a waxy feel. The various materials named waxes do not in practice form a chemically homogeneous group, but what is generally understood by chemists as a wax is a material containing long chain hydrocarbons, acids, alcohols or esters, or mixtures of these. Many also contain plant sterols and triterpenoids and their esters. In distinction from fats the esters are not normally formed with glycerol, to give triglycerides, but are rather compounds of the long chain acids and alcohols. Such materials are the products of both the animal kingdom (particularly the insects) and the plant kingdom (they often coat the surfaces of leaves or fruits), the latter being also the original source of the waxes of mineral origin such as paraffin wax.

Waxes have found many uses since the earliest times, beeswax being almost invariably the one employed. The ancient Egyptians used it for adhesive and surface coating purposes, and in shipbuilding. The Greeks and Romans likewise used it as a waterproofing agent and probably also as a surface treatment for painted walls. One of its best known uses in antiquity is as the medium for many of the so-called Fayum portraits of the Egypt of the Roman period. Its use continued into recent times as a modelling or casting material ('lost-wax' process), as a component of seals, as an ingredient of surface coatings and polishes, and, in the eighteenth and nineteenth centuries, as an ingredient of rather experimental painting media. From antiquity till the late nineteenth century wax candles were a luxury source of lighting for those who could afford to use them instead of the smellier and smokier tallow (animal fat). Waxes still find many uses in present-day conservation practice, as in the relining of canvas paintings. Another is the impregnation of fragile materials as in the treatment of waterlogged wood with the wax-like polyethylene glycols, dealt with among the synthetic materials (9.2.7).

The basic chemistry of waxes has already been adequately covered by the sections on paraffin hydrocarbons and fatty acids in Chapter 1. Most wax components are fully saturated materials and this results in considerable chemical stability. The more important waxes will be treated individually.

4.1 Insect and animal waxes

4.1.1 Beeswax

Beeswax is synthesized by the bees rather than collected from plants (as is honey) and consequently is of biogenetically determined, and approximately constant, composition. A study of eighty samples of Canadian beeswax showed only minor quantitative variation in composition[1].

The composition of waxes from different bee species or varieties has not been much investigated; that from the African bee, *Apis mellifera adansonii*, was much the same as that from the ordinary *A. mellifera* but ghedda wax, from Asiatic bees, was qualitatively similar but quantitatively quite different[2].

Beeswax contains hydrocarbons, free acids, and esters[3–5]. The esters themselves divide into several different groups, namely monoesters, di- and trie-

sters, hydroxy monoesters and hydroxy polyesters. Each of these groups may be further subdivided into several different types but this need not concern us. The basic composition is shown in *Table 4.1*.

After saponification beeswax yields, in addition to the original hydrocarbons and free acids, further free acids, monoalcohols, diols, and hydroxyacids.

The hydrocarbons range from 25 to 35 in carbon number, C_{27} being the major one. The even carbon-number hydrocarbons are present only in small amount. The C_{31} hydrocarbon is said to be accompanied by a proportion of the monounsaturated compound while the C_{33} hydrocarbon is mostly the unsaturated compound. The composition of the free-acid fraction is quite different from that of the esterified (or the total) acids. These are shown in *Table 4.2*. It will be noticed that the free acids contain only small proportions of palmitic and stearic acids while the total acids contain largely palmitic acid but otherwise maximize at C_{24}. This

Table 4.1 Composition of beeswax (after Tulloch[3])

Component	Weight (%)
Hydrocarbons	14.0
Monoesters	35.0
Diesters	14.0
Triesters	3.3
Hydroxy monoesters	3.6
Hydroxy polyesters	7.7
Free acids	12.0
Acid monoesters	0.8
Unidentified	8.6

Table 4.2 Composition of free and total acids of beeswax (after Tulloch[3])

Chain length	Whole wax	Free acids
16	59.8	—
18	2.6	—
18:1	4.1	—
20	1.5	—
22	1.3	3.3
24	11.9	46.8
26	4.2	12.3
28	4.3	12.1
30	3.8	8.4
32	3.2	7.8
34	3.1	8.3
36	0.2	1.0

18:1 signifies a chain length of eighteen carbons with one double bond (oleic acid).

high content of palmitic acid needs to be borne in mind when interpreting analysis of paint samples which may contain small quantities of beeswax.

Since analysis and identification of waxes are conveniently effected by gas chromatography, it is easiest to consider the composition of beeswax in terms of what can be observed on the gas chromatogram, for a considerable proportion of the original components (about 37%) consists of compounds of too high molecular weight, hence too involatile, to pass through the column even at quite high temperatures.

This chromatogram and that of the saponified material will be discussed in a later section (12.5). Tulloch has published comparative chromatograms of beeswax and a number of plant and insect waxes after methylation of free acids and acetylation of alcohols[2,5].

Beeswax melts at about 64°C and in fact the eighty samples in the study mentioned above all melted within the range 63.4–65°C. This melting point even remains fairly constant with ageing and was much used as a fairly reliable identifying feature in the early days of analysis of museum materials.

The infrared spectrum of beeswax is, again, a rather reliable and constant characteristic useful for the analysis of unmixed samples of sufficient size.

4.1.2 Shellac or lac wax

This constitutes a small fraction (3–4%) of crude shellac (Section 8.6) and is obtained from it as a by-product. It contains[5] only a small proportion of hydrocarbons, free alcohols (C_{28}, C_{30}, C_{32} and C_{34}, in diminishing quantity), and a wide range of esters of carbon numbers from 42 to 68 in two broad bands peaking at 44 and 64.

4.1.3 Chinese insect wax

Like shellac this is also a product of a *Coccus* insect, *C. ceriferus* Farb., and it is cultivated in China in much the same way. The product however is an almost pure wax which is melted from the twigs and strained. It contains[5] almost entirely esters (*c.* 83%) of carbon numbers between 48 and 60, maximizing at 52.

4.1.4 Spermaceti wax

The oil in the head cavity of the sperm whale, *Physeter macrocephalus* L., deposits on cooling about 11% of the hard white wax known as spermaceti.

How long it has been known and used is not certain; presumably for as long as whaling has been carried out.

In England it was already used in medicine in the fifteenth century, and until recently was still used in ointment bases and cosmetics. It has also been used in candles, and was the material for the standard one candle-power candle. Being of lower melting point than beeswax (about 44°C) yet harder, it often entered into the composition of modelling and casting waxes, at least from the seventeenth century.

The literature usually suggests that spermaceti consists largely of cetyl palmitate, cetyl alcohol being the C_{16} alcohol as palmitic acid is the C_{16} acid, but in fact the composition is more complex than this. The gas chromatogram of the wax shows four main peaks and several minor ones[6], and probably these are not homogeneous. After saponification and methylation the acids were shown[7] to be from C_{10} to C_{18}, with C_{12} the major one and lesser amounts of the higher acids.

The peaks of palmitate and stearate were broad but homogeneous as regards mass spectra, as if they might include branched chain esters of the same molecular weight. The major alcohols were C_{18}, C_{14}, and C_{16} in that order but the odd numbered C_{13}, C_{15}, and C_{17} were also present.

4.1.5 Lanolin or woolwax

Wool sheared from unwashed sheep contains a considerable proportion (10–24%) of greasy matter as well as a smaller percentage of salts of long chain fatty acids. After isolation during the scouring of the wool, or by solvent extraction, followed by further purification the product is known as hydrous or anhydrous lanolin depending on its water content.

The complex chemistry of lanolin has received fairly extensive study as it is an important by-product of the wool industry. After saponification the product consists of about 50% each of acids and non-saponifiable compounds. The acids consist[8] of long chain alkanoic acids, both straight chain and branched, and hydroxy acids.

The non-saponifiable matter consists principally of the sterol cholesterol and the triterpenoid lanosterol, with smaller amounts of long chain alcohols and diols. The acid value of lanolin is quite low and its saponification value quite high, consequently the sterols and triterpenoids must be largely esterified with the acids, though this has not been investigated in detail.

The chromatogram of lanolin after saponification and methylation is shown in *Figure 4.1*. Quite possibly not all of the higher molecular weight materials are eluted and some decomposition and loss of sterols and triterpenoids may also have occurred.

4.2 Plant waxes

There are large numbers of waxes which have been collected from plants but they are mostly of fairly recent utilization. only a few of the more important need be described here.

4.2.1 Carnauba wax

Several genera of palms yield waxes the most important being carnauba wax from the New World *Copernicia cerifera*, growing mostly in Brazil. The wax coats the leaves, which are partly shredded and then beaten to release it as a powder, subsequently purified by melting and filtering. The wax is quite often used in modern conservation practice to add to beeswax to give a harder, higher melting mixture for use in relining and for other purposes. Carnauba is particularly important as an ingredient of wax polishes. It may often, in commerce, be adulterated with other, less expensive, waxes particularly paraffin.

Carnauba contains triterpenes and esters of long chain alcohols and acids of rather higher carbon number (maximizing at 56 carbons) than those encountered in beeswax so that the presence of one in the other is easily detected by gas chromatography[2,6,9]. It also contains a high proportion (50%) of material too involatile to be observed during gas chromatography. This is said to consist of polyesters of hydroxy acids and diols and derivatives of p-hydroxy- and p-methoxycinnamic acids[10]

4.2.2 Ouricuri wax

This is another South American palm wax of rather uncertain botanical origin. It has similar properties to carnauba, the presence of small quantities of it considerably raising the melting point of paraffin wax, and so it is put to similar uses.

Its composition[5,11] is also somewhat similar to that of carnauba and it contains some 6% of triterpenes which include lupeol acetate, taraxerol acetate, lupenone and taraxerone.

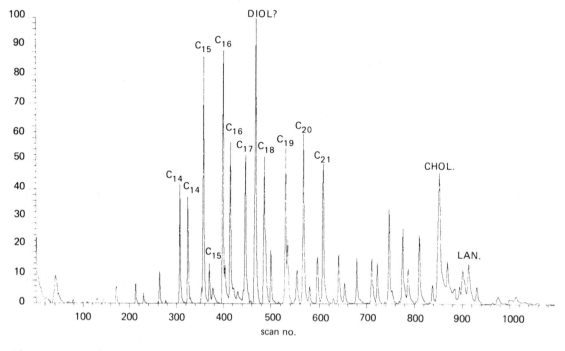

Figure 4.1 Capillary gas chromatogram of lanolin after saponification and methylation. Most of the main peaks are of saturated long chain fatty acid esters of the carbon numbers indicated (C_{14}, C_{15} etc), straight chain, iso, and anteiso, though which is which here has not been ascertained (they have very similar mass spectra). The major peak, labelled DIOL?, is, of MW 286 and may be an octadecanediol. CHOL. and LAN. are cholesterol and lanosterol.

4.2.3 Candelilla

This wax coats plants of *Euphorbia* spp. growing in Mexico and the Southern United States. It has been used with other waxes to harden them without at the same time much raising the melting point. It contains hydrocarbons, particularly C_{31}, rather low proportions of esters, and some triterpenoids[2,5]. The non-volatile part (37%) may include triterpenoid esters.

4.2.4 Esparto wax

A number of canes, reeds and grasses yield waxes but the only one likely to be encountered in the present context is esparto wax, obtained as a by-product in the preparation of esparto grass, *Stipa tenacissima*, for paper-making. Tulloch has remarked that it seems to be a variable product[5]. He shows a chromatogram indicating the presence of hydrocarbons, small amounts of esters and the C_{28} alcohol, plus unidentified triterpenoids.

A sample examined by White[6] lacked hydrocarbons and appeared to consist largely of sterols or triterpenes, at least as the observable volatile components.

Recently a curious theory has been advanced, unsupported by evidence from analysis, that the Punic wax referred to by Pliny was in fact esparto wax[12].

4.2.5 Japan wax

A wax in name only, Japan wax is really a fat or 'vegetable tallow' found between the kernel and outer skin of the berries of *Rhus* species, including those which yield Japanese lacquer. It contains a high proportion of palmitic acid triglycerides and also glycerides incorporating long chain dicarboxylic acids including the C_{22} and C_{23} compounds. It is much used in Japan to make candles.

4.2.6 Jojoba oil

A true liquid wax obtained from the bean-like seed of the jojoba, *Simmondsia* spp., abundant in Mexico and the Southern United States. It contains esters

derived largely from mono-unsaturated acids and alcohols especially the C_{20} and C_{22} straight chain compounds.

Said to have been used by the Indians as a hair dressing, it has become important in recent years as a substitute for sperm whale oil.

4.3 Fossil and earth waxes

4.3.1 Ozokerite and ceresine

Deposits of waxes are found in lignite beds in various parts of the world but more important are the earth waxes found at considerable depths and mined more or less like coal. Deposits of these are found in Galicia (Spain), the Carpathians (Romania) and several other parts of the world.

A purified and decolorized material obtained by treatment with sulphuric acid and then with animal charcoal is known as ceresine wax, though this name has also come to be applied to similar materials from petroleum and other sources and even, apparently, to mixtures prepared with a view to imitating its properties. It is thus probably not of consistent composition but it certainly consists wholly of saturated hydrocarbons which, in some samples, range from about C_{20} to about C_{32} and maximize (variably) between C_{23} and C_{29}, even carbon numbered compounds being equally important with the odd[6].

4.3.2 Peat waxes

Waxes extracted from peat, which is material in the early stages of coal formation, are less degraded than really old paraffin waxes and so still consist largely of esters and free acids.

Montan wax, mainly from Czechoslovakia, is the most important such product but the name is also applied more generally to similar materials from other countries. It has to be extensively chemically treated to render it sufficiently colourless for use, and as it can only be obtained by solvent extraction it does not have a very long history of use. Its chemistry relates to that of bitumen and coal and it contains triterpenoid derivatives (5.1.1).

4.3.3 Paraffin waxes

These are fractions from the distillation of petroleum and they come in various grades having different melting point ranges, between about 52°C

and 57°C. Fully refined paraffin wax is a perfectly white translucent material familiar from its use for making household candles since the second half of the nineteenth century.

The hydrocarbon composition seems to cover a wider range than that of ceresine, the amounts of the higher molecular weight materials falling off less sharply. Higher molecular weight hydrocarbon fractions tend to crystallize out as very small crystals and such materials form the basis of the so-called 'microcrystalline waxes'.

4.4 Detection and identification of waxes

Waxes were among the first organic materials to be identified with reasonable certainty from among samples from classical antiquity. Some materials of a fourth century encaustic painter were discovered in 1850 and the great French chemist M.E. Chevreul identified the presence of beeswax among them using simple tests of solubility and melting point.

Lucas reports many identifications of beeswax from Egyptian objects using similar methods. It seems to have been employed as an adhesive, in embalming practice, and in the construction of wigs.

In recent years, first infrared spectroscopy[13] and later gas chromatography[6] were adopted as analytical methods. The infrared spectrum of beeswax (*Figure 4.2*) changes little through oxidation, though sometimes partial hydrolysis can occur with samples exposed to groundwater. Several samples from diverse sources (Egyptian sarcophagus, Roman candle, mediaeval wax seal) all looked much the same[14] but a lump of material from the seventh century Anglo-Saxon Sutton Hoo ship burial showed reduced ester-group absorption relative to that due to free acid[15].

Infrared spectra also served to identify the materials of appliqué brocade materials in some polychrome wooden sculpture as being either in pure beeswax or in a beeswax/resin mixture[16]. The material of wax sculptures from the seventeenth to nineteenth centuries was likewise identified as usually pure beeswax[17]. The wax which had been used in the 1930s to impregnate Mantegna's paintings *The Triumphs of Caesar*, at Hampton Court, gave spectra indicative of a mixture of paraffin wax with lesser amounts of beeswax and also a small proportion of Venice turpentine (8.2.2)[14]. Infrared also served to identify beeswax on the surface of a Central Asian wall painting and as

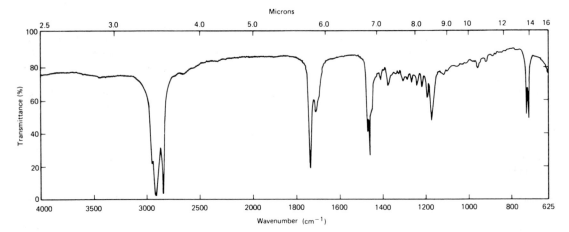

Figure 4.2 Infrared spectrum of beeswax (film from the melt). The twin bands at 720 and 730 cm^{-1} nare characteristic for long hydrocarbon chains. The carbonyl absorptions at *c.* 1711 and 1738 cm^{-1} are from free carboxylic acid and from esters respectively.

the medium of a Russian icon[18,19]. It has likewise been used[20] to identify beeswax in eighteenth century Italian paintings on canvas carried out in a reconstruction of the ancient encaustic technique, and in the study of wax seals dating from the thirteenth to eighteenth centuries[21].

Gas chromatography allows the examination of much smaller samples than infrared spectroscopy and also permits identification of mixtures of small amounts of one wax in another, as exemplified by a variety of samples including wax models, Fayum portraits and surface coatings[6]. Gas chromatography of underivatized samples of waxes and wax–resin mixtures has been recommended as a practicable method for their analysis[22]. Gas chromatography – mass spectrometry has been used as a very sensitive method of detecting beeswax in the mixed media used by the English eighteenth-century painter George Stubbs[23] (12.1.5).

Even mass spectrometry by itself has been applied to wax analysis, notably for the identification of beeswax in the bust of Nefertiti[24], while combined pyrolysis–mass spectrometry applied to Egyptian mummy cases (cartonnages) allowed classification of some 50% of samples, which also included gums and resins in their make-up in addition to waxes[25]. ^{13}C-nuclear magnetic resonance has been used for analysis of mediaeval wax seals[26,27]. Mediaeval samples were found to contain only beeswax while later ones also contained pine resin. Other waxes were also detected.

Other interesting findings of beeswax are: mixed with calcium carbonate (perhaps originally quicklime, i.e. calcium oxide) as a unique cement in a fifth-century BC Greek bronze head[28] and, perhaps mixed with resin, in an ancient Egyptian wig[29].

References

1 TULLOCH, A. P. and HOFFMAN, L. L., 'Canadian beeswax: analytical values and composition of hydrocarbons, free acids and long chain esters', *J. Amer. Oil Chem. Soc.*, 49(1972), 696–9

2 TULLOCH, A. P., 'Composition of some natural waxes', *Cosmetics and Perfumery*, 89(1974) no. 11, 53–4

3 TULLOCH, A. P., 'Beeswax: structure of the esters and their component hydroxy acids and diols', *Chem. Phys. Lipids*, 6(1971), 235–65

4 TULLOCH, A. P., 'Analysis of whole beeswax by gas liquid chromatography', *J. Amer. Oil Chem. Soc.*, 49(1972), 609–10

5 TULLOCH, A. P., 'Comparison of some commercial waxes by gas liquid chromatography', *J. Amer. Oil Chem. Soc.*, 50(1973), 367–71

6 WHITE, R., 'The application of gas-chromatography to the identification of waxes', *Stud. Conserv.*, 23(1978), 57–68

7 WHITE, R., unpublished results

8 DOWNING, D. T., KRANZ, Z. H. and MURRAY, K. E., 'Studies in waxes XIV. An investigation of the aliphatic constituents of hydrolyzed wool wax by gas chromatography', *Austral. J. Chem.*, 13(1960), 80–94

9 DOWNING, D. T., KRANTZ, Z. H. and MURRAY, K. E., 'Studies in waxes XX. The quantitative analysis of hydrolyzed carnauba wax by gas chromatography', *Austral. J. Chem.*, 14(1961), 619–27

10 VANDENBURG, L. E. and WILDER, E. A., 'The structural constituents of carnauba wax', *J. Amer. Oil Chem. Soc.*, 47(1970), 514–18

11 TULLOCH, A. P., 'The triterpenes of ouricuri wax', *Lipids*, 12(1977), 233–4

12 ENCAUST, 'Pictura reservata – über punisches Wachs', *Maltechnik*, 90(1984) no.3, 44–53

13 KÜHN, H., 'Detection and identification of waxes, including Punic wax, by infrared spectrography', *Stud. Conserv.*, 5(1960), 71–80.

14 MILLS, J. S., 'Identification of organic materials in museum objects', in *Conservation in the Tropics, Proceedings of the Asia-Pacific Seminar on Conservation of Cultural Property, New Delhi 1972*, ICCROM and Central Conservation Laboratory, New Delhi 159–70

15 MILLS, J. S., unpublished results

16 FRINTA, M., 'The use of wax for appliqué relief brocade on wooden statuary', including a note by J. Mills and J. Plesters on 'Analysis of wax appliqué', *Stud. Conserv.*, 8(1963), 136–49

17 MURRELL, V. J., 'Some aspects of the conservation of wax models', *Stud. Conserv.*, 16(1971), 95–109

18 BIRSTEIN, V. J. and TUL'CHINSKY, V. M., 'The identification of some painting materials on an encaustic icon, *Two Unknown Martyrs*. Methods of IR spectroscopy' (in Russian), *Khudozhestvennoe nasledstvo*, 5(1979), 198–201

19 BIRSTEIN, V. J., 'A study of organic components of paints and grounds in Central Asian and Crimean wall paintings', *ICOM Committee for Conservation, Report 75/1/10*, 4th Triennial meeting, Venice (1975), 9 pp

20 MATTEINI, M. and MOLES, A., 'Analisi di campioni di tele di Callani e Baldrighi, per l'accertamento della presenza di cere', in *Considerazione sulle Techniche della Pittura. L'Uso della Cera negli Artisti Parmensi del '700* (Edited by M. Simonetti and M. Sarti), Ministero dei Beni Culturali e Ambientali. Soprintendenza ai Beni artistici e storici di Parma e Piacenza, Parma (1979)

21 PARRA, E. and SERRANO, A., 'Chemical analysis of wax seals and dyed textile attachments from parchment documents. Preliminary investigations', *ICOM Committee for Conservation, 9th Triennial Meeting, Dresden, 26–31 August 1990: preprints*, edited by K. Grimstad (1990), 62–7

22 GLASTRUP, J. 'An easy identification method of waxes and resins', *Archaeometry: proceedings of the 25th international symposium*, edited by Y. Maniatis (1989), 245–52

23 MILLS, J. S. and WHITE, R., 'The mediums of George Stubbs: some further studies', *National Gallery Technical Bulletin*, 9(1985), 60–4

24 WIEDERMANN. H. G. and BAYER, G., 'The bust of Nefertiti', *Analyt. Chem.*, 54(1982), 619A, 620A, 622A, 624A, 626A and 628A

25 WRIGHT, M. M. and WHEALS, B. B., 'Pyrolysis–mass spectrometry of natural gums, resins, and waxes and its use for detecting such materials in ancient Egyptian mummy cases (cartonnages)', *J. Analytical and Applied Pyrolysis*, 11(1987). 195–211

26 CASSAR, M., ROBINS, G. V., FLETTON, R. A. and ALSTIN, A., 'Organic components in historical non-metallic seals identified using ^{13}C-NMR spectroscopy', *Nature*, 303(1983), 238–9

27 ROBINS, D., ALSTIN, A. and FLETTON, D., 'The examination of organic components in historical non-metallic seals with C-13 Fourier Transform Nuclear Magnetic Resonance Spectroscopy', *ICOM Committee for Conservation: 8th Triennial Meeting, Sydney, 6–11 September, 1987*, edited by K. Grimstad (1987), 87–92

28 FARNSWORTH, M. and SIMMONS, I., 'A unique cement from Athens', *Hesperia*, 29(1960), 118–22

29 COX, J. S., 'The construction of an ancient Egyptian wig (*ca.* 1400 B.C.) in the British Museum', *J. Egyptian Archaeol.*, 63(1977), 67–70

Bibliography

WARTH, A. H., *The Chemistry and Technology of Waxes*, 2nd edition, Reinhold, New York (1956)

5

Bituminous materials

This chapter covers bitumen, asphalt, tar and pitch, as well as harder, related materials such as coal. These terms have been very loosely used and the classification of the materials by gross physical and visual characteristics has been vague and confused. Now however they are usually placed in two broad categories, subdivided:

Natural products
I. Bitumen, asphalt
II. Pyrobitumens: peat, lignite and coals
Artificial products made by pyrolysis of wood, coal, or resin
III. Tars (distilled)
IV. Pitches (undistilled)

The chemistry of these materials is of great complexity and as yet far from completely established. A knowledge of it is necessary for anyone attempting their identification by analysis but to outline it here with any degree of completeness would be out of proportion to their importance in the field of art and archaeology. None the less the identification and uses of materials of this type have been the subject of considerable controversy in the past, particularly as concerns their use in mummification, and the history of this dispute has been interestingly reviewed[1]. The question seems never to have been fully resolved, though it now could be on the basis of the chemistry briefly to be outlined here.

Coal itself has little structural value though it was occasionally used in the Victorian period to make furniture, perhaps as a *tour de force*. The material

known as Kimmeridge shale, an oil-bearing clay mineral, was used to make simple objects which present some difficulties of conservation[2,3]. The mineral jet (essentially a very hard coal) is used in jewellery. The chief way in which the softer products proved of use to the artisans of the past was as adhesives, mortars and coatings. They are to be found thus used in small objects and large building structures alike and it is naturally of interest to be able to specify their nature.

It is now possible to distinguish the natural materials from those made by destructive distillation. The latter group can probably be further divided up more specifically but the problem of attributing a particular bitumen or asphalt sample to a particular geographical source, though receiving some attention by pollution laboratories in these days of spillage at sea of crude petroleum, is not yet fully solved, though a solution seems feasible since the isolation of the triterpane fractions of the bituminous fraction of crude oils (see below) has shown interesting variations from region to region. So far it has only been applied to petroleum from middle eastern sources that extend into Africa; from the North Sea, and from Alaska[4,5].

Another use for asphaltic or lignitic materials has been as a pigment for oil painting under such names as asphaltum, mummy, and Vandyke brown. These are fully dealt with in Harley's book on pigments (see Bibliography) and little more can be added here regarding their chemistry though it should prove to be closely related to that of the materials now discussed.

56

5.1 Asphalt and bitumen

The chemistry of these materials is essentially a further extension of that of petroleum or crude oil, already discussed in part in connection with hydrocarbon solvents (1.1.6) and earth waxes (4.3.1). The two terms, asphalt and bitumen, are not clearly distinguishable since they come from the Greek and Roman names, respectively, for the same material.

The name bitumen is now generally used for a substance containing essentially no inorganic or mineral matter but a high proportion of hydrocarbon solvent-soluble components ('maltenes') as opposed to insoluble components ('asphaltenes'). Consequently it is often used for the involatile residue from the distillation of petroleum, as well as for some of the materials found naturally.

Asphalt is the term for the native deposits found as outcrops, which result from seepage of crude petroleum through fissures to the surface, or exposure by erosion, followed by evaporation of the more volatile components. Such outcrops may well be associated with areas of volcanic activity or hot springs. Depending on the amount of admixed mineral matter, they are further divided into true asphalts (less than 10% minerals) and rock asphalts (more than 10% minerals). Asphaltites are a further category of higher melting, even infusible, materials which include named varieties such as glance pitch and Gilsonite.

Fossil organic materials are formed over millions of years from deposited biological remains and their present composition may partly reflect the nature of this original material, the two major categories of which are land-based and aquatic life.

One indicator is the gross carbon–hydrogen composition. High hydrogen-to-carbon ratio petroleums are now thought to have originated mainly from marine-life materials of a saturated, lipid-rich nature. In agreement with this is the high alkane and cycloalkane content of the older petroleums. This contrasts sharply with the low hydrogen-to-carbon ratio of some oil shales, peats, and coal, which is to be explained by the higher input of unsaturated (aromatic) starting materials, notably lignin (6.8) from land-based plants.

The precursors for petroleum, and hence asphalt, thus comprise the whole gamut of natural organic compounds described in this book plus many more. As the organisms die they are subjected to immediate changes by oxidative and biological action. As layers build up anaerobic conditions prevail and pressures and temperatures increase leading, over the period of geological time, to loss of functional groups, and fragmentation with losses of side chains. Disproportionation – that is to say transfer of hydrogen between molecules – also occurs, leading to both saturated and aromatized compounds. Only traces of functionalized compounds are likely to persist (other than as heterocyclic compounds) except within relatively young layers which have only been subjected to mild conditions in a non-catalytic environment.

The more detailed knowledge of the components of bitumen has been acquired in recent years largely through the use of gas chromatography, which is the only method capable of adequately separating the hundreds of components. In addition to the alkanes and cycloalkanes, already familiar to us, there are several classes of compounds which are close in composition to original plant constituents, modified only by defunctionalization and saturation, and these consequently constitute important biological markers helpful in 'fingerprinting' particular bitumens[6–8].

5.1.1 Biological markers

Isoprenoid compounds, particularly terpenoids, are discussed more fully in Chapter 8 in connection with natural resins. They are not confined to resins however but are widely distributed in the vegetable kingdom. Relics of them seem to survive in petroleum rather well and constitute the main class of observable biological markers.

Of acyclic isoprenoids two are particularly common: phytane (C_{20}) and pristane (C_{19}).

phytane

pristane

There are a number of compounds derived from cyclic mono- and diterpenoids[9,10], the latter including fichtellite (C_{19}).

fichtellite

Figure 5.1 Principal skeletal types for the natural phytosterols and tetracyclic triterpenes which may be found in bituminous materials.

The most important are, however, those related to the plant sterols (phytosterols) and the triterpenoids, which will be given a little more attention.

Figure 5.1 illustrates the range of skeletal types of natural phytosterols. Many derived saturated hydrocarbons (steranes) have been detected in the fossil materials while unsaturated hydrocarbons (sterenes) and even traces of saturated alcohols (stanols) have been detected in recent sediments. Many of these compounds have the original stereochemistry at the ring junctions but others are also found in which isomerization has occurred at one or more chiral (asymmetric) centre. Some compounds are also formed by complete 'backbone rearrangement' of the sterane nucleus, for example the diacholestanes:

diacholestanes

Detection of such compounds as these during analysis is, of course, good evidence that one is dealing with a fossil material since they do not occur in nature[11].

The triterpenoids of the natural resins are discussed in Section 8.3.1. Primitive organisms, including the marine algae, contain pentacyclic triterpenoids of several structural types as shown in *Figure 5.2*. These are called the primary triterpenoids as they are fully isoprenoid in structure, not having rearranged during biosynthesis. Bitumens containing dominant amounts of the hydrocarbons of these types therefore probably derive from deposits of marine organisms.

Bitumens commonly exhibit a complete range of homologues of hopane, ranging from C_{27} to C_{35}, as well as hopanes and moretanes which have undergone stereoisomerization at one or both of the asymmetric centres[12,13], namely at carbons 17 and 21 (in nature only compounds with the 17β and 21β hydrogens are encountered). It is now known that essentially *all* samples of sedimentary organic matter − shales, lignites, young muds, coals etc. − contain hopane hydrocarbons and this ubiquity is interpreted as indicating that they originate from the bacteria involved in the initial transformation of the varied dead plant or animal remains[14,15]. Hopane derivatives have indeed been isolated from several species of bacteria, in which they seem to be an important structural component of cellular membranes[15].

Triterpenoids with other skeletons (secondary triterpenes: i.e ones rearranged during biosynthesis) as shown in *Figure 5.3* are found in terrestrial higher plants of many families. Even functionalized compounds of these types are still to be found in peats and brown coals, and in montan wax obtained by solvent extraction of North Bohemian brown coal. The hydrocarbons of these skeletal types have been encountered in a variety of fossil products including crude petroleums from the Middle East, Nigeria, and Indonesia.

The above compounds are all ones which have undergone hydrogenation. The correspondingly dehydrogenated compounds − aromatic compounds − are also found and a selection of those which have been characterized is shown in *Figure 5.4*. Undoubtedly there are many more whose structures are yet to be clarified[13,16,17].

The later section of the capillary gas chromatogram of a natural bitumen from the island of Zakinthos, Greece (known and used since antiquity), is shown in *Figure 5.5*. It shows the presence of compounds of most of the classes mentioned above. The predominating components are hopanes while there are lesser amounts of moretanes and phytosteranes and others. *Figure 5.6* shows the mass spectrum of the largest peak, identified as a norhopane (see *Figure 5.2*).

Examples of the identification of some archaeological samples as bitumens, by detection of hopane compounds, are described in Chapter 12. Some samples from an ancient boat submerged in the Sea of Galilee proved particularly complex. Analysed by GLC−MS they showed both pine resin and bitumen[18]. Likewise some samples from Egyptian mummies (younger than the second century BC) were also analysed by GLC−MS and compared with asphalt from the Dead Sea area, which was found to be a likely source. Here too it was suggested that fresh plant resins and beeswax were also admixed[19,20].

5.2 Tars and pitches

The materials obtained by pyrolysis of wood and resin (or resinous wood) seem to have been important since antiquity, especially as caulking and waterproofing materials, in areas where native asphalts did not occur. Coal tar is apparently a product of the nineteenth century and, important though it became for the synthetic chemicals revolution, it can be dealt with rather briefly.

As already pointed out, starting materials for coal-forming processes were land-based plants rich in aromatic lignin. Condensation products of the humic acid type, containing oxygen and nitrogen functions, can form in various ways and these in turn can further condense with lignin and cellulosic debris. During coalification high molecular weight, highly condensed structures are formed. The hardest coals may even approach graphite in structure, i.e. they are almost pure carbon.

Pyrolysis of such material yields lower molecular weight aromatic compounds including phenols, heterocyclics, and polynuclear aromatic hydrocarbons. Much of this distils as coal tar. Higher molecular weight material simply fuses and flows away from residual carbon (coke) as coal pitch.

5.2.1 Wood and resin tars

Until recently rather little information has been available regarding the chemistry of wood and resin tars but with increasing interest in identifying such

Figure 5.2 Skeletal formulae of the primary triterpenoids (unrearranged during biosynthesis).

Figure 5.3 Skeletal formulae of secondary triterpenoids (rearranged during biosynthesis).

Figure 5.4 Some dehydrogenated (aromatized) pentacyclic triterpenoids from fossil sources with their molecular weights.

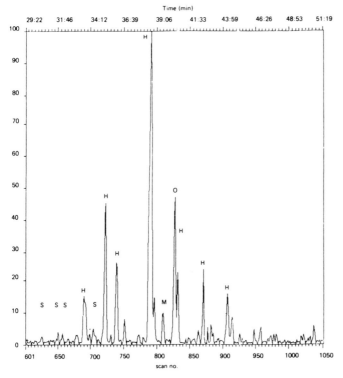

Figure 5.5 Later section of a capillary gas chromatogram of bitumen from Zakinthos, Greece. Letters identify component types as follows: H, hopanes; M, nor-moretanes; S, steranes; O, 18αH-oleanane.

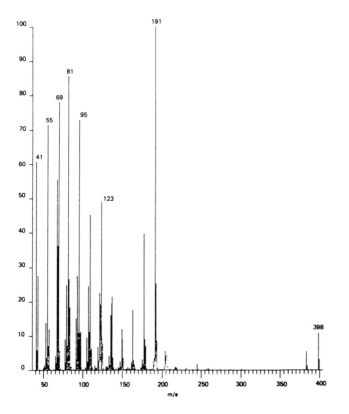

Figure 5.6 Mass spectrum of the main peak of the chromatogram of *Figure 5.5*, identifying it as a nor-hopane, MW 398.

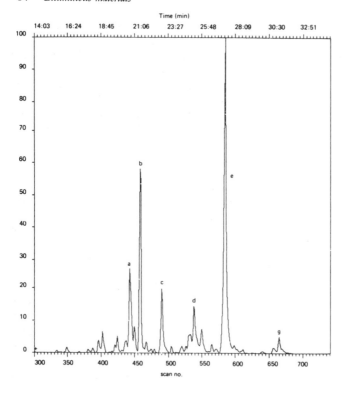

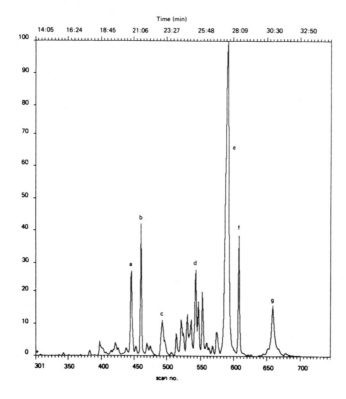

Figure 5.7 Capillary gas chromatograms (GLC–MS instrument) of (*top*) methylated rosin tar (made by destructively distilling wood rosin) and (*bottom*) softwood, or Stockholm tar (*pix liquida* BP). Components common to both evidently derive from the resin diterpenoids, and include: (a) and (b) 18-nor and 19-norabietatriene; (c) 1,2,3,4-tetrahydroretene; (d) retene; (e) methyl dehydroabietate; (f) methyl abietate; (g) methyl 7-oxodehydroabietate. The additional peaks in the softwood tar must result from the pyrolysis of cellulose and lignin in the wood. A chromatogram of unmethylated softwood tar shows a proportion of the diterpenoid acids to be already present as their methyl esters, formed during pyrolysis.

materials, even since the first edition of this book, they are increasingly understood. When softwoods (i.e. woods from conifers such as pines and spruces) are destructively distilled, the tars which result are largely formed from the resin content (predominantly acids of the abietane series, see 8.2.1) and consequently such tars have most components in common with that formed by destructively distilling the equivalent conifer resins. *Figure 5.7* compares the chromatograms of materials of these two types after methylation of free acids. Methyl dehydroabietate is the major constituent in both cases while its further dehydrogenated and/or decarboxylated derivatives, such as the two *nor*abietatrienes, 1,2,3,4-tetrahydroretene and retene itself, are the most prominent among the remainder.

norabietatrienes 1,2,3,4-tetrahydroretene

retene

Tar is now known to have been commonly made from birch bark[21,22]. Until recently little work had been reported on its chemistry though it was long ago claimed that the triterpenoid diol betulin is detectable in it by thin-layer chromatography, allowing it to be identified as the prehistoric adhesive for fixing flint implements to hafts of wood or antler[22]. This has now been substantiated by the isolation of betulin from such a tar and its positive identification by NMR and mass spectroscopy[23]. Several related triterpenoids have also been identified in birch bark tar using GLC–MS[24-26]. Mediaeval pitch ovens with remains of pitch have been examined at sites in Germany[27] and Poland[28]. In the former case abietic acid was an ingredient and a resinous coniferous wood was therefore supposed to

have been the raw material; in the latter birch bark was thought to have been used. Fifteenth century tar factories were also discovered in Bohemia[29] and seemed to show a fairly advanced technology. Pine wood is thought to have been the main raw material here. Birch tar was thought to be the origin of the pitch used on urns and a spear head from Ljubljana[30]. In the systematic study of archaeological and recent wood tars by GLC–MS already cited[24], twenty-eight substances present in them were identified. Fourteen of the archaeological samples were shown to be birch tar. In another[26], use of birch tar in ancient Britain was identified for the first time, it having been used as an adhesive for repairing a Roman pot.

An early gas chromatography study of a wood pitch coating on the back of a Rubens panel painting detected the presence of a mixture of abietic and dehydroabietic acids[31].

Some tars recovered from the wrecks of Henry VIII's flagship the *Mary Rose*, and from an Etruscan ship of 600 BC, have been identified by GLC–MS as softwood tar from conifers, having the components described above[32, 33]. Proton and [13]C NMR were used to make similar identifications of a number of tar samples from Australian wrecks dating from the seventeenth–nineteenth centuries, the *Mary Rose* tar, pine and spruce tars being used as comparison standards[34]. GLC–MS was again used in another case[35], the contents of tar barrels and tarred rope samples from a wreck of 1790 being again identified as pine wood tar from their high content of dehydroabietic acid and other resin-derived components.

When softwoods are destructively distilled to give tar a proportion of the resin acids is converted to methyl esters by some mechanism (methanol itself is produced during pyrolysis of wood). The presence of these methyl esters in the neutral fraction of the tar therefore indicates that the material was made from softwood rather than from the separated resin (which does not result in formation of esters) and this has been found to be the case with a sample of tar from the Hellenistic Kyrenia wreck (last decade fourth century BC)[36]. This GLC–MS study of four different samples from this site, which necessarily have had the same environmental history, allowed different compositions to be accounted for in terms of real differences of origin or method of processing. In several samples normal alkanes from C_{22} to C_{32} were found in significant quantities, indicating that petroleum in some form had been a component of the original mixture, presumably as a diluent.

5.3 Elementary carbon

The chemistry of elementary carbon is not usually considered a part of organic chemistry, but as forms of carbon often enter into the composition of museum objects (particularly as pigments in paint and inks) they deserve a mention here. Moreover carbon may be thought of as the ultimate product of the pyrolytic processes leading to the tars and pitches just discussed.

Pure carbon is chemically very unreactive but most carbons produced by pyrolysis or by incomplete combustion contain appreciable amounts of impurities with a variety of functional groups. The chemistry of carbon blacks, the general name for such materials, has been much studied as they are highly important commercially as black pigments and fillers, for example in black polythene bags or in rubber motor car tyres, and their presence very materially influences the properties and deterioration of these.

The carbon pigments have been reviewed by Winter[37], primarily from the viewpoint of their identification on manuscripts and paintings. Carbon itself exists in crystalline and non-crystalline forms, the former consisting of diamond and graphite (and some rare other forms which do not concern us); the latter are divisible into flame carbons, cokes and chars.

5.3.1 Graphite

Graphite occurs naturally in several parts of the world and it may also be prepared by heating cokes at high temperatures. In structure it may be considered to form flat sheets of condensed six-membered rings, like a condensed aromatic compound (1.1.4) of indefinite extent, though what happens at the edges is not clear.

These sheets are stacked one above another in a regular way but as there are no covalent bonds between them the crystals are very easily cleaved mechanically. This accounts for the slippery feel of graphite and its usefulness for purposes of lubrication.

As a pigment, graphite is known as *blacklead* or *plumbago*. Its best known use is in so-called lead pencils which date, apparently, from the sixteenth century[38]. In these the graphite is mixed with clays, the amount of which determines the 'hardness' of the pencil.

5.3.2 Non-crystalline carbons

The various flame carbons, made by burning fuels such as natural gas, oils, or wood, have been separated by Winter under the names *carbon black*, *lampblack* and *soot*. Their morphology readily distinguishes them from the materials discussed below in that they form aggregates of small spheres.

The amount of tarry impurities present depends to some extent on the distance of the flame to the collecting point. The pigment known as *bistre* is a soot collected from burning wood very close to the flames and it contains a rather high proportion of tars.

The chars made from wood, nutshells, cork etc. have names such as *charcoal black*, *fruit-stone blacks* and *cork black*. As the materials remain solid throughout the carbonizing process the chars can retain to a large extent the morphology (such as cellular structure) of the precursors.

Cokes are defined as a carbonized product from a precursor in a liquid or plastic state. They thus show no evidence of the original morphology but rather form irregular, porous lumps. Coke from bituminous coals is a case in point.

The carbon pigments formed by pyrolysis of animal matter, such as *ivory black* and *bone black*, fall within the category of cokes as the protein collagen (7.1.1) softens or liquefies before charring. Ivory and bone contain a high proportion of inorganic matter, elephant ivory about 55%. The inorganic components of this latter material are comprised of calcium phosphate (82%), magnesium phosphate (15%) and calcium carbonate (2%) and consequently the pigments formed from them contain an even higher proportion of inorganic material, mostly as hydroxyapatite, $Ca_5(OH)(PO_4)_3$.

The effect of temperature on ivory has been studied[39] to determine the weight losses and changes in colour; carbon, hydrogen and nitrogen content; and inorganic content. The colour passed through yellow (204°C) and brown (260°C) to brown-black (316–538°C) and black (593°C), after which it went to dark and to light grey blue (650–760°C) and finally to white (816°C) as the carbon finally burnt away. No detectable protein remained at 593°C.

References

1 CLARKE, M., 'Scientific and historical explanations and their place in technology', *Br. Corros. J.*, 13(1978), 1–4

2 PLENDERLEITH, H. J. and WERNER, A. E. A., *The Conservation of Antiquities and Works of Art*, 2nd edition, Oxford University Press, London (1971), 331–3

3 ODDY, W. A. and LANE, H., 'The conservation of waterlogged shale', *Stud. Conserv.*, 21(1976), 63–6

4 MARSCHNER, R. F. and WRIGHT, H. T., 'Asphalts from Middle Eastern archaeological sites', in *Archaeological Chemistry-II*, ACS Advances in Chemistry series, no. 171, Washington D. C. (1978), 150–71

5 PYM, J. G., RAY, J. E., SMITH, G. W. and WHITEHEAD, E. V., 'Petroleum triterpane fingerprinting of crude oils', *Anal. Chem.*, 47(1975), 1617–22

6 KIMBLE, B. J., MAXWELL, J. R. and EGLINTON, G., 'Identification of steranes and triterpanes in geolipid extracts by high-resolution gas chromatography and mass spectrometry', *Chem. Geol.*, 14(1974), 173–98

7 DOUGLAS, A. G. and GRANTHAM, P. J., 'Fingerprint gas chromatography in the analysis of some bitumens, asphalts and related substances', in *Advances in Organic Geochemistry 1973*, edited by B. Tissot and F. Bienner, Editions Technip, Paris (1974), 261–76

8 GALLEGOS, E. J., 'Identification of new steranes, terpanes and branched paraffins in Green River shale by combined capillary gas chromatography and mass spectrometry', *Anal. Chem.* 43(1971), 1151–60.

9 RICHARDSON, J. S. and MILLER, D. E., 'Identification of dicyclic and tricyclic hydrocarbons in the saturate fraction of a crude oil by gas chromatography/mass spectrometry', *Anal. Chem.*, 54(1982), 765–8

10 SIMONEIT, B. R. T., 'Diterpenoid compounds and other lipids in deep-sea sediments and their geological significance', *Geochim. Cosmochim. Acta*, 41(1977), 463–76

11 SEIFERT, W. K. and MOLDOWAN, J. M., 'The effect of biodegradation on steranes and terpanes in crude oils', *Geochim. Cosmochim. Acta*, 43(1979), 111–26

12 VENKATESAN, M. I., LINICK, T. W., SUESS, H. E. and BUCCELLATI, G., 'Asphalt in carbon-14-dated archaeological samples from Terqa, Syria', *Nature*, 295(1982), 517–19

13 SIMONEIT, B. R. T. and LONSDALE, P. F., 'Hydrothermal petroleum in mineralized mounds at the seabed of the Guaymas Basin', *Nature*, 295(1982), 198–202

14 OURISSON, G., ALBRECHT, P. and ROHMER, M., 'The hopanoids. Palaeochemistry and biochemistry of a group of natural products', *Pure Appl. Chem.*, 51(1979), 709–29

15 OURISSON, G., ALBRECHT, P. and ROHMER, M., 'The microbial origin of fossil fuels', *Scientific American*, 251 no. 2 (1984), 34–41

16 BENDORAITIS, J. G., 'Hydrocarbons of biogenic origin in petroleum–aromatic triterpenes and bicyclic sesquiterpenes', *Advances in Organic Geochemistry 1973*, edited by B. Tissot and F. Bienner, Editions Technip, Paris (1974), 209–224

17 WHITEHEAD E. V., 'Geochemistry of natural products in petroleum prospecting', in *Petroanalysis 81*, edited

by G. B. Crump, J. Wiley and Sons, Chichester and New York, 1982, 31–75

18 WHITE, R., 'Analysis of resinous materials' in *The Excavation of an Ancient Boat in the Sea of Galilee (Lake Kinneret)*, 'Atiqot. English Series 19 (1990), 81–8

19 RULLKOETER, J. and NISSENBAUM, A., 'Dead Sea asphalt in Egyptian mummies: molecular evidence', *Naturwissenschaften*, 75(1988), 618–21

20 NISSENBAUM, A., 'Molecular archaeology: organic geochemistry of Egyptian mummies', *J. Archaeological Science*, 19, 1(1992), 1–6

21 SCHOKNECHT, U. and SCHWARZE, E., 'Hinweise zur Pechbereitung in frühslawischer Zeit', *Ausgrabungen und Funde*, 12(1967), 205–10

22 FUNKE, H., 'Chemisch-analytische Untersuchungen verschiedener archäologische Funde', *Dissertation*, Hamburg (1969)

23 SAUTER, F., HAYEK, E. W. H., MOCHE, W. and JORDIS, U., 'Identification of betulin in archaeological tar', *Zeitschrift für Naturforschung. Section C: Biosciences*, 42(1987), 1151–2

24 HAYEK, E. W. H., KRENMAYER, P., LOHNINGER, H., JORDIS, U., MOCHE, W. and SAUTER, F., 'Identification of archaeological and recent wood tar pitches using gas chromatography-mass spectrometry and pattern recognition', *Analytical Chemistry*, 62(1990), 2038–43

25 BINDER, D., BOURGEOIS, G., BENOIS, F. and VITY, C., 'Identification de brai de bouleau (*Betula*) dans le Néolithique de Giribaldi (Nice, France) par la spectrometrie de masse', *Revue d'Archéometrie*, 14(1990), 37–42

26 CHARTERS, S., EVERSHED, R.P., GOAD, L.J., HERON, C. and BLINKHORN, P., 'Identification of an adhesive used to repair a Roman jar', *Archaeometry*, 35(1993), 91–101

27 BLECK, R.D., 'Das Pech von Ruppersdorf', *Alt-Thüringen*, 9(1967), 204–8

28 RAJEWSKI, Z., 'Pech und Teer bei den Slawen', *Z. für Archäologie*, 4(1970), 46–53

29 PLEINER, R., 'Medieval technology of the tar factory at Krasna Dolina near Rakovnik, Bohemia' (in Czech; German summary), *Pamatky Archeologicke*, 61(1970), 472–518

30 HADZI, D. and OREL, B., 'Spectrometric studies of the origin of amber and pitches from prehistoric sites in Slovenia' (in Slovenian), *Vestn. Slov. Kem. Drus.*, 25(1978), 51–62

31 ELSKENS, I., 'La descente de croix de Rubens: Problèmes particuliers. L'enduit au goudron de bois', *Inst. Royal du Patrimoine Artistique, Bull.*, 5(1962), 154–61

32 EVERSHED, R. P., JERMAN, K. and EGLINTON, G., 'Pine wood origin for pitch from the *Mary Rose*', *Nature*, 314(1985), 528–30

33 ROBINSON, N., EVERSHED, R. P., HIGGS, J., JERMAN, K. and EGLINTON, G., 'Proof of a pine wood origin for the pitch from Tudor (Mary Rose) and Etruscan

shipwrecks: application of analytical organic chemistry in archaeology', *Analyst*, 112(1987), 637–44

34 GHISALBERTI, E. L. and GODFREY, I., 'The application of nuclear magnetic resonance to the analysis of pitches and resins from marine archaeological sites', *Bulletin of the Australian Institute for Marine Archaeology*, 14(1990), 1–8

35 REUNANEN, M., EKMAN, R. and HEINONEN, M., 'Analysis of Finnish pine tar from the wreck of frigate St. Nikolai', *Holzforschung*, 43(1989), 33–9

36 BECK, C. W. and BORROMEO, C., 'Ancient pine pitch: technological perspectives from a Hellenistic shipwreck', *MASCA Research Papers in Science and Archaeology*, 7(1990), 51–8

37 WINTER, J., 'The characterization of pigments based on carbon', *Stud. Conserv.*, 28(1983), 49–66

38 CAIN, S., CANTU, A. A., BRUNNELLE, R. and LYTER, A., 'A scientific study of pencil lead components', *J. Forensic Sciences*, 23(1978), 643–61

39 BAER, N. S., INDICTOR, N., FRANTZ, J. H. and APPELBAUM, B., 'The effect of high temperature on ivory', *Stud. Conserv.*, 16(1971), 1–8

Bibliography

ABRAHAM, H., *Asphalts and related Substances*, 5th edition, 2 vols, Van Nostrand, New York (1945)

BUDD, P., CHAPMAN, B., JACKSON, C., JANAWAY, R. and OTTAWAY, B. (Editors), *Archaeological Sciences*, Oxbow Books, Oxford (1989)

CHILINGARIAN, G. V. and YEN, T. F. (Editors), *Bitumens, Asphalts and Tar Sands*, Elsevier, Amsterdam, Oxford and New York (1978)

DONNET, J.-B. and VOET, A., *Carbon Black: Physics, Chemistry and Elastomer Reinforcement*, Marcel Dekker Inc., New York and Basel (1976)

EGLINTON, G. and MURPHY, M. T. J. (Editors), *Organic Geochemistry – Methods and Results*, Springer-Verlag, Berlin, Heidelburg, New York (1969)

FORBES, R. J., 'Bitumens and petroleum in antiquity' in *Studies in Ancient Technology*, vol. 1, E. J. Brill, Leiden (1959), 1–120

HARLEY, R. D., *Artists' Pigments c. 1600–1835*, 2nd edition, Butterworth-Heinemann, Oxford (1982)

HOIBERG, H. J. (Editor), *Bituminous Materials: Asphalts, Tars, and Pitches*, 3 vols., Interscience, New York and London, (1964–6)

PHILP, R. P., *Fossil Fuel Biomarkers. Applications and Spectra*, Elsevier, Amsterdam (1985)

6

Carbohydrates: sugars and polysaccharides

Wood, paper, plant fibres, and the water-soluble plant gums used as adhesives and binding media are all made up of compounds coming within this category.

Originally the term carbohydrates was given to compounds of general empirical formula $C_x(H_2O)_y$ since they were thought of as 'hydrates of carbon'. This idea was soon dropped and the expression became less restrictive as to the ratios of the three elements, but many simple compounds made up of carbon, hydrogen and oxygen are still excluded. In practice we may here take it as referring to the sugars (monosaccharides) and their polymers, the polysaccharides.

These are probably the most abundant organic materials on the earth's surface since, in the form of cellulose and starch, they form a good proportion of the bulk of trees and plants. As is well known they are built up from water and the carbon dioxide in the atmosphere by the process of photosynthesis, the light energy from the sun being utilized for the purpose, mediated by the green plant pigment, chlorophyll.

6.1 Monosaccharides

Carbohydrate chemistry is a vast subject and difficult to condense to a brief summary. The sugars themselves are quite complex, they commonly exist in several different chemical forms and they combine with one another in different possible ways. This will be illustrated by reference to one of the commonest of them, glucose.

Glucose has molecular formula $C_6H_{12}O_6$. It has five hydroxyl groups and a carbonyl group and since

this latter can be oxidized to an acid it must be located on a primary rather than a secondary carbon atom, i.e. it is an aldehyde rather than a ketone. Glucose can be converted to n-hexanoic acid and so the carbons must be present as a straight chain. These features are accommodated by the following structure:

CHO
|
CHOH
|
CHOH
|
CHOH
|
CHOH
|
CH_2OH

This, however, is not the end of the matter. Aldehyde groups can react, reversibly, with hydroxyl groups to yield compounds known as hemiacetals and, with a second hydroxyl group, acetals:

$$R \cdot CHO \xrightarrow{R^1 \cdot OH} R \cdot C \overset{\displaystyle OR^1}{\underset{\displaystyle OH}{<}} \xrightarrow{R^2 \cdot OH} R \cdot C \overset{\displaystyle OR^1}{\underset{\displaystyle OR^2}{<}}$$

aldehyde hemi-acetal acetal

If the aldehyde and alcohol groups are present in the same molecule then a cyclic hemiacetal can form, and this is indeed preferred if the resulting ring is five or six membered. It can be seen that such is the case with glucose and that both five- and six-membered ring hemiacetals can be formed:

69

OH
|
CH——————
| ⌐
CHOH |
| | O
CHOH |
| |
CH——————
|
CHOH
|
CH₂OH furanose

OH
|
CH——————
|
CHOH ⌐
| |
CHOH O
| |
CHOH |
| |
CH——————
|
CH₂OH pyranose

The two structures are known as furanose (the five membered) and pyranose (six membered) forms. They are interconvertible via the open chain form. Most sugars in the crystalline state are in the pyranose form, when that alternative is available.

It can be seen that the four carbon atoms bearing the secondary hydroxyl groups in the open chain structure above are asymmetric, or chiral centres (1.1.1). The different isomers which arise from different configurations at these centres, corresponding to different sugars, are described below. A further asymmetric centre arises when the open chain converts to either of the cyclic structures, so giving rise to two possible isomers:

HO H
 \\ /
 C
 |
 CHOH
 |
 CHOH O
 |
 CHOH
 |
 CH——————
 |
 CH₂OH

H OH
 \\ /
 C
 |
 CHOH
 |
 CHOH O
 |
 CHOH
 |
 CH——————
 |
 CH₂OH

The two variants, known as α- and β-glucose, are indeed known for it happens that when glucose is crystallized from water below 50°C one is formed and when crystallized from water above 95°C the other is formed. When either is dissolved in water an equilibrium mixture of the two eventually results, since they are of course interconvertible via the open chain form. The two epimeric forms are known as anomers.

The monosaccharides are not confined to compounds with six carbon atoms (hexoses). The simplest polyhydroxy aldehyde has three carbon atoms and is the compound 2,3-dihydroxypropanal or glyceraldehyde. Since this has a single asymmetric centre there exist two enantiomers with equal and opposite optical rotations. The two enantiomers may be depicted as follows:

CHO
|
C···CH₂OH
H \\
 OH

CHO
|
C···CH₂OH
HO \\
 H

or using the so-called Fischer convention in which the horizontal bonds are deemed to come out from the plane of the paper and the vertical bonds recede:

CHO
|
H — C — OH
|
CH₂OH

D-(+)-glyceraldehyde

CHO
|
HO — C — H
|
CH₂OH

L-(−)-glyceraldehyde

The + and the − in the names of the two enantiomers indicate that the enantiomers have a positive or negative sign of rotation. The D- and the L- specify their absolute stereochemistry as indicated. These two enantiomers of glyceraldehyde are the parents of two series of sugars, the D-sugars and the L-sugars, in which the stereochemistries at the carbons most distant from the carbonyl group are as in the parent compounds.

Most, but not all, of the natural sugars belong to the D-family, thus glucose is D-(+)-glucose. It should be noted that although the symbols D- and L- originally arose from dextro and laevo (right and left; positive and negative) they no longer indicate the actual sign of rotation of the compounds to which they are attached.

Glyceraldehyde can be thought of as a triose. The family of D-aldoses of which it can be considered the parent is shown in Figure 6.1. There are two aldoses with four carbons (tetroses) known as erythrose and threose, four with five carbons (pentoses) known as ribose, arabinose, xylose, and lyxose, and eight hexoses: allose and altrose, glucose and mannose, gulose and idose, galactose and talose (listed as epimeric pairs).

Compounds in which the carbonyl group is present as a ketone rather than an aldehyde are known as ketoses. Thus fructose is a ketose:

CH₂OH
|
C=O
|
CHOH
|
CHOH
|
CHOH fructose
|
CH₂OH (open chain)

CH₂OH
|
HO — C——————
| |
CHOH |
| | O
CHOH |
| |
CH——————
|
CH₂OH fructose
 (cyclic
 hemi-ketal)

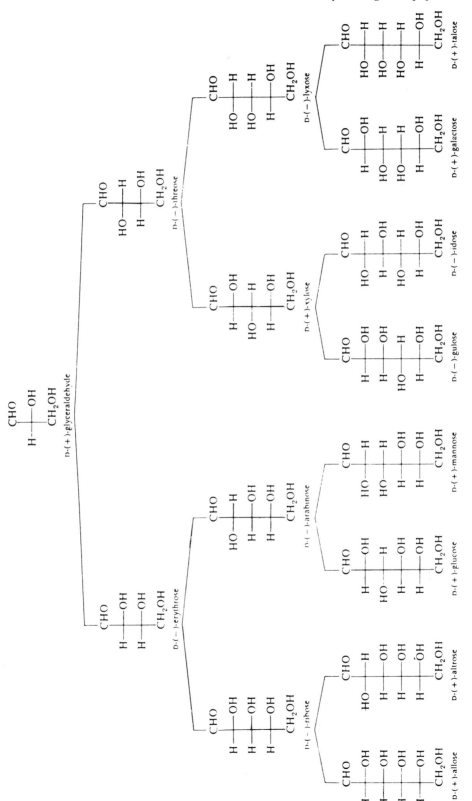

Figure 6.1 The series of D-aldose sugars.

Aldoses and ketoses show certain important differences in chemical properties due to the different reactivities of aldehyde and ketone groups. As aldehydes are easily oxidized to acids they are themselves correspondingly *reducing*, and the reduction of solutions of silver nitrate to metallic silver is a well known test of them. Aldoses are consequently known as reducing sugars.

A further group of compounds derived from the sugars must also be mentioned. These are the uronic acids which are the compounds in which the primary hydroxyl group has been converted to a carboxylic acid group. They are named after the sugars, e.g. glucuronic acid and galacturonic acid after glucose and galactose respectively. These compounds are important components of many polysaccharides, including the plant gums.

The system of representing the cyclic structures which has been used so far is not very satisfactory and they are more commonly shown in the so-called Haworth formulae as a planar ring with the substituents positioned above and below, thus α-D-glucose and β-D-glucose are represented as:

As explained for cyclic hydrocarbons (1.1.3) six-membered rings are not planar: to attain a strain-free conformation they adopt a chair or boat form. The cyclic hemiacetals also adopt a chair form but for convenience of representation we will use the Haworth formulae in what follows.

6.2 Oligosaccharides

Monosaccharides can form links with one another to form larger molecules. Oligosaccharides (oligo = few) range, rather arbitrarily, from the disaccharides up to compounds containing about ten sugar units. Most important are the disaccharides as these include common sugars of plant and animal origin such as sucrose and lactose. They are mostly made up from hexoses.

The linkage between the two monosaccharides in a disaccharide, which is known as a glycosidic linkage, takes the form of an acetal ether linkage.

That is to say the hydroxyl group of the hemiacetal group of one of the components has reacted with a hydroxyl group of the second component (which may also be the hydroxyl of its hemiacetal) to form an acetal, for example:

maltose

This structure represents that of maltose, formed from two glucose units by linkage of the hemiacetal of one with the C-4 hydroxyl of the other. This second unit still retains a hemiacetal group and hence, potentially, an aldehyde group. The molecule therefore still has reducing properties. The glycoside linkage in maltose is formed from the α-anomer. The β-anomer yields a different disaccharide, cellobiose, known as a hydrolysis product of cellulose (see below):

cellobiose

The disaccharide sucrose is what we know as ordinary white sugar (brown sugar is the same compound in impure form). Sucrose is formed by linkage of the hemiacetal group of glucose with the hemiketal group of fructose. It hence retains no potential aldehyde group and is not reducing.

sucrose

Sucrose is widely distributed through the plant kingdom and is the principal component of plant nectar. Honey thus consists mainly of sucrose but it also contains variable amounts of glucose and fructose resulting from hydrolysis aided by enzymes contributed by the bees.

6.2.1 Hydrolysis of glycosides

The glycoside linkage, in common with other acetals, is readily split by mild acid treatment to yield the individual monosaccharides. This fact is very important in the analysis and identification of oligo- and polysaccharides. The splitting of the glycoside is also readily effected by enzymes, as happens in digestion, fermentation by yeasts, and the degradation of cellulose by wood-rotting fungi.

6.3 Polysaccharides

Important polysaccharides include cellulose, starch, and the plant gums and mucilages. The first two of these are very high molecular weight materials which are simple and regular in composition and structure. The gums and mucilages are more complex.

6.4 Cellulose

Cellulose is the most abundant of all organic compounds and is, of course, common in the museum as wood, paper, and textiles made from plant fibres. It is a linear polymer of D-glucose in the β-pyranose form and can be represented as:

cellulose

It is possible that there are occasional irregularities in this structure, such as the presence of carboxyl groups, ester links, and linkages to other sugar residues. However, this may only be so for cellulose as isolated, rather than as in the plant material itself, for it is difficult to purify without modification of its composition, particularly by oxidation.

The molecular weight is very high but the degree of polymerization is not known exactly since some reduction and spread of molecular weight normally occurs during isolation, but it may sometimes exceed 10 000 or 15 000 units. The large number of hydroxyl groups allows for hydrogen bonding, both inter- and intramolecular. This means that the linear chains align themselves side by side to form microfibrils which in turn align themselves more or less along the axis of vegetable fibres. The arrangement of the molecules is sufficiently ordered for cellulose to give an X-ray diffraction pattern, essentially the same for material from all sources.

Because of its many hydroxyl groups, cellulose has a high affinity for water without being actually soluble, i.e. the formation of hydrogen bonds with water is not sufficient to overcome the strong hydrogen bonding between the molecules. Water is taken up from the atmosphere to the point of equilibrium: at 50% relative humidity this amounts to a water content of about 6% by weight, at 100% about 22%. The absorption of moisture by cellulose results in swelling and consequently changes in relative humidity result in dimensional changes in wooden objects which are dangerous for their stability.

Cellulose is more strongly swollen by strong alkali solutions such as sodium hydroxide, and its properties can be modified thereby. Such treatment forms the basis of 'mercerization' (c. 1850) for producing fibres with better dyeing properties and increased strength and, in a later modification, lustrous effects ('artificial silk').

Cellulose will dissolve in certain solutions as a consequence of being converted into soluble derivatives, and the cellulose itself can be reprecipitated by suitable treatment. This forms the basis for the preparation of the various artificial fibres and films of cellulose. The material prepared by regeneration from solution in cuprammonium sulphate solution (cuprammonium rayon) dates from about 1890 while the material formed by another process and known as viscose rayon dates from 1892. The process for making the thin transparent films of cellulose known as Cellophane dates from 1924. The history of regenerated celluloses has been reviewed[1].

The deterioration of cellulose, whether by oxidative or hydrolytic processes, is a topic of the greatest importance to the question of the preservation of books and manuscripts[2-4]. It is relatively stable to autoxidation at ordinary temperature but the primary hydroxyl groups can be progressively oxidized to carboxylic acid groups, especially under the influence of light. As with all high molecular weight polymers, even a small amount of oxidation or hydrolysis which results in chain breaking has a disproportionate effect on physical properties, since only one such break per chain halves the average molecular weight or degree of polymerization (DP).

Oxidative bleaching reagents used for paper[5] must be carefully chosen since some oxidize the primary hydroxyl groups to carbonyl or carboxyl and also reduce, or potentially reduce, DP.

As with other compounds containing the glycosidic linkage, cellulose is hydrolysed by aqueous acids, first of all at random points along the chain to give smaller cellulose units and ultimately to glucose itself. The hydrolysis is also effected by hydrolytic enzymes, called cellulases, which are produced by many species of moulds and other fungi. These can consequently break down cellulose and utilize the products for their own nutrition, hence the danger to wood, paper and textiles under damp conditions, for moisture is needed for the mould growth.

The hydroxyl groups of cellulose can, like other hydroxyl groups, be converted to their esters or ethers and a number of such products have been, and to some extent still are, important semisynthetic materials for plastics, adhesives, and coatings.

6.4.1 Cellulose nitrate

By treatment of cellulose with a mixture of sulphuric and nitric acids the hydroxyl groups are converted to their nitrate esters, $-ONO_2$. Discovered in 1833 and developed in the 1840s, the product was used as an explosive (guncotton). This is a highly nitrated material. A less completely nitrated (and somewhat more stable) product, modified by the addition of pigments and plasticizers (initially camphor; as much as 30% by weight) formed the basis, from the 1850s, for mouldable plastic materials used as artificial ivory for knife handles, piano keys etc., and also to make artificial tortoiseshell. It became a familiar material under the name Celluloid (men's collars; small dolls; ping-pong balls) while solutions in ether or alcohol/ether mixtures or other solvents were known under the name collodion and used for sealing small wounds.

Many proprietary glues still consist of solutions of cellulose nitrate[6]. As a surface coating it has had many applications, including use as a 'dope' for sealing fabrics in early aircraft. Other uses have been as a base for cinema film, the notorious 'nitrate stock' now long obsolete; for laminated glass for car windscreens; and in car paints. It has even been used as a varnish on an important German painting, which was much discoloured and difficult to remove[7].

Nitrate esters are inherently unstable compounds (11.1.2). The nitrates of the lower alcohols are extremely sensitive and can explode with little provocation while glycerol trinitrate ('nitroglycerin') is only slightly less sensitive. Cellulose nitrate needs to be detonated in order to explode but it is always extremely inflammable. In time it can decompose spontaneously even in the dark, in the process liberating highly acidic nitrogen dioxide which is deleterious to other materials in the vicinity. For example, scientific instruments lacquered with it can become highly corroded by the formation of metal nitrates[8]. It decomposes more rapidly in the light and turns yellow. This yellow discolouration was a familiar feature of the old laminated glass car windscreens mentioned above. The paper just cited reports research on the varying stabilities to heat of different commercial samples of nitrocellulose products and also on stabilization of museum objects containing it. Decomposition is autocatalytic, accelerating as the acidic decomposition products accumulate. These not only aid hydrolysis of further nitrate but also hydrolyse the cellulose chains themselves. Deacidification by water washing followed by treatment with mild alkali significantly increased subsequent stability.

In a more recent paper[9] a study of the thermal decomposition of a particular cellulose nitrate adhesive was made in comparison with pure cellulose nitrate itself. Rates of decomposition were higher under closed, as opposed to open, conditions and the adhesive (which contained a considerable proportion of dibutyl phthalate plasticizer) had a significantly slower rate of decomposition than the pure cellulose nitrate itself. This adhesive had been used since 1950 for repairing cuneiform tablets of sun-dried clay and from its condition it was deduced that this particular adhesive would have a useful life of at least one hundred years.

While ideally cellulose nitrate should never be used in modern conservation practice, if no other adhesive is found entirely suitable it can perhaps be used in cases such as the foregoing, where it is protected from light and air by the substrate, itself of a nature unlikely to be much affected by decomposition products. This is not, of course, the case with metals or organic materials.

Objects made of cellulose nitrate are very easily identified as such, for it has a characteristic infrared spectrum. Heating a small fragment in a combustion tube leads to decomposition and evolution of brown fumes of nitrogen dioxide. A sensitive colour test has also been described[6].

6.4.2 Cellulose acetate

While more stable than the nitrate ester, cellulose acetates are less stable materials than was once believed. They partly displaced the nitrate for various uses such as for safety film (1909) and aircraft 'dope' (*c.* 1917). Highly acetylated material is known as triacetate and the incompletely acetylated material (made by partial hydrolysis of the former or by a process of controlled acetylation) as secondary acetate. It should not be thought, however, that these correspond to two well-defined compounds; it is just a question of proportion of the total hydroxyl groups which are esterified.

The secondary acetate is more readily soluble and was first utilized for fibres in about 1927 while the more intractable triacetate only came into use for this purpose after the Second World War. Woven materials for clothes and other purposes are made from these fibres (acetate rayon).

Many types of moulded, extruded and otherwise fabricated objects have been made from the bulk material, which commonly consists of diacetate. Photographic film is made of the triacetate.

The stability or otherwise of cellulose acetates is of considerable importance since not only has it been used as above but it has also been employed as an archival material for storing documents and for laminating them. Considerable research has been done on the subject in the last few years in response to cases of obvious deterioration. It now appears that the problem is basically one of hydrolysis of the acetate groups and liberation of free acetic acid. This, in turn, catalyses further hydrolysis of ester groups and also promotes hydrolysis of the cellulose chain itself with resulting reduction in degree of polymerization.

In accordance with this mechanism is the fact that degradation is promoted by increased relative humidity and any initial presence of acid[10-12]. Because of the various mechanisms contributing to the deterioration, effective stabilization measures involve a combination of acid scavengers, phenolic antioxidants, and metal ion deactivators[13].

Deterioration of cellulose acetate is a serious problem in the case of sculptures by the artist Naum Gabo[14], which incorporate it in various forms together with cellulose nitrate and, after 1937, polymethyl methacrylate. Liberated acetic acid was readily detectable by its smell and beads of plasticizer were often exuded.

Like the nitrate, cellulose acetate may be readily identified from its infrared spectrum.

6.4.3 Other cellulose derivatives

Other esters of cellulose such as the propionate, the mixed acetate–propionate, and the acetate–butyrate are also manufactured at the present time and used for moulding materials which are tougher and more resistant than those made of cellulose acetate.

Various cellulose ethers are also made and these have come to be important in several ways. In these the $-OH$ groups of the cellulose are partly replaced by $-OR$ groups where $R = $ methyl ($-CH_3$), carboxymethyl ($-CH_2COOH$), or hydroxyethyl ($-CH_2CH_2OH$). Methyl cellulose is used for textile finishing and as a size and starch substitute, as an adhesive, an emulsifying agent and in other ways.

Carboxymethylcellulose, usually used as its water-soluble sodium salt, has similar uses and is also valuable as an addition to laundry detergents for preventing soil redeposition and to aid subsequent washing. It is also a common ingredient of present-day adhesives for wallpapers. The application of cellulose ethers in paper conservation and the effects of accelerated ageing have been reviewed[15].

Cellulose may also be modified by a process known as graft-polymerization, in which synthetic polymers are caused chemically to bond themselves to the cellulose chain, usually through free radical reactions. Strength and chemical resistance can be improved thereby and its application to aged paper has been investigated[16].

6.5 Starch

This abundant material is the principal carbohydrate reserve of the vegetable kingdom, occurring as minute granules in roots, bulbs, tubers and seeds. It is easily isolated from these in fairly pure form.

Like cellulose, starch consists of polymers of glucose but it contains two different materials named amylose and amylopectin. The first of these is a linear polymer with α-glycosidic bonds (cellulose having the β-configuration). The amylopectin has a branched structure with each of the branches as in amylose (with about 25 glucose units) but branching occurs through 1,6 linkages, i.e. to the primary hydroxyl group, but where exactly on the amylose chain this linkage occurs is uncertain. It may be quite random.

amylose

amylopectin

The proportions of these two ingredients are very variable from source to source and consequently the properties of starches are also variable. Starch is not soluble in cold water but the granules do swell reversibly. When the suspension is heated the granules burst and a thick, viscous dispersion – starch paste – results. More amylose means a thicker gel and a tougher film but adhesivity seems to depend on a number of factors.

The practical properties of starches from several sources have been tested[17,18], as have the effects of modifying them chemically in several different ways[18]. It was found that partial hydrolysis with acid at temperatures below the gelatinization point improved adhesivity. Wheat starch paste (*shin-nori*) is much used by the Japanese mounter/conservator and great care is given to its preparation. A paste aged for up to ten years (*furu-nori*) is also prepared and has far greater adhesivity[19]. Presumably it too has undergone partial hydrolysis, possibly as a result of enzymatic activity from the moulds which form on top.

As is well known, starch has long been important for sizing paper and for use in stiffening articles of clothing. It is a permanent material as regards resistance to autoxidation but is, of course, a good growth medium for moulds in damp conditions.

Starch is sometimes encountered in paintings grounds[20] and it was once a common ingredient of relining adhesives[21]. It has been detected by means of the characteristic reaction with iodine which gives a blue colour (it is the amylose component which is responsible for this). It has also been found mixed with the organic pigments (indigo, gamboge, red dye) on Japanese prints[22], and in the plaster of seventeenth century Bulgarian murals[23].

Dextrin, or British Gum, is a starch modified by heating to render it completely soluble in cold water. It has been used as an adhesive for paper and cardboard.

6.6 Plant gums and mucilages

Many trees and plants exude polysaccharide gums when accidentally or deliberately wounded. These are water-soluble or water-dispersible materials of high molecular weight. Some are of considerable economic importance and are produced in very large quantities, gum arabic (gum acacia) being the most notable.

The chemistry of the gums is quite complex for usually several sugars, and the acids derived from them, enter into their composition as shown in *Table 6.1*. The actual ways in which these are linked together are generally only partly known and for the most part we will not concern ourselves with this here. Gums have been important in art as the principal medium for 'watercolours', miniatures, and for manuscript illumination. Otherwise they are important as adhesives, as for postage stamps and envelopes (now partly replaced by polyvinyl alcohol; see 9.2.3), for being edible they may be licked without harm: indeed their main use is in foodstuffs. The following paragraphs describe the most important gums. A more comprehensive list may be found in a recent review[24].

6.6.1 Gum arabic or gum acacia

Gum arabic is the product of a number of *Acacia* species of which *Acacia senegal* is the most important. Most of the material of commerce originates from the Sudan where this tree occupies large stands in the wild, and is also cultivated. Gum arabic was extensively used in ancient Egypt and has been an article of commerce for thousands of years.

The demand continues unabated and exports from the Sudan have been as much as 50 or 60 000 tons per annum in recent times. Considerable quantities are also produced in other parts of Africa. Other species are the sources of the *Acacia* gums of India, and of Australia where the material is known as wattle gum.

Table 6.1 Sugar and uronic acid components of some gums and mucilages

	Arabinose	Rhamnose	Galactose	Glucose	Mannose	Xylose	Fucose*	Glucuronic acid	Galacturonic acid
Gum arabic	+ +	+	+ +					+	+
Tragacanth	+		+			+	+		+
Cherry gum	+ .+		+		+	+		+	
Guar gum			+		+ +				
Carob or locust bean			+		+ +				
Tamarind seed gum	+ (?)		+	+		+			
Karaya gum		+	+						+ +
Ghatti gum	+ +		+ +		+	+		+	
Cholla gum	+	+	+						+
Olibanum	+		+					+ (4-O-methyl-)	
Myrrh	+		+					+ (4-O-methyl-)	

* 6-deoxy-L-galactose.
+ indicates that the sugar is present; ++ indicates a major component

Since gum arabic incorporates glucuronic acid it is of course acidic and in fact exists as a salt with calcium, magnesium, and potassium cations. Treatment with acid or ion-exchange resins gives the free acid known as arabic acid. Solutions of this have a pH of about 2.7 and the equivalent weight is about 1380.

6.6.2 Gum tragacanth

This is another material known since classical times for it is obtained from species of *Astragalus* (Leguminosae) growing in Asia Minor and the near East, particularly Iran. As collection is a time-consuming process the material is correspondingly expensive and probably has been much less used than gum arabic. It is not wholly soluble in water; the part that dissolves is known as tragacanthin, that which simply swells bassorin.

6.6.3 Cherry gum

The exuded gums of several *Prunus* species have found use in Europe for centuries since they are available from indigenous trees. Cherry gum, from *P. cerasus* has been the most mentioned but the gums from the almond, apricot, plum, and peach are similar and were probably not clearly distinguished.

Like tragacanth these gums are only partially soluble and swell to a jelly with water. Apparently cherry gum was still in use as an artist's medium in the nineteenth century[25]. As mentioned in a later section, fruit tree gums have also been much used in murals in Central Asia.

6.6.4 Carob or locust gum

The carob or locust tree *Ceratonia siliqua* (Leguminosae), of the Mediterranean area, has been utilized since antiquity. It produces large quantities of the beans containing the kernels which yield the gum.

The beans have been used as a food for animals and by people and the gum is said to have been employed by the Egyptians for binding mummy wrappings. Today the gum is still widely used in foodstuffs but most importantly as an additive in paper making.

6.6.5 Tamarind mucilage

Tamarindus indica is a large evergreen tree common in India and Southeast Asia which produces large flat pods. The pulp of this pod is much used in food while the seeds, among many uses, afford a gum or mucilage now used for sizing fibres and in foodstuffs. This is said to have been the principal paint medium for Indian murals and miniatures.

6.6.6 Other gums

Many other plants yield gums and mucilages which have been and are utilized. In the Indian sub-continent important materials are guar gum, from *Cyanaposis tetragonolobus* (Leguminosae); karaya gum from *Sterculia urens* (Sterculiaceae), in which the polysaccharide is partially acetylated; and ghatti gum from *Anogeissus latifolia* (Combretaceae) which occurs as a calcium–magnesium salt of the acidic polysaccharide and is put to uses similar to those of gum arabic.

In the New World also there are many utilizable gums and mucilages. In the North and Mexico the mesquite, *Prosopis juliflora* and other species, is one that has been used as a substitute for gum arabic. In Mexico and the Southern United States the prickly pear cactus, *Opuntia fulgida* (Nopal) is said to yield a gum in hot dry spells (cholla gum). In West Africa the West African mahogany tree *Khaya grandifolia* yields khaya gum.

The gum resins, such as myrrh and olibanum, have a content of gum in addition to their resin, as has also gamboge, but little seems to have been reported on the carbohydrate chemistry of the latter. Even some conifers yield gum resins, notably *Araucaria* species, the compositions of which have been determined[26–28].

In Japanese artistic and conservation practice a mucilage obtained from a seaweed is sometimes employed[29]. The source plants are macroscopic marine algae, chiefly *Gloiopeltis furcata* and other species. The mucilage extracted with hot water, is known as funoran. It is a polysaccharide composed largely of D-galactose units, partly esterified as sulphate. The material known as agar–agar, from other red algae, is similar with a lower proportion of sulphate groups.

Another important seaweed product is alginic acid, mainly from *Laminaria* spp. This is a poly-mannuronic acid which, as the sodium or calcium salt, can be made into fibres. These are made into textiles or other artefacts where ready disposability is called for, since they can be dissolved in water or mild alkali solutions.

6.7 Identification of polysaccharides

Most analytical work on polysaccharides in the museum field is directed towards their detection and possible identification in paintings of various kinds. The presence of saccharide material can usually be revealed by the so-called furfural reaction. Heating pentoses with acid results in dehydration yielding furfural while other sugars yield related compounds.

$$CHOH-CHOH \atop R \cdot CHOH \quad CHOH \cdot CHO \xrightarrow{H^+} \quad R \diagdown O \diagup CHO$$

<div style="text-align:center">sugar furfural-type compound</div>

Furfural and similar aldehydes react with aniline or other aromatic amines to give coloured compounds known as Schiff bases[30]. The test is usually carried out as follows.

The sample (either whole or as an aqueous extract) is warmed in a small test tube with a drop of syrupy phosphoric acid while a strip of filter paper moistened with a solution of aniline acetate is held in the upper part of the tube. The aldehydes are volatilized and give a violet or pink colour with the reagent. Amounts down to a few micrograms of saccharide can be detected. It should be remembered that cellulose itself reacts and consequently care needs to be taken when looking for gums in paint samples which are on paper or which are liable to contain plant fibres (as with certain murals).

Infrared spectra of saccharides are not usually very informative but may be adequate to identify them in a general way or at least distinguish them from water-soluble protein. In an account of methods of analysis of polysaccharides, the spectra of the more important gums have been published as well as spectra of extracts from particular works of art[31]. Rather large quantities of sample had to be used to obtain enough extract for infrared and the result was not very informative.

A problem which must necessarily accompany any use of water extraction is that water-soluble salts may be present in the extract and confuse the spectrum if not removed. This can be done with methanolic hydrochloric acid or, in the case of polysaccharides, by dialysis but this is difficult to manipulate on a small scale.

More precise identification of polysaccharide gums involves determination of the sugar and uronic acid residues after acid hydrolysis. The hydrolysis is rather tricky and can result in a considerable amount of humin formation if carried out in the presence of large amounts of inorganic material. 1 N sulphuric acid is commonly used with heating at 100°C for 10–12 hours. The solution is neutralized with barium carbonate, filtered from the

insoluble barium sulphate and evaporated to dryness.

The sugars can be separated by paper, thin-layer, or gas chromatography though for the last of these they need to be derivatized first. Birstein used thin-layer chromatography on microcrystalline cellulose using an ethyl acetate/pyridine/water system. To reveal the spots the plate was treated with aniline phthalate solution. For gas chromatography he first reduced the sugar mixture with sodium borohydride (this would reduce aldehyde groups to alcohols but would not affect carboxylic acid groups) and acetylated the product with acetic anhydride/pyridine.

Birstein's results on Central Asian wall paintings[32,33] seem to confirm the tradition that plant gums were often used as medium. In two cases, paintings from Toprak-Kala (third to fourth century) and a palace at Khiva (nineteenth century), the findings agreed best with cherry or apricot gum. Reviewing earlier findings and literary sources he says that mixtures of gum and egg-yolk were sometimes used as well as a mucilage extracted from the roots of *Eremurus* spp. (Liliaceae). Yarosh applied various methods to the analysis of the medium of paint from Kara-tepe in Central Asia[34]. Preliminary tests and infrared spectra suggested polysaccharides, while chromatographic comparisons with samples of gums suggested plum tree gum as the closest contender, though differences existed.

Both thin-layer and gas chromatography have been used by Masschelein-Kleiner *et al.*[35,36]. In an examination of materials from an Egyptian sarcophagus of polychrome wood (twenty-first dynasty), thin-layer chromatography was effected on a stationary phase of mixed alumina and silica with an eluent of propanol/ethyl acetate/water/25% ammonia, in the proportions 30/5/15/5. The colour reagent was naphthoresorcinol. Gas chromatography was carried out on the trimethylsilyl derivatives of the sugars on a column of E301 silicone. A complication here was that, because of the different forms in which individual sugars can exist, several different derivatives are obtained from each sugar, thus making the gas chromatogram more difficult to interpret.

However two samples of a surface coating, one supposedly more altered than the other, were distinguished by their compositions. The former contained glucose, xylose, lesser amounts of fructose and possibly mannose. The latter contained arabinose, galactose, and galacturonic acid. The latter was interpreted as being best in agreement with gum tragacanth. The paint medium of the sarcophagus yielded only glucose and fructose, which agrees with the presence of honey.

Examination of the paint of some Egyptian epitaphial stelae in the National Museum of Cracow also lead to the conclusion that the paint medium was gum tragacanth[37]. The interpretation of the composition (without rhamnose) as indicating gum tragacanth ought perhaps to be reconsidered in the light of analyses carried out on the readily water-soluble medium of the paintings in the Tomb of Nefertari[38,39], in the Valley of the Queens at Luxor. While all commercial samples of gum arabic from different origins showed the presence of rhamnose, arabinose, galactose and galacturonic acid, the medium of the paintings lacked rhamnose. However, a local sample of the gum from an *Acacia* sp. tree growing near the Ramasseum equally lacked this sugar and had proportions of the remaining sugars almost identical to that of the paint medium. Various forms of chromatography were used, including gas chromatography.

If investigations on the polysaccharides present in wall paintings are difficult, those on paint samples from illuminated manuscripts are even more so given the smaller samples available. Flieder[40] has carried out a careful study and improved the hydrolysis and isolation procedures. The sample was hydrolysed with 3% hydrochloric acid in a sealed tube at 105°C for 24 hours and the mixture then evaporated to dryness at 45°C under nitrogen. The residue was deacidified with an ion-exchange resin (Amberlite IRA68), evaporated and chromatographed on silica gel using butanol/ethanol/water (57/27/16) as eluent.

Naphthoresorcinol was used as the colour reagent for the separated sugars. The chromatograms obtained did not completely separate the sugars and uronic acids, in particular they were not able to separate glucuronic and galacturonic acids. However results appeared clear enough positively to identify gum arabic as the probable medium of a sixteenth century manuscript illumination.

Other extensive surveys of analytical methods for polysaccharides have also appeared, one on chromatographic methods[41]. Pyrolysis gas chromatography has also been found useful[42]. Five different gums gave readily distinguishable pyrograms and although these were liable to variation in the presence of pigments this could be minimized by reducing the pyrolysis temperature from 700°C to 400°C. Optimum results were obtained with 20–100 µg of sample but identifications could still be achieved

with 1 µg. Another variation is pyrolysis mass spectrometry[43]. This has been applied to the identification of the materials of ancient Egyptian mummy cases (cartonnages) between two and four thousand years old. Here waxes and resins were involved as well and the examination of some fifty samples allowed classification of about 50% of them.

6.8 Lignin

Although not a carbohydrate or related in any way to cellulose, the natural polymer known as lignin must be discussed here on account of its importance as a component of wood. It is lignin which gives the necessary strength to cells to allow them to endure the stresses and strains put upon trees and plants. It is also to be found in roots, husks, and shells.

6.8.1 Chemical composition[44]

Lignin is a polymer made up of units consisting primarily of coniferyl alcohol but with a number of similar compounds also incorporated, for example:

trans-coniferyl
alcohol

trans-sinapyl
alcohol

trans-p-coumaryl
alcohol

These units are linked together, not in any sort of regular arrangement as with many natural polymers, but in an almost random manner and by means of several different types of grouping; ether, acetal, ketal, ester etc. In the plant it seems that links may

also exist to polysaccharide molecules, including of course cellulose.

The possible structures that can be present in the polymer are best approached by consideration of the mechanism of formation by phenol oxidation. This important subject is touched on again later when the drying of Japanese lacquer is explained (8.7.2).

Oxidation of the phenolate anion by the oxidized form of an enzyme (either a peroxidase or laccase) gives a phenol radical. In the case of coniferyl alcohol this radical is stabilized by the possibility of several resonance forms (Structure 6.1):

Coupling can take place between any two of these radicals to give a dimer with carbon–oxygen and carbon–carbon bonds between different positions. Further phenol radicals can then be formed from the dimers resulting in coupling to give trimers, tetramers, and finally high molecular weight polymer.

Lignin is a reactive material easily oxidized to coloured (yellow–brown) compounds and acidic products. This is one of the reasons why its presence in paper and cardboard is undesirable, for these acid products can catalyse hydrolysis of the cellulose, resulting in lowered molecular weight and consequent embrittlement.

The chemistry of papermaking is a subject on its own and it must suffice to say here that the principal purpose of the several pulping processes for making paper from wood is the solubilization and removal of the lignin, leaving the cellulose in as pure a state as possible. However with the so-called high-yield pulping procedures, for making cheap papers such as newsprint, much lignin remains. Such papers yellow rapidly in light, as commonly observed with newspapers.

Pyrolysis of wood gives rise to monomeric lignin-derived products and some eighty-three of these have been identified by GLC–MS in a study of various wood species, specific characterization of which is claimed[45].

6.9 Lignans

These are the low molecular weight counterparts to lignin, being dimers of the phenylpropane alcohols/phenols of the types indicated in the preceding section. They are present in the heartwoods of trees, including the conifers, and sometimes exude as a kind of resin from cut trunks or branches, though they are quite unrelated chemically to the terpenoid resins obtained by tapping.

Structure 6.1

Lignans are of little significance to us here but it should be mentioned that one such material, at least, is produced in large quantities (up to 10 000 tons annually) and used for various purposes as a substitute for phenolic resins. This is the ethanol-soluble material extracted, in Brazil, from the knots of the Parana pine (*Araucaria angustifolia*). This has been shown to consist of a mixture of lignans including secoisolariciresinol and related compounds[46,47].

secoisolariciresinol

References

1 HUTCHINS, J. K., 'Regenerated cellulosics: their fabrication and finishing before 1940', *ICOM Committee for Conservation Report 84.9.19–21*, 7th Triennial Meeting, Copenhagen (1984)

2 PADFIELD, T., 'The deterioration of cellulose', *Problems of Conservation in Museums*, Editions Eyrolles, Paris and Allen and Unwin, London, (1969), 110–64

3 STUHRKE, R. A., 'The development of permanent paper', in *Preservation of Paper and Textiles of Historic and Artistic Value*, ACS Advances in Chemistry Series no. 164, Washington D.C. (1977), 24–36

4 WILLIAMS, J. C., FOWLER, C. S., LYON, M. S. and MERRIL, T.L., 'Metallic catalysts in the oxidative degradation of paper', in *Preservation of Paper and Textiles of Historic and Artistic Value*, ACS Advances in Chemistry Series, no. 164, Washington D.C. (1977), 37–61

5 HEY, M., 'Paper bleaching: its simple chemistry and working procedure', *The Paper Conservator*, 2 (1977), 10–23

6 KOOB, S. P., 'The instability of cellulose nitrate adhesives', *The Conservator*, 6 (1982), 31–4

7 KAUTZ, D., 'Removal of a layer of synthetic varnish' (in German), *Beiträge zur Erhaltung von Kunstwerken*, 1 (1982), 129–31

8 GREEN, L. and BRADLEY, S., 'An investigation into the deterioration and stabilization of nitrocellulose in museum collections', *Modern Organic Materials: preprints of the Symposium 14 & 15th April, 1988*, Scottish Soc. for Conservation, Edinburgh (1988), 81–95

9 SHASHOUA, Y., BRADLEY, S. M. and DANIELS, V. D., 'Degradation of cellulose nitrate adhesive', *Stud. Conserv.*, 37 (1992), 113–19.

10 EDGE, M., ALLEN, N. S., JEWITT, T. S., APPLEYARD, J. H. and HORIE, C. V., 'Cellulose acetate: an archival polymer falls apart', *Modern Organic Materials: preprints of the Symposium 14 and 15th April, 1988*, Scottish Soc. for Conservation, Edinburgh (1988), 67–79

11 ALLEN, N. S., EDGE, M., APPLEYARD, J. H., JEWITT, T. S., HORIE, C. V. and FRANCIS, D., 'Acid-catalysed degradation of historic cellulose triacetate cinematographic film: influence of various film parameters', *European Polymer Journal*, 24 (1988), 707–12

12 ALLEN, N., EDGE, M., APPLEYARD, J. H., JEWITT, T. S., HORIE, C. V. and FRANCIS, D., 'Degradation of cellulose triacetate cinematographic film: prediction of archival life', *Polymer Degradation and Stability*, No. 23 (1988), 43–50

13 ALLEN, N. S., EDGE, M., JEWITT, T. S. and HORIE, C. V., 'Stabilization of cellulose triacetate base motion picture film', *J. Photographic Science*, 38 (1990), 26–9

14 PULLEN, D. and HEUMAN, J., 'Cellulose acetate deterioration in the sculptures of Naum Gabo', *Modern Organic Materials: preprints of the Symposium 14 and 15th April, 1988*, Scottish Soc. for Conservation, Edinburgh (1988), 57–66

15 BAKER, C. A., 'Methylcellulose and sodium carboxymethylcellulose: an evaluation for use in paper conservation through accelerated aging', *Adhesives and Consolidants*, IIC, London (1984), 55–9

16 BURSTAL, M. L., MOLLETT, C. C. and BUTLER, C. E., 'Graft copolymerization as a method of preserving papers: problems and potentialities', *Adhesives and Consolidants*, IIC, London (1984), 60–3

17 INDICTOR, N., BAFR, N. S. and PHELAN, W. H., 'An evaluation of pastes for use in paper conservation', *Restaurator*, 2 (1975), 139–50

18 VAN STEENE, G. and MASSCHELEIN-KLEINER, L., 'Modified starch for conservation purposes', *Stud. Conserv.*, 25 (1980), 64–70

19 WILLS, P., 'The manufacture and use of Japanese wheat starch adhesives in the treatment of Far Eastern pictorial art', *Adhesives and Consolidants*, IIC, London (1984), 123–6

20 BROCHWICZ, Z., 'The identification of starch and proteins on cross-sections of paint and ground layers' (in Polish), *Materialy Zachodnio-Pomorskie*, 6 (1960), 539–63

21 TAMS, K. and WESTERUDD, O., 'The restoration of two oil paintings painted by the Dutchman Albert Eckhout, 1641, in Brazil' (in Danish), *Nationalmuseets Arbejdsmark 1977*, (1977), 7–13

22 GROVE, N., *Ukiyo-e Prints and Paintings; the Primitive Period, 1680–1745, by Donald Jenkins. Catalogue of Exhibition in Memory of Margaret O. Gentles*, Art Institute of Chicago, (1971)

23 BROCHWICZ, Z. and WALKOWA, D. M., 'The structure of the 17th century mural paintings in the St. George orthodox church at Weliko Turnowo (Bulgaria)', *Ochrona Zabytkow*, 25 (1972), 143–59

24 TWILLEY, J. W., 'The analysis of exudate plant gums in their artistic applications: an interim report', in *Archaeological Chemistry III*, ACS Advances in Chemistry Series, No. 205, Washington D.C. (1984), 357–94

25 KÜHN, H., 'Böcklins Farbenmaterial', *Maltechnik*, 80 (1974), 206–9

26 ASPINALL, G. O. and FAIRWEATHER, R. M., '*Araucaria bidwillii* gum', *Carbohydrate Res.*, 1 (1965), 83–92

27 ASPINALL, G. O. and MCKENNA, J. P., '*Araucaria bidwillii* gum Part II. Further studies on the polysaccharide components', *Carbohydrate Res.*, 7 (1968), 244–54

28 ANDERSON, D. M. W. and MUNROE, A. C., 'The presence of 3–0-methylrhamnose in *Araucaria* resinous exudates', *Phytochem.*, 8 (1969), 633–4

29 WINTER, J., 'Natural adhesives in East Asian Paintings', *Adhesives and Consolidants*, IIC, London (1984), 117–20

30 FEIGL, F., *Spot Tests in Organic Analysis*, 5th edition, Elsevier, Amsterdam (1956), 372

31 BIRSTEIN, V. Y. and TUL'CHINSKY, V. M., 'Study and identification of polysaccharides removed from archaeological specimens' (in Russian), *Khim. Prirod. Soedinenii*, (1976), No. 1, 15–19

32 BIRSTEIN, V. J., 'On the technology of Central Asian wall paintings: the problem of binding media', *Stud. Conserv.*, 20 (1975), 8–19

33 BIRSTEIN, V. J., 'On the technology of antique and early medieval Central Asian wall paintings – identification of binding media' (in Russian), *Artistic Heritage*, 3 (1977), No. 3, 3–7

34 YAROSH, V. N., 'Analysis of painting binding materials containing polysaccharides by photometry methods as well as by paper and liquid column chromatography', *ICOM Committee of Conservation, 9th Triennial Meeting, Dresden, 26–31 August, 1990, preprints*, Ed. K. Grimstad (1990), 95–8

35 MASSCHELEIN-KLEINER, L. and TRICOF-MARCKX, E., 'La détection de polysaccharides dans les matériaux constitutifs des oeuvres d'art', *Bull. Inst. Roy. Patrimoine Artistique*, 8 (1965), 180–91

36 MASSCHELEIN-KLEINER, L., HEYLEN, J. and TRICOT-MARCKX, E., 'Contribution à l'analyse des liants, adhésifs et vernis anciens', *Stud. Conserv.*, 13 (1968), 105–21.

37 SZYSZKO, W., 'Technological examination of three Egyptian epitaphial stelae on wood supports, I and II' (in Polish), *Ochrona Zabytkow*, 25 (1972), 170–82.

38 MORA, P., MORA, L. and PORTA, E., 'Conservation et restauration de la tombe de Néfertari dans la Vallée des Reines', *ICOM Committee for Conservation, 9th Triennial Meeting, Dresden, 26–31 August 1990: preprints*, Ed. K. Grimstad (1990), 518–23.

39 PALET, A. and PORTA, E., 'Análisis químico de los pigmentos y aglutinantes empleados en las pinturas murales de la tumba de Nefertari', *Congreso de Conservación de Bienes Culturales: Valencia, 20–23 Setiembre de 1990*, Ed. P. Roig Picazo (1990), 452–60

40 FLIEDER, E., 'Mise au point des techniques d'identification des pigments et des liants inclus dans la couche picturale des enluminures de manuscrits', *Stud. Conserv.*, 13 (1968), 49–86

41 MATOUŠOVÁ, M. and BUCIFALOVÁ, J., 'Polysaccharides as part of a colour layer and their identification' (in Czech), *Sbornik Restaurátorských Praci*, (1989), No. 4, 60–74.

42 DERRICK, M. and STULIK, D. C., 'Identification of natural gums in works of art using pyrolysis-gas chromatography', *ICOM Committee for Conservation, 9th Triennial Meeting, Dresden, 26–31 August 1990: preprints*, Ed. K. Grimstad (1990) 9–13.

43 WRIGHT, M. M. and WHEALS, B. B., 'Pyrolysis-mass spectrometry of natural gums, resins, and waxes and its use for detecting such materials in ancient Egyptian mummy cases (cartonnages)', *J. Analytical and Applied Pyrolysis*, 11 (1987), 195–211.

44 HARKIN, J. M., 'Lignin – a natural polymeric product of phenol oxidation', in *Oxidative Coupling of Phenols*, edited by W. I. Taylor and A. R. Battersby, Edward Arnold, London (1967) 243–321.

45 FAIX, O., MEIER, D. and FORTMANN, I., 'Thermal degradation products of wood. Gas chromatographic separation and mass spectrometric characterization of monomeric lignin-derived products', *Holz als Rohund Werkstoff*, 48, 7–8 (1990), 281–5.

46 WEISSMANN, G., 'Über ein neues Extraktharz aus *Araucaria angustifolia*', *Phytochem.*, 13 (1974), 193–7.

47 ANDEREGG, R. J. and ROWE, J. W., 'Lignans, the major component of resin from *Araucaria angustifolia* knots', *Holzforschung*, 28 (1974), 171–5.

Bibliography

BROMMELLE, N. S., PYE, E. M., SMITH, P. and THOMSON, G. (Editors), *Adhesives and Consolidants. Preprints of the Contributions to the Paris Congress, 2–8 September 1984*, IIC, London (1984)

BROWNING, B. L., *Analysis of Paper*, Dekker, New York (1977)

CASEY, J. P., *Pulp and Paper. Chemistry and Technology*, 2nd edition, Interscience, New York (1960)

DYKE, S. F., *The Carbohydrates*, Interscience Publishers INC., New York (1960)

FENGEL, D. and WEGENER, G., *Wood. Chemistry, Ultrastructure, Reactions*, Walter de Gruyter, Berlin and New York (1984)

GOULD, R. F. (Editor), *Lignin Structure and Reactions*, ACS Advances in Chemistry Series No. 59, Washington D.C. (1966).

HOWES, F. N., *Vegetable Gums and Resins*, Chronica Botanica Co., Waltham, Mass. (1949)

PIGMAN, W. and HORTON, D. (Editors), *The Carbohydrates. Chemistry and Biochemistry*, Academic Press, London and New York (1970)

RADLEY, J. A., *Starch and its Derivatives*, 4th edition, Chapman and Hall, London (1968)

ROFF, W. J. and SCOTT, J. R., *Fibres, Films, Plastics and Rubbers*, Butterworth, London (1971)

SARKANAN, K. V. and LUDWIG, C. H. (Editors), *Lignins: Occurrence, Formation, Structure and Reactions*, Wiley-Interscience, New York (1972)

SMITH, F. and MONTGOMERY, R., *The Chemistry of Plant Gums and Mucilages*, Reinhold, New York (1959)

WHISTLER, R. L. (Editor), *Industrial Gums: Polysaccharides and their Derivatives*, Academic Press, New York and London (1973)

WILLIAMS, J. C. (Editor), *Preservation of Paper and Textiles of Historic and Artistic Value*, ACS Advances in Chemistry Series, No. 164, Washington D.C. (1977)

WILLIAMS, J. C. (Editor), *Preservation of Paper and Textiles of Historic and Artistic Value II*, ACS Advances in Chemistry Series, No. 193, Washington D.C. (1981)

7

Proteins

Proteins are encountered widely within the museum and art gallery since essentially all raw materials of animal origin incorporate them. Proteins are to the animal world what cellulose is to the vegetable and consequently such apparently diverse materials as dentine, sponge, bone and ivory; silk, wool and hair; skin products such as leather and parchment are made of, or contain, protein. Other protein materials such as eggs, animal and fish glue, and milk or casein are incorporated into paintings and other objects as binding media and adhesives.

Although proteins take a great range of forms, physical characteristics and biological function, they are made up of rather a limited range of chemical building blocks, known as amino acids[1]. These are nitrogen-containing acids and they can be liberated from a protein by hydrolysis. Twenty common amino acids are involved together with a handful of others found in specialized proteins, chemically degraded molecules, and fossilized materials. These common monomeric units are aliphatic compounds, branched chain aliphatics, heterocyclic and aromatic nitrogen-containing compounds as indicated in *Figure 7.1*.

It can be seen that all of the amino acids, other than glycine, possess at least one asymmetric carbon atom, namely the one bearing the amino and carboxylic acid groups. It is traditional to use a D- and L-nomenclature, as with the sugars (6.1), to describe the absolute configuration at this centre. In nature only the L-forms are utilized in protein synthesis so it is only these which are encountered in materials from living sources.

The relationship of L-alanine to L-glyceraldehyde is as follows:

$$
\begin{array}{cc}
\text{COOH} & \text{CHO} \\
H_2N\!-\!\overset{|}{C}\!-\!H & HO\!-\!\overset{|}{C}\!-\!H \\
\text{CH}_3 & \text{CH}_2\text{OH} \\
\text{L-alanine} & \text{L-glyceraldehyde}
\end{array}
$$

The amino acids are what is known as *amphoteric*, i.e. they carry both an acidic and a basic group on the same molecule. In consequence of this they usually exist as zwitterions or internal salts, for example glycine:

$$ H_3N^+CH_2CO_2^- \rightleftarrows H_2NCH_2COOH $$

This salt formation has consequences for their physical properties: they commonly melt at a rather high temperature (with decomposition) and they are correspondingly involatile.

By a form of condensation involving an amino group and a carboxylic acid group, carried out enzymatically *in vivo*, these amino acid units are linked together by $-$NHCO$-$ groups, known as peptide linkages. Polymers containing between two and about fifty units are generally referred to as peptides or polypeptides. Larger molecules are usually known as proteins.

The identification of proteins or polypeptides directly is a matter of some difficulty, especially when old and 'denatured', i.e. when their original composition has been modified. It is rarely a practical proposition in the case of museum materials. They have rather to be analysed in terms of their constituent amino acids, after liberation by acid hydrolysis. Again, as far as the proteins of museum objects are concerned there are no unique amino

84

Figure 7.1 Structures of the amino acids obtained from the acid hydrolysis of proteins. They include both the natural acids and those formed as artefacts. Asymmetric centres are indicated by an asterisk.

Table 7.1 Amino acid compositions of proteins used as adhesives and media

Amino acid	Gelatin	Egg white	Egg yolk	Casein
Glycine	24.7	3.6	3.5	1.7
Alanine	10.1	6.3	5.6	2.7
Valine	2.2	8.3	6.4	7.2
Leucine	3.7	10.3	9.2	9.0
Isoleucine	1.2	6.2	5.1	6.0
Proline	13.0	4.5	4.5	13.2
Phenylalanine	1.6	5.2	3.9	5.1
Tyrosine	0.0	1.4	2.8	5.5
Serine	4.0	5.8	9.1	4.0
Threonine	2.2	3.7	5.6	2.7
1/2 cystine	0.0	1.9	1.9	0.0
Methionine	1.4	1.2	2.3	2.3
Arginine	8.2	6.8	5.5	4.0
Histidine	1.5	2.4	2.4	3.6
Lysine	4.1	8.0	5.7	6.7
Aspartic acid	5.0	10.5	11.5	6.1
Glutamic acid	9.7	13.9	15.0	20.2
Hydroxyproline	7.4	0.0	0.0	0.0

Results are taken from Keck and Peters[30] and converted to weight per cent of total.

acids for particular proteins whose presence serves to identify them, but an identification is often possible by means of a quantitative assay of the amino acids. A summary of overall amino acid compositions for a range of proteins employed as adhesives and media appears in *Table 7.1*.

Some epimerization of the amino acids at the common asymmetric centre can take place when they are liberated by base hydrolysis of proteins. Loss of amino acids during hydrolysis also occurs through formation of humins. These are dark brown substances formed by condensation of amino groups (NH_2) and the indole nucleus of tryptophan with aldehydes formed *in situ*[2,3].

7.1 Kinds of protein

7.1.1. Collagen and keratin

These are examples of fibrous proteins, in which the linear polypeptide chains align themselves more or less parallel with each other. Collagen is the structural protein of connective tissues in animals and fish, including the various parts such as skin, muscle tissue, bone and hide. Like other fibrous proteins, collagen is insoluble in water but when boiled for an extended period, or treated in a pressure-vessel with superheated water, it gradually leaches into the boiling solvent as gelatine, a partly degraded protein. This is freely soluble in mildly acidic water and has a molecular weight of about one third that of collagen.

Structural studies of collagen show that it contains frequently repeating glycine–proline–hydroxyproline sequences[4, 5].

There appear to be three separate protein strands, each coiled with each other in the α-helix conformation. They are rigidly held together in one overall complex by strong hydrogen-bonding interaction between the hydroxyl of the hydroxyproline and the amino hydrogens of adjacent glycine units[6, 7]. Gelatine results from the separation of the three strands as a consequence of breaking of the hydrogen bonds between them and their replacement with hydrogen bonds to solvent water instead.

The solution of leached material (for concentrations in excess of 2%) sets on cooling to a stiff gel, which has powerful adhesive properties on drying. Such material – animal glue – has since time immemorial found wide application as a strong adhesive for wood and fabric, as a pigment binder in paint, and as an adhesive in the preparation of grounds on easel paintings.

While mild treatment of collagenous material, i.e. less prolonged boiling, gives lighter-coloured materials known as gelatins, glues tend to be darker, thicker and more turbid as a result of partially solubilized impurities and greater formation of dark humins. Fish glues are reported to be of lower structural stability than those from animal sources[8]. This possibility has been linked to a lower proportion of imino acids (hydroxyproline and proline residues) present in the molecule[9].

Keratin[10–12] is the structural protein found in hair, wool, feather, horn, nail and hoof. It is somewhat harder than collagen and is very insoluble as a result of a high degree of dithio ($-S-S-$) cross-linking between chains. It is thus usually associated with a high content of the sulphur-containing amino acid cystine, typically in the region of 12% in the case of wool or hair. *Table 7.2* gives the amino acid compositions for a variety of proteins of these kinds.

Tanning[13–15] of protein (usually skin) to give leather is a two-stage process in which any keratin present in the hide (hair and epithelial skin layers) is dissolved away by scission of the dithio cross-linkages between cystine residues by application of a reducing agent. The second stage, tanning proper, involves cross-linking of the collagen peptide chains to give extra structural stability of the fibrils. This usually takes the form of condensation with the

Table 7.2 Amino acid compositions of some structural proteins

Amino acid	Collagen	Keratin (wool)	Keratin (feather)	Fibroin (silk)
Glycine	26.6	6.0	7.2	42.8
Alanine	10.3	3.9	5.4	33.5
Valine	2.5	5.5	8.8	3.3
Leucine	3.7	7.9	8.0	0.9
Isoleucine	1.9	3.8	6.0	1.1
Proline	14.4	6.7	10.0	0.5
Phenylalanine	2.3	3.7	5.3	1.3
Tyrosine	1.0	5.2	2.2	11.9
Tryptophan	0.0	1.9	0.7	0.9
Serine	4.3	8.4	14.0	16.3
Threonine	2.3	6.6	4.8	1.4
Cystine	0.0	12.8	8.2	0.0
Methionine	0.9	0.6	0.5	0.0
Arginine	8.2	9.9	7.5	1.0
Histidine	0.7	3.0	0.7	0.4
Lysine	4.0	0.9	1.7	0.6
Aspartic acid	6.9	6.9	7.5	2.2
Glutamic acid	11.2	14.5	9.7	1.9
Ammonia	0.6	0.0	0.0	0.0
Hydroxyproline	12.8	0.0	0.0	0.0
Hydroxylysine	1.2	0.2	0.0	0.0

Results are taken from Ward and Lundgren[11], Boews *et al.*[31] and Lucas *et al.*[32] and converted to weight per cent of total.

polyfunctional phenolic materials known as the vegetable tannins (10.2.8). It has been proposed that the main reason for the excellent preservation of bodies found immersed in peat bogs is the tanning effect of tannins therein[16].

7.1.2 Albumins

The name albumen is often used for white of egg while the general term albumin refers to the class of proteins which occurs in eggs and some other materials. Eggs, either entire or as the yolk or the white, have been used widely as a paint medium, that which includes the yolk being known as egg tempera.

The albumins are readily soluble in water and belong to a class known as globular proteins. These are held in a tight ball conformation by internal hydrogen-bonding between adjacent amino acid clusters in such a way that the more polar, hydrophilic groups line the outer surface of the ball and the hydrophobic groups are folded away within. However, these albumins quickly 'denature', under the effects of heat and certain reagents, by which is meant that they become insoluble as, for example, when an egg is boiled. What happens is that the internal hydrogen bonds rupture and the molecular structure opens up and adopts an open chain-like structure, the overall hydrophilicity being lost.

The two components of egg – the white and the yolk – qualitatively show no difference in terms of the amino acids present. Nevertheless, there are some subtle quantitative differences and it is possible to distinguish between the two by analysis in favourable cases. The proteins of egg contain moderate amounts of asparagine, glutamine and leucine. The first two residues are converted to the corresponding acids aspartic and glutamic acid upon hydrolysis. An assay of these amino acids in particular permits distinction of egg tempera from glue or casein paint media.

The actual composition of eggs in terms of individual proteins is quite complex but need be only briefly sketched here[17]. Egg white contains a glycoprotein (i.e. a protein linked to a carbohydrate), ovalbumin, as the principal protein – about 50% of the egg-white proteins of hens' eggs. It can be further separated into two components (A and B) by electrophoresis. It has an overall molecular weight of about 45 000. Unlike casein (see below), egg white contains only one non-glycoprotein, namely lysozyme[18]. This has a molecular weight of around 17 000 and accounts for about 3% of egg-white proteins. A further 15% of egg white is made up of a second glycoprotein, conalbumin (MW 85 000)[19]. Amino acid compositions for these proteins are to be found in *Table 7.3*.

Table 7.3 Amino acid compositions of egg white proteins.

Amino acid	Ovalbumin	Conalbumin	Lysozyme
Glycine	2.9	5.0	5.3
Alanine	4.5	3.8	6.3
Valine	6.6	7.1	4.1
Leucine	8.4	7.6	6.2
Isoleucine	6.6	4.3	4.6
Proline	3.2	4.3	1.4
Phenylalanine	7.0	5.0	2.9
Tyrosine	3.3	4.0	3.2
Tryptophan	1.2	2.7	6.0
Serine	7.6	5.5	7.4
Threonine	3.8	5.1	5.6
1/2 cystine	1.7	1.7	5.7
Methionine	4.8	1.8	1.8
Arginine	5.3	6.6	10.2
Histidine	2.2	2.2	0.9
Lysine	5.9	8.8	5.2
Aspartic	8.6	11.6	17.2
Glutamic acid	15.4	10.4	4.3
Ammonia	1.1	1.1	1.8

Results are taken from Haurowitz[33] and Jolles[34], and converted to weight per cent of total.

Egg yolk is rich in proteins[20] which are associated with phosphorus-containing lipids and these include:

phosphovitin[21] (MW 21 000), a composite protein;

α- and β-lipovitellins, lipoproteins[22, 23] containing phospholipids;

α-, β- and γ-livetins.

7.1.3 Casein and milk[24]

These have found applications principally as a strong glue – casein glue – and, occasionally, milk tempera medium. Cows' milk, the one most generally encountered, contains about 5.5% fat (*Table 3.2*), 4.9% of the sugar lactose, and between 3 and 5% protein.

The principal protein in milk is casein, a phosphoprotein complex, which may be precipitated by acidification of skimmed milk. This is what is happening when milk is curdled to make cheese. Overall, casein contains about 1% phosphorus, mainly in the form of phosphoric acid esterifying the hydroxyl groups of serine and, in part, glutamic acid. The caseins are insoluble in water and the principal fractions are:

α-casein, itself composite (75%). MW 27 600
β-casein. MW 19 800
γ-casein (3%)
κ-casein. MW 26 000, responsible for stabilizing the casein micelles.

These caseins are the main component proteins of the solids from milk known as 'curds'. When washed (with acid in the case of modern, commercial material) and dried, the product is known as 'casein'. This forms a sludge with water, but in alkaline solutions, a colloidal suspension results. Whereas traditional recipes employ slaked lime to effect solution, ammonia solution is generally employed at the present time.

With the casein component removed we are left with the 'whey', whose proteins include lactalbumin (MW 16 000) and β-lactoglobulin (MW 37 000). In total these make up only a small proportion of the milk proteins. They can be precipitated by ammonium sulphate solution. The amino acid compositions for the major milk proteins appear in *Table 7.4*.

Table 7.4 Amino acid composition of milk proteins

Amino acid	Lactalbumin	β-Lactoglobulin	Caseins α	Caseins β	Caseins γ
Glycine	2.9	3.1	2.5	2.2	1.4
Alanine	1.9	1.8	3.3	1.5	2.1
Valine	4.2	4.1	5.7	9.0	9.5
Leucine	10.4	9.2	7.1	10.2	10.8
Isoleucine	6.1	6.4	5.8	4.9	4.0
Proline	1.4	1.6	7.4	14.1	15.3
Phenylalanine	4.0	4.8	4.2	5.1	5.2
Tyrosine	4.8	4.5	7.3	2.8	3.3
Tryptophan	6.3	6.6	1.4	0.6	1.1
Serine	4.3	4.1	5.7	6.0	5.0
Threonine	5.0	4.9	4.4	4.5	4.0
Cystine	5.8	5.7	0.4	0.0	0.0
Methionine	0.9	0.8	2.3	3.0	3.7
Arginine	1.0	1.4	3.9	3.0	1.7
Histidine	2.6	3.0	2.6	2.7	3.3
Lysine	10.4	9.6	8.0	5.7	5.6
Aspartic	16.8	17.1	7.6	4.3	3.6
Glutamic acid	11.6	11.4	20.3	20.4	20.6

Results are taken from Gordon and Ziegler[35], Block and Weiss[38], Gordon *et al.*[37] and Gordon *et al.*[38] and are converted to weight per cent of total.

7.1.4 Vegetable proteins[25–8]

The seeds of leguminous plants and cereals contain varying amounts of protein. Aqueous extracts have found application as pastes and adhesives[29]. The seeds or beans of the former plant-types can contain as much as 50% protein by weight of dry, de-fatted material. Generally cereal grains contain on average 10% by weight of protein. At most, only 0.5% of the total protein content of seeds is in the form of albumins, the bulk of the proteinaceous material having the properties of globulins, that is, they are precipitated by the action of 50% saturated ammonium sulphate solution in contrast to the albumins.

These globulins may be further sub-divided into prolamins, which are soluble in aqueous ethanol, and glutelins which fail to dissolve in either alcohol or salt solutions, but can be extracted by dilute acid or alkali. Soluble globulins include those isolated from hemp seed (edestin), excelsin (brazil nuts), amandin (almonds), legumin (lentils), gliadin (wheat), zein (corn) and hordein (barley). They are called prolamins in that they appear to have a high imino acid content. In addition some appear to contain large amounts of glutamic acid (from glutamine) residues. Indeed gliadin is known to contain about 40% of glutamic acid (compositions given in *Table 7.5*).

Table 7.5 Amino acid compositions of some cereal proteins

Amino acid	Edestin (Hempseed)	Gliadin (Wheat)	Zein (Corn)
Glycine	5.0	–	–
Alanine	5.1	2.1	10.5
Valine	6.4	2.7	4.0
Leucine	7.9		21.1
Isoleucine	5.5	11.9	5.0
Proline	3.8	13.6	10.5
Phenylalanine	6.3	6.4	7.3
Tyrosine	4.9	3.2	5.3
Tryptophan	1.2	0.7	0.2
Serine	5.9	4.9	7.1
Threonine	3.7	2.1	3.4
Cystine	1.2	2.6	0.8
Methionine	2.4	1.7	2.4
Arginine	17.3	2.7	1.7
Histidine	2.9	1.8	1.3
Lysine	2.9	0.7	0.0
Aspartic acid	13.2	1.3	4.6
Glutamic acid	21.3	45.7	26.9
Ammonia	3.1	4.5	23.0

Results are taken from Haurowitz[33] and are converted to weight per cent of total.

Amongst the glutelins we may note glutenin, a sticky substance, whose properties result from dithio groups between protein sub-units. Tables of amino acid compositions for a wide range of component proteins are to be found in the literature[26–8].

7.2 Properties and durability

Proteins are rather stable to oxidation and undergo little chemical change under normal conditions of temperature and humidity. Moisture is their enemy, not only because this can by itself effect slow hydrolysis of the peptide linkages and so reduce average molecular weight, but also because it permits fungi and bacteria to flourish. These secrete protolytic enzymes which break the protein down so that the amino acids can be digested by the organism.

The changes which proteins can undergo on ageing and which lead, for example, to diminished solubility of gelatin glue, have been considered by several authors[39–41]. Birstein[39] has noted the infra-red changes which occur in artificially aged gelatin and related them to possible changes in structure. Karpowicz[41] has given a general account of protein changes including a brief mention of the reactions of proteins with oxidizing lipids and with carbohydrates.

Photochemistry of proteins and amino acids has been considered in connection with the yellowing and 'tendering' of wool[42–4]. It was concluded that both peptide and cystine linkages are broken by light, particularly ultraviolet.

7.3 Analysis of proteins

Analysis of proteins is mostly of interest in connection with their use as paint media and adhesives, though residues in jars or pots have also been sometimes identified as particular proteins[45]. Bulk materials such as leather or animal fibres rarely call for analysis to pinpoint their nature, nevertheless amino acid analyses of old protein fibres have been carried out[46]. A thin layer of material on a box of the first century AD was identified as horn[30].

When sufficient sample is available, hydrolysis of the protein and analysis of the amino acid composition has for long been the preferred approach to such analysis. Paper chromatography was applied to the problem even forty years ago and led to convincing identifications[47,48]. Even recently, modified methods have been recommended, notably circular paper chromatography which allows different reagents to be applied to different sections of the chromatogram[49]. Thin-layer chromatography has likewise been used, for its greater convenience[50–54].

All this work was done with the free amino acids using the colour reaction with ninhydrin as the method for visualizing the spots. Unfortunately this has some disadvantages as this reagent only reacts rather weakly with hydroxyproline, the amino acid particularly valuable for identifying gelatin. An improved procedure using derivatives of amino acids has been recommended[55]. This utilizes the 'dansyl' (i.e. the 5-dimethylaminonaphthalenesulphonyl) derivatives which are easily made and which can be detected on the thin-layer plates by their fluorescence under ultraviolet light at levels of less than 10^{-10} mol. The ability to distinguish between gelatin, casein, yolk and egg white is claimed. The same derivatives have also been used for separations on micropolyamide plates, egg and glue protein being readily distinguishable[56].

The above two methods do not easily allow quantitative estimation of the amino acids which, as we have already indicated, is necessary for convinc-

ing identification. Quantitative estimation using the amino acid analyser, a machine employing ion-exchange chromatography and automatic quantitation using the ninhydrin colour reaction, has been much used for many years in biochemical studies but has been little used for museum materials, partly on account of the relatively large sample (0.3 mg) needed although one study has secured good results with it[30]. The same method is said to have been used for the identification of the varnish found on certain pigmented areas of the Nefertari tomb paintings as egg white[57].

Gas chromatography has, as always, great advantages as regards small sample size and ready quantitation but the disadvantage that both the amino and carboxylic acid groups of the amino acids must be derivatized to give adequate volatility. A simple approach to this is to silylate both groups at once[58]. Another is to prepare methyl esters of the acids and convert the amino groups to their trifluoro-acetates[59].

An experimental application of high performance liquid chromatography (HPLC) to examination of protein hydrolysates (after conversion of the amino acids to their 3-phenyl-2-thiohydantoin derivatives) has also been effected though without seeming to show any particular advantages over gas chromatography[60].

More recently an integrated commercial system of hydrolysis/derivatization/HPLC has been used to examine standards and actual paint samples, and also to determine the effect on results of pigments present with the sample during hydrolysis[61]. Samples were hydrolysed with the *vapour* from 6 N hydrochloric acid at 110°C for 24 hours in an inert atmosphere. The hydrolysed samples were then converted to their *iso*-thiocyanato derivatives and injected, in a suitable buffer solution, on to the HPLC column.

Excellent separations of seventeen amino acids were obtained, detection being by the ultraviolet absorbance at 254 nm. Quantification of the components was made using an on-line data-processing program with reference to an internal standard and a calibration table. Egg protein and collagen were readily distinguished but with actual samples from a painting by Cosimo Tura the results were not necessarily easy to interpret in terms of painting technique as some appeared to contain both materials. It was found that when samples were hydrolysed in the presence of the copper-containing pigment malachite, amino acids were reduced to background levels.

The presence of the amide linkages in proteins gives rise to certain distinctive absorption bands in the infrared spectrum of these materials and Fourier transform infrared spectrometry (FTIR) is showing promise for their detection in small paint samples[62]. FTIR showed a discoloured varnish material on a painting by Van Gogh to be egg white, apparently applied as a temporary measure and never removed[63].

An approach to identifying proteins as such, rather than as a hydrolysate, is by immunological methods. This is based on the reaction of the protein to antiserum to that protein, produced in rabbits which had been inoculated with it. The method was investigated more than twenty years ago with a certain success[64] and has recently received further study[65]. In this latter work, although fluorescence was weak, results were reproducible and a positive response for egg white was obtained with a number of ancient paint samples.

Sometimes samples are so small that evidence simply for the presence of protein, without specifically identifying it, is all that can be hoped for. A number of simple tests are applicable to this end, mainly based on liberation of alkaline vapours of ammonia or amines when the protein is heated alone or in the presence of bases, which can be detected with indicator papers. A test for glue or gelatin, based on the presence of small amounts of free hydroxyproline, is a very sensitive colour reaction known as the modified Ehrlich test[66].

Responses to staining reagents have been rather widely used to detect or identify protein media in paint cross-sections. These will be reported in the general discussion of this approach in Chapter 12.

7.4 Amino acid dating of proteinaceous materials

It has been noted that the less thermodynamically stable amino acids are deficient or totally absent in fossilized proteins.

In the laboratory this phenomenon may be simulated by controlled heating of both proteins and amino acids. In some cases there is a breakdown of the material to yield different amino acids, whilst there are also instances of epimerization at the asymmetric carbons[67].

Examples of the former include arginine converted to ornithine and citrulline and aspartic acid converted to β-alanine:

```
HN=C—NH₂              CONH₂
    |                    |
   NH       CH₂—NH₂     NH
    |          |         |
  (CH₂)₃     (CH₂)₂     (CH₂)₃
    |          |         |
 H—C—NH₂ →  H—C—NH₂  + H—C—NH₂
    |          |         |
  COOH       COOH       COOH
 arginine   ornithine  citrulline
```

```
   COOH        NH₂
    |           |
   CH₂         CH₂
    |           |
 H—C—NH₂  →    CH₂
    |           |
   COOH        COOH
aspartic acid  β-alanine
```

Illustrations of epimerization include the formation of alloisoleucine from isoleucine and that of D-aspartic acid from the natural L-form.

```
   C₂H₅              C₂H₅
    |                 |
 H—C—CH₃          H—C—CH₃
    |        →        |
 H—C—NH₂          H₂N—C—H
    |                 |
   COOH              COOH
 isoleucine       alloisoleucine
```

```
   COOH              COOH
    |                 |
   CH₂               CH₂
    |        →        |
 H—C—NH₂          H₂N—C—H
    |                 |
   COOH              COOH
 L-aspartic acid  D-aspartic acid
```

The kinetics of these reactions having been measured at a variety of elevated temperatures (to give measurable amounts of products in a short period) rates may be predicted, by means of the Arrhenius extrapolation, for temperatures nearer to those average for fossils and archaeological material.

Once these parameters have been established, a quantitative assay of the ratios of amino acid epimers, or of decomposition product and precursor, permits the age (i.e. the reaction time) to be estimated[68–70]. In general aspartic acid epimerization[71–3] seems to permit the most reliable dating of samples from approximately 1000 years BP to 100 000 years BP[74–8]. This is because of the superior analytical precision with which these epimers may be determined. Nevertheless, in excess of 100 000 years BP, work on fossil bones and teeth has shown apparent anomalies.

The epimerization of isoleucine to alloisoleucine, significant over longer time-scales, appears to offer a solution here[79]. Amino acid dating techniques seem to be of application to material at least as old as the Miocene (26 million years BP). Doubts have been placed on the method as a whole, or at least for bones and teeth of the late Pleistocene period (c. 110 000 BP). Dates from racemization ratios did not agree with those obtained by other, presumably more absolute, methods involving isotope ratios (^{230}Th/^{234}U)[80].

Amino acids can also be involved in quite another way in dating procedures, namely in the ^{14}C dating of bone. To avoid error from later contamination the pure amino acids may be isolated from the collagen of the bone and put through the ^{14}C dating process instead of using the whole protein[81,82].

References

1. FINAR, I. L., *Organic Chemistry*, 3rd edition, vol. 1., Longmans, London (1959), 307
2. GORTNER, A. and BLISH, M. J., 'On the origin of humin formed by the acid hydrolysis of proteins', *J. Amer. Chem. Soc.*, 37(1915), 1630–6
3. PÖHM, M., 'Zur spaltung der Peptidbindung mit Hilfe von Kationenaustauschern', *Naturwiss.*, 48(1961), 551
4. GRASSMANN, W., NORDWIG, A. and HORMANN, H., 'Über den Bau der apolaren Bereiche der Kollagenfaser; Abbau mit Kollagenase', *Zeitschr. für physiolog. Chemie*, 323(1961), 48–60
5. BEAR, R. S. 'The structure of collagen fibrils', *Adv. Protein Chem.*, 7(1952), 69–160
6. HARRINGTON, W. F. and von HIPPEL, P. H., 'The structure of collagen and gelatin', *Adv. Protein Chem.*, 16(1961), 1–138
7. TRAUB, W. and PIEZ, K. A., 'The chemistry and structure of collagen', *Adv. Protein Chem.*, 25(1971), 243–352
8. PRIVALOV, P. L., 'Stability of proteins', *Adv. Protein Chem.*, 35(1982), 55–104
9. NEUMAN, R. E. and LOGAN, M. A., 'The determination of hydroxyproline', *J. Biol. Chem.*, 184(1950), 299–306
10. CREWTHER, W. G., FRASER, R. D. B., LENNOX, F. G. and LINDLEY, H., 'The Chemistry of Keratins', *Adv. Protein Chem.*, 20(1965), 191–346
11. WARD, H. W. and LUNDGREN, H. P., 'The formation,

composition and properties of keratin', *Adv. Protein Chem.*, 9(1954), 243–97

12. BRADBURY, J. H., 'The structure and chemistry of keratin fibers', *Adv. Protein Chem.*, 27(1973), 111–211

13. RUDALL, K. M., 'The proteins of the mammalian epidermis', *Adv. Protein Chem.*, 7(1952), 253–90

14. HASLAM, E., *Chemistry of Vegetable Tannins*, Academic Press, London and New York (1966), 1–9

15. GUSTAVSON, K. H., 'Some protein-chemical aspects of tanning processes', *Adv. Protein Chem.*, 5(1949), 353–421

16. DICKSON, G. R., JOPE, E. M. and BOYDE, A., 'Preservation in bogs', *Nature*, 324(1986), 622

17. FEVOLD, H. L., 'Egg proteins', *Adv. Protein Chem.*, 6(1951), 187–252

18. JOLLES, P. and LEDIEU, M., 'Le lysozyme de rate de chien. II. Composition en acides aminés et residus N- et C-terminaux', *Biochem. Biophys. Acta*, 31(1959), 100–3

19. FULLER, R. A. and BRIGGS, D. R., 'Some physical properties of hen's egg conalbumin', *J. Amer. Chem. Soc.*, 78(1956), 5253–7

20. BERNARDI, G. and COOK, W. H., 'An electrophoretic and ultracentrifugal study of the proteins of the high density fraction of egg yolk', *Biochim. Biophys. Acta*, 44(1960), 86–96

21. CONNELLY, C. and TABORSKY, G., 'Chromatographic fractionation of phosphovitin', *J. Biol. Chem.*, 236(1961), 1364–8

22. BERNARDI, G. and COOK, W. H., 'Separation and characterization of the two high density lipoproteins of egg yolk, α- and β-lipovitellin', *Biochim. Biophys. Acta*, 44(1960), 96–105

23. BERNARDI, G, and COOK, W. H., 'Molecular weight and behaviour of lipovitellin in urea solutions', *Biochim. Biophys. Acta*, 44(1960), 105–9

24. MCMEEKIN, T. L. and POLIS, B. D., 'Milk proteins', *Adv. Protein Chem.*, 5(1949), 201–28

25. BLISH, M. J., 'Wheat gluten', *Adv. Protein Chem.*, 2(1945), 337–59

26. BLOCK, R. J., 'The amino acid composition of food proteins', *Adv. Protein Chem.*, 2(1945), 119–34

27. TRISTRAM, G. R., 'The amino acid composition of purified proteins', *Adv. Protein Chem.*, 5(1949), 83–153

28. TRISTRAM, G. R. and SMITH, R. H., 'The amino acid composition of some purified proteins', *Adv. Protein Chem.*, 18(1963), 227–318

29. SACK, P. S. , TAHK, F. C. and PETERS JR, T., 'A technical examination of an ancient Egyptian painting on canvas', *Stud. Conserv.*, 26(1981), 15–23

30. KECK, S. and PETERS JR, T., 'Identification of protein-containing paint media by quantitative amino acid analysis', *Stud. Conserv.*, 14(1969), 75–82

31. BOWES, J. H. , ELLIOT, R. G. and MOSS, J. A., 'The composition of collagen and acid-soluble collagen of bovine skin', *Biochem. J.*, 61(1955), 143–50

32. LUCAS, F., SHAW, J. T. B. and SMITH, S. G., 'The silk fibroins', *Adv. Protein Chem.*, 13(1958), 107–242

33. HAUROWITZ, F., *The Chemistry and Function of Proteins*, 2nd edition, Academic Press, London and New York (1963) 200

34. JOLLES, P., 'Lysozyme', in *The Enzymes*, edited by P. Boyer, H. Lardy and K. Myrbäck, vol. 4, Academic Press, London and New York (1959/1961), 436–8

35. GORDON, W. G. and ZIEGLER, J., 'Amino acid composition of crystalline α-lactalbumin', *Arch. Biochem. Biophys.* 57(1955), 80–6

36. BLOCK, R. J. and WEISS, K. W., 'Studies on bovine whey proteins. IV. The amino acid analyses of crystalline β-lactoglobulin and α-lactalbumin by quantitative paper chromatography', *Arch. Biochem. Biophys.*, 55(1955), 315–20

37. GORDON, W. G., SEMMETT, W. F, CABLE, R. S. and MORRIS, M., 'Amino acid composition of α-casein and γ-casein', *J. Amer. Chem. Soc.*, 71(1949), 3293–7

38. GORDON, W. G., SEMMETT, W. F. and BENDER, M., 'Alanine, glycine and proline contents of casein and its components', *J. Amer. Chem. Soc.*, 72(1950), 4282

39. BIRSTEIN, V. J. and TUL'CHINSKY, V. M., 'IR-spectroscopic analysis of aged gelatins', *ICOM Committee for Conservation, Report 81/1/9*, 8 pp., 6th Triennial Meeting, Ottawa (1981)

40. GRATTAN, D. W., 'The oxidative degradation of organic materials and its importance in deterioration of artifacts', *J. IIC – Canadian Group*, 4(1978), No.1, 17–26

41. KARPOWICZ, A., 'Ageing and deterioration of proteinaceous media', *Stud. Conserv.*, 26(1981), 153–60

42. NICHOLLS, C. H., 'Photodegradation and photoyellowing of wool', *Developments in Polymer Photochemistry*, 1(1980), 125–44

43. ASQUITH, R. S., HIRST, L. and RIVETT, D. E., 'A study of the ultraviolet yellowing of amino acids, peptides and soluble proteins', *Textile Research J.*, 40(1970), 285–9

44. SIMPSON, W. S. and PAGE, C. T., *Effect of Light on Wool and the Inhibition of Light Tendering*, Wool Research Organisation of New Zealand, Christchurch (WRONZ Report No. 60) (1979)

45. VON ENDT, D. W., 'Amino-acid analysis of the contents of a vial excavated at Axum, Ethiopia', *J. Archeol. Sci.*, 4(1977), 367–76

46. KASHIWAGI, K. M., 'An analytical study of pre-Inca pigments, dyes, and fibres', *Bull. Chem. Soc. Japan*, 49(1976), 1236–9

47. HAMSIK, M., 'Paper chromatography – a new method for the characterization of binding media', *Umeni (Prague)*, 2(1954), 58–63

48. HEY, M., 'The analysis of paint media by paper chromatography', *Stud. Conserv.*, 3(1958), 183–93

49. BROCHWICZ, Z., 'Investigations on the identification of casein and egg media in murals by chromato-

graphic separations on filter-paper discs' (in Polish), *Materialy Zachodnio-Pomorskie*, 16(1970), 601–37

50. KLEBER, R. and TRICOT-MARCKX, F., 'Essai d'identification d'une colle animale utilisée par Rubens', *Bull. Inst. Roy. Patrimoine Artistique*, 6(1963), 57–62

51. MASSCHELEIN-KLEINER, L., HEYLEN, J. and TRICOT-MARCKX, F., 'Contribution à l'analyse des liants, adhésifs et vernis anciens', *Stud. Conserv.*, 13(1968), 105–21

52. FLIEDER, F., 'Mise au point des techniques d'identification des pigments et des liants inclus dans la couche picturale des enluminures de manuscrits', *Stud. Conserv.*, 13(1968), 49–86

53. KARASZKIEWICZ, P., 'Analysis of protein paint binders by two-dimensional thin-layer chromatography', *Zesz. Nauk. Akad. Sztok Pieknych*, 10(1977), 18–21

54. ZHELNINSKAYA, Z. M., 'Adaptation of thin-layer chromatographic method for analysing protein and carbohydrate-containing binders used in painting' (in Russian), *Soobshch. Vses. Tsent. Nauch.-Issled. Lab. Konserv. Restavratsii Muz. Khudoshestvennykh Tsennostei*, (1971), no. 26, 3–23

55. MASSCHELEIN-KLEINER, L., 'An improved method for the thin-layer chromatography of media in tempera paintings', *Stud. Conserv.*, 19(1974), 207–11

56. TOMEK, J. and PECHOVÁ, D., 'A note on the thin-layer chromatography of media in paintings', *Stud. Conserv.*, 37(1992), 39–41

57. MORA, P., MORA, L. and PORTA, E., 'Conservation et restauration de la tombe de Néfertari dans la Vallée des Reines', *ICOM Committee for Conservation, 9th Triennial Meeting, Dresden, 26–31 August, 1990: preprints*, Ed. K. Grimstad, (1990), 518–23

58. MASSCHELEIN-KLEINER, L., 'Contribution to the study of aged proteinaceous media', in *Conservation and Restoration of Pictorial Art* edited by N. Brommelle and P. Smith, Butterworths, London (1976), 84–7

59. WHITE, R., 'The characterization of proteinaceous binding media in art objects', *National Gallery Tech. Bull.*, 8(1984), 5–14

60. ROELOFS, W. G., 'Some experiments with high performance liquid chromatography in analysing binding media in objects of art', *ICOM Committee for Conservation, Report 75/15/5*, 21 pp., 5th Triennial Meeting, Venice (1975)

61. HALPINE, S. M., 'Amino acid analysis of proteinaceous media from Cosimo Tura's *The Annunciation of Saint Francis and Saint Louis of Toulouse*', *Stud. Conserv.*, 37(1992), 22–38

62. MEILUNAS, R. J., BENTSEN, J. G. and STEINBERG, A., 'Analysis of aged paint binders by FTIR spectroscopy', *Stud. Conserv.*, 35(1990), 33–51

63. STRINGARI, C., 'Vincent van Gogh's triptych of trees in blossom, Arles (1888), part I. Examination and treatment of the altered surface coatings', *Cleaning, Retouching and Coatings: preprints of the Brussels Congress, 1990*, IIC, London (1990), 126–130

64. LLOYD JONES, P., 'Some observations on methods for identifying proteins in paint media', *Stud. Conserv.*, 7(1962), 10–16

65. KOCKAERT, L., GAUSSET, P. and DUBI-RUQUOY, M., 'Detection of ovalbumin in paint media by immunofluorescence', *Stud. Conserv.*, 34(1989), 183–8

66. COLLINGS, T. J. and YOUNG, F. J., 'Improvements in some tests and techniques in photograph conservation', *Stud. Conserv.*, 21(1976), 79–84

67. HARE, P. E., 'Amino acid dating – a history and an evaluation', *MASCA Newsletter*, 10(1974), no. 1–4

68. BADA, J. L. and SCHROEDER, R. A., 'Amino acid racemization reactions and their geochemical implications', *Naturwiss.*, 62(1975), 71–9

69. HOOPES, E. A., PELTZER, E. T. and BADA, J. L., 'Determination of amino acid enantiomeric ratios by gas liquid chromatography of the N-trifluoroacetyl-L-prolyl-peptide methyl esters', *J. Chromatogr. Sci.*, 16(1978), 556–60

70. BISCHOFF, J. L. and CHILDERS, W. M., 'Temperature calibration of amino acid racemization: age implications for the Yuha skeleton', *Earth and Planetary Sci. Lett.*, 45(1979), 172–80

71. BELLUOMINI, G., 'Direct aspartic acid racemization dating of fossil bones from archaeological sites of central southern Italy', *Archaeometry*, 23(1981), No. 2, 125–37

72. BADA, J. L., HOOPES, E., DARLING, D., DUNGWORTH, G., KESSELS, H. J., KVENVOLDEN, K. A. and BLUNT, D. J., 'Amino acid racemization dating of fossil bones. I. Interlaboratory comparison of racemization measurements', *Earth and Planetary Sci. Lett.*, 43(1979), 265–8

73. IKE, D., BADA, J. L., MASTERS, P. M., KENNEDY, G. and VOGEL, J. C., 'Aspartic acid racemization and radiocarbon dating of an early milling stone horizon burial in California', *American Antiquity*, 44(1979), 524–30

74. ABE, I., IZUMI, K., KURAMOTO, S., and MUSHA, S., 'Resolution of amino acid enantiomers in fossil trees by gas chromatography and its basic approach to age dating', *Bunseki Kagaku*, 30(1981), 711–14

75. BADA, J. L. and HELFMAN, P. M., 'Amino acid racemization dating of fossil bones', *World Archaeology*, 7(1975), 160–73

76. BADA, J. L., MASTERS, P. M., HOOPES, E. and DARLING, D., 'The dating of fossil bones using amino acid racemization', in *Radiocarbon Dating, 9th Int. Conf., 1976, Proceedings*, edited by R. Berger and H. E. Suess (1979), 740–56

77. MASTERS, P. M. and BADA, J. L., 'Amino acid racemization dating of bone and shell', in *Archaeological Chemistry 2*, ACS Advances in Chemistry Series no. 171, (1978), 117–38

78. ABE, I., TSUJIOKA, H. and WASA, T., 'Solvent extraction clean-up for pre-treatment in amino acid analysis by gas chromatography. Application to age estimation from the D/L ratio of aspartic acid in human dentin', *J. Chromatography*, 449(1988), 165–74

79. BADA, J. L., 'Racemization of amino acids in fossil

bones and teeth from the Olduvai Gorge region, Tanzania, East Africa' *Earth and Planetary Sci. Lett.*, 55(1981), 292–8

80. BLACKWELL, B., RUTTER, N. W. and DEBNATH, A., 'Amino acid racemization in mammalian bones and teeth from La Chaise-de-Vouthon (Charente), France', *Geoarchaeology*, 5(1990), 121–47

81. HASSAN, A. A. and HARE, P. E., 'Amino acid analysis in radiocarbon dating of bone collagen', in *Archaeological Chemistry 2*, ACS Advances in Chemistry Series no. 171 (1978), 109–16

82. STAFFORD, T. W., DUHAMEL, R. C., HAYNES, C. V. and BRENDEL, K., 'Isolation of proline and hydroxyproline from fossil bone', *Life Sciences*, 31(1982), 931–8

Bibliography

ASQUITH, R. S. (Editor), *The Chemistry of Natural Protein Fibers*, Plenum Press, New York and London (1977)

GUSTAVSON, K. H., *The Chemistry of Tanning Processes*, Academic Press, New York (1956)

HARE, P. E., 'Geochemistry of proteins, peptides, and amino acids' in *Organic Geochemistry*, edited by G. Eglinton and M. T. J. Murphy, Springer-Verlag, Berlin, Heidelberg and New York (1969), 438–63

HAUROWITZ, F., *The Chemistry and Function of Proteins*, 2nd edition, Academic Press, London and New York (1963)

JOLY, M., *A Physico-chemical Approach to the Denaturation of Proteins*, Academic Press, New York and London (1965)

LEACH, S. J. (Editor), *Physical Principles and Techniques of Protein Chemistry*, Parts A to C, Academic Press, London and New York (1969–73)

MCKENZIE, H. A., *Milk Proteins*, 2 vol, Academic Press, London and New York (1970–71)

NEURATH, H. and HILL, R. L. (Editors), *The Proteins*, 3rd edition, 5 vols, Academic Press, London and New York (1975–82)

O'FLAHERT, F., RODDY, W. T. and COLLAR, R. M. (Editors), *The Chemistry and Technology of Leather*, ACS Advances in Chemistry Series No. 134, 4 vols, Reinhold, New York (1956–65)

RAMACHANDRAN, G. N. (Editor), *Treatise on Collagen*, vol. 1, Academic Press, London and New York (1967)

TRISTRAM, G. R. and SMITH, R. H., 'The amino acid composition of some purified proteins', in *Advances in Protein Chemistry*, vol, 18, edited by C. B. Afinsen Jr, M. L. Anson and J. T. Edsall, Academic Press, New York (1963)

VARIOUS AUTHORS, *Conservation and Restoration of Leather, Skin and Parchment. Papers from the Nordic Extra-mural Course April 3–14, 1978, Kulturen, Lund, Sweden* (in Danish, Swedish, German and English), Konservatorskolen Det Kongelige Danske Kunstakademi, Copenhagen (1980)

VEIS, A., *The Macromolecular Chemistry of Gelatin*, vol. 5, Academic Press, London and New York (1964)

WALDSCHMIDT-LEITZ, E. and KIRCHMEIER, O., *Chemie der Eiweisskorper*, 3rd edition, Ferdinand Enke Verlag, Stuttgart (1968)

WHITAKER, J. R. and FUJIMAKI, M., *Chemical Deterioration of Proteins*, ACS Symposium Series no. 123, Washington D. C. (1980)

8

Natural resins and lacquers

A large number of trees and plants spontaneously exude sticky, water-insoluble by-products of their metabolism which are loosely referred to as resins. Others, on tapping, yield liquid water/oil emulsions with excellent film-forming properties, known as natural lacquers. As they were so easily obtained, resins have always been attractive materials for use as adhesives and coatings and it is in this form that they occur most commonly as museum materials. However they have sometimes also been used to make actual objects, such as jewellery or small sculptures, especially in the case of fossil resins such as amber, or the various hard copals. Their chemistry is diverse but most resins are composed of compounds belonging to the extensive chemical class known as the terpenoids. These are widely distributed in nature in both the plant and animal kingdoms.

The terpenoids may formally be considered as made up of units of the C_5 compound isoprene:

$$CH_2 = C - CH = CH_2 \quad \text{isoprene}$$
$$| \atop CH_3$$

They fall into groups as follows:

monoterpenoids	C_{10} compounds
sesquiterpenoids	C_{15} compounds
diterpenoids	C_{20} compounds
sesterterpenoids	C_{25} compounds
triterpenoids	C_{30} compounds
carotenoids	C_{40} compounds
polyisoprenoids	$(C_5)_n$ polymers

The sesterterpenoids are a small and rare group of no significance to us. The carotenoids are an important group of natural colouring matters one of which, β-carotene, has already been discussed in Section 2.2.2 in connection with unsaturation and visible spectrometry. The essential oils of plants are composed largely of mono- and sesquiterpenoids while the natural resins contain mono-, sesqui-, di-, and triterpenoids. Interestingly, and very conveniently for classification and identification, di- and triterpenoids are not found together in the same resin.

8.1 The monoterpenoids

8.1.1 Oil of turpentine

Most natural resins, whether di- or triterpenoid, owe their initial fluidity to their admixture with the normally liquid mono- or sesquiterpenoids, or both. Oil of turpentine is the mixture of monoterpenes (sometimes with small amounts of sequiterpenes) obtained by distillation of crude pine resin, the relatively involatile diterpenoid components remaining in the retort to be recovered as 'rosin' or 'colophony'.

The terpene hydrocarbons have the general formula $C_{10}H_{16}$ and have a number of different basic skeletal structures, varied further by the positioning of double bonds. Structures of some of the more important terpenes are shown in *Figure 8.1*, most of them being components of oil of turpentine. The oxygenated terpenoids are the compounds responsible for the odours of flowers and aromatic herbs, of which they form the essential oils.

Many different *Pinus* species form the basis for the world's production of oil of turpentine and so

the composition of this is by no means uniform. A great deal of work has been carried out on these oils but unfortunately much of it before the development of gas chromatography[1,2]. Some of the results of later work using gas chromatography[3-13] are reported in *Table 8.1*. The main component is usually α-pinene but some species yield material of quite different composition.

It has also been shown that compositions can vary within a species, resulting in a number of so-called chemical subspecies. The compositions of turpentines from different countries, unidentified by species, have been summarized[14].

The oil of turpentine available in commerce comes as three kinds. First there is the 'gum turpentine', distilled from the resin as just described. 'Wood turpentine' is obtained by steam distillation of grubbed-up stumps of pine trees which have been felled for timber, while 'sulphate turpentine' is obtained as a by-product of the paper pulping industry. Most of this last kind comes from the South Eastern United States, the major production area for pine products. It has a composition of some 60–70% α-pinene, 20–25% β-pinene and 6–12% of other components. It is generally considered that wood and sulphate turpentines are inferior to gum

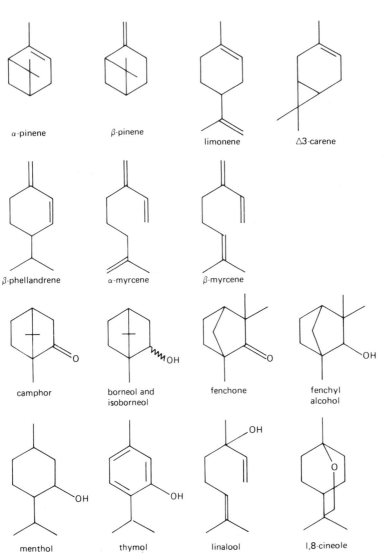

Figure 8.1 The structures of some monoterpenoid components of oil of turpentine and essential oils.

Table 8.1 Monoterpenoid composition of some *Pinus* oils of turpentine

Species	Origin	α-pinene	β-pinene	Δ3-carene	Limonene	Myrcene	β-phellandrene	Ref.
P. pinaster	Europe	68	30					3
P. halepensis	Europe	94	4					3
–var. *brutia*	Europe	63	20	15				3
P. pinea	Europe	1.5	2		96			3, 4
P. longifolia	India	34	16	49				3
P. sylvestris	Eurasia	68	7	23				3
P. ponderosa	N. America	7	33	36	13	9		5
P. elliottii	N. America	57	35				3.5	6
P. contorta	N. America	6	6	9	2.5	4	69	7
P. occidentalis	Caribbean	64	22	8				8
P. merkusii	Indonesia	76	2	14	1.5			9
P. khasya	Burma	76	19		1		2	10

Figures are percentages. They are approximate and can vary widely. Minor components are omitted.

turpentine for use in painting practice, though the grounds for this belief are not clear.

The presence of double bonds, particularly conjugated double bonds, means that turpentine components are readily subject to oxidation to give oxygenated, perhaps polymerized, materials which are involatile and consequently remain incorporated into a varnish film when oil of turpentine has been used as the solvent. This is usually thought of as undesirable and a probable cause of yellowing.

Most of the resins from the other genera of the Pinaceae, namely *Larix*, *Abies*, *Picea* etc., also yield volatile oils of comparable composition to those from *Pinus* but as these resins are only available in much smaller quantities, and are consequently much more expensive, there is little evidence that the oils have been much prepared or used.

8.1.2 Other monoterpenoid products

The ketone camphor is a rare example of a natural product which is an almost pure chemical compound. It can readily be isolated from the wood of the tree *Cinnamomum camphorae* Nees, either by water extraction or by subliming with gentle heat. It has been known in South East Asia, where the tree grows, since early times and it was introduced to the West by the Arabs. Among other things it has found use as a plasticizer, notably for cellulose nitrate (6.4.1). So-called Borneocamphor is the main component of the oil from *Dryobalanops aromatica* Gaertn. It is in fact not the ketone but borneol, one of the two enantiomeric alcohols corresponding to camphor.

Oil of Spike (i.e. spike lavender, *Lavandula spica*

DC) has, like oil of turpentine, been known since the beginning of the sixteenth century. It is a complex mixture of monoterpenoids, both hydrocarbon and oxygenated, together with some sesquiterpenoids. An analysis of one sample showed linalool and linalyl acetate as the major components[15].

Oil of rosemary (*Rosmarinus officinalis*) was also one of the earliest known oils. In a study of eight samples from different areas of Spain (a major producer), camphor was the major component in each case[16].

The content of oxygenated monoterpenoids in the above two oils means that they are much less volatile than oil of turpentine.

8.1.3 The art of distillation

Distillation, in some crude form, seems to have been practised since Ancient Egyptian times, and according to Laurie[17] the process was first clearly described in the early Christian era. Alembics, the old type of distillation apparatus, are to be found among early Arabic glassware. In Europe the practice of distillation seems to have been minimal however, until the later fifteenth century when the large-scale preparation of essential oils appears to have developed. In the *Distillation Book* of the Strasbourg doctor Hieronymus Brunschwig (1450–1534), published in Strasbourg in 1507, an elaborate distillation apparatus with fractionating column is illustrated, and the preparation of several oils described[18]. Thereafter several other books also appeared and the list of distilled products was much amplified.

Table 8.2 Diterpenoid natural resins and their sources

Coniferae			*Leguminosae*
Pinaceae	*Cupressaceae*	*Araucariaceae*	
Pinus species (Common or Bordeaux turpentine, rosin or colophony)	*Tetraclinis articulata* (sandarac)	*Agathis* species (kauri, manila)	*Hymenaea* species (East African or Zanzibar copal; Brazil copal)
Picea species (Burgundy pitch; scrape resin)	*Juniperus* species	*Araucaria* species	*Copaifera* species (copaibas)
Abies species (Strasbourg turpentine; Canada balsam)	*Cupressus* species		*Guibourtia; Tessmannia; Daniellia;* (other African copals; Congo, Accra, Benguela, Sierra Leone, etc.)
Larix species, notably *L. decidua* (Venice turpentine) *Pseudotsuga menziessii* (Oregon balsam)			

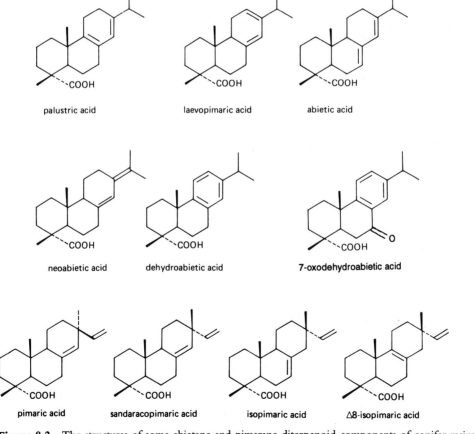

Figure 8.2 The structures of some abietane and pimarane diterpenoid components of conifer resins. 7-oxodehydroabietic acid is not an original component but is commonly found in old, oxidized samples.

8.2 Diterpenoid resins

8.2.1 The diterpenoids

The diterpenoids, and polymers formed from them, are the bulk material of two large groups of natural resins, those from the families Coniferae and Leguminosae. The resin-producing genera of the Coniferae, and the common names of the resins they yield, are summarized in *Table 8.2*. There are, in addition to the three subfamilies of the Coniferae given there, two others, namely the Taxodiaceae and the Podocarpaceae, which do not yield significant amounts of resin. Many minor genera are also omitted from the table since they also only yield small quantities.

The conifer resins contain diterpenoids principally of three main skeletal types. Pimarane and abietane compounds (*Figure 8.2*), almost exclusively acids, are most abundant in the Pinaceae resins, which are mainly 'soft' (i.e. soluble, unpolymerized) resins or balsams. Labdane compounds (*Figure 8.3*) are the main constituents of resins of the Cupressaceae. They are often conjugated diene compounds such as communic acid which readily polymerize to give low molecular weight polymer, still fairly soluble in rather polar solvents. All three groups of compounds are found in the Araucariaceae resins but these too contain mainly polymerizable labdane compounds.

The Leguminosae yield two kinds of material. Very liquid resins of the copaiba balsam type, containing non-polymerizing labdane compounds dissolved in sesquiterpenes, and 'copals', hard resins of the polymerized labdadiene type.

R=COOH *cis*-communic acid
R=CH$_2$OH *cis*-communol

R=COOH trans-communic acid
R=CH$_2$OH trans-communol

'iso-communic acid'

R=CH$_3$ ent-copalic acid
R=COOH agathic acid
R=CH$_2$OH agatholic acid

lambertianic acid

cis-abienol

R=H epimanool
R=OH larixol
R=OAc larixyl acetate

R=CH$_2$OH torulosol
R=COOH torulosic acid

Figure 8.3 The structures of some labdane diterpenoid components of conifer resins.

8.2.2 Pinaceae resins

Of the various resin-producing genera of the Pinaceae the pines (*Pinus* spp.) are the most important. Pines occur naturally only in the northern hemisphere and are the most abundant source of resin in the temperate regions. The resin exudes naturally from the trunks of many species and it must have been realized from the earliest times that the flow could be promoted by slashing through the bark.

The quantities obtainable from a tree can be quite large; up to 3 kg per annum for the European *P. pinaster*, 4 or 5 kg for some North American species, and since the trees are either abundant naturally or are easily and quickly grown the supply of resin greatly exceeds that from any other source.

Pine resins have always been the cheapest available and the most frequently used. Enormous amounts are still collected today, for the resin continues to be used in cheap products while the distilled oil of turpentine is a valued raw material for the synthesis of many organic materials.

Table 8.3 gives the composition, in terms of major components, of the main resin-yielding species of Europe, Asia, and North America, together with some less important ones included for their unusual compositions[11–13,19–25]. As can be seen, qualitative compositions of many species are essentially the same. Quantitative compositions are variable but do not remain constant due to isomerization of double bonds and oxidation and it is therefore only in exceptional circumstances that species and hence geographical origin of a sample can be determined by analysis. The few species which do have highly characteristic compositions are unfortunately not among the major resin producers. The *P. cembroides* group (Mexico and South-western United States) have very high proportions of $\Delta 8$-isopimaric acid[23].

Other American species besides *P. monticola*, including *P. aristata* and *P. ayacahuite* also show the high content of ent-copalic acid[20]. Again a number of East Asian species including *P. armandii*, *P. wallichiana*, *P. parviflora*, *P. koraiensis*, and *P. sibirica* also show the high content of lambertianic acid characteristic for the North American *P. lambertiana*. There are also more subtle indicators of species origin such as the relative proportions of pimaric and sandaracopimaric acid.

It should be noted that the composition of the solid colophony or rosin left after distillation of the oil of turpentine has a composition which is somewhat changed from that of the original resin. The several abietadiene acids, laevopimaric, palustric, abietic, and neoabietic acids are interconvertible through isomerization of the double bonds. The equilibrium mixture, which is formed during heat treatment, such as inevitably occurs during distillation, contains predominantly abietic acid, and very little laevopimaric acid is left. Some disproportionation also occurs with formation of dehydro- and dihydroabietic acids.

Compositional variations can only be of significance when considering the origins of resin samples which have been preserved in bulk or under circumstances in which oxidative changes have been kept to a minimum. This does happen and examples will be discussed in a later section. More commonly, though, the resin has been used as a component of a surface coating or paint, probably mixed with a drying oil and possibly subjected to heat during processing of the original varnish or other material. The diterpene acid composition will have been greatly changed and only the most stable of the components, notably dehydroabietic acid, will remain to indicate the original presence of a conifer – probably a pine – resin[25–6].

The larches (*Larix* spp.) are also distributed through Eurasia and North America but the only species yielding a resin which seems to have been put to use is the European *L. decidua* Miller, the source of the semi-liquid resin known as Venice turpentine. This continued to be collected in the Austrian Tyrol until recently though Laurie, in his book, reports it as difficult to obtain even eighty years ago. The name still confuses some people who think of it as if it were an oil of turpentine. It is not, nor is there any reason to suppose that an oil of turpentine was regularly distilled from it since it would probably always have been rather expensive for this purpose. However preparation of an oil of turpentine in this way is specifically mentioned in the seventeenth century De Mayerne manuscript, alongside with the use of Venice turpentine, as such, as a varnish.

Venice turpentine has a very characteristic composition[27], matched only by that of the north-east Asian species *L. gmelinii*[28,29]. It has a high proportion of neutral labdane compounds, namely epimanool, larixol, and larixyl acetate. The latter two compounds have not been observed in the resins of any other genus and so their detection in a sample at once pinpoints the presence of this larch resin. The acid components are similar to those from the pines.

Table 8.3 Diterpenoid composition of pine and other Pinaceae resins

Source	Pimaradiene acids				Abietadiene and -triene acids				Other components	Ref.
	Δ8-iso-pimaric	pimaric	sandaraco-pimaric	isopimaric	laevo-pimaric/palustric	abietic	neo-abietic	dehydro-abietic		
P. pinaster	0.2	8.0	2.0	12	39	14	18	4		19
P. halepensis		1.2	10	39	37	10	1.5			19
P. sylvestris	1	19	3	1.5	34	28	10	4		19
P. merkusii			10	15	38	16	3	8	merkusic acid (dihydro agathic acid) 10%	21
P. elliottii	1	4.5	1.5	21	38	9	3	4	communic acid 4%	19
P. palustris		5.5	1	10	52	9	13	8		19
P. ponderosa		7.5	3	15	40	11	11	8		19
P. lambertiana	0.5		3	22	4	4	2	8	lambertianic acid 56%	22
P. cembroides	60	0.5	6	13	1	10	0.5	8	ent-copalic acid 60%	20
P. monticola	1	1	3	13	1	1	0.5	8	abienol 46%	24
Abies alba (Strasbourg turpentine)			1	1.5	12	20	17	0.6		25
A. balsamea (Canada balsam)				3	20	20	20	0.7	abienol 27%	25
Larix decidua (Venice turpentine)		0.5	1	18.5	12.5	7.5	5.5	2	epimanool, 7.5, larixol 3, larixyl acetate 33%	27

Venice turpentine is often mentioned in early recipes for varnishes, both as a paint additive and as a raw material for the preparation of the soluble green pigment or glaze 'copper resinate'. It is not in fact very satisfactory for any of these purposes and it is hard to understand why it should have been thought to be so. It dries very slowly to a rather yellow film and when dry the film is quite brittle. It has no polymerizable components (unlike *Abies* resins, to which it has only a superficial resemblance) and so is unlikely to incorporate itself into the polymer network of a drying oil film. Thirdly, its high proportion of neutral components means proportionately less acids to react with copper compounds to give copper resinate; pine resin, with almost 100% of resin acids is better for the purpose.

Venice turpentine has sometimes also been added to waxes when used for various purposes, probably with the idea that it would plasticize the mixture, or improve its co- or adhesivity.

The firs (*Abies* species) accumulate their very fluid oleoresin in blisters on the trunks of young trees and it flows out when they are punctured. Two are known to have been exploited, others may well have been. The European silver fir *Abies alba* yields Strasbourg turpentine, the *olio d'abezzo* of the Italians, while the North American *A. balsamea* yields Canada balsam, well known for its use as a mounting medium in microscopy.

The two materials are rather similar in their diterpenoid composition, both containing the familiar pimarane and abietane resin acids but also quite a large proportion of a labdane alcohol, *cis*-abienol[25,30]. This compound, with its conjugated diene system in the side chain, readily polymerizes, and this may be partly responsible for the setting qualities of the resin. It may also be though that the β-phellandrene content of the monoterpenes plays a part in this.

A painting medium incorporating Canada balsam was devised in the nineteenth century and was named Palmaroli's medium after its inventor[31].

The Oregon Douglas fir, *Pseudotsuga menziessi*, yields the so-called Oregon balsam which can collect in very large amounts (it is said up to 15 gallons) in pockets or cracks in the trunks of old trees. The material has been available commercially but it is not known to what uses it may have been put. In addition to the usual resin acids, this oleoresin contains about 10% of a monocyclic diterpenoid alcohol thunbergol (also called cembrol) and its dehydration product thunbergene

(cembrene)[32,33]. These, and related compounds, are also found in a number of pine resins[34,35].

8.2.3 Cupressaceae resins

The compositions of the resins of this family are not easily summarized as they are rather varied, though having certain features in common. Many contain phenolic compounds such as totarol and ferruginol; most contain pimaradiene acids,

totarol ferruginol

particularly sandaracopimaric acid; many contain the labdanoid communic acid as (initially) the major component. This very readily polymerizes to give a low molecular weight polymer usually known as polycommunic acid[36,37]. This polymer (and related ones formed from similar dienes) are important materials, being the key to the formation, and survival in nature, of the copals and fossil resins such as amber.

Sandarac resin from *Tetraclinis articulata* (formerly *Callitris quadrivalvis*) from North Africa has a composition which fits the above picture, with perhaps 70% of polymerized communic acid[36]. The remaining diterpenoids (still detectable by gas chromatography) are sandaracopimaric acid (major component) together with its 12-acetoxy derivative, some phenols including totarol, and some minor labdanoid compounds.

The properties of resins such as sandarac are essentially those of polycommunic acid; thus they are rather polar materials and the resin is not soluble in non-polar solvents such as turpentine or white spirit but needs polar solvents such as alcohol. Likewise they are insoluble in drying oils and cannot be incorporated into an oil/resin varnish unless subjected first to severe heat treatment to decarboxylate, and perhaps also partly depolymerize, the polycommunic acid.

The resins of *Juniperus* and *Cupressus* species are again rather similar to sandarac and contain high proportions of polycommunic acid. The European cypress, *Cupressus sempervirens*, often yields quite a lot of resin though its use never seems to have been

specifically mentioned. Its chemistry has been studied and follows the general pattern[38].

Juniper resins seem sometimes to have been confused with sandarac in the past, though whether because of uncertainties over the botanical origins of the two or because resins from junipers were actually used is not known for certain. *J. thurifera*, growing in Spain, yields resin in good quantity.

The Australian cypress pines (*Callitris* spp.) yield so-called Australian sandarac which once again consists largely of a form of polycommunic acid though here the monomer is perhaps largely the isomer of communic acid, 'iso-communic acid'. A characteristic component of these resins is callitrisic acid, 4-epidehydroabietic acid[39,40].

8.2.4 Araucariaceae resins

The genus *Agathis* is the main resin-producing conifer genus in the southern hemisphere, particularly in Australia, New Zealand and the East Indies. The most important resin is kauri, the produce of a huge tree, *Agathis australis*, once abundant in New Zealand but much reduced by logging during the nineteenth century. It is now confined to small preserves north of Auckland. The resin flows copiously from the trunk and has, in the past, accumulated in large quantities in the forest soil. It was this 'semifossil' resin which was collected and exported in the nineteenth century for use in the manufacture of high quality varnishes. Being a hard and durable material it has also been used locally as a base for carving.

Kauri has a characteristic composition[41–3] and is easily identified as a bulk material. Much of it is a polymer of the communic acid type but with the variation that, since the fresh resin contains as much of the alcohol communol as the acid communic acid, the polymer consists of a co-polymer of these two compounds. Other major components of the resin are abietic acid, sandaracopimaric acid with its corresponding alcohol sandaracopimarol, and agathic acid. Some samples also contain large amounts of torulosic acid.

Manila copal, from *Agathis dammara* (also known as *A. alba*), goes under a variety of names supposedly reflecting the 'hardness' of the sample. Thus, fresh material obtained by tapping is called 'melengket' or 'loba'; older, or hard varieties are called 'pontianak' or 'boea'. The 'hardness' is presumably a reflection of the degree of polymerization of the communic acid.

The botany of *A. dammara* is rather uncertain and more than one species may be involved.

Samples of Manila copal (different pieces from the same batch) showed two compositional patterns[44]. In addition to communic acid, both contained sandaracopimaric acid, with large amounts of agathic acid and the acetate of agatholic acid, while one variant also showed large amounts of torulosic acid. The chemistry of the resins of other *Agathis* species has also been examined[45–48].

Some *Araucaria* species are abundant producers of resin though whether this has found uses is not known. The resins of the few species that have been chemically examined are of rather complex composition[49,50]. Some species yield resin which is admixed with a water-soluble plant gum (6.6.6), insoluble in the solvents which dissolve the resin. *Araucaria angustifolia*, growing in Brazil, yields an extractable resinous material of quite different chemical type (6.9).

8.2.4 Leguminosae resins

The family Leguminosae is an enormous one but the resin-producing trees are all from tropical genera within the tribe Detarieae of the sub-family Caesalpinioideae[51]. The origin of many of the copals and copaibas is sometimes unclear. This is because of uncertainties in the botany of the trees involved and also because the actual source of many of the resins in commerce is not known exactly, material passing through many hands between collector and final purchaser. The chemistry has also been much less studied than that of conifer resins, especially in the case of the African copals.

The diterpenoid content is different from conifer resins in certain important ways. Firstly the diterpenes are all (with rare exceptions) of the enantiomeric series; that is to say the skeletal structures are the mirror images of the corresponding compounds in the normal series (when such exist). The prefix ent- (short for enantiomeric) in a name implies this. However this fact is immaterial when it comes to analysis since it does not affect the physical properties of the compounds except for their optical rotations.

Gas chromatography, mass spectrometry, spectral methods such as infrared, will give no information as to which series the detected compound belongs to. Most of the diterpenoids are labdane compounds and many, but not all, correspond to compounds known also from other sources. A selection is shown

in *Figure 8.4*. Enantiomeric pimarane and abietane compounds seem not to be found, however.

The solid copals are mostly very highly polymerized materials and the diterpenoid responsible for this polymer seems usually to be ozic acid, which is the enantiomer of communic acid except that the carboxylic acid group is equatorial rather than axial[52]. The polymer formed from this seems for some reason to be more highly cross-linked than polycommunic acid for, when swollen by solvent (ether, for example), it often remains as rubbery lumps retaining their original form. The proportion of such polymer in a number of African copals examined by the authors varied from 45 to 85%. The highest figure was found in a sample of East African or Zanzibar copal, the source of which is well authenticated as *Hymenaea verrucosa* (formerly *Trachylobium verrucosum*).

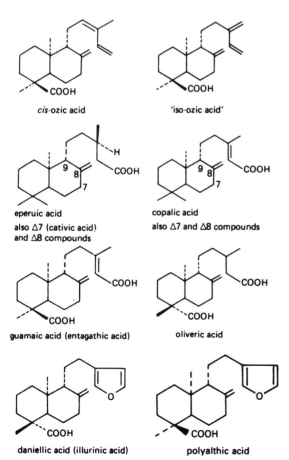

cis-ozic acid

'iso-ozic acid'

eperuic acid
also Δ7 (cativic acid)
and Δ8 compounds

copalic acid
also Δ7 and Δ8 compounds

guamaic acid (entagathic acid)

oliveric acid

daniellic acid (illurinic acid)

polyalthic acid

Figure 8.4 The structures of some labdane diterpenoid components of Leguminosae resins (copals and copaibas).

A large number of fresh copals from authenticated botanical sources were examined in the early 1950s by Hellinckx by infrared spectrometry[53]. Unfortunately this was just before the technique was adequately developed and the spectra obtained tell rather little about the possible chemical makeup. A number of old (probably fifty years or more) samples of African copals were examined[44] by gas chromatography – mass spectrometry to see whether named kinds were of consistent and distinctive composition. To some extent this was so; thus samples labelled Sierra Leone copal were indeed similar and distinct from other types, and this was also true of another group named Accra copal. Samples labelled simply Congo copal were variable, at least quantitatively, and not clearly distinguishable from other samples labelled Angola and Benguela copal, in turn also rather variable. It must be said also that samples of East African copals were themselves quite variable despite supposedly all originating from the same botanical source.

By no means all the compounds observed remaining in the soluble part of these resins have been identified but some have. Eperuic acid was present in most samples as was copalic acid, though this was not observed in Sierra Leone copal. Almost all the resins contained the ozic acid isomer 'iso-ozic acid'. This has been found[54] to constitute up to 95% of the ether-soluble components of fresh *Hymenaea verrucosa* resin.

The New World representatives of this type of resin all come from different species of *Hymenaea*, and these were once known in commerce under the name of Brazil copal[55-7]. The major source in Central America and Mexico is *Hymenaea courbaril* but sources of the resin going under this name in South America would appear to be variable for commercial samples of the resin are variable in properties. Most contain high proportions of ozic acid polymer, like all the African copals mentioned above, but some are completely ether-soluble and thus can hardly contain any.

It should perhaps be noted here that *copalli* was the Aztec name for resins in general. 'Copal' was said to be much used as a burnt offering in pre-Columbian Mexico but it may have been any one of the several kinds of resin in use there at that time which also included pine resins and the triterpenoid Burseraceous resins (see below).

To sum up: the composition of the leguminous copals is highly characteristic as a group and they can be very readily distinguished from conifer resins, probably even by infrared spectroscopy. Distinguish-

ing one from another would, in the present state of knowledge, be a much more doubtful proposition.

It has been found possible[44] to detect small amounts of some of the labdanoid acids in a one-hundred-year-old sample of copal varnish preserved in a bottle despite the fusion of the resin during its initial preparation, but so far no copal components have been certainly identified in old dried varnish films.

The copaiba balsams are obtained from several species of *Copaifera* and they are collected largely in the territories of Amazonia. They are mobile liquids containing mostly labdane diterpenoids of the enantiomeric series dissolved in sesquiterpenes[58–61]. They collect in hollows in the trunks of the trees, sometimes in very large volumes, and interest in them revived at the time of the energy crisis in the 1970s, since some kinds can be used directly as fuel in diesel engines.

Their use in medicine is now discredited as is their one-time popularity with paintings restorers who used them as an additive to the solvents used for removal of old varnish. Their effect was to act as a temporary varnish on the cleaned areas of the painting (since they do not evaporate completely), thus avoiding the matt appearance inherent in the complete removal of old varnish. Treatment with solutions of copaiba was one variation of the nineteenth and early twentieth century 'Pettenkofer process' for 'reforming' old varnish on paintings instead of removing it, and there is evidence of damage resulting from this[62,63].

Copaiba balsam is said to have been used by painters of certain schools of South American painting of the colonial period[64].

A number of other viscous liquid balsams similar to the South American copaibas also exist. Thus 'African copaiba', otherwise known as wood oil or illurin balsam, is a similar product from the large savannah tree *Daniellia oliveri*. It contains a high proportion of daniellic acid (illurinic acid)[65,66], the enantiomer of the lambertianic acid found in certain pine resins. Cativo gum[67] is the oleoresin from the Central American cativa tree, *Prioria copaifera*. Yet another Caribbean tree, *Eperua falcata*, yields a similar oleoresin[68].

8.3 Triterpenoid resins

The triterpenoid resins originate from numerous genera of broad-leaved trees, predominantly but not exclusively tropical. Several plant families are involved and as the botanical origins do not, as they do with the diterpenoid resins, allow any clear forecast of the chemistry of the resins to be made, less emphasis will be put here on the botanical classification.

One can state generally that the triterpenoids found in resins are of a non-polymerizing but easily oxidizable nature. In the softer or semi-liquid resins they occur mixed with, or dissolved in, sesquiterpenoids rather than monoterpenoids. In some of the resins, such as dammar and mastic, there may also be a certain proportion of low molecular weight hydrocarbon polymer.

It is the triterpenoid resins, and particularly dammar and mastic, which have proved most valuable as spirit-soluble varnish resins for paintings. This is probably because they are less yellowing than most of the conifer resins and more readily soluble than the leguminous copals. They are pale in colour initially and though they do yellow with time, such thin films can be applied that the discolouration is never very serious. The optical properties of natural resin varnish films have long been considered almost optimum, and more attractive than those yielded by most of the more stable synthetics. Their oxidation results in polar products, probably of lower molecular weight, and this means that more polar solvents are needed to remove varnish films of them than were used for their original application. None the less they are easily removed with the lower alcohols and ketones. They do have disadvantages though, for in addition to yellowing they can also craze and become matt and very brittle. It is by no means clear why they should form good films in the first place. In recent years ways have been sought and found for stabilizing natural varnish resin films, such as those of dammar (11.2.2).

8.3.1 The triterpenoids

This large class of compounds[69,70] having thirty carbon atoms results biosynthetically from the cyclization of the unsaturated triterpene hydrocarbon squalene, or rather its 2,3-epoxide. Squalene itself is only occasionally found in nature, notably in some fish liver oils. The actual mechanism of the biosynthesis of the triterpenoids has been determined in considerable detail[71]. Different pathways lead to several different basic skeletons, mostly tetraor pentacyclic though tri- and even bicyclic compounds are also known.

What function, if any, the triterpenoids play in the physiology of the plant is not known, nor is the

Figure 8.5 The structures of some triterpenoid resin components.

reason for the production of resins in plants and trees. The skeletons of some of the most important structural types have already been given in *Figures 5.2* and *5.3* in connection with the occurrence of triterpanes in crude petroleum. In nature nearly all compounds have a functional group at position 3 and a group (or a double bond) at the other end of the molecule also. Some of the more important resin components are shown in *Figure 8.5*.

8.3.2 The dammars

The dammars are resins originating from trees of the sub-family Dipterocarpoideae of the family Dipterocarpaceae. This comprises some fifteen genera containing above 500 species of large tropical trees all of which yield resins[72]. Probably only a few of these have been exported to the West for use as varnish resins but undoubtedly many others, which often have vernacular names, have been used locally and may well be encountered as components of ethnographic objects.

The family occurs from the Seychelles to the Philippines and New Guinea but it is most concentrated in the Malaya/Indonesia region. In Borneo some 280 species are known. In India, Burma, and Siam the picture is less confused, the principal resin yielders being *Balanocarpus heimii*, *Shorea robusta*, *Vateria indica*, and *Hopea odorata*. In Sri Lanka two species of *Doona* are the main source. Only a few of the resins have been examined from the point of view of their chemical composition. Even if they had all been it is unlikely that they would prove to be easily distinguishable.

The material referred to as dammar in Europe and the USA, still freely available both as the resin and as the made-up varnish solution, appears to be of fairly consistent composition though still of imprecise botanical origin. It is supposed to originate from species of *Hopea* or possibly *Shorea* and most of it comes from Malaya or Indonesia. In composition[73-5] it consists largely of compounds of the tetracyclic dammarane series (to which it gave the name), the pentacyclic compounds ursonic acid and its corresponding aldehyde, ursonaldehyde, and a proportion of polymeric hydrocarbon, insoluble in methanol or ethanol, known as β-resene. The non-polymeric part of the neutral fraction was once known as α-resene before the individual components had been isolated. Such names have no chemical significance. Dammars from identified species have also been examined chemically[76-8].

Dammar appears to have been first used as a varnish resin only in about 1829 and was probably more widely used only fifteen or more years later[79]. The dried residue in a bottle of varnish left in Turner's studio on his death (1851) was identified as dammar[80-82]. Towards the end of the nineteenth century the French chemist J.B. Vibert devised a retouching varnish consisting of the non-polar β-resene fraction ('resin V'), plasticized by the addition of a little poppyseed oil and dissolved in white spirit, and this was available commercially for many years[83].

Certain other materials originate from this family, notably the Gurjun balsams from *Dipterocarpus* spp. These are fluid oleoresins somewhat similar to the copaibas in appearance but consisting of triterpenoids dissolved in sesquiterpenoids[84]. They have been used locally as caulking materials and as ready-made varnishes. Resins from the Dipterocarpaceae are the most important of the many resins from different botanical sources used by peoples of the indigenous cultures of south east Asia and a survey of these from the ethnographical and archaeological points of view has been started[85,86].

8.3.3 Mastic

Mastic is the most important of a small group of resins from trees of the genus *Pistacia* of the Anacardiaceae family. The small shrub *P. lentiscus* grows along many Mediterranean coasts but the larger tree form which yields the resin is found only on the Greek island of Chios, where its collection is still an important local industry. As a Mediterranean product the resin has naturally been known from antiquity, its main use during the Ottoman period being for use as a kind of chewing gum. Whether (and if so, how) it was used as a varnish material before the development of distilled essential oils is not known. Mastic dissolves readily in oil of turpentine but rather incompletely in mineral spirits unless aromatics such as toluene or xylene are added.

Mastic has some compounds in common with the dammars though its components are more varied and have not been completely elucidated. Several tetracyclic compounds of the euphane series, including masticadienonic acid and its isomer isomasticadienonic acid, have also been isolated as well as compounds of the pentacyclic oleanane series[87,88]. These include oleanonic acid and its double bond isomer moronic acid. This last appears

to be relatively stable and can often be detected by GLC–MS even in old varnish films, so serving to identify these as containing mastic. A hitherto unknown bicyclic diol has also been isolated[89]. Like dammar, mastic contains a proportion of polymeric hydrocarbon which is insoluble in lower alcohols.

Most of the remaining *Pistacia* species and their varieties also yield resins including *P. vera*, the source of the edible pistachio nuts[90]. The resin produced in the galls of other species has also been looked at[91]. There exists a kind of mastic resin from a *Pistacia* sp. growing in India but the correct name of this species is uncertain (though often referred to as *P. lentiscus*[92]).

A viscous liquid resin, once important, known variously as Chios, Chio or Chian turpentine or Cyprus balsam, originates from a large and imposing tree, whose correct name is *P. atlantica* Desf. though in the past it was sometimes considered a variety of *P. terebinthus*, a common species which yields very little resin. *P. atlantica* occurs naturally from the Canary Islands, across North Africa into the Near and Middle East, and into Transcaucasia and Turkey, as well as in the east Mediterranean islands where it is often planted as a shade tree. In the nineteenth century there was quite a large production of Chios turpentine on the island of that name, where there were estimated to be about two thousand trees[93]. It is still sometimes collected in Cyprus (particularly near Paphos) and, like mastic, made into a kind of chewing gum. This material was the original terebinth or turpentine, the name only later being transferred to conifer resins. Because of its more fluid nature, Chios turpentine could conceivably have been used as a varnish or coating without the need for a diluent or solvent.

On the basis of simple physical and chemical characteristics Lucas suggested that more than 50 kg of resin, found filling the gap between an Egyptian sarcophagus and its outer case, was this material[94,95]. This identification, as well as others from the nineteenth century, receives some support from the recent identification of amphora resins from a bronze-age shipwreck as Chios turpentine[96], described in more detail in Chapter 12.

This finding also confirms the proposal, put forward in a remarkable but little known monograph by the French Egyptologist Loret in 1949, that the ancient Egyptian material *sonter*, the hieroglyph for which often appears written on representations of amphorae, was in fact the resin of the terebinth tree[97].

Various species of *Schinus*, notably *S. molle* the 'pepper tree', of Central and S. America also yield resins, sometimes called American mastic. This seems however to be a gum resin with a proportion of material insoluble in resin solvents.

8.3.4 Elemis

Various genera of the family Burseraceae yield resins, notably *Canarium*, *Bursera*, *Amyris*, and *Protium*. All of these have been sometimes given the name elemi though this is now generally restricted to Manila elemi from *Canarium luzonicum* growing in the Philippines.

Canarium species are mainly distributed from northern Australia through east and south-east Asia (including India) and Africa, while the other genera occur mainly in Central and South America. Mexican elemi is the product of *Amyris elemifera*, West Indian from *Dacryodes hexandra*. Names are sometimes misleading, that from the Indian *C. strictum* for example being known as black dammar[98].

The elemis usually contain a good deal of liquid sesquiterpenes and are soft malleable materials with a strong, pleasant citrus odour. The component triterpenes[99,100] sometimes crystallize out giving an opaque white appearance. Most of the elemis contain large amounts of the pentacyclic alcohols α- and β-amyrin (originally isolated and named from *Amyris* resins) while the so-called elemi acids of the euphane group were originally isolated from Manila elemi. The group of resins as a whole has not been systematically studied but a useful survey of the chemistry of the family has appeared[101].

Because of their initial malleability, elemis have been supposed to be good plasticizing materials and consequently have been included in recipes for varnishes and relining wax mixtures. There is no reason to suppose though that they have any lasting effect of this kind since the mono- and sesquiterpenoids responsible for the original softness will eventually evaporate.

8.3.5 Miscellaneous resins

The family Burseraceae also yields a group of so-called gum-resins which contain a proportion of water-soluble gum. This group includes the myrrhs from *Commiphora* species and Olibanum (frankincense) from *Boswellia* species, both of which contain triterpenoids in the resinous part[102–5]. These materials, originating mostly in Africa, and the Near and Middle East, including India, have found uses as

incense and in medicine and cosmetics and so are more likely to be found in archaeological contexts rather than incorporated into artifacts.

Of diverse botanical origins are the so-called balsamic resins, of which the main components are not terpenoid but esters of aromatic acids (benzoic and cinnamic acids) with corresponding aromatic alcohols. Although of early introduction into Europe their main uses have again been medicinal or in cosmetics or perfumes. Benzoin, however, has sometimes been used as a varnish dissolved in alcohol.

Both Sumatra and Siam benzoin come from species of *Styrax* (Styracaceae). Little work has been done on their chemistry in recent years; as well as triterpenes they contain large amounts of coniferyl benzoate[106]. The materials known as storax from *Liquidambar* species (Hammamelidaceae) likewise contain triterpenes and similar aromatic compounds[107]. The South American Tolu and Peru balsams, from two varieties of *Myroxylon balsamum* (Leguminosae), also contain aromatic esters such as coniferyl benzoate and benzyl benzoate[108].

The various coloured resins are discussed in Section 10.2.

8.3.6 Analysis and findings of resins

The detection of resins in paint media and varnishes has until recently been uncertain, and their specific identification almost impossible. General schemes for their analysis have been proposed and some successes reported[109-11]. Early methods have been critically examined and the advantages of gas chromatography demonstrated[112], while the analysis of some early instrument varnishes has been reported using this technique[113]. Success was claimed for infrared and thin-layer chromatography in identifying a varnish on a painting by Rubens as mastic[114].

The differences between mastic and dammar, as revealed by Fourier-transform infrared spectroscopy (FTIR), have been studied[115]. Infrared spectroscopy of a large sample of an original varnish from an eighteenth-century painting failed to give a certain identification[116]. The resin composition of European lacquers has been investigated with the analytical findings being perhaps rather overinterpreted[117]. With the more widespread availability of FTIR instruments there have been several attempts at assessing the potential for analysing old varnishes using this technique though success has been only limited, especially in the case of mixtures[118,119].

In an archaeological context, with larger samples, there is more scope for positive identifications. Conifer resins (probably from pines) have been detected by gas chromatography in a sixth century BC Egyptian jar[120], as an adhesive in a Punic vessel and other sources[25], and in amphorae[121,122]. This latter finding has sometimes been misinterpreted as representing the remains of resinated wine when in fact the resins were used to seal the interior of the unglazed vessel, as explained by Lucas[123]. Resin is very insoluble in aqueous alcohol of the strength encountered in wine. Most of the flavour imparted to resinated wine comes from the liquid monoterpenoid constituents.

Many of the above findings are based on the detection of the relatively stable dehydroabietic acid but in some cases (the Punic ship material for example) the resin shows the whole range of pine resin components through having been preserved in an anaerobic environment, i.e. at the bottom of the sea. As mentioned above (8.3.3) this was true also of the triterpenoids of the bronze age amphora resins detected by GLC–MS.

GLC–MS examination of traces of what was possibly a 600 year old oil-resin varnish found on an Italian tempera painting revealed the presence of sandaracopimaric acid, a component of Cupressaceae resins, in this case probably originating from sandarac resin[124].

Detection of the resin galbanum (from *Ferula galbanifera*, Umbelliferae) in the wrappings of an Egyptian mummy has been briefly reported[125]. Both FTIR and GLC–MS were applied to the analysis of resinous substances from fifteenth and seventeenth century shipwreck sites in the waters off Thailand and Saipan. Some samples were identified as almost certainly the balsamic resins (benzoin) from *Styrax* sp., while others used as sealants for the lids of storage jars and hull caulks contained sesqui- and triterpenoids and were probably from Dipterocarps[126].

8.4 Fossil resins

The term 'fossil' does not have any very precise meaning but as applied to resins it implies a material of age measurable on the geological time scale rather than of some thousands of years, as with say the 'semi-fossil' kauri found buried on the sites of old forests. Such fossil resins are sometimes found within geological mineral strata or in coal measures but these have found few uses and little work has

been done on them except to make unsatisfactory attempts to classify them mineralogically. The fossil resins which have found favour as jewellery and as a raw material for constructing objects, with primitive peoples and with sophisticated civilizations alike, are usually known as ambers. These are materials which, geologically speaking, are often of secondary deposition and have been subject to weathering and polishing by soil and water.

8.4.1 Baltic amber

The best known of the ambers is Baltic amber (Succinite, to give it its mineralogical name) which is found primarily in the 'blue earth' stratum on the Baltic coast of what was formerly East Prussia and is now partly in Poland but largely in Lithuania. However it is also found elsewhere because its density is such that it just floats in salt water and so sometimes arrives on the shores of the other Baltic countries and even as far afield as the coast of England. It is also found in Russia and on the shores of the Black Sea, brought down by the river Dnieper.

As a rare and precious material, amber has been the subject of speculation and experiment since antiquity. A bibliography of the extensive amber literature has been compiled[127,128] and there are recent books on different aspects of it. It has long been accepted that it is a resin of plant origin, and study of the palaeobotanical remains associated with it led, in the last century, to the certainty that the plant source was a conifer and to the naming of this source as *Pinites succinifer*. Later this name was changed, rather unfortunately, to *Pinus succinifera* although it was recognized that the source tree did not closely resemble any modern *Pinus* species.

Early work on the chemistry showed that amber contained the dibasic acid succinic acid, $HOOCCH_2CH_2COOH$, both free and esterified, but the chemistry of the bulk of the resin led only to the isolation of poorly defined and non-homogeneous fractions. These were given the elaborate names characteristic of resin chemistry at the end of the last century when the idea of polymers with a continuous range of molecular weights had not yet been developed. The chemistry of amber will here be discussed only in the light of recent findings[129–37].

Amber is only very incompletely soluble in organic solvents; in ether, for example, roughly 20% dissolves. The insoluble fraction is partly swollen by solvent, without losing the original form of the

pieces, to give a material of firm but rubbery consistency – behaviour typical of a high molecular weight cross-linked polymer. This in fact is what it is, and of a kind which could be thought of as a natural alkyd resin (9.3.1) – the product of esterification of a polyvalent alcohol with a dibasic acid. At the same time it also has some of the properties of an ion-exchange resin, for the polymer has a proportion of free carboxylic acid groups on it.

The polyvalent alcohol is (with perhaps some modifications caused by ageing) the co-polymer of communol and communic acid as found in kauri resin (8.2.4); the dibasic acid is succinic acid. Succinic acid esters are easily saponified, consequently fairly mild alkali treatment of amber polymer gives (after acidification) a product with an infrared spectrum very similar to that of communol–communic acid co-polymer.

Conversely, succinylation of the polymer from kauri gives a very insoluble product with an infrared spectrum close to that of amber polymer. Only about half of the hydroxyl groups on the amber polymer are succinylated, the rest are still free. The esterification by succinic acid serves to link together (cross-link) different polymer molecules, or different parts of the same molecule, thus increasing average molecular weight and structural rigidity, factors which raise melting point and diminish solubility.

Esterification of the succinic acid can also take place with other alcohols present in amber (see below) which can therefore be attached to the polymer through a succinyl link. The ^{13}C nuclear magnetic resonance spectrum[133,137] of Baltic amber shows up the exocyclic methylene group and can be readily interpreted on the basis of the above structure for amber polymer. This spectrum was obtained using a technique known as 'magic angle spinning' which allows spectra to be obtained from solid samples.

The ether-soluble part of amber also contains polymeric material, presumably less cross-linked and of lower molecular weight, but more interestingly it also contains very small amounts of several hundred individual compounds which can be readily separated and in part identified by GLC–MS[129,130]. The chromatogram obtained (*Figure 8.6*) is qualitatively fairly constant from sample to sample, though proportions of components may vary, and it allows Baltic amber to be certainly identified and distinguished from other resins.

The compounds observed fall into groups. Earliest emerging are monoterpenoids including bor-

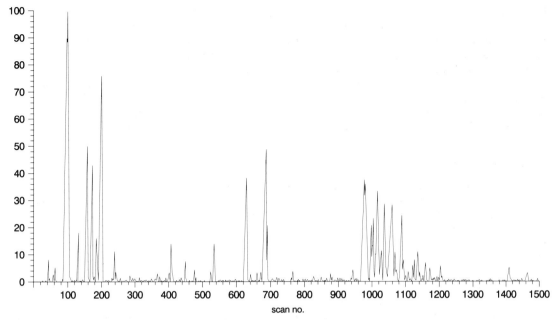

Figure 8.6 Capillary gas chromatogram of the ether-soluble components of Baltic amber after methylation of acids with diazomethane. The earliest group of peaks contains dimethyl succinate (largest peak) and several monoterpenoids; the two major peaks in the middle of the chromatogram are due to methyl fenchyl succinate and methyl bornyl succinate; the group of peaks from about scan 950 onward mostly consists of familiar diterpenoid methyl esters.

neol, camphor, fenchyl alcohol and fenchone (see *Figure 8.1*). In the same region comes a large peak of dimethyl succinate (when the extract has been methylated). Then follows a long section with many minor compounds and only one or two relatively major ones which include fenchyl methyl succinate and bornyl methyl succinate, originally present in the resin as the fenchyl and bornyl hemisuccinates.

The last and most interesting section of the chromatogram consists mainly of diterpenoid resin acid esters including many of the familiar ones known from fresh conifer resins. Although present in only small amounts (the most abundant, $\Delta 8$-iso-pimaric acid, probably represents only some 0.4% of the whole resin) their survival at all over the millions of years of the resin's existence is very remarkable. This must mean that at no time can it have been subjected to severe geological conditions which can lead (e.g. as in the case of petroleum) to loss of functional groups and consequent formation of hydrocarbons.

The question of amber's palaeobotanical origin is not of relevance here; suffice it to say that it evidently came from a tree with a resin chemistry closer to that of the present-day Araucariaceae family than the Pinaceae family. The succinic acid content is, however, uncharacteristic of any Coniferous resin though interestingly small amounts of the hemisuccinate of agatholic acid have recently been detected[138] in the resin of the Japanese pine *P. pumila*.

Attempts to show that amber is formed from abietic acid[139,140] were misconceived, based as they were on the idea that, since the source tree had been named *Pinus succinifera*, its resin chemistry must have been essentially similar to that typical of modern *Pinus* species. There is no evidence to show that a high molecular weight polymer can be formed from abietic acid, either in the laboratory or under natural conditions.

8.4.2 Amber objects and finds

The principal use for amber has been as jewellery, and items of this nature are often found as grave goods. Identification of the material as Baltic amber (or otherwise) is therefore of great interest from the point of view of trade routes and the extent of intercourse between widely dispersed peoples. Much work was carried out in the late nineteenth

century, particularly by Otto Helm, to identify the origins of amber finds from Mycenae and other Mediterranean cultures. Simple tests were used including observations of colour, density, hardness and, most particularly, the formation of succinic acid on heating. This last needed a large sample, however, and was not always reliable. This work has been summarized and critically assessed by Beck[141].

The situation was transformed by the introduction of infrared spectrometry[142,143]. The infrared spectrum of Baltic amber (*Figure 8.7*) is quite characteristic and distinctive (at least when considering only European ambers; some North American ambers have a similar spectrum) and is, essentially, that of the amber polymer discussed above. Beck and his co-workers have shown that, using only small samples, archaeological amber finds can usually be easily identified as to type[144,145].

As already indicated, gas chromatography is even more precise a method but infrared spectrometry is less time-consuming and better adapted to the examination of large numbers of samples. A method involving gas chromatographic estimation of the succinic acid has sometimes however been used additionally in cases where the sample was so weathered as to give an ambiguous infrared spectrum[146]. However because succinic acid also occurs in some other fossil resins this is not a wholly convincing confirmation and ^{13}C NMR has now also been applied to confirm the results[137].

Needless to say, infrared spectrometry readily allows the distinction of amber from numerous modern imitation ambers (used especially in jewellery), made of several kinds of synthetic resins. Early twentieth century examples of these are usually of phenol–formaldehyde resin (Bakelite); more recent kinds (in the 1970s and 1980s) are commonly polystyrene. Examples of the latter, incorporated into 'ethnic' jewellery, can be found in street markets from Marrakech to Katmandu. It is sometimes, though not always, possible to make the distinction using quite simple tests such as the effect of heat, solubility, or even density.

Amber varnish, which is made in the same way as other hard resin/oil varnishes by fusing the resin and adding hot drying oil, would seem to have been manufactured in considerable quantities during the peak period of amber production in East Prussia from the small pieces and cuttings which were otherwise unusable. It might prove impossible to identify such a varnish since the small amounts of characteristic diterpenoids might have been destroyed by the heating process. No work has in fact been done so far to such an end. Amber varnish, quite possibly genuine, is still available. It is hard to think of any valid use for it; certainly it has none in the field of conservation.

Despite the fact that amber is many millions of years old, and might be thought to have achieved chemical stability, this is not so. Unbroken pieces of amber are indeed protected by their weathered

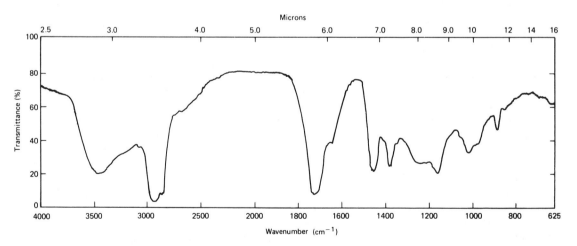

Figure 8.7 Infrared spectrum (KBr disc) of Baltic amber. The main features of the spectrum derive largely from the amber polymer, a co-polymer of communol and communic acid (*Figure 8.4*) cross-linked by partial succinylation. The band at *c.* 1160 cm^{-1} is due to the succinyl ester group; the broad band at *c.* 1710–40 cm^{-1} is due to ester and carboxylic acid groups; those at *c.* 3040, 1640, and 885 cm^{-1} are due to the exocyclic methylene group; that at *c.* 1025 cm^{-1} is from unesterified hydroxyl groups (axial hydroxymethylene).

outer layer (very thin, as can be seen when freshly broken open) but when fresh surface is exposed, as with worked amber, then reactive components are exposed to oxidation and further change. This means that amber artefacts sometimes degrade physically and are occasionally treated with 'consolidants'. Such treatments would of course make any subsequent provenance studies by infrared or other means virtually impossible.

8.4.3 Other fossil resins

There are several other fossil resins which also go under the name of amber. Some are of European origin[147] and consequently it was to be able to distinguish these from Baltic amber that examination of archaeological finds were undertaken. Little or no work has been done on their chemical composition, which remains a field ripe for investigation. They have however been studied as regards their [13]C NMR spectra[137], which have suggested various ways in which their structures (and hence either their botanical provenances or their diagenesis under differing geological conditions) differ.

Sicilian amber (Simetite) was naturally a prime contender in the identification of Mediterranean-culture amber finds, which however have often turned out to be of Baltic origin. Moreover it appears that Baltic amber was largely imported into Sicily in the nineteenth century for use by the amber workers there, the native variety being in short supply. Succinite itself co-occurs with several other varieties with such names as Glessite, Gedanite, Beckerite, Stantienite etc. The first is apparently a fossil triterpenoid resin since it has been shown by its X-ray diffraction pattern to contain α- or β-amyrin[148]. The NMR spectrum of Stantienite does not resemble that of an amber at all; Beckerite is not distinguishable from Succinite by NMR, and Gedanite, despite its differing physical properties, is also very similar.

A group of named varieties seems to cluster around Rumanian amber (Rumanite). The [13]C NMR spectrum of this differs from that of Succinite, principally in the absence of the resonance due to the exocyclic methylene group. Caution is required in attributing this absence to a different botanical provenance rather than to diagenesis since in the same paper[137] it is shown that in pressed amber (small pieces of Succinite that have been fused together by high pressure, getting hot in the process) this resonance has also been lost, presumably due to isomerization of the double bond into the ring system.

Another European variety is Spanish amber, originating from the north coast of Spain, on which no chemical work has been done. A brown pigment used in the prehistoric cave paintings of Altamira was identified, using both infrared spectroscopy and gas chromatography, as being this fossil resin[149]. It was mentioned above that succinite polymer could behave as an ion-exchange resin and this was evidently the case with this amber also. Hard water in the caves had converted the polymer to its salt (probably mainly the calcium salt) but simply treating with dilute hydrochloric acid returned this to the hydrogen form (the free acid) with an infrared spectrum close to that of an authentic sample of the fossil resin[150].

Objects made of carved resin are sometimes found in Central America and these seem to be made either of the leguminous copal from *Hymenaea courbaril* or the fossil resin (Chiapas amber etc.) which is believed to have originated from similar trees[151,152]. Colombian amber is very probably also of *Hymenaea* origin.

Another variety of amber, currently very much in demand, comes from the Dominican Republic. The botanical affinities of these and other ambers to modern resins of known source have been examined on the basis of infrared spectrometry[143] and, more recently, [13]C nuclear magnetic resonance (NMR)[153]. These ambers, like other insoluble fossil resins, result predominantly from the polymerization of labdadienoid compounds.

Japanese ambers, and objects made from them, have also received some attention in recent years mostly using infrared spectrometry[154,155].

In a general study of samples of different ambers and related resins, pyrolysis mass spectrometry was used followed by multivariate analysis of the resulting patterns of masses and their intensities[156]. Clusterings and affiliations were detected which indicated that different ambers were differentiable by this method. Unfortunately with this approach there seems to be no way of assessing additional results without complete re-analysis of the data set as a whole.

8.5 Polyisoprenoids – rubber

The term 'rubber' nowadays embraces synthetic materials in addition to the natural product, but only the latter, also known as caoutchouc and 'gum elastic', need concern us here.

Many different plants yield, by tapping, a milky emulsion of raw rubber in water known as latex. Most of these are indigenous to Central and South America, the product from *Hevea brasiliensis* (Euphorbiaceae) being the most important both as regards yield and quality. The conversion of this latex to useful articles was known to the natives of the New World for long before it was introduced into Europe: balls (for games), shoe soles, coated fabrics, small sculptures were all produced from rubber by the Aztecs, Mayas and South American peoples.

After its introduction into Europe it must for long have remained little more than a curiosity until the discoveries of the processes of mastication and vulcanization allowed the modification of some of its properties which had made for difficulties of handling or use.

The rubber in the latex is suspended as negatively charged particles of average diameter $0.5\,\mu m$ and comprises about 35% of the emulsion. It is coagulated by acidification to about pH 4.2 with acetic or formic acid and the raw material is rolled into sheets or processed in other ways.

8.5.1 Structure of rubber

The hydrocarbon isoprene was first obtained as a quite minor product of the pyrolysis of rubber and after the observation that it, on standing, yielded a rubber-like material, Bouchardat suggested in 1879 that isoprene was a foundation stone of rubber. The fact that rubber was made up solely of carbon and hydrogen in proportions corresponding to the empirical formula C_5H_8 had been established earlier in the century. Later it was shown that rubber has one double bond to each C_5H_8 unit and is of high molecular weight. During the present century the idea that the rubber molecule consisted of long chains formed by the regular linking of isoprene units was only quite slowly established; there was resistance to the whole idea of long polymer chains in the first decade and rival theories involved ring structures and non-covalent bonding involving the double bonds.

However it was shown that reaction of rubber with ozone (O_3; ozonolysis) followed by hydrolysis gave levulinic aldehyde, $CH_3COCH_2CH_2CHO$, in amounts accounting for 95% of the rubber hydrocarbon. This could only be consistent with a structure involving regular head-to-tail linking of the isoprene units:

$$-CH_2\overset{\underset{\displaystyle CH_3}{|}}{C}=CHCH_2CH_2\overset{\underset{\displaystyle CH_3}{|}}{C}=CHCH_2CH_2\overset{\underset{\displaystyle CH_3}{|}}{C}=CHCH_2-$$

$$\Big\downarrow {\scriptstyle O_3 \text{ then}}\atop{\scriptstyle H_2O}$$

$$-CH_2\overset{\underset{\displaystyle CH_3}{|}}{C}=O + O=CHCH_2CH_2\overset{\underset{\displaystyle CH_3}{|}}{C}=O +$$

$$O=CHCH_2CH_2\overset{\underset{\displaystyle CH_3}{|}}{C}=O + O=CHCH_2-$$

The presence of different substituents on the double bonds allows for the existence of geometric or *cis–trans* isomerism. It is now known that in fact natural rubber is the all *cis* isomer:

$$\underset{CH_2CH_2}{\overset{CH_3}{\diagdown}}C=C\underset{CH_2CH_2}{\overset{H}{\diagup}}\quad\underset{}{\overset{CH_3}{\diagdown}}C=C\underset{CH_2CH_2}{\overset{H}{\diagup}}$$

The materials known as gutta-percha from *Palaquium oblongifolium* (Sapotaceae), growing in South East Asia, and balata from *Mimusops globosa*, of South America, are also polyisoprenes and both have the all *trans* structure:

$$\underset{CH_2CH_2}{\overset{CH_3}{\diagdown}}C=C\underset{H}{\overset{CH_2CH_2}{\diagup}}\quad\underset{CH_3}{\overset{}{\diagdown}}C=C\underset{CH_2CH_2}{\overset{H}{\diagup}}$$

Modern spectroscopic methods such as nuclear magnetic resonance spectroscopy have failed to detect even small amounts of polymeric material in natural rubber resulting other than from 1,4 (head-to-tail), all *cis* linkaging. It should not be supposed that rubber is actually formed in the plant by polymerization of isoprene. In common with other isoprenoids its biosynthesis involves quite different routes.

8.5.2 Properties and modification of raw rubber

The polymer chains of natural rubber are very long and the material has an average molecular weight of more than a million. The properties of rubber, especially its elasticity, are a consequence of this and the regular alignment of the chains in the solid. Extending such a linear molecule involves deforming the bond angles so that the carbon atoms lie

more nearly in a straight line. Energy – the force required to stretch the rubber – is needed and will be released again as heat when the material is allowed to resume its natural form.

Since these chains are not significantly cross-linked, raw rubber is soluble in suitable non-polar solvents and such rubber solutions have found many uses. As a material for making objects however it has disadvantages in that it becomes soft and sticky when warm and firm when cold. Experiments on ways to render its properties less temperature-dependent were undertaken in the 1830s by Charles Goodyear, and following up earlier observations by others he devised the process of heating with elementary sulphur which subsequently came to be known as vulcanization.

While it is known that the overall result of this process is to effect cross-linking between the polymer chains, so producing a more rigid, insoluble material with properties less affected by temperature changes, the nature of these cross-links has not been wholly clarified. When large amounts (up to 30%) of sulphur are used the product is a hard rubber, formerly known as vulcanite or ebonite, which is no longer flexible and can be machined.

Rubber, even when vulcanized, still contains a high proportion of double bonds and so is susceptible both to oxidation and, more particularly, to the action of the ozone in the air which causes it to become hard and brittle. The chains are broken down in the way indicated above to give low molecular weight products.

As with all high polymers even small chemical changes have quite disproportionate effects on physical properties. The effect of one molecule of ozone per polymer chain is to reduce average molecular weight by half. For an initial average molecular weight of one million this needs only one part in about 20 000 by weight of ozone. Ozone is formed from oxygen when an electrical discharge is passed through it and consequently it is often found in the vicinity of various kinds of electrical apparatus, with consequent damage to rubber insulation and possibly also the health of users. This used to be the case with photocopiers but usually these now incorporate devices to suppress its formation.

8.5.3 Conservation of rubber

Articles made of rubber are relatively uncommon in the museum but are bound to be encountered more frequently with the increased interest in modern

artefacts and industrial archaeology. The problems of conserving such material are great, given the chemical vulnerability of rubber, and are increased by the complexity of the formulation of rubber products: many materials both organic and inorganic were added. The topic was the subject of a pioneering review[157] and this has since been followed by a number of other articles[158–162]. The main enemy is undoubtedly the ozone naturally present in the atmosphere but in fact it is very easy to protect from this by keeping the object inside a container made of equally vulnerable material such as cardboard, which absorbs it.

8.6 Insect resins – shellac

There is essentially only one important resin of insect source: shellac. This is secreted by a scale insect, *Kerria lacca* Kerr (as well as a number of related insects), which infests a number of possible host trees, so as to completely cover the twigs and branchlets. The raw lac, as scraped from the twigs, is known as stick-lac. After partial purification by crushing, sieving, water washing (which removes the dye; see below) and sedimentation in water to remove woody material it is known as seedlac.

The shellac of commerce comes in various forms such as buttons, pellets, sheets etc. India has always been the major source of this material which was, and remains, of considerable economic significance for that country.

Shellac has been used as a varnish material for every kind of object, especially furniture ('French polish') but also metal fittings and scientific instruments. It has also found uses in the West as an insulating material in early radio and other electrical equipment, as a component of phonograph cylinders and 78 rpm gramophone records, and numerous other applications. In India and other southwest Asian countries it is used as a varnish or lacquer, applied either in solution or, with warming, as the melted material. In the museum it was in the past commonly used as an adhesive, particularly for repairing broken pottery.

8.6.1 Chemistry of shellac

The chemistry of shellac is complicated and although worked on for over a century has only been clarified significantly in the last twenty years. The earlier work has been well summarized elsewhere[163] and there has also been a more recent

review[164]. The composition is said to be to some degree dependent on the nature of the host tree on which the insect feeds, the principal host in India being *Butea monosperma* Lamk. The extent of the variations has not been clarified but the following results[165-75] are based on resin from this source tree.

Stick-lac contains some 70–80% of 'resin', 4–8% of colouring matters (which are important dyestuffs and are discussed in Section 10.2.2) and 6–7% of 'wax', defined as the alcohol-insoluble/benzene-soluble fraction. It is the 'resin' fraction, itself subdivided into 'hard' (ether-insoluble) and 'soft' (ether-soluble) resins, which determines the overall

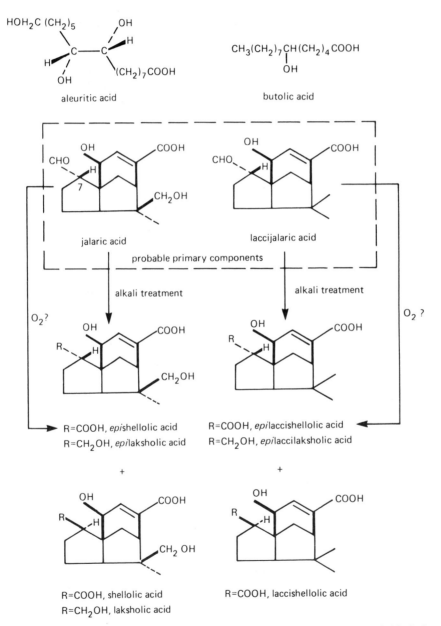

Figure 8.8 Aliphatic and sesquiterpenoid components of shellac. The two probable 'primary' sesquiterpenoids are shown in the dotted box; the other compounds below could result from the alkali treatment used in the isolation procedure, while two of them could also be formed by autoxidation as indicated.

useful properties of shellac and whose chemistry is now discussed.

It was realized early on that shellac consisted largely of low molecular weight polymers (oligomers) made up by the esterification of polyhydroxy carboxylic acids one with another, and work concentrated on the isolation and characterization of these acids after saponification of the polyester. The acid components proved to be of two types: aliphatic compounds related to the common fatty acids, and alicyclic compounds of the sesquiterpene series (*Figure 8.8*). Eventually it also became clear that several of the latter were not original, or 'primary', components of the resin but artefacts resulting from simple transformations of these during the alkali treatment.

The two aliphatic acids are aleuritic acid (major component) and butolic acid, the former being in fact a trihydroxypalmitic acid and the latter 6-hydroxytetradecanoic acid (6-hydroxymyristic acid). The alicyclic acids are derivatives of the sesquiterpene cedrene. Unfortunately they have been given clumsy trivial names which are confusing. The basic material is jalaric acid which is a dihydroxy, monocarboxylic acid with an aldehyde group.

Epishellolic acid and epilaksholic acids are the corresponding compounds in which the aldehyde group is replaced by a carboxyl group and a hydroxymethylene group respectively. Shellolic and laksholic acids are the epimers of these last two compounds at position 7. It has been shown that these last four compounds are all formed when jalaric acid is given a prolonged alkali treatment and so they are possibly simply artefacts formed during saponification. Jalaric acid can also be autoxidized to epishellolic acid.

A second group of compounds is related to those of the first simply by the absence of the primary hydroxyl group common to all of these. Once again it is the aldehydo compound which is considered to be the primary component, the others probably being artefacts formed by the alkali treatment (or by autoxidation). These are relatively minor constituents.

Quantitative estimation of these various components by gas chromatography was difficult for several reasons. Firstly the reaction of jalaric acid with diazomethane to give its methyl ester is not simple: the aldehyde group also reacts in part to give a methyl ketone. Secondly the various hydroxy acid esters partly decompose on the gas chromatograph

column. The first difficulty can be partly overcome by oxidizing jalaric acid to epishellolic acid before making the estimation, and the second by converting all the hydroxyl groups to their formates by treatment with acetic formic anhydride.

Once the basic components of the resin had been characterized an attempt was made to determine the actual makeup of the original polyester. The 'hard resin' was split up into further fractions by solvent precipitation and a centre cut, further purified by repeated solvent precipitation, was designated (perhaps rather arbitrarily) 'pure lac resin'. This was found to be essentially homogeneous in terms of molecular weight (approximately 2100); to be made up of essentially equimolar amounts of sesquiterpene acids and aleuritic acid; and hence to contain on average four molecules of each of these per polymer molecule.

The basic structure of the material is therefore as shown as in Structure 8.1 though it must not be taken from this that the sequence of linkaging of the units is necessarily regular or consistent: it represents an average situation. The soluble 'soft' resin contained, as one would expect, lower molecular weight units, including dimers made up of one molecule of aleuritic acid (as the acid) esterified with one molecule of sesquiterpene compound (the alcohol). Probably the 'pure lac resin' and the 'soft resin' are simply fractions of a continuum of oligomers of a range of molecular weights.

Aldehyde groups are very easily oxidized and consequently in shellac they are gradually converted to carboxylic acid groups. As can be seen there are plenty of free hydroxyl groups still available and so it is conceivable that further esterification, resulting in cross-linking and increase in average molecular weight, could continue in a shellac film. There is essentially no information available on this except that shellac certainly becomes less alcohol-soluble with time.

Bleached shellac is shellac which has been bleached (usually in aqueous alkaline solution) by treatment with chlorine gas. It contains a certain amount of chlorine incorporated chemically into it (probably by addition across the double bonds) which does not, *a priori*, seem a sound idea as regards durability and its possible effect on metals in contact with it.

Shellac in bulk can be easily identified by its infrared spectrum and even, sometimes, by its reaction with alkali to give a bright red colour (from erythrolaccin)[176]. Small amounts of old samples can be identified using gas chromatography (12.2.1).

R = CHO/COOH
R' = CH₂OH/CH₃

Structure 8.1 Generalized structure of 'pure lac resin'

8.6.2 Another insect 'resin'

In certain of the Mexican states, particularly in Michoacan, the Indians practised a form of painting using a mixture of drying oil with a product obtained from an insect, *Coccus axin*, and known as *axin* or *aje*. It was also in use in Yucatan by descendants of the Maya and was known as *niin*. It was obtained by boiling up the insects with water and collecting the soft water-insoluble material which exuded from them[177,178]. Nothing is known of its chemical nature.

Originally the painting was only in white or a few earth colours but with Spanish influence other colours were also used. It was mostly of a decorative nature, being applied to wooden articles or pots and other containers, and the result was said to be extremely durable. The drying oils used were argemone (from the seeds of the Mexican poppy, *Argemone mexicana*) or chia oil (from the seeds of *Salvia hispanica*). Later linseed oil was also used.

8.7 Japanese lacquer

A number of trees belonging to the Anacardiaceae family yield, by tapping, a liquid water in oil emulsion which, when spread as a film, sets by polymerization to a tough, flexible, and durable film. Pre-eminent among such materials is Japanese,

or Chinese lacquer (urushi) from the tree *Rhus verniciflua* Stokes (the correct name but also known as *Rhus vernicifera* D.C.) growing in Japan and China. Taiwanese and Vietnamese lacquer originate from another species, *Rhus succedanea*, while Thai, and probably also Burmese lacquer, is from a tree of a different genus, *Melanorrhoea usitata*.

Archaeological finds indicate that use of Chinese lacquer as a coating material for small objects dates from the early neolithic period (4000 BC), techniques having reached an advanced level by the Shang dynasty (1600–1100 BC). It has also been used to make objects of large size and considerable strength by repeatedly applying it on a base and carving the resultant solid. Many different inorganic materials, such as pigments (above all vermilion) and powdered metals, can be incorporated to give a range of decorative effects.

The chemical composition and the mechanism of drying of these materials are complex but have been largely elucidated in recent years. The problem of identifying Japanese lacquer, and distinguishing the different varieties, is also of great interest and, while not yet wholly solved, has also been the subject of some studies.

8.7.1 Composition of lacquers

Raw lacquer from the tree consists of acetone-soluble/water-insoluble material (60%), water

(30%) gummy (polysaccharide) materials (7%) dissolved in the water, water-insoluble glycoproteins (2%), and two enzymes which are copper glycoproteins, laccase and stellacyanin (*c.* 0.1%).

The components of the major, hydrophobic, fractions of the three main groups of lacquer mentioned above (Japanese, Taiwanese, Thai) have been given such names as 'urushiol', 'laccol' and 'thitsiol'. These (along with some other substituted phenols) are, in fact, not single substances but mixtures of similar substances of general formulae:

The different side chains (R), generally of fifteen and seventeen carbon atoms, may be saturated or have one, two or three double bonds. The double bonds, furthermore, may have *cis* or *trans* geometry. A further structural variation is found in the lacquer from *Melanorrhoea usitata*, which has compounds with side chains of eighteen carbons which include a terminal phenyl group. These various possibilities allow for large numbers of different compounds but there is usually only a limited number of major ones and several trace components. It has been found possible to analyse the raw lacquer using capillary column gas chromatography of the underivatized material, and detailed compositions of the three types have been obtained[179-82].

The qualitative composition for *Rhus verniciflua* was the same for Chinese and Japanese materials though the quantitative composition varied between different samples from either country. 'Urushiol' derivatives were predominant though there were also smaller amounts of 'thitsiol' derivatives. Thus the main component (up to 60% but as low as 38% in some Chinese samples) was the triene whose systematic name is 3-[8'(Z),11'(E),13'(Z)-pentadecatrienyl]catechol:

The other major component (usually about 20–25% but up to 47% in the low-triene sample) was the monoene 3-[8'(Z)-pentadecenyl]catechol:

The lacquer from *Rhus succedanea* is different in that it has a predominance of C_{17} side chains rather than C_{15}. The Thai/Burmese lacquer has high proportions of saturated side chains with terminal phenyl group (decylphenyl and dodecylphenyl groups) which means that its drying is relatively slow.

8.7.2 Drying of lacquer

Despite the fatty acid-like side chains of the urushiol, the drying of Japanese lacquer is, initially at least, by a completely different mechanism to that of drying oils because of the phenolic structure of the rest of the molecule. It is peculiar also in that the drying rate, and indeed the resulting chemical structure and physical properties of the film formed, are dependent on atmospheric humidity levels. It should firstly be said that the raw lacquer is sometimes used as it is but more usually is subjected to a sort of pre-polymerization treatment. These two materials, which are referred to as 'sap' and 'lacquer'[183,184], dry to give films with significantly different properties, the second being more durable. The pre-polymerization process consists of stirring the raw lacquer in a wooden vessel open to the air for four hours at 40°C. The resultant material has been separated into its individual components, or groups of components and the nature of the polymerization reactions clarified[185]. To simplify the complex mixture which resulted, the acetone-soluble fraction was first subjected to gel permeation chromatography to give a dimeric fraction, this was methylated (to convert hydroxyl groups to their methyl ethers) and hydrogenated (to saturate any remaining double bonds in side chains) and separated into its components by preparative scale liquid chromatography. The products found fell into five groups, as follows:

1. (26.6%) Biphenyls formed by coupling of two urushiol nuclei, the major component being that formed by 5—5 coupling, viz.

2. (10.8%) Dibenzofurans, formed by elimination reaction of the foregoing biphenyls, e.g.

3. (18.3%) Dimers formed by linkage of the nucleus of one molecule to the side chain of another, e.g.

4. (12.5%) Compounds of groups 1 and 2 with the side chain further oxidized with formation of extra hydroxyl groups.

5. (33.3%) Unknown (further oxidized nucleus to side chain dimers).

The reaction which initiates these dimerizations is a one-electron oxidation, mediated by the laccase, of the phenol or rather the phenolate anion to the semiquinone radical. This can rearrange to other radicals and also undergo disproportionation to yield the orthoquinone:

The overall drying process has also been carefully studied by observing the changes in the infrared spectrum of the film[186], which are more informative than is often the case. The initial step observed is the oxidation of the urushiol (the side chain is irrelevant at this stage) to the orthoquinone. This occurs very quickly and a characteristic absorption in the infrared at $1652\,cm^{-1}$ reaches a maximum after two hours. At this time a band at $850\,cm^{-1}$, characteristic for 1,2,3,5 substituted benzene, starts appearing, indicating the formation of the biphenyl compounds. At the same time also the bands due to conjugated diene at 948 and $985\,cm^{-1}$ diminish and a band at $993\,cm^{-1}$ due to conjugated triene appears and increases rapidly, indicating dimerization involving the side chain either through $C-O$ or $C-C$ linking, though as seen from the work described above there is no evidence for other than $C-C$ linking.

The dimers can themselves then dimerize with further orthoquinone formed either from urushiol monomer or, possibly, dimer. Eventually all dihydric phenols will be highly substituted by dimerization and the scope for further internuclear coupling correspondingly diminished. Further linking to unsaturated side chains may continue, or it is possible that at this point oxidative polymerization of the side chain, as in drying oils, could ensue: either could be responsible for the appearance of *trans* single double bond infrared absorption at

It is still not entirely clear whether the dimerization reactions leading to the products above are the result of coupling of rearranged semiquinone radicals or of the attack of such radicals on urushiol itself.

$975\,cm^{-1}$. This might be the position after about a week. Thereafter changes are slower and the infrared spectrum becomes more blurred but the most notable feature is appearance of carbonyl

absorption at about $1720 \, cm^{-1}$. This is strong after three months and dominant after ten years or so but what precisely it represents has not yet been clarified.

The foregoing appears to be the sequence of reactions taking place at moderate humidities. The presence of water seems to be essential to the formation of the phenol dimers, for at 0% relative humidity the absorption at $850 \, cm^{-1}$, indicative of dimer formation, does not appear even in 50 days and there is no formation of insoluble products. At 100% humidity all the above drying processes appear to proceed simultaneously and rather rapidly and a poor lustreless and fragile film results. The reasons for this may be partly physical in that the film retains some 22% of water even after a hundred days so must be quite porous when finally allowed to dry out.

The formation of phenol dimers in the drying of lacquer is a particular example of a very general oxidative phenol coupling reaction of great importance in the biosynthesis of a wide range of natural products including tannins, alkaloids, pigments and, most importantly to us, lignin, the structural element of wood (6.8). These reactions are all mediated by enzymes and a little more should perhaps be said regarding laccase. This has given its name to a whole class of enzymes (laccases) as it was the first to be detected, as long ago as 1883. Similar materials have been widely found throughout the vegetable kingdom, in plants, fungi and bacteria. Laccase is a glycoprotein (amino acids 55%, sugars 45%) of molecular weight around 120 000 with four co-ordinated copper atoms to the molecule. This copper can only be removed by dialysis against solutions of strong complexing agents such as citric acid or cyanide ion, the activity of the enzyme being destroyed thereby. As explained above, oxidation of phenol substrates involves single electron transfer from Cu^{2+} to give the phenoxy radical, the resulting Cu^+ being reoxidized to Cu^{2+} by atmospheric oxygen.

8.7.3 Related lacquers

While the chemistry of other lacquers has not been studied as carefully as that of Japanese lacquer, the infrared spectra of their dried films have been recorded and published[187,188]. Japanese, Taiwan, and Thailand/Burmese lacquers are said to be distinguishable as three-year-old films. The Taiwan lacquer gives a spectrum similar to that from *Rhus orientalis* (Tsuta-urushi). Other varieties are that from *R. javanica* (Nurude) and *R. trichocarpa* (Yama-urushi), both of which are quite similar to Japanese lacquer.

Trees from three genera of the family Araliaceae yield resinous saps which were apparently used as a readily photopolymerizable protective varnish for armour and other metalwork in ancient Japan. The three trees involved in Japan were *Dendropanax trifidus* Makino (Kakuremino), *Acanthopanax sciadophylloides* Fr. and Sav. (Koshiabura), and *Evdiopanax innovans* Nakai (Takanotsume). All three of these were variously known as *Gonzetsu* or *Koshiabura*. Other species of *Dendropanax* yielded a similar material in Korea and China, known during the T'ang dynasty as *oshitsu* (golden varnish). All the Japanese saps have been shown to contain polyacetylenic compounds, that from *Evdiopanax innovans* yielding some 29% of *cis*-1,9-heptadecadiene-4,6-diyn-3-ol[189]

$$CH_3(CH_2)_5 CH_2 \diagdown_{CH=CH} \diagup CH_2 C \equiv CC \equiv CC HCH = CH_2 \atop OH$$

This compound, as well as the raw sap, polymerizes very rapidly in sunlight, yielding a hard yellow film in one hour.

Another lacquer-like material is obtained from the related cashew tree, *Anacardium occidentale*, of south-east Asia. This tree yields many useful products including nuts, the shells of which expel a highly vesicant liquid – cashew nutshell liquid – on heating. It contains compounds closely related to those of Japanese lacquer[190] and it has been used industrially in this century as a baking enamel. The main centre of production is India where it is said to have found local use as a preservative for boats and fish nets and also to prevent attacks on woodwork by insects and termites. The infrared spectrum of its dried films is closely similar to those of lacquer films but it is claimed that it can be distinguished[188].

8.7.4 Identification and classification

Although the lacquers from different trees are in principal distinguishable, as explained above, examination of samples from lacquer objects is limited by their insolubility and the presence of inorganic admixtures. It is claimed that the dried lacquer can be separated from the heavier pigments and other inclusions by a flotation process using organic solvents of suitable specific gravity, such as carbon tetrachloride[191]. The separated lacquer can then be examined by infrared spectrometry.

More recently samples of lacquer from furniture have been examined by FTIR with a view to distinguishing authentic urushi from European imitation lacquer films based on natural resins[192]. Very small samples (20–50 μg) were used either as KBr discs or in a diamond cell, in both cases in connection with a beam condenser. The spectra obtained were compared with those given by authentic reference samples. The usual black and red pigments of urushi (carbon and vermilion) did not interfere, having no significant bands in the spectral region examined. Some bands attributable to quartz and to clay minerals were observed but could be readily discounted. It was found possible to distinguish genuine urushi from shellac and from copal- or sandarac-based varnish. In some cases original urushi was found to have been coated with a European finish, which meant that care had to be taken in sampling.

Rather little else has been done in the way of distinguishing the various types but some exploratory work has been carried out on a possible method using pyrolysis followed by mass spectrometry[193]. Four complete mass spectra were collected for each sample during the temperature-programmed pyrolysis and the data so obtained were subsequently subjected to a clustering procedure. Forty-four samples were separated into eight groups. Reassuringly, repeat measurements clustered together, as did samples from superimposed layers on the same object. Recent and also contaminated samples separated out and there was some indication that other groups were forming of samples of similar age.

References

N.B. The Russian journal *Khim. Prirod. Soedinenii* appears in English translation as *Chem. Nat. Compounds* though in recent years some articles have not been translated.

1. MIROV, N. T., *Composition of Gum Turpentines of Pines*, U.S. Department of Agriculture, Forest Service, Technical Bulletin No. 1239 (1961)
2. GILDERMEISTER, E and HOFFMAN, FR., *Die Ätherischen Öle*, edited by W. Treibs, 4th edition, vol. IV (1956), 39
3. BRUS, G., LEGENDRE, P. and NIOLLE, G., 'L'analyse de l'essence de térébenthine par chromatographie en phase vapeur', *Annales des Fraudes et de l'Expert. Chim.* (1961), No. 627, 142–50
4. SMIDT, E., 'Terpenoids of *P. pinea* oleoresin' (in Russian), *Khim. Prirod. Soedineniii* (1981), 665. (Not in *Chem. Nat. Compounds*)
5. ZAVARIN, E. and FIELDS, W. C., 'Oleoresin variability in *Pinus ponderosa*', *Phytochemistry*, 9(1970), 2509–15
6. MIROV, N. T., FRANK, E. and ZAVARIN, E., 'Chemical composition of *Pinus elliottii var elliottii* turpentine and its possible relation to taxonomy of several pine species', *Phytochemistry*, 4(1965), 563–8
7. SMITH, R. H., 'The monoterpenes of lodgepole pine oleoresin', *Phytochemistry*, 3(1964), 259–62
8. MIROV, N. T., ZAVARIN, E. and BICHO, J. G., 'Composition of gum turpentine of pines. *Pinus nelsonii* and *Pinus occidentalis*', *J. Pharm. Sci.*, 5(1962), 1131–5
9. WEISSMANN, G. and SIMATUPANG, M. H., 'Indonesisches Kolophonium aus *Pinus merkusii* De Vriese', *Farbe u Lacke*, 80(1974), 932–6
10. FISHER, G. S., 'Composition of turpentine from *Pinus khasya*', *Chem. Ind.* (London) (1963), 1761
11. COPPEN, J. J. W., ROBINSON, J. M. and MULLIN, L. J., 'Composition of xylem resin from five Mexican and Central American *Pinus* species growing in Zimbabwe', *Phytochemistry* 27(1988), 1731–4
12. COPPEN, J. J. W., ROBINSON, J. M. and KAUSHAL, A. N., 'Composition of xylem resin from *Pinus wallichiana* and *P. roxburghii*', *Phytochemistry*, 27(1988), 2873–5
13. WEISSMANN, G., 'Production, structure and properties of Chinese balsam rosin and turpentine', *Adhäsion*, 29(1985), 10–11
14. CIURLO, R. and CARLISI, E., 'Gascromatografia e considerazioni merceologiche sull'essenza di trementina', *Riv. Ital. Essenze, Profumi, Pianti Offic., Olii Veg.*, 51(1969), 631–5
15. KUBELKA, V., MITERA, J. and ZACHAR, P., 'Analysis of spike oil by gas chromatography – mass spectrometry', *J. Chromatog.*, 74(1972), 195–9
16. CABO TORRES, J., MALDONADO, R., JIMENEZ, J., VILLAR DEL FRESNO, A. and BRAVO, L., 'Estudio chromatografico de las essencias de romero español III Analisis comparativo de diversas muestras por chromatografia gaseosa', *Boll. Chim. Farm.*, 111(1972), 573–8
17. LAURIE, A. P., *Materials of the Painters' Craft*, T. N. Foulis, London and Edinburgh (1910), 70–3
18. GILDERMEISTER, E. and HOFFMAN, FR., *Die Ätherischen Öle*, edited by W. Treibs, 4th edition, vol. 1 (1956) 20, Fig. 2
19. JOYE, N. M. and LAWRENCE, R. V., 'Resin acid composition of pine oleoresins', *J. Chem. and Eng. Data*, 12(1967), 118–21
20. GOUGH, L. J., Private communication
21. WEISSMANN, G., 'Merkusinsäure, eine Dicarbonsäure im Balsam von *Pinus merkusii*', *Holzforschung*, 28(1974), 186–8
22. DAUBEN, W. G. and GERMAN, V. F., 'The structure of lambertianic acid', *Tetrahedron*, 22(1966), 679–83
23. ZINKEL, D. F. and CONNOR, A. H., 'Diterpenes of *Pinus quadrifolia*', *Phytochemistry*, 12(1973), 938–9

24. ZINKEL, D. F., TODA, J. K. and ROWE, J. W., 'Occurrence of anticopalic acid in *P. monticola*', *Phytochemistry*, 10(1971), 1161

25. MILLS, J. S. and WHITE, R., 'Natural resins of art and archaeology. Their sources, chemistry, and identification', *Stud. Conserv.*, 22(1977), 12–31

26. MILLS, J. S. and WHITE, R., 'Organic mass spectrometry of art materials: work in progress', *National Gallery Tech. Bull.*, 6(1982), 3–18

27. MILLS, J. S., 'Diterpenes of *Larix* oleoresins', *Phytochemistry*, 12(1973), 2407–12, and refs. cited therein

28. SHMIDT, E. N. and PENTEGOVA, V. A., 'Chemical composition of the oleoresin of *Larix dahurica*' (in Russian), *Khim Prirod. Soedinenii*, (1974), 675–6. (*Chem. Nat. Compounds*, 698–9)

29. KONOPLEVA, N. R. and SKVORTSOV, N. P., 'Isolation and analysis of oxidized resin acids' (in Russian), *Khim. Drev.*, (1983) No. 4, 18–20. *Chem. Abstr.*, 99(1983), 106968

30. GRAY, P. S. and MILLS, J. S., 'The isolation of abienol from Canada balsam, the oleoresin of *A. balsamea* (L) Mill.', *J. Chem. Soc.* (1964), 5822–5

31. EASTLAKE, C., unpublished letter to Sir Thomas Lawrence, August 15 (1822). London, Royal Academy, Lawrence letters vol IV, p.14

32. ERDTMANN, H., KIMLAND, B. and NORIN, T., 'The constituents of the "Pocket Resin" from Douglas fir *Pseudotsuga menziessii* (Mirb.) Franco', *Acta Chem. Scand.*, 22(1968), 938–42

33. KIMLAND, B. and NORIN, T., 'Thunbergol, a new macrocyclic diterpene alcohol', *Acta Chem. Scand.*, 22(1968), 943–8

34. DAUBEN, W. G., THIESSEN, W. E. and RESNICK, P. R., 'Cembrene, a fourteen-membered ring diterpene hydrocarbon', *J. Org. Chem.*, 22(1965), 1693–8

35. RALDUGIN, V. A. and PENTEGOVA, V. A., '4-Epiisocembrol – a new diterpenoid from the oleoresin of *P. koraiensis* and *P. sibirica*' (in Russian), *Khim. Prirod. Soedinenii*, (1971) No. 5, 669–70. (*Chem. Nat. Compounds*, 651)

36. GOUGH, L. G., 'Conifer resin constituents', *Chem. Ind.* (London), (1964), 2059–60

37. CARMAN, R. M., COWLEY, D. E. and MARTY, R. A., 'Diterpenoids XXV. Dundathic acid and polycommunic acid', *Austral. J. Chem.*, 23(1970), 1655–65

38. GOUGH, L. J. and MILLS, J. S., 'The occurrence of imbricatolic acid in *Cupressus* resins', *Phytochemistry*, 9(1970), 1093–6, and refs. cited therein

39. GOUGH, L. J., 'Callitrisic acid: a new diterpenoid', *Tetrahedron Letters* (1968), 295–8

40. CARMAN, R. M. and DEETH, H. C., 'Diterpenoids XXVI. A new diterpenoid acid from the oleoresin of *Callitris columellaris*', *Austral. J. Chem.*, 24(1971), 353–9

41. THOMAS, B. R., 'The bled resins of *Agathis australis*', *Acta Chem. Scand.*, 20(1966), 1074–81

42. THOMAS, B. R., 'Kauri resins – modern and fossil', in *Organic Geochemistry*, edited by G. Eglinton and M. T. J. Murphy, Springer-Verlag (1969), 599–618

43. THOMAS, B. R., 'Modern and fossil plant resins', in *Phytochemical Phylogeny*, edited by J. B. Harborne, Academic Press, London (1970), 59–79

44. MILLS, J. S. and WHITE, R., unpublished results

45. CARMAN, R. M. and MARTY, R. A., 'Diterpenoids XXIV. A survey of the *Agathis* species resins of North Queensland. Two new resin acids', *Austral J. Chem.*, 23(1970), 1457–64

46. CARMAN, R. M., CRAIG, W. J. and SHAW, I. M., 'Diterpenoids XXXI. Three new resin acids', *Austral. J. Chem.*, 26(1973), 209–14

47. SMITH, R. M., MARTY, R. A. and PETERS, C. F., 'The diterpene acids in the bled resins of three Pacific kauri, *Agathis vitiensis*, *A. lanceolata* and *A. macrophylla*', *Phytochemistry*, 20(1981), 2205–7

48. MANH, D. D. K., BASTARD, J. and FETIZON, M., 'Plantes de Nouvelle Caledonie'. LXXVI. Diterpènes d'*Agathis lanceolata*, *J. Nat. Prod.*, 46(1983), 262–73

49. CAPUTO, R., MANGONI, L., MONACO, P., PELOSI, L. and PREVITERA, L., 'Neutral diterpenes from *Araucaria bidwillii*', *Phytochemistry*, 15(1976), 1401–2 and earlier papers cited therein

50. MONACO, P., PREVITERA, L. and MANGONI, L., 'Terpenes of the bled resins of *Araucaria hunsteinii*', *Rend. Accad. Sci. Fis. Nat. Naples*, 48(1980–81), 465–70

51. LANGENHEIM, J. H., 'Leguminous resin producing trees in Africa and South America', *Tropical Forest Ecosystems in Africa and South America: a Comparative Review*, Edited by B. J. Meggers, E. S. Ayensu and W. D. Duckworth, Smithsonian Institution Press, Washington D. C. (1973), 89–104

52. BEVAN, C. W. L., EKONG, D. E. W. and OKOGUN, J. I., 'West African timbers. Part XXI. Extractives from *Daniellia* species. The structure of a new diterpene, ozic acid', *J. Chem. Soc. (C)* (1968), 1063–6

53. HELLINCKX, L., *Les Propriétés des Copals du Congo Belge en Relation avec leur Origine Botanique*, Institut National pour l'Etude Agronomique de Congo Belge, Série Technique No. 44, Bruxelles (1955), 8–25

54. MARTIN, S. S. and LANGENHEIM, J. H., 'Enantio-8(17),13(16),14-labdatrien-18-oic acid from trunk resin of Kenyan *Hymenaea verrucosa*', *Phytochemistry*, 13(1974), 523–5

55. LANGENHEIM, J. H., 'Amber: a botanical inquiry', *Science*, 163(1969), 1157–69

56. CUNNINGHAM, A., MARTIN, S. S. and LANGENHEIM, J. H., 'Labd-13-en-8-ol-15-oic acid in the trunk resin of Amazonian *Hymenaea courbaril*', *Phytochemistry*, 13(1974), 294–5

57. CUNNINGHAM, A., MARTIN, S. S. and LANGENHEIM, J. H., 'Resin acids from two Amazonian species of *Hymenaea*', *Phytochemistry*, 12(1973), 633–5

58. FERRARI, M., PAGNONI, U. M., PELLIZONI, F., LUKES,

v. and FERRARI, G., 'Terpenoids from *Copaifera langsdorfii*', *Phytochemistry*, 10(1971), 905–7

59. DELLE MONACHE, F., CORIO, E., LEONCIO D'ALBUQUERQUE, I. and MARINI-BETTOLO, G. B., 'Diterpenes from *Copaifera multijuga* Hayne.-Note 1', *Annali di Chimica*, 59(1969), 539–51

60. DELLE MONACHE, F., LEONCIO D'ALBUQUERQUE, I., DELLE MONACHE, G. and MARINI-BETTOLO, G. B., 'Diterpenes from *Copaifera multijuga* Hayne.-2. Copaiferolic acid and 11-hydroxy-labd-8(20),13-dien-15-oic acids', *Annali di Chimica*, 60(1970), 233–45

61. MARAJAN, J. R. and FERREIRA, G. A. L., 'New diterpenoids from copaiba oil', *An. Acad. brasil Cienc.*, 43(1971), 611–13

62. BRAMMER, H., 'Durch Restaurierungsmaßnahmen beschädigte Gemäldeoberflächen: 2 Beispiele aus der Kasseler Gemäldegalerie', *Zeitschrift für Kunsttechnologie und Konservierung*, 1(1987), 95–104

63. SCHIESSL, U., ' "Apage Satanas! Apage Copaiva!" Über Materialmoden in der Restaurierungsgeschichte', *Zeitschrift für Kunsttechnologie und Konservierung*, 1(1987), 165–75

64. URQUIJO, J. M. M., 'Las escuelas de dibujo y pintura de Mojos y Chiquitos', *Anales del Instituto de Arte Americo*, 9(1956), 37–51

65. HAEUSER, J., LOMBARD, R., LEDERER, F and OURISSON, 'Isolement et structure d'un nouveau diterpène: l'acide daniellique. Stéréochimie de l'acide daniellique', *Tetrahedron*, 12(1961), 205–14

66. MILLS, J. S., 'Identity of daniellic acid with illurinic acid', *Phytochemistry*, 12(1973), 2479–80

67. ZEISS, H. H. and GRANT, F. W., 'The constitution of cativo gum', *J. Amer. Chem. Soc.*, 79(1957), 1201–5

68. BLAKE, S. and JONES, G., 'Extractives from *Eperua falcata*. The petrol-soluble constituents', *J. Chem. Soc.*, (1963), 430–3, and refs. cited therein

69. KULSHRESHTHA, M. J., KULSHRESHTHA, D. K. and RASTOGI, R. P., 'The triterpenoids – a review', *Phytochemistry*, 11(1972), 2369–81

70. PANI, P. and RASTOGI, R. P., 'The triterpenoids – a review', *Phytochemistry*, 18(1979), 1095–108

71. MULHEIRN, L. J. and RAMM, P. J., 'The biosynthesis of sterols' (includes triterpenoids), *Chem. Soc. Reviews*, 1(1972), 259–91

72. BISSET, N. G., CHAVANEL, V., LANTZ, J.-P. and WOLFF, R. E., 'Constituants sesquiterpèniques et triterpèniques des résines du genre *Shorea*', *Phytochemistry*, 10(1971), 2451–63, and refs. cited therein

73. MILLS, J. S. and WERNER, A. E. A., 'The chemistry of dammar resin', *J. Chem. Soc.*, (1955), 3132–40

74. MILLS, J. S., 'The constitution of the neutral, tetracyclic triterpenes of dammar resin', *J. Chem. Soc.*, (1956), 2196–202

75. BREWIS, S. and HALSALL, T. G., 'The acidic constituents of dammar resin', *J. Chem. Soc.* (1961), 646–50

76. CHEUNG, H. T. and WONG, C. S., 'Studies of triterpenes from *Dryobalanops aromatica*', *Phytochemistry*, 11(1972), 1771–80

77. CHEUNG, H. T. and YAN, T. C., 'Triterpenoids of *Shorea acuminata* and *S. resina-nigra*', *Austral. J. Chem.*, 25(1972), 2003–12

78. BANDARANAYAKE, W. M., GUNASEKERA, S. P., KARUNANAYAKE, S., SOTHEESWARAN, S. and SULTANBAWA, M. U. S., 'Terpenes of *Dipterocarpus* and *Doona* species', *Phytochemistry*, 10(1971), 2043–8

79. FELLER, R. L., 'First description of dammar picture varnish translated', *IIC. Bull. of the American Group*, 7(1966) Nos. 1, 8 and 20

80. HANSON, N. W., 'Some painting materials of J. M. W. Turner', *Stud. Conserv.*, 1(1954), 162–73

81. HANSON, N. W., 'Some recent developments in the analysis of paints and painting materials', *Off. Digest* (1953), No. 338, 163–74

82. MILLS, J. S. and WERNER, A. E. A., 'Partition chromatography in the examination of natural resins', *J. Oil Colour Chem. Assoc.*, 37(1954), 131–42

83. HAVEL, M., 'Un élément nouveau dans la couche picturale de la peinture moderne: le vernis de retoucher. Un exemple: le vernis de retoucher Vibert', *ICOM Committee for Conservation, Report 19/72/10* 11., 3rd Triennial Meeting, Madrid (1972)

84. DE SILVA, L. B., RODRIGO, S. and WIJESEKERA, R. O. B., 'Extractives of Ceylonese Dipterocarpaceae', *J. Sci. Ind. Res. (India)*, 21B(1962), 403

85. GIANNO, R., VON ENDT, D. W., ERHARDT, W. D., KOCHUMMEN, K. M. and HOPWOOD, W., 'The identification of insular Southeast Asian resins and other plant exudates for archaeological and ethnological application', in *Recent advances in the conservation and analysis of artifacts*, compiled by James Black, Institute of Archaeology, London (1987), 229–38

86. GIANNO, R., *Semelai Culture and Resin Technology: Memoirs of the Connecticut Academy of Arts and Sciences Vol. XXII*, New Haven (1990)

87. BARTON, D. H. R. and SEOANE, E., 'The constitution and stereochemistry of Masticadienonic acid', *J. Chem. Soc.* (1956), 4150–57

88. SEOANE, E., 'Further crystalline constituents of gum mastic', *J. Chem. Soc.* (1956), 4158–60

89. BOAR, R. B., COUCHMAN, L. A., JAQUES, A. J. and PERKINS, M. J., 'Isolation from *Pistacia* resins of a bicyclic triterpenoid representing an apparent trapped intermediate of squalene 2,3-epoxide cyclization', *J. Amer. Chem. Soc.*, 106(1984), 2476

90. CAPUTO, R., MANGONI, L., MONACO, P., AYNHEHCHI, Y. and BAGHERI, M., 'Triterpenes of the bled resin of *Pistacia vera*', *Phytochemistry*, 17(1978), 815–17

91. CAPUTO, R., MANGONI, L., MONACO, P. and PALUMBO, G., 'Triterpenes of the galls of *Pistacia palestina*', *Phytochemistry*, 18(1979), 896–8

92. KHARBADE, B. V., SRIVASTAVA, N., JOSHI, G. P. and

AGRAWAL, O. P., 'Thin-layer chromatographic analysis of some Indian natural resins ocurring in objects of art', *J. Chromatography*, 439(1988), 430–40

93. PASQUA, I., 'La terebintina di Scio', *Bull. R. Soc. Toscana Orticultura.*, 6(1881), 19–21

94. LUCAS, A., 'Resin from a tomb of the Saïte period', *Annales Service Antiquités Egypte*, 33(1933), 187–9

95. LUCAS, A., *Ancient Egyptian Materials and Industries*, 3rd edition, Edward Arnold. London, (1948), 373–5

96. MILLS, J. S. and WHITE, R., 'The identity of the resins from the late Bronze Age shipwreck at Ulu Burun (Kaş)', *Archaeometry*, 31, 1(1989), 37–44

97. LORET, V., *Recherche d'archéologie de philologie et d'histoire, Tome 19: La résine de térébinth (sonter) chez les anciens Egyptiens*, Imprimerie de l'Institut Francais d'Archéologie Orientale, Cairo (1949)

98. HINGE, V. K., WAGH, A. D., PAKNIKAR, S. K. and BHATTACHARYA, S. C., 'Constituents of black dammar resin', *Tetrahedron*, 21(1965), 3197–205

99. COTTERRELL, G. P., HALSALL, T. G. and WRIGLESWORTH, M. J., 'Clarification of the nature of the tetracyclic triterpene acids of elemi resin', *J. Chem. Soc. (C)* (1970), 739–43, and refs. cited therein

100. BANDARANAYAKE, W. M., 'Terpenoids of *Canarium zeylanicum*', *Phytochemistry*, 19(1980), 255–7

101. PERNET, R., 'Phytochimie des Burseracées', *Lloydia*, 35(1972), 280–7

102. THOMAS, A. F. and WILLHALM, B., 'Triterpenes of *Commiphora*. Part 4. Mass spectra and organic analysis (5). Mass-spectroscopic studies and the structure of commic acids A and B. ', *Tetrahedron Lett.* (1964), 3177–83, and refs. cited therein

103. SNATZKE, G. and VERTESY, L., 'Neutral sesqui- and triterpenes of frankincense', *Monatshefte*, 98(1967), 121–32

104. PARDHY, R. S. and BHATTACHARYYA, S. C., 'β-Boswellic acid, acetyl-β-boswellic acid, acetyl-11-keto-β-boswellic acid and 11-keto-β-boswellic acid, four pentacyclic triterpene acids from the resin of *Boswellia serrata* Roxb.', *Indian J. Chem.*, 16B(1978), 176–8

105. FATTORUSSO, E., SANTACROCE, C. and XAASAN, F., 'Dammarane triterpenes from the resin of *Boswellia freerana*', *Phytochemistry*, 24(1985), 1035–6

106. SHROEDER, H. A. 'The p-hydroxycinnamyl compounds of Siam benzoin gum', *Phytochemistry*, 7(1968), 57–61

107. HUNEK, S., 'Triterpenes of the balsam of *Liquidambar orientalis* Muller. (Storax)', *Tetrahedron*, 19(1963), 479–82

108. HARKINS, K. J. and LINLEY, P. A., 'Determination of balsamic acids and esters', *Analyst*, 98(1973), 819–22

109. KLEBER, R. and MASSCHELEIN-KLEINER, L., 'Contribution à l'analyse des composés résineux utilisés dans les oeuvres d'art', *Bull. Inst. Roy. Patrimoine Artist.*, 7(1968), 196–218

110. MASSCHELEIN-KLEINER, L., HEYLEN, J. and TRICOT-MARCKX, F., 'Contribution à l'analyse des liants, adhésifs et vernis anciens', *Stud. Conserv.*, 13(1968), 105–21

111. MASSCHELEIN-KLEINER, L. and TAETS, P., 'Contribution to the study of natural resins in art', *ICOM Committee for Conservation, Report 81/16/3*, 8 pp., 6th Triennial Meeting, Ottawa (1981)

112. WHITE, R., 'A review, with illustrations, of methods applicable to the analysis of resin/oil varnish mixtures', *ICOM Committee for Conservation, Report 81/16/2*, 9 pp., 6th Triennial Meeting, Ottawa (1981)

113. WHITE, R., 'An examination of varnish from three 18th century musical instruments', *ICOM Committee for Conservation, Report 78/16/1*, 5 pp., 5th Triennial Meeting, Zagreb (1978)

114. KLEBER, R. and TRICOT-MARCKX, F., 'Identification d'un vernis moderne recouvrant la Descente du Croix de Rubens', *Bull. Inst. Roy. Patrimoine Artistique.*, 6(1963), 63–8

115. LOW, M. J. D. and BAER, N. S., 'Dammar and mastic infrared analysis', *ICOM Committee for Conservation, Report 78/16/5*, 6 pp., 5th Triennial Meeting, Zagreb (1978)

116. PETIT, J., 'Examen chimique d'un vernis de la fin du 18ème siècle après viellissement naturel sur un tableau', *ICOM Committee for Conservation, Report 75/22/7*, 7 pp., 4th Triennial Meeting, Venice (1975)

117. GRYGLEWICZ, E. W. A., 'The technique and technology of European lacquer on the basis of physical and chemical studies' (in Polish), *Ochrona Zabytkow*, 23(1980), 305–10

118. SHEARER, G., 'Use of diffuse reflectance Fourier transform infrared spectroscopy in art and archaeological conservation', in *Recent advances in the conservation and analysis of artifacts*, compiled by J. Black, Institute of Archaeology, London, (1987), 253–6

119. DERRICK, M., 'Fourier transform infrared spectral analysis of natural resins used in furniture finishes', *J. Amer. Institute of Conservation*, 28(1989), 43–56

120. SEHER, A., SCHILLER, H., KROHN, M. and WERNER, G., 'Untersuchungen von "Ölproben" aus archäologischen Funden', *Fette, Seifen Anstrichmittel*, 82(1980), 395–9

121. ADDEO, F., BARLOTTI, L., BOFFA, G., DI LUCCIA, A., MALORNI, A. and PICCIOLI, G., 'Costituenti acidi di una oleoresina di conifere rinvenuta in anfore vinarie durante gli scavi archeologici di Oplonti', *Ann. Fac. Sci. Agrar. Univ. Studi. Napoli, Portici*, 13(1979), 144–8

122. CONDAMIN, J. and FORMENTI, F., 'Détection du contenu d'amphores antiques (huiles, vin). Etude méthodologique', *Revue d'Archéometrie* (1978), no.2, 43–57

123. LUCAS, A., *Ancient Egyptian Materials and Industries*,

3rd edition, Edward Arnold, London (1948), 27–9

124. DUNKERTON, J., KIRBY, J. and WHITE, R., 'Varnish and early Italian tempera paintings', *Cleaning, Retouching and Coatings. Preprints of the Brussels Congress, 3–7 September 1990*, IIC, London, (1990), 63–9

125. BENSON, G. G., HEMINGWAY, S. R. and LEACH, F. N., 'Composition of the wrappings of an ancient Egyptian mummy', *J. Pharm. Pharmacol.*, 30(1978), 78P

126. GIANNO, R., ERHARDT, D., VON ENDT, D. W., HOPWOOD, W. and BAKER, M. T., 'Archaeological resins from shipwrecks off the coasts of Saipan and Thailand', *MASCA research papers in science and archaeology*, 7(1990), 59–67

127. BECK, C. W., GERVING, M. and WILBUR, E., 'The provenience of archaeological amber artifacts. Part 1, 8th century BC to 1899', *Art Arch. Tech. Abst.*, 6(1966) no.2, 215–302

128. BECK, C. W., GERVING, M. and WILBUR, E., 'The provenience of archaeological amber artifacts. Part 2, 1900 to 1966', *Art Arch. Tech. Abst.*, 6(1967) no.3, 203–73

129. GOUGH, L. J. and MILLS, J. S., 'The composition of succinite (Baltic amber)', *Nature*, 239(1972), 527–8

130. MILLS, J. S., WHITE, R. and GOUGH, L. J., 'The chemical composition of Baltic amber', *Chem. Geol.*, 47(1984/85), 15–39

131. MOSINI, V., FORCELLESE, M. L., NICOLETTI, R., 'Presence and origin of volatile terpenes in succinite', *Phytochemistry*, 19(1980), 679–80

132. BOTTA, M., DE ANGELIS, F., NICOLETTI, R. and TRICARICO, M., 'The role of acid catalysis in the genesis of amber', *Phytochemistry*, 21(1982), 381–4

133. LAMBERT, J. B. and FRYE, J. S., 'Carbon functionalities in amber', *Science*, 217(1982), 55–7

134. LANGENHEIM, J. H., 'Amber: a botanical inquiry', *Science*, 163(1969), 1157–69

135. BECK, C. W., 'Aus der Bernstein-Forschung', *Naturwiss.*, 59(1972), 294–8

136. BECK, C. W., 'Succinum redivivum', *Acta Praehistorica et Archaeologica*, 18(1986), 189–90, and references cited therein

137. LAMBERT, J. B., BECK, C. W. and FRYE, J. S., 'Analysis of European amber by carbon-13 nuclear magnetic resonance spectroscopy', *Archaeometry*, 30(1988), 248–63

138. RALDUGIN, V. A. and PENTEGOVA, V. A., 'Derivatives of anticopalic acid and other new compounds' (in Russian), *Khim. Prirod. Soedinenii*, (1983), 158–63. (*Chem. Nat. Compounds*, 149–54)

139. ROTTLÄNDER, R. C. A., 'Neue Beiträge zur Kenntnis des Bernsteins. 11. u 12. Mitteilung.', *Acta Prehistorica et Archaeologica*, 11/12(1980–81), 21–34, and refs. cited therein

140. ROTTLÄNDER, R. C. A., 'On the formation of amber from *Pinus* resin', *Archaeometry*, 12(1970) no.1, 35–52

141. BECK, C. W., 'Analysis and provenience of Minoan and Mycenaean amber, I', *Greek, Roman and Byzantine Studies*, 7(1966), 191–211

142. BECK, C. W., WILBUR, E., MERET, S., KOSSOVE, D. and KERMANI, K., 'Infrared spectra of amber and the identification of Baltic amber', *Archaeometry*, 8(1965), 96–109

143. LANGENHEIM, J. H. and BECK, C. W., 'Infrared spectra as a means of determining botanical sources of amber', *Science*, 149(1965), 52–5

144. BECK, C. W., 'Authentication and conservation of amber: conflict of interests', *Science and Technology in the Service of Conservation. Preprints of the Washington Congress, 1982*, IIC, London (1982), 104–7

145. BECK, C. W., 'The origin of the amber find on the Moosbühl mountain', *Jahrbuch des Bernischen Historischen Museums*, 63–4(1983–4), 263–6

146. BECK, C. W., GREENLIE, J., DIAMOND, M. P., MAC-CHIARULO, A. M., HANNENBERG, A. A. and HAUCK, M. S., 'The chemical identification of Baltic amber at the Celtic oppidum Staré Hradisko in Moravia', *J. Archaeol. Sci.*, 5(1978), 343–54

147. BECK, C. W., 'Amber from the eneolithic necropolis of Laterza', *Origini*, 5(1971), 301–5

148. FRONDEL, J. W., 'X-ray diffraction study of fossil elemis', *Nature*, 215(1967), 1360–1

149. CABRERA GARRIDO, J. M., 'Les matériaux de peinture de la caverne d'Altamira', *ICOM Committee for Conservation, Report 78/15/3*, 9 pp., 5th Triennial Meeting, Zagreb (1978)

150. MILLS, J. S. and WHITE, R., unpublished work

151. LANGENHEIM, J. H. and BECK, C. W., 'Catalogue of infrared spectra of fossil resins (ambers). I. North and South America', *Botanical Museum Leaflets, Harvard University*, 22(1968), no. 3, 65–120

152. LANGENHEIM, J. H. and BALSER, C. A., 'Botanical origin of resin objects from aboriginal Costa Rica', *Vinculos. Revista de Antropologia del Museo Nacional de Costa Rica*, 1(1975), no. 2, 72–82

153. CUNNINGHAM, A. C., GAY, I. D., OEHLSCHLAGER, A. C. and LANGENHEIM, J. H., '^{13}C NMR and IR Analyses of structure, aging and botanical origin of Dominican and Mexican ambers', *Phytochemistry*, 22(1983), 965–8

154. MUROGA, T., 'The origin of archaeological amber in Japan. An infrared study' (in Japanese), *Archaeology and Natural Science*, 9(1976), 59–64

155. FUJINAGA, T., TAKENAKA, T. and MUROGA, T., 'The origin of the archaeological amber in Japan. Studies by infrared spectra' (in Japanese), *Nippon Kagaku Kaishi (J. Chem. Soc. Japan)*, (1974) no. 9, 1653–7

156. POINAR, G. O. and HAVERKAMP, J., 'Use of pyrolysis mass spectrometry in the identification of amber samples', *J. Baltic Studies*, 16(1985), 210–21

157. CLAVIR, M., 'An initial approach to the stabilization of rubber from archaeological sites and in museum

collections', *J. International Institute for Conservation – Canadian Group*, 7(1982), 3–10

158. ALLINGTON, C., 'The treatment of social history objects made of natural rubber', *Modern Organic Materials: preprints of the Symposium, April 1988*, Scottish Soc. for Conservation, Edinburgh (1988), 123–32

159. MCCORD, M. and DANIELS, V., 'The deterioration and preservation of rubber in museums: a literature review and survey of the British Museum's collections', *Modern Organic Materials: preprints of the Symposium, April 1988*, Scottish Soc. for Conservation, Edinburgh (1988), 133–41

160. KAMINITZ, M., 'Amazonian ethnographic rubber artifacts', *Modern Organic Materials: preprints of the symposium, April 1988*, Scottish Soc. for Conservation, Edinburgh (1988), 143–50

161. BLANK, S., 'Rubber in museums: a conservation problem', *AICCM Bulletin*, 14, 3 & 4(1989), 53–93

162. BLANK, S., 'An introduction to plastics and rubbers in collections', *Stud. Conserv.*, 35(1990), 53–63

163. BOSE, P. K., SANKANARAYANAN, Y. and SEN GUPTA, S. C., *Chemistry of Lac*, Indian Lac Research Institute, Namkum, Ranchi, Bihar, India (1963)

164. BROWN, K. S., 'The chemistry of aphids and scale insects', *Chem. Soc. Reviews*, 4(1975), 263–88

165. COOKSON, R. C., LEWIN, N. and MORRISON, A., 'Shellolic acid and *epi*-shellolic acid', *Tetrahedron*, 18(1962), 547–58

166. COOKSON, R. C., MELERA, A. and MORRISON, A., 'Determination of the stereochemistry of shellolic acid by proton magnetic resonance spectroscopy', *Tetrahedron*, 18(1962), 1321–3

167. YATES, P. and FIELD, G. F., 'Lac – I. The structure of shellolic acid', *Tetrahedron*, 26(1970), 3135–58

168. YATES, P., BURKE, P. M. and FIELD, G. F., 'Lac – II. The stereochemistry of shellolic and epishellolic acids', *Tetrahedron*, 26(1970), 3159–70

169. WADIA, M. S., KHURANA, R. G., MHASKAR, V. V. and SUKH DEV, 'Chemistry of lac resin – I. Lac acids (Part 1): butolic, jalaric and laksholic acids', *Tetrahedron*, 25(1969), 3841–54

170. SINGH, A. N., UPADHYE, A. B., WADIA, M. S., MHASKAR, V. V. and SUKH DEV, 'Chemistry of lac resin – II. Lac acids (Part 2): laccijalaric acid', *Tetrahedron*, 25(1969), 3855–67

171. KHURANA, R. G., SINGH, A. N., UPADHYE, A. B., MHASKAR, V. V. and SUKH DEV, 'Chemistry of lac resin – III. Lac acids (Part 3): an integrated procedure for their isolation from hard resin; chromatographic characteristics and quantitative determination', *Tetrahedron*, 26(1970), 4167–75

172. UPADHYE, A. B., WADIA, M. S., MHASKAR, V. V. and SUKH DEV, 'Chemistry of lac resin – IV. Pure lac resin – 1: isolation and quantitative determination of constituent acids', *Tetrahedron*, 26(1970), 4177–87

173. UPADHYE, A. B., WADIA, M. S., MHASKAR, V. V. and

174. SINGH, A. N., UPADHYE, A. B., MHASKAR, V. V. and SUKH DEV, 'Chemistry of lac resin – V. Pure lac resin – 2: points of linkage of constituent acids', *Tetrahedron*, 26(1970), 4387–96

174. SINGH, A. N., UPADHYE, A. B., MHASKAR, V. V. and SUKH DEV, 'Chemistry of lac resin – VI. Components of soft resin', *Tetrahedron*, 30(1974), 867–74

175. SINGH, A. N., UPADHYE, A. B., MHASKAR, V. V., SUKH DEV, POL, A. V. and NAIK, V. G., 'Chemistry of lac resin – VII. Pure lac resin – 3: structure', *Tetrahedron*, 30(1974), 3689–93

176. VOLLMAN, H., 'Identification of shellac', *J. Oil Colour Chem. Assoc.*, 40(1957), 175–82

177. JENKINS, K. D., '*Aje* or *Ni-in* (The fat of a scale insect). Painting medium and unguent', *Acta y Memorias del XXXV Congreso Internacional de Americanistas*, vol I, Mexico (1962), 625–36

178. PORTELL, J. D., 'Coloured glazes on silver-gilded surfaces', *Conservation of the Iberian and Latin American Cultural Heritage. IIC Congress, Madrid, 1992*, IIC, London (1992),

179. DU, Y., 'The production and use of Chinese raw urushi and the present state of research', *Urushi. Proceedings of the Urushi Study Group, June 10–27 1985, Tokyo*, Ed. N. S. Brommelle and P. Smith, The Getty Conservation Institute, (1988), 189–97

180. DU, Y., OSHIMA, R., IWATSUKI, H. and KUMANOTANI, J., 'High-resolution gas-liquid chromatographic analysis of urushiol of the lac tree *Rhus vernicifera*, without derivatization', *J. Chromatography*, 295(1984), 179–86

181. DU, Y and OSHIMA, R., 'Analysis of long-chain phenols in the sap of the Burmese lac tree, *Melanorrhoea usitate* by capillary gas–liquid chromatography', *J. Chromatography*, 318(1985), 378–83

182. DU, Y., OSHIMA, R., YAMAUCHI, Y., KUMANOTANI, J. and MIYAKOSHI, T., 'Long chain phenols from the Burmese lac tree *Melanorrhoea usitate*', *Phytochemistry*, 25(1986), 2211–18

183. KUMANOTANI, J., ACHIWA, M., OSHIMA, R. and ADACHI, K., 'Attempts to understand Japanese lacquer as a superdurable material', *International Symposium on the Conservation and Restoration of Cultural Property, 1978. Cultural Property and Analytical Chemistry*, Tokyo, (1979), 51–62, and refs. cited therein

184. KUMANOTANI, J., 'The chemistry of oriental lacquer (*Rhus verniciflua*)', *Urushi. Proceedings of the Urushi Study Group, June 10–27 1985, Tokyo*, Ed. N. S. Brommelle and P. Smith, The Getty Conservation Institute, Marina del Rey, California (1988), 243–51

185. OSHIMA, R., YAMAUCHI, Y., WATANABE, C. and KUMANOTANI, J., 'Enzymic oxidative coupling of urushiol in the sap of the lac tree, *Rhus vernicifera*', *J. Org. Chem.*, 50(1985), 2613–21

186. KENJO, T., 'Effect of humidity on the hardening of lacquer', *International Symposium on the Conservation and restoration of Cultural Property, 1977. Conservation of Wood*, Tokyo (1978), 151–63

187. KENJO, T., 'Studies on the analysis of lacquer (part 2). Infrared spectrometry of lacquer films' (in Japanese), *Sci. Papers Jap. Antiques and Art Crafts*, 26(1981), 32–9

188. KENJO, T., 'Infrared absorption spectra of a few natural products similar to Japanese Urushi' (in Japanese), *Science for Conservation*, 21(1982), 47–53

189. TERADA, A., TANOUE, Y. and KISHIMOTO, D., "(−)-(9Z)-1,9-heptadecadiene-4,6-diyn-3-ol as a principal component of the resinous sap of *Evdiopanax innovans* Nakai, Japanese name Takanotsume, and its role in an ancient golden varnish of Japan', *Bull. Chem. Soc. Japan*, 62(1989), 2977–80

190. TYMAN, J. H. P., 'Non-isoprenoid long chain phenols', *Chem. Soc. Reviews*, 8(1979), 499–537

191. KENJO, T., 'Studies on analysis of Japanese lacquer. Part 1. Utilization of the difference in specific gravity' (in Japanese), *Science for Conservation*, 17(1978), 6–10

192. DERRICK, M., DRUZIK, C. and PREUSSER, F., 'FTIR analysis of authentic and simulated black lacquer finishes on 18th century furniture', *Urushi. Proceedings of the Urushi Study Group, June 10–27, 1985, Tokyo*, The Getty Conservation Institute, Marina del Rey, California (1988), 227–34

193. BURMESTER, A., 'Far Eastern lacquers: classification by pyrolysis mass spectrometry', *Archaeometry*, 25(1983) no. 1, 45–58

Bibliography

BARRY, T. H., *Natural Varnish Resins*, Ernest Benn, London, (1932)

BROMMELLE, N. S. and SMITH, P. (Editors), *Urushi. Proceedings of the Urushi Study Group*, June 10–27 1985, Tokyo, The Getty Conservation Institute, Marina del Rey, California (1988)

DE MAYO, P., *Mono- and Sesquiterpenoids*, Interscience, New York (1959)

DE MAYO, P., *The Higher Terpenoids*, Interscience, New York (1959)

DERFER, J. M. and DERFER, M. M., 'Terpenoids', in *Kirk-Othmer Encyclopedia of Chemical Technology*, 3rd edition, John Wiley and Sons, New York, vol. 22, 709–62

GILDERMEISTER, E. and HOFFMANN, FR., *Die Ätherischen Öle*, edited by W. Treibs, 4th edition, 7 vols., Akademie-Verlag, Berlin (1956–61)

GUENTHER, E., *The Essential Oils*, 6 vols., Van Nostrand, New York, (1949–52)

HOWES, F. N., *Vegetable Gums and Resins*, Chronica Botanica Co., Waltham, Mass. (1949)

LARSSON, S. G., *Baltic Amber – a Palaeobiological Study*, Scandinavian Science Press, Entomonograph vol. 1 (1978)

LAURIE, A. P., *Materials of the Painters' Craft*, T. N. Foulis, London and Edinburgh (1910)

MARTINEZ-CORTES, F., *Pegamentos, Gomas y Resinas en el México Prehispanico*, Resistol S. A. , Mexico (1970)

MASADA, Y., *Analysis of Essential Oils by Gas Chromatography and Mass Spectrometry*, John Wiley and Sons, New York (1976)

NEWMAN, A. A. (Editor), *Chemistry of Terpenes and Terpenoids*, Academic Press, London and New York (1972)

RICE, P. C., *Amber – the Golden Gem of the Ages*, Van Nostrand Reinhold Co., New York (1980)

SANDERMANN, W., *Naturharze, Terpentinöl, Tallöll*, Springer-Verlag, Berlin, (1960)

SIMONSEN, J. L., *The Terpenes*, 2nd edition, revised, 5 vols., Cambridge University Press, Cambridge, (1947–57)

TSCHIRCH, A. and STOCK, E., *Die Harze*, Borntraeger, Berlin (1933–36)

WAKE, W. C., TIDD, B. K. and LOADMAN, M. J. R., *Analysis of Rubber and Rubber-like Polymers*, 3rd edition, Applied Science Publishers, London and New York (1983)

9

Synthetic materials

Several semisynthetic materials, that is to say modified natural materials, have already been discussed earlier, among them cellulose derivatives (6.4) and modified rubber (8.5.2). Yet to come are the alkyd resins, which sometimes incorporate drying oils.

However, the main subject of this chapter is the high molecular weight polymers of a wholly synthetic nature, most of which have been discovered and developed in the last fifty years. They can thus constitute the raw material only of relatively modern artefacts, a minor though increasingly important part of museum collections. More significant, probably, is their extensive use in display and packing, the construction or decorating of museums themselves and, above all, their use in conservation practice. Their chemical compositions are therefore discussed here though this can only be an outline of what is an extensive field.

Since the first edition of this book a number of surveys have appeared of the introduction of modern synthetic materials and their significance in museum collections[1-3]. Discussion of some aspects of chemical change in polymers will be found in Chapter 11 but coverage of their physical properties and an extended account of their applications in conservation belong elsewhere.

9.1 Kinds of polymer

The concept of a polymeric or macromolecule – a large molecule formed by linking together many small molecules (monomers) with normal covalent bonds – has already been encountered earlier since many natural materials are comprised of molecules of this type.

Some of the natural polymers, the proteins for example, are made up of a number of monomers combined together in different but regular arrangements to result in different polymers. Others, such as cellulose and rubber, are made up from single monomers combined together in a very regular way. Most synthetic polymers are formed from single monomers or by the co-polymerization of rarely more than two different monomers.

There are two main subdivisions of high molecular weight polymers: those formed from monomers containing double bonds by addition polymerization (usually by a free radical reaction), nothing being eliminated in the process, and those formed by condensation reactions (ionic reactions), in which something – usually water – is eliminated. For a molecule to be able to polymerize it must be at least *bifunctional*, the concept of functionality here being slightly expanded from that earlier employed in the term *functional group* since a double bond is effectively bifunctional in addition polymerization (see below).

Polymerization of a bifunctional monomer results in a *linear* polymer, in which the monomer units are linked together to form a long chain, thus:

$$M-M-M\ldots M-M-M \quad \text{or} \quad M-(M)_n-M$$

where M is the monomer and $n+2$ is the degree of polymerization or number of monomer units in the molecule. In the case of a co-polymer of bifunctional monomers A and B then the product is normally a polymer with a random arrangement of

the two, not a mixture of the pure polymers of A and of B:

$$A - A - B - A - B - B - A - \text{ etc.}$$

When the functionality of the monomer, or of one of the monomers in a co-polymer, is more than two then *non-linear* or *branched* structures become possible. Thus if B is a trifunctional molecule its co-polymer with a bifunctional A can have a structure like the following:

$$A - A - A - \dots$$
$$|$$
$$A - A - A - B - A - A - A - B - A - A - \dots$$
$$|$$
$$A - A - A - B - A - A - A - \dots$$
$$|$$
$$\dots - A - A - A - B - A - A - A - \dots \text{ etc.}$$

Such structures, which can be highly ramified, can arise in three ways:

1. by deliberate intention in the initial polymerization reaction, as for example in the preparation of alkyd resins (see below);

2. as a deliberate modification of existing linear polymers by the formation of *cross-links*;

3. in the unintended cross-linking of polymers through autoxidative reactions.

An example of the second type which we have already met with (8.5.2) is the 'vulcanization' of rubber, in which the linear rubber molecules are linked together with occasional sulphur cross-links, while the third may be exemplified by the progressive insolubilization which results from the cross-linking of certain of the linear methacrylate polymers (see below).

When the cross-links are few then the resulting structure may be only slightly branched and may yet remain solvent-soluble. In highly cross-linked structures a network may be formed in which there is essentially one giant molecule which can only be swollen, not dissolved, with an appropriate solvent.

9.2 Vinyl polymers

The polymerization of vinyl compounds appears to have been observed quite early; about 1835 in the case of vinyl chloride. However, the products were not developed until this century, the first seemingly being polyvinyl acetate, which was put into production in Germany and in Canada in 1917.

The subject of free radical chain reactions has already been broached in connection with the drying of drying oils (3.4.1). In the case of these, oxygen in the air plays a role and the product can be thought of as a co-polymer of the drying oil components and oxygen. In the polymerization of vinyl monomers to form useful polymers oxygen is excluded as far as possible so that only carbon–carbon bonds are formed.

Polymerization of vinyl groups is initiated by a free radical initiator, I^\cdot, which may add to a substituted vinyl group in two possible ways:

$$I^\cdot + CH_2{=}CHR \Bigg\langle \begin{array}{l} \overset{\displaystyle R}{\overset{|}{I - CH_2 - C^\cdot H}} \\[2mm] \underset{\displaystyle I - CH - C^\cdot H_2}{\overset{R}{\overset{|}{}}} \end{array}$$

If R=H (as with ethylene), then the two products are the same, but when it is anything else formation of the radical on the more substituted carbon normally predominates. This radical may then in turn attack a second vinyl molecule, again in the same two possible ways:

$$I{-}CH_2{-}C^\cdot H + CH_2{=}CHR \Bigg\langle \begin{array}{l} \overset{R\qquad\; R}{\overset{|\qquad\;\;|}{I - CH_2 - CH - CH_2 - C^\cdot H}} \\[2mm] \overset{R\quad\;\; R}{\overset{|\qquad|}{I - CH_2 - CH - CH - C^\cdot H_2}} \end{array}$$

Again the preferred addition is the one yielding the more substituted radical, so-called *head-to-tail* addition. Addition to further molecules then occurs in the same way until the chain reaction is terminated:

$$I{-}CH_2{-}\overset{\overset{\displaystyle R}{|}}{CH}{-}(CH_2{-}\overset{\overset{\displaystyle R}{|}}{CH})_n{-}CH_2{-}\overset{\overset{\displaystyle R}{|}}{C^\cdot H} + T^\cdot \longrightarrow$$

$$ICH_2CH(CH_2{-}\overset{\overset{\displaystyle R}{|}}{CH})_n CH_2{-}\overset{\overset{\displaystyle R}{|}}{CH}T$$

The terminator, T^\cdot, may be of several kinds. It may simply be a second polymer radical; it may be a hydrogen atom abstracted from another molecule; or it may be any one of a number of adventitious materials which might happen to be present, including oxygen (which would lead initially to formation of a hydroperoxide and possible further reaction). These various possibilities need not concern us here. In any case in practice the

polymers formed are the result of linking hundreds or thousands of monomer units to give very long chains and the proportion of extraneous terminator groups (as also of initiator groups) must therefore be very low.

The group R may be very varied. For example, if it is hydrogen then the monomer is simply ethylene and the polymer is polyethylene, commonly known (in the UK) as polythene; if it is $-OCOCH_3$ (acetate) then the product is polyvinyl acetate. This is sometimes, perhaps more correctly, written poly(vinyl acetate) but this convention will not be followed here since in practice no confusion arises from omitting the parentheses.

The polymerization of the monomer may be effected as the pure liquid; in solution; or suspended or emulsified in water. The first method results in solid polymer, usually of relatively low molecular weight. The heat evolved makes it difficult to control and it is not normally employed for the commercial preparation of polymers. The procedure is however of importance for polymerization *in situ* for purposes of impregnation of stone, wood etc.[4,5].

Polymerization in solution also has its limitations since polymer solutions become extremely viscous even at quite low concentrations. Polymerization in suspension or emulsion has considerable advantages in that the product can have a high solids content (as much as 50%) and yet remain workably fluid; polymerization is rapid and, surprisingly, considerably higher average molecular weights can be achieved than in the case of solution polymerization. If required, the polymer can be coagulated to a solid but more commonly the polymer emulsion finds uses as it is.

In order to form the initial emulsion and effect the polymerization a number of additives are called for and it must be remembered that these (or their transformation products) remain in the emulsion and consequently form part of any film or adhesive bond formed when it dries – a potential source of weakness and deterioration. A typical formulation for an emulsion for polymerization would be:

monomer	100 parts
water	180 parts
fatty acid soap	2–5 parts
potassium persulphate (initiator)	0.1–0.5 parts

Many other emulsification agents and initiators are also used.

9.2.1 Polyethylene and other hydrocarbon polymers

The simplest polymer of this group, though not the easiest to make, is that formed by polymerization of ethylene. This was found to take place under high pressure at temperatures up to 2000°C and production was first carried out in the early 1940s. Later, low pressure processes employing special catalysts were developed.

Commercial polyethylenes come in a wide range of possible degrees of polymerization. The less-polymerized materials, the polyethylene waxes, are of 70–700 units per molecule, while plastics are usually 1500–7000 but can be up to 200 000. As a saturated hydrocarbon, polyethylene is chemically very inert and resistant to polar solvents, especially water. This accounts for its overwhelming popularity for the production of utensils and containers of all kinds, including the ubiquitous polyethylene bags employed for short-term packaging.

It should be noted that the film used for these usually incorporates a plasticizer, commonly a phthalate ester, which in time exudes to the surface with resulting sticky feel. Phthalate esters have been found as common contaminants in samples stored in plastic bags.

Analogous polymers are also made from homologues of ethylene, notably propylene. The resulting material, like polyethylene, is now utilized, by extrusion, blow moulding and injection moulding, for the manufacture of an endless variety of objects. Any future museum of twentieth century objects will be filled with it, but that time is not yet.

$$CH\!=\!CH_2$$

styrene

The aromatic hydrocarbon styrene, in which one hydrogen of the ethylene molecule is substituted by phenyl, was isolated from the natural resin storax (8.3.5) in 1831 and its polymerization to a solid observed shortly thereafter.

Commercial development dates from the 1930s though large amounts were produced only after the Second World War. It is used in similar ways to the polyethylenes but is perhaps most familiar as polystyrene foam, used for insulation, wall and ceiling tiles, and as a shock-absorbing filler in packaging. Many co-polymers of styrene with other vinyl monomers are also produced, as physical properties can be modified thereby.

9.2.2 Polyvinyl acetate

Vinyl acetate, $CH_2 = CHOCOCH_3$, is a liquid b.p. 73°C. It is the acetate of the enol form of acetaldehyde, which alcohol does not itself exist in bulk, as the equilibrium is in favour of the aldehyde:

$$CH_3CHO \quad \longleftrightarrow \quad CH_2{=}CHOH$$

acetaldehyde vinyl alcohol

(aldo form) (enol form)

It very readily polymerizes, both in the presence of radical initiators and also under the influence of ultraviolet light. This is often carried out in emulsion medium to produce the familiar milky aqueous suspension much used as an adhesive and as the medium of many domestic emulsion paints.

Polyvinyl acetate is also available as the solid polymer in a number of different molecular weight ranges, which determine its physical properties. It was one of the first synthetic materials to be used in conservation, being already available in the 1930s, and it found application in applying facings to oriental wall paintings prior to transfer[6] and in other ways[7].

Despite its stability it has not found great favour as a varnish resin, in part because it needs to be dissolved in toluene or similar slightly polar solvent (which could affect retouchings carried out in varnish medium). It is also soluble in ethanol containing a small proportion of water. The physical properties required of a varnish resin, which determine the selection of the molecular weight grade of a particular polymer, have been discussed[8,9].

9.2.3 Polyvinyl alcohol

As mentioned above, vinyl alcohol does not exist as a pure compound and consequently polyvinyl alcohol is made by hydrolysis (or partial hydrolysis) of polyvinyl acetate. This being so, the degree of polymerization of polyvinyl alcohol is that of the material from which it is made, while the average molecular weight is about half since about half is lost, as acetate, on hydrolysis.

Polyvinyl alcohol is soluble in water and the solution finds uses where a water-soluble adhesive is called for. It is also used as a size for textiles. It can however cross-link to some extent by the formation of ether groups from two hydroxyls but the resulting polymer is still readily swellable and removable with water.

Polyvinyl alcohol forms a film which has exceptionally low permeability to oxygen. In consequence of this it was once suggested[10] that it might prove valuable as a varnish on top of the more conventional varnish on paintings since it would perform the dual function of protecting this lower film from oxidation while being itself readily removable (together with attached dirt) and renewable. This seems not to have been developed as a practical procedure, however.

Further derivatives of polyvinyl alcohol are polyvinyl formal, acetal, and butyral. They are formed by reacting it with formaldehyde, acetaldehyde, or butyraldehyde respectively to give materials of general structure

$$-CH_2-\overset{\displaystyle CH_2}{\underset{\displaystyle O}{\overset{|}{CH}}}\underset{\displaystyle \underset{\displaystyle \underset{R}{|}}{\underset{CH}{O}}}{\overset{|}{CH}}-$$

with $R = H$, CH_3, or C_3H_7

9.2.4 Polyacrylates

These are derived from acrylic and methacrylic acids

$$CH_2 = CHCOOH \qquad CH_2 = C(CH_3)COOH$$

acrylic acid methacrylic acid

The polyacids themselves are of relatively little importance. It is the polymers formed from the various esters, and co-polymers formed from mixtures of such monomers, which have become valuable as perfectly white transparent plastics and varnish materials.

The lower esters of the methacrylates are the hardest and most rigid, the materials becoming more waxy as the series is ascended. Thus polymethyl methacrylate (known as Perspex in the UK) is valuable in sheet form for windows, light fittings, showcases etc. where a relatively non-breakable, glass-like material is needed.

Some of the acrylic co-polymers have proved themselves to be stable, non-yellowing, non-cross-linking resins of value in conservation practice as varnishes and retouching media. One such is Paraloid B-72, a co-polymer of methyl acrylate and ethyl methacrylate[8,11].

As with polyvinyl acetate a partial drawback to

use of this material as a varnish resin is the fact that it is not soluble in petroleum- or white spirit-type solvents alone but needs a high proportion of aromatics such as toluene. An acrylic co-polymer which is petroleum-soluble, but not quite so resistant to cross-linking, is Paraloid B-67.

Another disadvantage of polyacrylates as varnish resins is that the optical properties of the films are thought by some to be less satisfactory than those of the low molecular weight natural resins or the cyclohexanone resins (see below, 9.3.6). This is said to be due to their relatively low refractive index. A co-polymer of phenyl acrylate and methyl methacrylate has been prepared and is said to be superior in this regard[12].

Interest in the use of polyacrylates as varnish resins arose as early as the 1950s and the then available materials, such as the polymers from *iso*-amyl methacrylate (sometimes known as 27H) and *n*-butyl methacrylate, were in fact often applied to paintings after restoration. It was also found in the 1950s that these materials could cross-link, especially under the influence of light, and so become progressively more difficult to remove with solvents. In a recent study[13] of paintings varnished with these materials it was found that the first type was removable with relatively mild solvents (though often by swelling rather than dissolution) while the *n*-butyl methacrylate varnishes sometimes needed solvents as polar as acetone. This is of particular concern when possibly vulnerable nineteenth century paintings are in question, especially as the degree of insolubility is likely to increase. The variable effects of different white pigments and extenders on the cross-linking and insolubilization of poly-*n*-butyl methacrylate used as a retouching medium has been investigated[14].

Acrylic emulsions have, like polyvinyl acetate, become a popular medium for domestic paints and these materials have even been found used on Australian aboriginal painted objects[15]. A butyl acrylate methyl methacrylate co-polymer (as well as PVA) was identified as the paint medium of several such objects which had become seriously mould-infested.

The so-called superglues are cyanoacrylates, e.g. methyl cyanoacrylate, $CH_2 = C(CN)COOCH_3$. Such monomers polymerize with extraordinary ease on surfaces of mildly basic reaction or which carry a film of water. The bond formed is hardened up to about 80°C but its strength is impaired at temperatures much above that. These materials have not so far found a use in conservation.

9.2.5 Polyvinyl chloride

After an early discovery this material, well known as PVC, was developed in the 1930s. It is now very extensively used as a rigid material for pipes, ducts and structural items. The plasticized material is likewise used for hosepipes, sheets, tarpaulins, protective clothing and upholstery covering, and in floor 'tiles' and other coverings which have replaced linoleum.

Polyvinyl chloride is not very stable on its own, being decomposed by both light and moderate heat with formation of hydrogen chloride, perhaps by a chain reaction. This is partly prevented, or at least slowed down, by incorporating basic compounds which act as scavengers for the HCl, for example basic lead carbonate. However, because of this possibility of liberating acids, PVC is not considered a suitable material for use in the museum, either in display or in conservation practice.

9.2.6 Polytetrafluoroethylene

This material, well known under the name Teflon, results from the polymerization of tetrafluoroethylene, $CF_2 = CF_2$ and is the fully fluorine-substituted version of polyethylene.

Its great value lies in its extreme stability and resistance to chemical attack, in addition to its well-known 'non-stick' properties, yet it has so far found few uses in conservation practice, perhaps largely owing to its insolubility.

9.2.7 Polyethylene oxide (polyethylene glycols)

Ethylene oxide can be induced to polymerize by treatment with acids or alkalis, free radicals being without effect. The product, which can have molecular weights ranging from about 1000 to 10 000, is a polyether with a hydroxyl group at the end of the chain, the unit being $-CH_2-CH_2-O-$.

These are water-soluble materials whose most familiar use in conservation is in impregnating and stabilizing waterlogged wood[16,17] and other water-degraded organic materials such as leather[18]. Its use for these purposes has however been questioned since it is not a stable material, partly depolymerizing at quite low temperatures[19].

9.2.8 Poly-*p*-xylylenes (Parylene)

This is a type of hydrocarbon polymer, produced *in situ*, which has been known for some thirty years and has very important industrial applications[20], but has only recently found some experimental applications in the field of conservation[21-4]. The solid dimer of para-xylylene evaporates at 160°C in a light vacuum (*c.* 0.1 Torr) and if the vapour is subjected to pyrolysis at about 680°C it splits to the monomeric diradical, which is in equilibrium with para-xylylene itself:

The monomer readily diffuses into material placed within the vacuum chamber and polymerizes as soon as it condenses on solids. This occurs not just on the surface of the object, but so as to coat its individual elements, such as paper or textile fibres. The structure of the polymer, Parylene, is

This basic material is known as Parylene N and there is also a chloro-substituted material known as Parylene C. These polymers are colourless, insoluble and very resistant to chemical attack. As the impregnation of the substrate with the polymer is carried out at room temperature and without solvents, virtually no stress is placed upon it and consequently very deteriorated and fragile materials may be treated. Thus paper and books[21,22], a large variety of natural history samples and fragile archaeological and ethnographic specimens[23] have all been impregnated with virtually no change in appearance and greatly increased strength, so that they may be freely handled.

Studies of the thermal ageing[24] indicate very long useful lifetimes for both polymer types (in the absence of light), namely 2200 years for N and 130 000 years for C.

9.3 Condensation polymers

9.3.1 Alkyd resins

This class of materials resembles, and is sometimes partly made from, drying oil. An alkyd consists of an ester formed from a polyfunctional alcohol and a polyfunctional acid, the sum of the functionalities from the two components being a minimum of five, i.e. a trihydric alcohol with a dicarboxylic acid or vice versa.

The alcohols which may be employed include ethylene glycol, CH_2OHCH_2OH, glycerol, and pentaerythritol. The dibasic acids commonly include phthalic acid and its isomers.

The product can be further modified by incorporation of drying oil fatty acids, this being usually effected simply by addition of drying oils at an elevated temperature so that trans-esterification occurs, i.e. an exchange of the acid moiety of the esters between the alkyd esters and the triglycerides.

These products are known as oil-modified alkyds, and they are further categorized as short-, medium- or long-oil alkyds (35–45, 46–55, and 56 to >70% oil in the final resin).

Clearly a dihydric alcohol and a dicarboxylic acid are sufficient to allow the formation of a linear polymer: when either of these components becomes trifunctional then cross-linking is possible. An alkyd is thus polymeric to start with, and indeed care has to be taken in their manufacture that cross-linking does not result in gelling and a completely insoluble product.

With the incorporation of unsaturated drying oil fatty acids there is the potential for further cross-linking by the usual free radical drying mechanism. The overall result is a very highly cross-linked and insoluble network.

Alkyds were developed from around 1930 and later became an important and versatile medium for house paints of all kinds, both for interior and exterior use. They have also been used for varnishes for woodwork, probably substituting for the older copal-oil varnishes. Such varnishes are occasionally encountered by restorers on paintings.

Using gas chromatography, several tough, insoluble varnishes have been identified as being of this type, by the presence of phthalic acid among the saponification products[25]. Such a varnish film is even less soluble than the dried oil of a normal paint medium and is consequently virtually irremovable without damage to the paint.

In recent years artists' paints employing an alkyd medium have been marketed. Clearly here the increased insolubility of the dried paint can only be an advantage. At the same time such paints should never be employed in paintings conservation since they become irremovable.

9.3.2 Other polyesters

The important fibre-forming polyester known under the trade names Terylene, Dacron etc., is a linear polymer formed from ethylene glycol and terephthalic acid with the following repeat unit:

In addition to its use as a fibre for textiles etc., polyethylene terephthalate is used in film form in many applications, including magnetic recording tape and as a cinema film base.

Polycarbonates are a plastic of recent origin (since the 1950s) important for making objects with strength and rigidity. One of the commonest has the following repeat unit:

9.3.3 Polyamides

These polymers, best known under the name nylon, may be thought of as a synthetic equivalent of proteins. The first type results from the self condensation of ω-amino acids, that is to say amino acids with the amino and carboxylic acid groups at opposite ends of the methylene chain, or by polymerization of the cyclic amides of these which are known as lactams.

$$H_2N(CH_2)_nCOOH$$

$$-[NH(CH_2)_nCO]-$$

$$\begin{array}{c} HN \\ |\ \ \ \ \ \ \diagdown \\ |\ \ \ \ \ \ \ \ (CH_2)_n \\ OC \diagup \end{array}$$

Nylon 6 (n = 5)

A second type of polyamide results from condensation of diamines with dicarboxylic acids:

$$H_2N(CH_2)_nNH_2 + HOOC(CH_2)_mCOOH$$

$$-[HN(CH_2)_nNHCO(CH_2)_mCO]-$$

Nylon 6.6 (n = 6, m = 4)

As may be seen, different polymers can result from different values of n and m in the above formulae. In the first type n=5 for nylon 6, and 10 for nylon 11. For the second type n=6, m=4 for nylon 6.6; n=6, m=8 for nylon 6.10.

Nylons are most familiar for their use as fibres in the manufacture of textiles. Only the higher molecular weight materials (>10 000) give useful fibres, e.g. nylons 6 and 6.6. The non-fibrous types are good electrical insulators and also find uses for low-friction bearings, gears, joints etc.

Unmodified nylons form densely-packed, crystalline units, the long polymer chains being held together by hydrogen bonding between the amide hydrogen and the carbonyl group oxygen. They are consequently very insoluble but this property can be modified by derivatizing the amide group, which diminishes the hydrogen bonding. Such a derivative is useful industrially since it is unstable, reverting on treatment with mild aqueous acids to a highly insoluble product, consisting of both the original unmodified nylon and a cross-linked material formed by a condensation reaction between adjacent polymer chains.

One such soluble nylon with the amide hydrogen partially substituted, predominantly by a methoxymethyl group ($-CH_2OCH_3$), known by the trade name Calaton was extensively used in conservation work for a variety of purposes, seemingly without these reactions having been adequately taken into account. It was soon found that insolubilization did indeed occur, even in very mildly acidic water. Thus material used to fix paint on Egyptian stonework, prior to a lengthy aqueous desalting procedure,

became brown and almost irremovable after two years[26]. It was suggested that its use should be discontinued and further work, involving both practical testing[27] and a careful study of mechanism and kinetics[28], has further strengthened this warning. A study of the photochemical ageing of Calaton CA has suggested alternative insolubilization routes, and also indicated that these can be greatly slowed down by incorporating standard antioxidants[29].

9.3.4 Epoxy resins

These are well known as adhesives formed from two parts: the intermediate resin and the curing agent or hardener. When these are mixed cross-linking ensues and proceeds to completion in a few hours at normal temperatures or much more quickly at elevated ones. Each of these two components can be of very varied chemical composition but an essential of the intermediate resin is an epoxide group, that is to say a three-membered ring cyclic ether. A common intermediate is formed by reaction of epichlorhydrin (1-chloro-2,3-epoxypropane) with the bisphenol diphenylolpropane $(HOC_6H_4C(CH_3)_2C_6H_4OH)$, and is shown as Structure 9.1, where n ranges from 0 to 15.

Unfortunately these resins can yellow, both by thermal reactions in the dark and photochemically, and studies have been carried out to determine which are the most acceptable from this point of view[30-32].

9.3.5 Phenol-formaldehyde resins

These were the earliest synthetic resins to be brought into commercial production, having been developed by Baekeland in the first decade of this century. Both soluble varnish resins and thermosetting resins for making mouldings could be produced, depending on the phenol/formaldehyde ratio.

Phenols react with formaldehyde both by addition and by condensation with elimination of water:

Structure 9.1

Structure 9.2

In a study of fifty-five epoxy resin formulations this material was the resin component in all but one of them[30].

Such materials will 'cure' by reaction with several types of reagent but the commonest are amines, as in Structure 9.2.

Epoxy resins have come to be of enormous commercial importance and can be employed in the fabrication of large structures including buildings and bridges. In conservation work they are of particular value for glass repair as they are sufficiently polar to form a good and durable adhesive bond with this material and they have the right refractive index.

The condensation product is, of course, still a phenol and can continue to react in similar ways. The addition reaction is favoured in the presence of excess formaldehyde and the product is a mixture of fairly low molecular weight products containing the hydroxymethylene or methylol grouping known as a *Resol* or *A stage resin*.

The products formed under conditions of excess phenol tend to be condensation products with few methylol groups. These are known as *Novolacs*. Both types of material will cross-link and harden further on heating though the Novolacs require the addition of further formaldehyde-donating material as a hardening agent.

These resins have been used as baking enamels (often for coating iron) and, both with and without fillers, for making moulded objects and fittings of many kinds, especially during the first half of this century. Such uses have included the imitation of natural materials such as amber and tortoiseshell. Bakelite resins are commonly of dark yellow, amber or brown colours, probably owing to the formation of quinone methide structures by elimination of water from the methylol groups:

Phenol–formaldehyde resins were used by Van Meegeren in his notorious faked 'Vermeers' and 'Pieter de Hooghs', in order to produce an insoluble paint film. They were positively identified in samples from these using pyrolysis gas chromatography[33]. Characteristic pyrolysis products of such resins, such as phenol and the various methyl- and dimethylphenols, were detected.

9.3.6 Cyclohexanone resins

A range of low molecular weight resins can be made from ketones, particularly cyclohexanone and its methyl-substituted derivatives. While not of great commercial importance, these have been very much used in recent years in varnishes for paintings because their properties are similar to, but in many ways an improvement on, those of the natural resins dammar and mastic[34].

Unfortunately their chemistry is not altogether clear, for a number of reasons. Firstly they are proprietary resins, methods of manufacture of which are not readily accessible and may indeed vary from time to time. Secondly their structures are not known precisely and may, indeed, vary considerably depending on the exact conditions of manufacture. An attempt is made here to clarify their chemistry and history of use. A more extended account, with references to the early work on their chemistry is to be found in a recent paper[35].

Cyclohexanone can be converted to low molecular weight polymer in two ways: by treatment with methanolic alkali either alone or in the presence of added formaldehyde. The difference in the product is not as clear-cut as this might suggest since formaldehyde is also produced *in situ* in the first case. The resins which have been used in conserva-

tion practice seem to have been of the first type and discussion will be centred on these.

The structure of the product formed by direct reaction of cyclohexanone molecules with one another (resulting from aldol condensation) may be as follows:

Early studies indicated that these compounds could be easily dehydrated, the tertiary hydroxyl group being lost to give a double bond. NMR studies however failed to indicate the presence of a significant number of vinyl protons[35].

The above structure cannot, in any case, represent the exclusive mode of reaction since according to one report[36] a typical product (comprising six units) possessed one carbonyl, one methoxy, one other ether group, and three hydroxyl groups. The key to the formation of some of these other groupings lies in the fact that ketones and alcohols can undergo hydrogen exchange in the presence of alkali, the ketone oxidizing the alcohol[37]. This is the well known Oppenauer oxidation, often made use of in organic synthesis. In the present case the reaction is

The formaldehyde can then react with cyclohexanone by addition, followed by condensation etc.

Such oligomers can themselves oxidize further methanol to formaldehyde, being themselves partly reduced to yield secondary hydroxyl groups. Ether formation between two methylol groups can also occur[38]. A theoretical molecule in which all the above reactions had played a part could therefore have Structure 9.3.

Structure 9.3

Such a structure has primary and secondary hydroxyls (readily acetylatable) and tertiary hydroxyls (not readily acetylatable) in accord with what is found by experiment.

The well known product AW2 (BASF), which was the basis of many proprietary picture varnishes, has been stated to be of this type[39,40] and its infrared spectrum is in accord with this. AW2 is said to have been a co-polymer of cyclohexanone with methylcyclohexanone, the latter possibly as a mixture of all three of its isomers (the methyl group can be ortho, meta, or para to the carbonyl group) though probably low in the ortho isomer.

An infrared band at about $1380\,cm^{-1}$ is probably due to the presence of such methyl groups. The resin which replaced AW2, Ketone Resin N, has a similar infrared spectrum but with a diminished, or absent, band at *c.* $1380\,cm^{-1}$, suggesting that it is made from cyclohexanone alone.

In the 1950s a resin known as MS2 was made by Howards of Ilford in England and was supposedly a product resembling AW2 made under license. At the suggestion of G. Thomson, Scientific Adviser at The National Gallery, London, Howards produced a fully reduced resin in which carbonyl groups had been converted to hydroxyl groups by reduction with sodium borohydride. The expectation that this product – MS2A – would be more stable to light-induced oxidation than the original material containing ketone groups was fully realized, and although tending to be somewhat brittle and easily scratched it became with many restorers a preferred material for a final varnish on cleaned paintings.

The methylcyclohexanones used in the manufacture of the starting material for MS2A (MS2) were originally made by processing a mixture of cresols (i.e. methylphenols) but in 1963 a decision was made by the manufacturers to use cyclohexanone alone rather than together with this mixture of methylcyclohexanones to make what was still called MS2. It was then found that reduction of this new material gave an 'MS2A' which was uselessly brittle.

For some years Howards then produced another material, known as MS2B, using AW2 as the starting material for reduction. This was fully as satisfactory as MS2A as a varnish but in turn had to cease production when AW2 was replaced by Ketone Resin N. This latter material, like the modified MS2, also gave a uselessly brittle material on reduction, which tends to confirm the infrared indications that it is likewise a cyclohexanone rather than a methylcyclohexanone resin.

Recently interest has revived in preparing modified resins from starting materials of this kind. Although produced by a different process, the resin Laropal K 80 (BASF) is apparently chemically indistinguishable from Ketone Resin N, and a fully reduced resin has been prepared from this[35]. This too was extremely brittle, and a variety of modified materials was made by partial esterification of the hydroxyl groups in the expectation that this would result in a degree of internal plastification. Long chain esters, such as the stearate, were excessively soft but the propionates made with different amounts of propionic anhydride were found to be usefully less brittle as well as significantly slower to autoxidize and diminish in solubility.

9.4 Other synthetic varnish resins

Two other types of resins have been tested as experimental picture varnishes: so-called *hydrocarbon resins* and *aldehyde resins*[41]. The first type consists of hydrocarbon oligomers; the second is formed by condensation of aldehydes with urea to give products of uncertain structure. Particular types were found to be very promising, especially when stabilized with HALS-type antioxidants. Their appearance, moreover, compared favourably with that of natural resin varnishes[42].

9.5 Analysis of synthetic resins

Because of their simpler composition and their greater resistance to oxidative change, synthetic materials are mostly easier to identify than natural ones. Very often infrared spectroscopy alone will

serve for the purpose if there is sufficient sample available. Otherwise pyrolysis gas chromatography (2.1.5) has proved a very satisfactory method.

Use of these techniques has served to identify the nature of a number of commercial varnishes for paintings, as well as synthetic painting media, as being various types of polyacrylics, vinylics or ketone resins[43]. In some instances the method also served to detect any plasticizer, such as dibutyl phthalate, which might have been included in the formulation.

References

1. HILLMAN, D., 'A short history of early consumer plastics', *J. IIC – Canadian Group*, 10–11(1985–6), 20–7

2. LODGE, R. G., 'A history of synthetic painting materials with special reference to commercial materials', *American Institute for Conservation, Preprints of the sixteenth annual meeting, New Orleans, 1988*, AIC, Washington (1988), 118–27

3. BLANK, S., 'An introduction to plastics and rubbers in collections', *Stud. Conserv.*, 35(1990), 53–63

4. ŠIMŮNKOVÁ, E., ŠMEJKALOVÁ, Z. and ZELINGER, J., '*Consolidation of wood by the method of monomer polymerization* in the object', *Stud. Conserv.*, 28(1983), 133–44

5. AMOROSO, G. G. and FASSINA, V., *Stone Decay and Conservation*, Elsevier, Amsterdam (1983)

6. STOUT, G. L. and GETTENS, R. J., 'Transport des fresques orientales sur de nouveau supports', *Mousseion*, 17/18(1932), 107–12

7. GETTENS, R. J., 'Polymerized vinyl acetate and related compounds in the restoration of objects of art', *Technical Studies in the Field of the Fine Arts*, 4(1935/6), 15–27

8. FELLER, R. L., 'New solvent-type varnishes' in *Recent Advances in Conservation*, edited by G. Thomson, Butterworths, London (1963), 171–5

9. FELLER, R. L., JONES, E. H. and STOLOW, N., *On Picture Varnishes and their Solvents*, 2nd edition, Case Western University Press, Cleveland (1971)

10. THOMSON, G., 'New Picture Varnishes', in *Recent Advances in Conservation*, edited by G. Thomson, Butterworths, London (1963), 176–84

11. FELLER, R. L., 'Thermoplastic polymers currently in use as protective coatings and potential directions for further research', in *Conservation: The Art, the Craft and the Science*, ICCM, Brisbane (1983), 5–18

12. DE WITTE, E., GOESSENS-LANDRIE, M., GOETHALS, E. J., VAN LERBERGHE, K. and VAN SPRINGEL, C., 'Synthesis of an acrylic varnish with high refractive index', *ICOM Committee for Conservation Report 81/16/4*, 6th Triennial Meeting, Ottawa (1981)

13. LOMAX, S. Q. and FISHER, S. L., 'An investigation of the removability of naturally aged synthetic picture varnishes', *J. American Institute of Conservation*, 29(1990), 181–91

14. WHITMORE, P. M. and BALILIE, C., 'Studies on the photochemical stability of synthetic resin-based retouching paints: the effects of white pigments and extenders', *Cleaning, Retouching and Coatings: preprints of the contributions to the Brussels Congress, 1990*, IIC, London (1990), 144–9

15. GATENBY, S., 'An investigation into cleaning procedures for mould stained Australian aboriginal objects', *ICOM Committee for Conservation, 9th Triennial Meeting, Dresden, 1990: preprints*, edited by K. Grimstad (1990), 157–62

16. GRATTAN, D., 'Advances in the conservation of waterlogged wood 1981–1984', *ICOM Committee for Conservation Report 84.7.8–11*, 7th Triennial Meeting, Copenhagen (1984)

17. DE WITTE, E., TERFVE, A. and VYNCKIER, J., 'The consolidation of the waterlogged wood from the Gallo-Roman boats of Pommeroeul', *Stud. Conserv.*, 29(1984), 77–83

18. MILLS REID, N. K., MACLEOD, I. D. and SANDER, N., 'Conservation of waterlogged organic materials: comments on the analysis of polyethylene glycol and the treatment of leather and rope', *ICOM Committee for Conservation Report 84.7.16–20*, 7th Triennial Meeting, Copenhagen (1984)

19. PADFIELD, T., WINSLØW, J., PEDERSEN, W. B. and GASTRUP, J., 'Decomposition of polyethylene glycol (PEG) on heating', *ICOM Committee for Conservation, 9th Triennial Meeting, Dresden, 1990: preprints*, edited by K. Grimstead, (1990), 243–5

20. LEE, S. M., 'Xylylene polymers' in *The Kirk Othmer Encyclopedia of Chemical Technology*, 3rd edition, vol. 24, John Wiley and Sons, New York (1984), 744–71

21. HUMPHREY, B. J., 'The application of Parylene conformal coating technology to archival and artifact conservation', *Stud. Conserv.*, 29(1984), 117–23

22. HUMPHREY, B. J., 'Vapor phase consolidation of books with the Parylene polymers', *J. American Institute of Conservation*, 25(1986), 15–29

23. GRATTAN, D. W., 'Parylene at the Canadian Conservation Institute – an initial survey of some applications', *ICOM Committee of Conservation, 9th Triennial Meeting, Dresden, 1990: preprints*, edited K. Grimstead (1990), 551–6

24. GRATTAN, D. W. and BILZ, M., 'The thermal aging of Parylene and the effect of antioxidant', *Stud. Conserv.*, 36(1991), 44–52

25. MILLS, J. S. and WHITE, R., unpublished results

26. DE WITTE, E., 'Soluble nylon as consolidation agent for stone', *Stud. Conserv.*, 20(1975), 30–4

27. SEASE, C., 'The case against using soluble nylon in conservation', *Stud. Conserv.*, 26(1981), 102–10

28. BOCKHOFF, F. J., GUO, K.-M., RICHARDS, G. E. and

BOCKHOFF, E., 'Infrared studies of the kinetics of insolubilization of soluble nylon', *Adhesives and Consolidants*, IIC, London (1984), 81–6

29. FROMAGEOT, D. and LEMAIRE, J., 'The prediction of the long-term photo-aging of soluble polyamides used in conservation', *Stud. Conserv.*, 36(1991), 1–8

30. DOWN, J. L., 'The yellowing of epoxy resin adhesives: report on natural dark aging', *Stud. Conserv.*, 29(1984), 63–76

31. TENNENT, N. H., 'Clear and pigmented epoxy resins for stained glass conservation: light ageing studies', *Stud. Conserv.*, 24(1979), 153–64

32. BRADLEY, S. M. and WILTHEW, S. E., 'An evaluation of some polyester and epoxy resins used in the conservation of glass', *ICOM Committee for Conservation Report 84.20.5–9*, 7th Triennial Meeting, Copenhagen (1984)

33. BREEK, R. and FROENTJES, W., 'Application of pyrolysis gas chromatography on some of Van Meegeren's faked Vermeers and Pieter de Hooghs', *Stud. Conserv.*, 20(1975), 183–9

34. DE LA RIE, E. R., 'The influence of varnishes on the appearance of paintings', *Stud Conserv.*, 32(1987), 1–13

35. DE LA RIE, E. R. and SHEDRINSKY, A. M., 'The chemistry of ketone resins and the synthesis of a derivative with increased stability and flexibility', *Stud. Conserv.*, 34(1989), 9–19

36. ROFF, W. J. and SCOTT, J. R., *Fibres, Films, Plastics and Rubbers*, Butterworth, London (1971), 65

37. THOMSON, G., unpublished notes of conversations with manufacturers, *c.* 1957

38. SOLOMON, D. H., *The Chemistry of Organic Film Formers*, John Wiley and Sons, New York (1967), 223

39. HILL, A., 'Manufacture and use of AW-2 resin', *Modern Plastics*, 25(Aug 1948), 64–78

40. RICHARDSON, S. H., 'Polyketones', in *Encyclopedia of Polymer Science and Technology*, vol. II (Ed. N. M. Bikales), John Wiley and Son, New York (1964–77), 276–9

41. DE LA RIE, E. R. and MCGLINCHEY, C. W., 'New synthetic resins for picture varnishes', *Cleaning, Retouching and Coatings: preprints of the contributions to the Brussels Congress, 1990*, IIC, London (1990), 168–73

42. LEONARD, M., 'Some observations on the use and appearance of two new synthetic resins for picture conservation', *Cleaning, Retouching and Coatings*, IIC, London (1990), 174–6

43. SONODA, N. and RIOUX, J.-P., 'Identification des matériaux synthétiques dans les peintures modernes. I Vernis et liants polymères', *Stud. Conserv.*, 35(1990), 189–204

Bibliography

ALLEN, N. S., EDGE, M. and HORIE, C. V. (Editors), *Polymers in Conservation*, Royal Society of Chemistry, Cambridge (1992)

BIKALES, N. M. (Editor), *Encyclopedia of Polymer Science and Technology*, 16 vols. + 2 vols. suppl. + index, John Wiley and Son, New York (1964–77)

BROMMELLE, N. S., PYE, E. M., SMITH, P. and THOMSON, G. (Editors), *Adhesives and Consolidants. Preprints of the contributions to the Paris Congress, 2–8 September 1984*, IIC, London, (1984)

BRYDSON, J. A., *Plastics Materials*, 4th ed, Butterworth, London (1982)

HASLAM, J., WILLIS, H. A. and SQUIRRELL, D. C. M., *Identification and Analysis of Plastics*, 2nd ed. Iliffe Books, London (1972)

HORIE, C. V., *Materials for Conservation; Organic Consolidants Adhesives and Coatings*, Butterworth, London, (1987)

LENZ, R. W., *Organic Chemistry of Synthetic High Polymers*, Interscience Publishers, New York (1967)

MONCRIEFF, R. W., *Man-made Fibres*, 5th ed, Heywood Books, London (1970)

ROFF, W. J. and SCOTT, J. R., *Fibres, Films, Plastics and Rubbers*, Butterworths, London (1971)

SCOTTISH SOCIETY FOR CONSERVATION AND RESTORATION, *Modern Organic Materials: Symposium held at The University of Edinburgh, 14 & 15 April 1988: preprints*, Edinburgh, (1988)

TATE, J. O., TENNENT, N. H. and TOWNSEND, J. H. (Editors), *Resins in Conservation*, Scottish Society for Conservation and Restoration, Edinburgh (1983)

10

Dyestuffs and other coloured materials

Coloured organic materials enter into the composition of museum objects in several important ways, most obviously as dyestuffs in textiles. They may also be used as pigments in painting – in various media – either as they are or, more commonly, adsorbed on an inorganic support as lake pigments.

The small group of coloured resins is also to be found used in paintings and other art works, usually as coloured varnishes or glazes. Synthetic dyestuffs, in addition to their use in textiles, are used in inks for colour printing and in colour photographs.

10.1 Colour and dyeing

Materials are coloured when they absorb light selectively in the visible region. The electromagnetic spectrum, that section of it which is visible to human beings, and the structural features which cause organic compounds to absorb in this region have been discussed in connection with the use of spectra for analytical purposes in Section 2.2.2. There it was shown how absorption of light shifts into the longer wavelength (visible) region with increasing length of a conjugated double bond system.

It will be seen from the structures of compounds in this chapter that ketone and other groups, and aromatic systems, are also common features of coloured compounds, the latter especially in those useful as dyes since aromatic systems are commonly more stable chemically than long chain conjugated compounds.

Some terms which may be encountered are as follows. A *chromophore*, or *chromophoric group* originally meant a functional group (such as ketones, nitro and diazo groups) which led to absorption in the visible region and hence colour. Now however it is often used of groups giving rise to absorptions in the ultraviolet and infrared regions also.

An *auxochrome* was conceived of as a group which, while not giving rise to colour itself, caused a 'deepening' of colour (i.e. a lengthening of wavelength) when introduced into the structure of an already coloured compound. Amino and hydroxyl groups could be thought of as being of this kind. The distinction is not really so simple and absolute as this would seem to suggest: all the groups contribute to the spectrum of a compound on an equal basis though some have a greater, others a lesser effect.

A *bathochromic* effect is a shift of absorption to a longer wavelength; a *hypsochromic* effect the reverse.

Not all coloured compounds are dyes. In order for one to act satisfactorily as a dye for textile fibres it must meet two main criteria. It must be:

1. capable of being taken up from solution by the fibre and bind itself sufficiently strongly that it is not removed, or otherwise affected, by washing or dry cleaning, and
2. reasonably stable to light.

As we have seen, natural fibres are of two main kinds – vegetable and animal (cellulose and protein) – and the same dyes are not necessarily satisfactory for both. The various categories of suitable dyes for

141

these will be briefly outlined. A third category of fibre – synthetic materials such as cellulose acetate or polyesters – is in its turn generally not satisfactorily dyed by dyes suitable for the other two and requires a special group known as *disperse dyes*. The class of *solvent dyes* embraces the non–water–soluble dyes used in inks etc. These too are sometimes used to dye or stain synthetic and other materials.

The other dye classes are:

1. *Direct dyes*. These are taken up directly by cellulosic fibres without requiring any special treatment. Few common natural dyestuffs fall into this category.

2. *Vat dyes*. This rather special group, applicable to wool and cotton though mainly the latter, is applied as a solution of a colourless reduced, or *leuco* form. This is then oxidized back to the coloured dyestuff on the fibre, either by atmospheric oxygen or by means of added oxidizing agents. Indigo is the most familiar natural dyestuff applied in this way. The dye remains on the surface of the fibre largely by virtue of its insolubility in water and it can to some extent be simply rubbed off (as may be seen on blue jeans).

3. *Acid dyes*. These are dyes, generally applied in an acid dye bath, which have acidic groupings in their structure. They are mainly for animal fibres since they attach themselves to the amino groups, or potential amino groups, which have not been utilized in forming the peptide bonds of the protein. Most modern synthetic dyes for wool are of this type.

4. *Mordant dyes*. This is a slightly ambiguous term as it has been applied both to dyes linked to the fibre via an organic compound – tannins – and, more commonly, to those requiring a metallic hydroxide precipitated on to the fibre as the absorbent. Most of the natural red and yellow dyes are of this latter type, the mordant most commonly used being aluminum in the form of alum. It is probable that the dyestuff is not simply physically adsorbed on the metallic hydroxide but forms a chelated complex since the colour which results depends on the metal ion. Thus madder (see below) can give red, violet, and orange colours when mordanted with aluminum, iron, and tin compounds respectively.

10.2 Natural dyestuffs

The natural dyestuffs[1–3] are the products of both plants and insects, though the latter are the source only of red colours. They are largely restricted to red, yellow, blue, and brown dyes, the other colours resulting from mixtures of these or the use of different mordants.

Very many different plants have been used for dyeing. By no means all of these have been examined chemically with a view to identifying the dyestuffs present, and the following survey aims to cover only the most important European and Near Eastern materials. A good deal of information has appeared in recent years on other plant sources if not on their chemistry. For example on the natural dyes of Mexico[4], of Peru[5], and of Scotland[6,7].

10.2.1 Red vegetable dyestuffs

The majority of red dyestuffs are quinones, being substituted derivatives of naphthaquinone and anthraquinone.

naphthaquinone anthraquinone

It is possible to imagine countless structures based on substitution of these basic structures with varying numbers of different groups in different positions and many such are indeed known. Methyl, hydroxyl, hydroxymethylene and carboxyl groups are the commonest substituents.

By far the most important of the red dyestuffs of vegetable origin, and one known and used since antiquity, is madder, which is prepared from the roots of the madder plant *Rubia tinctorum* and other species. These are of wide geographical distribution and the plant was also extensively cultivated.

The dye is a mixture of several components, all anthraquinone derivatives, the proportions of which can be variable depending on the source of the plant and the process used for extracting the dye. The main components are alizarin, purpurin, pseudo-purpurin, alizarin 2-methyl ether, rubiadin and munjistin (*Figure 10.1*). When mordanted with aluminium salts the first three of these give bright red shades; the last three orange–yellow shades, and consequently the overall tone obtained depends on their relative proportions in the particular source of this very variable plant. When mordanted with iron salts, or with aluminium salts with a proportion of iron, violet or purple shades are obtained.

The isolation and the elucidation of the structures of these and other quinonoid compounds involved much work over many years, a good account of which is to be found in a book by Thomson[8].

Many other plant genera also contain alizarin, as well as related compounds not mentioned here, and have in fact been used for dyeing[9], for example *Odenlandia* spp. '(Indian madder'; 'Chayaver' or chayroot), *Morinda* spp. ('suranjee'), and *Galium* spp. (ladies' bedstraw), and this must obviously be taken into account when interpreting dye analyses.

Alizarin was synthesized in 1868 and became commercially available the following year, thereafter largely displacing the natural madder for industrial use. In addition to its use as a dye for textiles, madder was the colourant for one of the most important lake pigments, madder lake, alumina (precipitated with alkali from a natural potassium alum, $KAl_3(OH)_6(SO_4)_2$) being the usual inorganic support though calcium carbonate may also sometimes have been used.

Madder lakes may originally have been a by-

Figure 10.1 Structural formulae of some red plant dyestuffs.

product of the dyeing process, settling out from the dye-bath. Later they, like red lakes from other sources, were often made by re-extracting the dyestuff from clippings of dyed textiles[10], and this of course introduces the possibility of their containing mixtures of dyestuffs.

The soluble redwoods, or Brazil wood, are the wood of several species of *Caesalpinia*, known from long before the discovery of South America since they grow in south-east Asia. They were imported into Europe from the thirteenth century or earlier and are mentioned in Arabic sources (for staining leather for bookbinding) in the eleventh century. The main colouring matter is brasilein, which forms in the rasped wood by autoxidation of a precursor, brasilin.

The related compound haematin, which has an extra hydroxyl group, is the main dyestuff of logwood from *Haematoxylon campechianum* of South and Central America.

The root of the anchusa, *A. tinctoria* Lamm., found in south-east Europe and Asia Minor, yields a red dye, alkanet, known from antiquity. Its coloured component is a naphthoquinone, alkannin or anchusin, which, along with its optical isomer shikonin, is also the main dyestuff present in many other dye plants (e.g. *Lithospermum* spp., *Macrotomia* spp. and *Onosma* spp.).

Other red dyes include archil or orchil, well known as the acid–alkali indicator litmus, which is obtained from lichens (*Roccella* spp.), and safflower (*Carthamus tinctoria*) whose petals yield both a yellow (unidentified) and a red dye (carthamin). Dyeing with the latter is said to be difficult and expensive, and the resulting colour very fugitive. The orange–red dye henna, from *Lawsonia alba* Lam., owes its colour to the compound lawsone, which is closely related to juglone from walnut husks.

10.2.2 Red insect dyestuffs

The red dyes of scale insect origin are of great importance in the history of early textiles and lake pigments. They have received a good deal of attention in the last few years from the point of view of their specific insect origins (rather confused in the past) and their identification on textiles[11–13], for this can be valuable evidence for disputed questions of age and place of origin. The most important insect dyes are as follows: lac, from *Kerria lacca* Kerr; kermes, from *Kermes vermilio* Planchon; Polish cochineal, from *Porphyrophora polonica* L; Ararat or Armenian cochineal from *Porphyrophora hamelii*

Brandt; and cochineal, from *Dactylopius coccus* Costa and perhaps other species.

Like madder these dyestuffs are also composed of anthraquinone derivatives (*Figure 10.2*) and they are applied using mordants, usually alum but sometimes tin or iron salts which give rise to different colours.

The production of shellac by cultivation of *Kerria lacca* Kerr. (*Coccus laccae* L.) has been described in Section 8.6. As a raw material this can contain up to 10% of dyestuff and this is extracted from the resin with water or dilute sodium carbonate solution. The principal components are laccaic acids A and B. The others, C, D, and E, are minor, C being most unusual in that it is a substituted amino acid. Laccaic acid D is identical with flavokermesic acid (also once named xanthokermesic acid)[14]. Laccaic acid E has not been obtained pure but is probably deacetyl laccaic acid A, as indicated (*Figure 10.2*).

Lac was a product not only of India but also of China and most other south-east Asian countries, and it was used in Middle Eastern countries from early times. It was well known in Egypt in early Arab times and it has been found in Persian and Egyptian carpets of the fifteenth and sixteenth centuries. It seems to have been extensively used in European dyeing practice only in the late eighteenth century, though cited in commercial documents from the fifteenth. It was later, like the other old world insect dyes, largely displaced by cochineal.

Kermes is the dye from the gravid (egg-bearing) females of *Kermes vermilio* Planchon which lives on a species of oak, *Quercus coccifera*, growing in countries round the Mediterranean. Although now seemingly rare[11] it must once have been abundant and it was the principal insect dye in Europe before the discovery of America, and thus of cochineal. Its main component is kermesic acid.

Cochineal[15] is obtained from the scale insect *Dactylopius coccus* Costa and other species living on the nopal cactus, or prickly pear, *Opuntia coccinellifera* Mill. Its native country is Mexico but it was imported into Europe extensively within fifty years of its discovery in the sixteenth century on account of its superiority to kermes. In the nineteenth century its cultivation was started in the Canary Islands and elsewhere and by the 1860s production was as high as 2.9 million kg of insects per annum, though it subsequently declined through the competition of synthetics.

The main component of cochineal is carminic acid which, as can be seen, is a C-glycoside, that is to say the linkage to a sugar molecule is by a

Figure 10.2 Structural formulae of the red insect dyestuffs.

carbon–carbon bond rather than through an oxygen linkage. Unlike O-glycosides (in which form many of the anthraquinone dyestuffs may originally be present in the plant and which may be broken down in the process of extraction) C-glycosides are rather stable to removal of the sugar moiety through acid or enzymatic hydrolysis.

The other two principal scale insect sources of dye are of relatively minor importance though that known as Polish cochineal, from *Porphyrophora polonica* L., appears to have been rather extensively used on fifteenth and sixteenth century silks. The major component is carminic acid though both *P. polonica* and *P. hamelii* also contain small percentages of kermesic acid. They are consequently difficult to distinguish one from another and also, more importantly, from cochineal.

The key to making these distinctions appears to lie in paying more attention to the other so far unidentified components revealed using HPLC[11–13]. These other components, which are not necessarily minor, are distributed through most of the above insect species. Their ultraviolet/visible spectra, obtained in the course of diode-array HPLC, have been published[12] and may perhaps eventually help with their specific identification. Thin-layer chromatography appears to be too insensitive to detect the small quantities of kermesic acid present in the *Porphyrophora* spp. dyes and so would fail to distinguish them from cochineal[16].

10.2.3 Red resins

Some red natural resins have found uses in paintings and other artefacts. The best known of these is dragon's blood, of which there exist two distinct types. The kind that was probably first in use in Europe comes from *Dracaena* spp. (Liliaceae) which

grow as large trees on Socotra and the Atlantic islands. There seems to have been no recent chemical work done on this.

The other variety, which is that mostly met with today, comes from *Daemonorops* species (Palmae) from south-east Asia. Coloured components of this include dracorubin and dracorhodin[17]:

dracorubin

dracorhodin

The accroides or grass-tree resins are products of *Xanthorrhoea* species, unique to Australia. They were employed in the fabrication of aboriginal artefacts and were to some extent also exported and used in England and the USA for various purposes. They are very complicated, chemically, and contain a good deal of polymerized material[18].

The compounds represented by I are relatively major components of the resins from some species. Pinocembrin (5,7-dihydroxyflavanone) represented about 10% of the soluble part of *X. preissii* resin, while xanthorrhone and hydroxyxanthorrhone were also isolated from this source.

I

$R^1 = H$, $R^2 = CH_3$,
xanthorrhoein
$R^1 = COOCH_3$, $R^2 = H$,
xanthorrhoeol

pinocembrin

R = H, xanthorrhone
R = OH, hydroxyxanthorrhone

10.2.4 Yellow dyes

The natural yellow dyes are mostly flavonoid compounds, which are widely distributed in the vegetable world. This being so, the choice of plant utilized as source is often very much a question of what is locally available[3]. The principal compounds are shown in *Figure 10.3*. They are by no means all of equal merit as regards colour and light fastness. The best from the latter point of view is luteolin, and the best source of this is weld, or dyers weed *Reseda luteola* L. which was used in European textiles and early Anatolian carpets alike. In the former case it was always the main yellow dye though after the discovery of America it was partially replaced by fustic, and after the late eighteenth century quercitron also was used.

Quercitin is in fact the most commonly found yellow dyestuff and it occurs in a wide range of plants both alone and with other compounds. It is mainly present as a glucoside, quercitrin. Quercitron, the main source, is the inner bark of an oak, *Quercus tinctoria*, a native of central and southern United States.

Morin is the main component of old fustic, the wood of the dyer's mulberry *Chlorophora tinctoria* Gard., imported to Europe from America and used together with weld, despite its inferior light fastness. Young fustic is the wood of Venetian or dyer's sumach, *Cotinus coggygria* (formerly *Rhus cotinus* L.), the main component of which is fisetin.

Other flavonoid dye-yielding plants can be only briefly mentioned. Persian berries, from *Rhamnus* spp., contain mainly rhamnetin with quercitin and the anthraquinone pigment emodin. The fugitive watercolour pigment sap green (which owes its colour mainly to chlorophyll) was prepared from *Rhamnus* berries. Emodin is most abundant in the berry-bearing alder, *Frangula alnus*. Dyer's broom,

Figure 10.3 Structural formulae of some yellow plant dyestuffs.

Genista tinctoria L., contains the isoflavonoid genistein. This is native to England where it was the only yellow dye before importation of others in the middle ages.

A yellow-flowered delphinium (*D. zalil* or *D. sulphureum*), known as isparuk or asbarg, has been much used for dyeing yellow in Central Asia, Afghanistan and India but is not found at all in Turkish rugs. It contains roughly equal amounts of three flavonols: quercitin, kaempferol and isorhamnetin, and the presence together of these is apparently good evidence for use of this dyestuff[19].

Berberin is a dyestuff from *Berberis* spp. and also the bark of two *Phellodendron* spp., *P. Amurense* Rupprecht and *P. saccharinense* Sargent. This material has long been used in Japanese traditional dyeing but also, in China, for colouring paper from very early times, and especially during the T'ang dynasty (AD 618–907). Such yellow-dyed paper was appreciated for its resistance to insect attack as well as for its colour[20].

Saffron, the stigmata of the crocus *C. sativus*, yields an expensive and little used yellow dye containing as main colouring matter the polymethine crocetin, which also occurs in the material as a glycoside crocin.

crocetin

Flavonoid dyestuffs from plants are also the colouring matters for the usually yellow or yellow–brown pigments known as *pinks*. The dyestuffs are adsorbed on an inorganic support as in the case of the red lakes. Persian berries, dyer's broom, and quercitron seem all to have been used in their preparation, for a full discussion of which see Harley's book.

The curious pigment known as Indian yellow appears to have come into use in European watercolours in the eighteenth century. Its use in Indian miniatures is supposed to have started after 1400. It is, or was, prepared in India from the urine of cows fed largely on a diet of mango leaves. The colouring matter is a calcium or magnesium salt of an anthraquinone, euxanthic acid. This is a glucoside of the mango pigment euxanthone which is metabolized by the cow with oxidation of the glucose residue to glucuronic acid, which forms the salt.

euxanthic acid

euxanthone

The history and use of Indian yellow have been extensively reviewed[21,22].

Turmeric, the ground dried rhizomes of *Curcuma longa* L. and perhaps other species, is best known as an ingredient of curry powder but it is also used as a pigment[23] and dyestuff, the latter especially in Indian textiles. The yellow dye ingredient is curcumin.

curcumin

10.2.5 Yellow resins

The yellow gum-resin gamboge is an exudate from the wounded bark of *Garcinia hanburyi* Hook. f. and possibly other species growing in south-east Asia. It contains about 73% of acetone-soluble resin, the remainder being water-soluble polysaccharide gum which allows it to be used directly as a watercolour paint. It was imported to England at latest by the early seventeenth century. The chemistry of the resin seems now to have been clarified[24]. The main coloured component, easily isolated as a crystalline pyridinium salt, is gambogic acid:

gambogic acid

The material known as aloes may sometimes have been used in painting or the decorative arts as a yellow or yellow–brown glaze. It is the evaporated juice which emerges from the cut leaves of certain *Aloe* species, notably *A. vera* (West Indies) and *A. ferox* and *A. perryi* (South and East Africa). A major constituent (up to 25%) is the lemon-yellow barbaloin (aloin), a C-glycoside derived from the anthraquinone aloe-emodin, itself also present in aloes in small amount.

10.2.6 Blue dyes

The only significant natural blue dye is indigo, or indigotin to give it its correct name (*Figure 10.4*), and this occurs in several plants. The dyestuff is not, strictly speaking, itself present in the plants but rather a glycoside, indoxyl, which is converted to indigo during the fermentative isolation process. The principal source is *Indigofera tinctoria* and it was from this plant that it was isolated in India and exported in large quantities until displaced by the synthetic product. The other main source, which is much inferior in terms of dye content, is woad, *Isatis tinctoria*, which grows in Europe, including the British Isles, and as an escaped cultivated plant in Anatolia. In France this plant was extensively cultivated in the Languedoc, the prepared dyestuff being known as *pastel*. Another plant which contains indigotin is *Polygonum tinctoria* (Japan and Korea).

To dye with indigo it is necessary first to reduce it to the colourless and water-soluble *leuco* form:

This intermediate is adsorbed on to the textile fibres and the insoluble indigotin then formed by ready re-oxidation with atmospheric oxygen. Indigo dyeing is thus a skilled procedure usually left to specialist dyers[25].

As well as its use as a dye, indigo has been used as a pigment in paintings (for examples see references 26 and 27). It is also the colouring matter for the blue paper often favoured for renaissance and later drawings[28]. A simple method for its identification, based on its easy reduction to the colourless form and re-oxidation to the blue, has been described[29]. It is now believed that the American pigment known as Maya blue consists of a low proportion of indigo adsorbed on a clay called attapulgite[30,31].

Various modifications of the indigo molecule are also known. The pigment indirubin occurs variably

Figure 10.4 Structural formulae of indigo and related dyestuffs.

with it in plants. The expensive and famous dyestuff of antiquity known as royal or Tyrian purple[32-34] was obtained from marine snails, *Murex* and *Purpura* spp. It occurs in these as a *leuco* form, the violet colour being obtained by a lengthy dyeing process. The dye is a dibromoindigo and, given its structure, is naturally not very stable. It can dehydrobrominate and re-oxidize to give both the monobromo compound and indigotin itself. The same dyestuff was obtained from marine snails along the Pacific coast from Mexico to Peru in pre-Columbian times, and still is to some extent[35].

A semi-synthetic dye, indigodisulphonic acid, is made by treating indigo with sulphuric acid. It is said to have been prepared as long ago as the sixteenth century in central Germany though known to science only from 1740. It gives a lighter, more turquoise colour than indigo and is quite commonly found in nineteenth century Anatolian rugs[3].

10.2.7 Mixed colours

Some colours, most importantly green, are often obtained using combinations of others for lack of a good single dye. Green is formed by dyeing twice, first with indigo (sometimes indigodisulphonic acid) and then with one of the yellow flavonoid dyes. A comparable way of producing the colour is used in Japanese prints (gamboge over indigo or, later, Prussian blue), and sometimes in European – especially Dutch seventeenth century – oil paintings (yellow lake over a blue underpaint). All three of these green colorations in time tend to suffer from the same defect: the more light-fugitive yellows fade leaving only the blue.

An interesting identification of a green dyestuff on furniture or marquetry work has recently been made. A piece of furniture dating from 1779 included wood dyed with indigodisulphonic acid but other samples of intarsia work from the sixteenth to the eighteenth century were shown by HPLC, both alone and combined with ultraviolet/visible spectroscopy, to contain a different, initially unidentified compound[36]. Further investigation by additional methods, including mass spectrometry, showed this to be xylindein, a pigment produced by moulds of the genus *Chlorospienium* which can infest wood. The pigment itself was isolated from such material more than a hundred years ago. Apparently the green-tinted wood was made use of for several centuries. Infested poplar was the first to be used in Italy and may have been exported for use abroad.

xylindein

The green pigment consisting of copper salts of the diterpenoid resin acids and known as 'copper resinate' has been mentioned earlier (8.2.2). It occurs frequently in early Italian paintings and unfortunately it frequently discolours, going a dark brown, yet sometimes its colour is almost perfectly preserved. Despite the importance of this phenomenon little can be said with certainty about its chemistry. It is generally attributed to browning of the resin content or, more plausibly, formation of brown copper compounds such as the oxide.

Other combinations of dyes which are encountered are: yellow with some red, to give orange (common in Turcoman rugs, for example[19]); red and blue to give purple (rather rare since purple can be obtained directly from madder and other red dyes with suitable mordants).

10.2.8 Brown and black dyes – the tannins

Rather few brown dyes are available. One is juglone, from the husks of walnuts, *Juglans regia*:

juglone

Most of the other browns are tannins which can dye a brown colour alone or give a darker shade in combination with iron. Their use in this way parallels their use for making ferrogallate inks, and it results in a similar degradation of the substrate. The crumbling away of wools dyed black with iron and tannins is a familiar feature of many textiles and carpets, as is the falling out of letters written in

ferrogallate inks on parchment and paper. This phenomenon is usually loosely attributed to 'acidity' and this may well be so in the case of the inks, which can be acidic.

With the woollen textiles a similar mechanism may be operative if the dye-bath has been highly acidic but it is also possible that the iron salts are catalysing free radical autoxidation reactions. Iron is known to promote such reactions, in common with other polyvalent metals.

Vegetable tannins have been defined as polyphenols of MW range 500–3000 but here we shall also include the lower molecular weight compounds in the definition. They are usually divided into the *hydrolysable* and *condensed* tannins, the former being readily hydrolysed by acids (or enzymes) to a sugar, or polyhydric alcohol, and a phenol carboxylic acid. Dependent on the nature of the latter (gallic acid or ellagic acid or simple derivatives of these) tannins are divided further into gallotanins and ellagitannins.

gallic acid ellagic acid

By contrast the condensed tannins do not hydrolyse with acids to identifiable products, but undergo progressive polymerization to amorphous materials. Rather little is known regarding the structures of the condensed tannins[37] but they are believed to be formed from flavonoid precursors by condensation–polymerization reactions in ways analogous to the formation of lignin from coniferyl alcohol etc.

The hydrolysable tannins are more amenable to chemical study. Some of their sources are indicated in *Table 10.1*. The tannins can be extracted from the plant material with cold water or aqueous acetone and further purified by extraction from the aqueous solution with ethyl acetate. Large numbers of gallotannins have been isolated and characterized, much of the early work being effected by paper chromatography. In many of these the alcohol moiety of the molecule is a sugar, commonly glucose. Other galloyl esters which have been found include those with itself, namely digallic and trigallic acids.

digallic acid

trigallic acid

A number of crystalline ellagitannins are known, among them chebulinic acid, the major constituent of myrobalans, the fruit of *Terminalia chebula*, an important tannin source. The molecule is made up of glucose esterified with three molecules of gallic and one of ellagic acid.

The chemistry of the tannins used for the preparation of iron tannate inks has been surveyed by Flieder *et al.*[38] who have published the gas chromatograms yielded by the hydrolysed and silylated materials from a number of plant sources. In another paper[39] they have essayed the identification of actual samples of such inks from manuscripts by gas chromatography – mass spectrometry.

The composition of tannin mixtures from a number of natural sources has been determined by thin-layer chromatography with the hope of being

Table 10.1 Sources of some hydrolysable tannins

Tannin	Source
Chinese tannin	Galls and leaves of *Rhus semialata*
Turkish tannin	Galls on wood of *Quercus infectoria* (Aleppo galls)
Sumach tannin	Leaves of *Rhus coriaria* and R. *typhina*
Myrobalans	Fruit of *Terminalia chebula*
Valonea	Acorn cups of *Quercus valonea*
Chestnut	Wood of *Castanea sativa*
Tara	Fruit pods of *Caesalpinia spinosa*
Divi-Divi	Fruit pods of *Caesalpinia coriaria*
Algarobilla	Fruit pods of *Caesalpinia brevifolia*
Knoppern nuts	Fruit of *Quercus pedunculata*
Pomegranate	Fruit, twigs, root of *Punica granatum*

After E. Haslam, *Chemistry of Vegetable Tannins*, Academic Press, London and New York (1966).

able to identify the sources of tannins in dyed textiles[40]. Essentially all contained gallic and ellagic acid but different patterns of minor components. On the textiles, however, only the two major components survived to be detected.

10.2.9 Analysis of natural dyes

The analysis of the dyes in textiles has been attempted for many years. In the last twenty years the approach has usually been either that of thin-layer chromatography (TLC)[16,41–45] and/or spectrometric examination in the ultraviolet and visible regions[42,45,46]. Increasingly, HPLC is becoming the preferred technique for those to whom it is available[13,47,48]. Infrared has not been much used, available samples not often being large enough, though it and other techniques such as fluorescence methods have been experimented with[49,50]. *In situ* fluorescence of dyes on textiles, excited by laser light of specific frequencies, has been examined as an analytical method apparently with success but unfortunately results have largely appeared only in Japanese[51–53].

The preferred stationary phase for TLC which has emerged is polyamide[54,55], while mobile phases usually involve mixtures of methanol with acids such as formic acid.

Much work has been reported by Dutch workers on a wide range of European textiles and tapestries. In addition to their early reports already cited[1,2], the occurrence and distribution with time of red dyestuffs between 1450 and 1600 has been plotted[56,57]. Yellow dyestuffs have likewise been surveyed[58], and the extent to which they may be distinguished by TLC established. However in a later paper[59] it was reported that 80% of some hundreds of samples from well-dated textiles from between 1500 to 1850 were dyed with weld (luteolin). Some seventeenth century Dutch textiles showed a wide range of dyestuffs including many used as mixtures[60].

Tapestries of the fifteenth and sixteenth centuries from the low countries showed principally weld, madder, and indigo. Other less stable dyes such as orchil and brazil were less common[61]. In the sixteenth century the tapestries show a similar pattern but in the next century a new shade, scarlet from cochineal mordanted with tin, appears[62].

A number of Turkish and Persian textiles of the sixteenth to seventeenth centuries were analysed for their dyestuffs. Safflower was found to be the characteristic red dye for the Persian textiles though

lac and brazilwood were also found[45]. In a survey of ancient dyeing techniques[63] one result reported was the identification of kermes as the red dye of the twelfth-century coronation mantle of the Holy Roman Emperors.

The difficult task of identifying dyes on archaeological textiles has been attempted with some success[42,64]. Despite interference from colours from the decaying textile or staining from soil, madder and indigotin were positively identified using visible spectrometry and observation of the changes in spectra induced by adding magnesium acetate solution.

In recent years much work has been done on the dyes of Near Eastern carpets in the hope of distinguishing patterns of dye use for the different groups[65–72]. Whiting has reported an easily conducted test of red dyes using a simple liquid–liquid partition method which permits distinction between madder, lac, and cochineal[68]. Using this method along with TLC and visible spectra he has been able to report on the dye use in Turcoman carpets[19,65] and other groups[69]. Turkish carpets have been a special study of some German workers (using TLC)[67,70] and a book already cited[3] has included analyses for most of the carpets illustrated.

The high performance liquid chromatography (HPLC) studies on the anthraquinone dyestuffs of vegetable and insect origin, mentioned above[11–13], have been tested using wools which had been dyed with known dyes and (in some cases) artificially aged[13,72]. The method has been successfully applied to identification of dyes in some early textiles including Coptic fabrics as early as the third century BC. Also, in varied fabrics from the seventh to the seventeenth centuries, mixed red dyes were often found, Indian carpets, for example, showing lac mixed with madder (or chayroot)[72].

The analysis of the dyes in lake pigments is more challenging than in the case of textiles. Samples are usually much smaller and it is more difficult to remove the dye from its inorganic support and any enveloping oil medium without destroying components of it. Some results on red lakes used in manuscript illuminations (and presumably in a watercolour medium) have been published using TLC on acetylated cellulose[73].

Kirby has described a spectrometric method for distinguishing the several dyes on cross-sections of paintings, though the spectra are rather similar[74]. In later, unpublished work[75], the boron trifluoride–methanol complex has been used to break up oil paint and liberate the red dyes which were then

separated on polyamide TLC plates or by HPLC. A sample of red pigment from a reference collection was identified as madder lake on alumina by means of Fourier-transform infrared spectrophotometry[76].

The same technique has enabled the purple dye adsorbed on some thirteenth-century BC potsherds to be identified as dibromoindigotin[33]. The sherds are presumed to be the remains of dyepots used for dyeing Tyrian purple. The identification of the dyestuffs in yellow lake pigments is still an unsolved problem.

Japanese prints of the eighteenth and nineteenth centuries contain a range of organic pigments including several already mentioned but also other plant dyes unique to them. They have been surveyed and their spectral reflectance curves have been measured. It was found possible to identify several of them on prints in this way[77].

Many other studies, which cannot be detailed here, are reported in papers presented at the several annual meetings on Dyes on Historical and Archaeological Textiles (see Bibliography).

10.3 Synthetic dyestuffs

The vast field of synthetic dyes is, in the present context, of less concern than that of natural dyes and it can only be touched on, principally from the historical viewpoint.

Benzene was first isolated from coal tar in 1845, and in the years that followed numerous other aromatic compounds were also isolated and converted to a range of organic chemicals. These were the basis for the dyestuffs industry to come.

In 1857 W.H. Perkin set up a factory to manufacture the red–violet dye Mauveine, which he had discovered the previous year on treating crude aniline (which contained ortho and para toluidines; i.e. methyl anilines) with an oxidizing agent consisting of potassium dichromate and sulphuric acid. Mauveine is a mixture of compounds of complex composition and not a very good dye. Slightly superior, and of different composition, was Magenta or Fuchsine (*Figure 10.5*), discovered at about the same time by Natanson and by Hofmann, and this was marketed from 1863 onwards and became widely used. It is one of the triarylmethane group of dyes and is not necessarily a single compound as indicated but may include a proportion of compounds with additional C–methyl groups. Fuchsine gave a very brilliant

colour to wool, silk, and cotton but it has poor light fastness, fading to a pale mushroom colour where exposed. This phenomenon – colourless on the front; vivid violet on the back – is often to be seen on late nineteenth-century rugs, particularly those originating in East (Chinese) Turkestan.

Derivatives of Fuchsine followed soon after. N-Phenylation of the amino group(s) gave Aniline Blue and Imperial Violet (1860) and sulphonation of these gave acid dyes Soluble Blue and Alkali Blue (1862). Methylation of Fuchsine gave the Hofmann Violets (1863) while more highly methylated derivatives constituted Methyl, or Gentian Violet (1861, marketed 1866). This last was once familiar as the usual colouring agent in 'marking inks', ink pads for rubber stamps and typewriter ribbons. The image produced was extremely light-fugitive.

Griess in 1858 discovered the diazotization reaction of amines with nitrous acid and later the coupling of the resulting diazonium salts (1864), but the chemistry involved was not understood and it was only in 1870 that Kekulé coupled diazotized aniline with phenol to make the first azo dye and also determined the structures of these compounds.

$$ArNH_2 + HNO_2 + HCl \rightarrow ArN_2Cl + 2H_2O$$

diazotization

$$ArN_2Cl \rightleftharpoons ArN^+\equiv NCl^- \ +$$

coupling

(Ar = aryl, or aromatic group)

The primary and the secondary components can be very varied and the structures of the products are often indicated as follows: 2,4-xylidine → 2-naphthol-3,6-disulphonic acid (Ponceau 2R), meaning that the first component was diazotized and coupled to the second. The way was now open to produce the great range of diazo dyestuffs, still the most numerous class. Of these Orange IV (Roussin 1876), the red Ponceau 2R and Amaranth (Baum, 1878) are mentioned here since they, together with some others, are among the earliest and commonest synthetics to be found in the Central Asian carpets of the late nineteenth and early twentieth centuries, having been supplied by Russian merchants[19].

A few other important discoveries may be mentioned. Methylene Blue (Caro, 1876), isolated

Figure 10.5 Structural formulae of some early synthetic dyestuffs.

as a double salt with zinc chloride, has remained as an important basic dye. Congo Red (Bötteger, 1884) was the first direct cotton dye and was thus important even though fugitive. Indanthrene Blue (Bohn, 1901) led to the development of a whole series of anthraquinone vat dyes.

In the twentieth century some particularly stable, newly discovered dyestuffs found uses as pigments, both commercially and for artists' paints[78]. The most important of these are the phthalocyanines, given the commercial name Monastral Fast Blues. First noticed and patented in the 1920s their structures were determined in the early 1930s and they were marketed soon after. Many differently substituted varieties were prepared, but only a few proved of permanent value, such as the original copper phthalocyanine (C. I. Pigment Blue 15), the metal-free pigment (C. I. Pigment Blue 16), and a green polychloro copper phthalocyanine (C.I. Pigment Green 7).

C.I. Pigment Blue 15

C.I. Pigment Blue 16

The structures of these compounds are closely related to those of both chlorophyll, the green pigment of plants, and haemin, the pigment of animal blood. The phthalocyanines are extra-ordinarily stable to light, heat, and chemical reagents and are very widely used.

10.4 Fading of dyes

The rate of fading of naturally dyed textiles has been studied since the eighteenth century. The fading is related directly to the amount of light received (time × intensity) but it is influenced by wavelength and other factors such as humidity level, the nature of the substrate (wool or cotton), and the mordant used.

The most complete study of recent years is that of Padfield and Landi[79], whose findings were later confirmed and extended by measurement of colour changes in addition to fading[80]. Their main finding can be summarized by the statement that natural dyes are generally far less stable than modern synthetic dyes, despite the bad reputation of the early 'aniline' dyes. They conclude:

> 'The poor light fastness of nearly all the natural dyes is established beyond question and their preservation in the presence of light is not yet possible.
>
> Fifty years of permanent exhibition in the dimmest tolerable conditions would destroy the yellow dyes and the red dye-woods and impair the brilliance of light dyeings of Madder and Cochineal. Indigo on cotton would fade and only the blue of Indigo on wool and some of the browns and blacks would survive. This is why browns, heavy red, and Indigo blue are the dominant colours of museum textiles'.

The influence of the mordant on the lightfastness of a number of natural yellow dyestuffs (mostly from locally grown Kansas plants) on wool has been studied[81]. It was found that aluminium and tin mordants resulted in a much greater rate of fading than did chromium, copper, and iron, and that this variation was much greater than the variations between the dyes themselves.

The influence of oxygen on the lightfading of some organic dyestuffs, both natural and synthetic, has also been studied[82] and was found to be variable. In some cases the fading rate was directly proportional to the oxygen concentration (i.e. there was a linear relationship between the two). In most cases there was a linear relationship between the fading and the square root of the oxygen concentration, in general accord with the prediction of Thomson[83]. In a few cases fading *increased* in the absence of oxygen. The results are of interest since the exhibition of sensitive materials in display cases

containing inert gases has sometimes been considered. However a significant enhancement of 'life-expectancy', even in the complete absence of oxygen, could be expected only for certain identified colouring matters which were known to be particularly fugitive.

The fading of the organic pigments used in Japanese prints has been studied[77]. Most are very fugitive even in visible light and consequently their lightfastness is little improved by protection from ultraviolet. Clearly for good conservation the maintenance of low light levels is very important here.

The effects of relative humidity on photochemical fading of a number of natural pigments have been reported[84], as have those of the substrate (protein or carbohydrate) on the fading of natural anthraquinones[85]. The effects of some air pollutants on fading of dyes has also received some study. Unsurprisingly, ozone reacts with (and fades) dyestuffs containing olefinic double bonds such as curcumin[86], indigo[87] and alizarin[88]. Its effects on the whole range of traditional Japanese pigments, including the three just mentioned, have been assessed[89]; some such as cochineal lake and gamboge were found to be somewhat less affected. Other atmospheric pollutants whose effects on colourants have been examined include nitrogen dioxide, NO_2, which has a significant effect on some including flavonoid and anthraquinone dyes[90], and formaldehyde, which had no significant effect[91].

References

1. HOFENK-DE-GRAAFF, J. H., 'Natural dyestuffs for textile materials. Origin, chemical constitution, identification', *ICOM Committee for Conservation Report 67/15*, Brussels (1967), 55 pp
2. HOFENK-DE-GRAAFF, J. H., 'Natural dyestuffs. Origin, chemical constitution, identification', *ICOM Committee for Conservation Report 69/16*, Amsterdam (1969), 112 pp
3. BRÜGGEMANN, W. and BÖHMER, H., *Rugs of the Peasants and Nomads of Anatolia*, Kunst und Antiquitäten, Munich (1983)
4. CASTELLO ITURBIDA, T., *Colorantes Naturales de Mexico*, Industrias Resistol S. A., Mexico (1988)
5. ANTÚNEZ DE MAYOLO, K. K., 'Peruvian natural dye plants', *Economic Botany*, 43(1989), 181–91
6. GRIERSON, S., DUFF, D. G. and SINCLAIR, R. S., 'Natural dyes of the Scottish Highlands', *Textile History*, 16 1(1985), 23–43
7. GRIERSON, S., DUFF, D. G. and SINCLAIR, R. S., 'Colour and fastness of natural dyes of the Scottish Highlands',

J. Soc. Dyers and Colourists, 101(1985), 220–8
8. THOMSON, R. H., *Naturally Occurring Quinones*, 2nd edition, (1971), 367–565
9. WALLERT, A., 'Fluorescent assay of quinone, lichen and redwood dyestuffs', *Stud. Conserv.*, 31(1986) 145–55
10. KIRBY, J., 'The preparation of early lake pigments: a survey', *Dyes on Historical and Archaeological Textiles: 6th Meeting, University of Leeds, September 1987*, Edinburgh, National Museum of Scotland (1988), 12–18
11. VERHECKEN, A. and WOUTERS, J., 'The coccid insect dyes. Historical, geographical and technical data', *Institut Royal du Patrimoine Artistique, Bulletin*, 22(1988–9), 207–239
12. WOUTERS, J. and VERHECKEN, A., 'The scale insect dyes (Homoptera: Coccoidea). Species recognition by HPLC and diode-array analysis of the dyestuffs', *Annales Soc. Entomologique de France (N. S)*, 25(1989), 393–410
13. WOUTERS, J. and VERHECKEN, A., 'The coccid insect dyes: HPLC and computerized diode-array analysis of dyed yarns', *Stud. Conserv.*, 34(1989), 189–200
14. WOUTERS, J. and VERHECKEN, A., 'The chemical nature of flavokermesic acid', *Tetrahedron Letts.*, 28(1987), 1199–1202
15. DONKIN, R. A., 'Spanish red: an ethnographical study of cochineal and the *Opuntia* cactus', *Trans. Amer. Philosophical Soc.(N. S)*, 67,5(1977), 5–84
16. SCHWEPPE, H., 'Identification of red madder and insect dyes by thin-layer chromatography', *Historic Textile and and Paper Materials II: Conservation and Characterization*, ACS symposium series no. 410, (1989), 188–219
17. OLANYI, A. A., POWELL, J. W. and WHALLEY, W. B., 'The pigments of "dragon's blood" resin. Part VII. Synthesis of draconol, O-methyl draconol, O-methylisodraconol, and derivatives; the structure of dracorubin', *J. Chem. Soc. Perkin I*, (1973), 179–84, and refs. cited therein
18. BIRCH, A. J. and DAHL, C. J., 'Some constituents of the resins of *Xanthorrhoea preissii*, *australis* and *hastile*', *Austral. J. Chem.*, 27(1974), 331–44
19. WHITING, M. C., 'The dyes in Turkmen carpets', in *Turkmen: Tribal Carpets and Traditions*, Eds. L. W. Mackie and J. Thompson, The Textile Museum, Washington (1980), 217–24
20. ZHONG, Z. B., 'The preservation of ancient Chinese paper', *The Conservation of Far Eastern Art. Preprints of the Kyoto Congress 1988*, IIC, London (1988), 19–21
21. BAER, N. S., INDICTOR, N. and JOEL, A., 'The chemistry and history of the pigment Indian yellow', *Conservation of Paintings and the Graphic Arts. Preprints of the Lisbon Congress 1972*, IIC, London (1972), 401–8
22. BAER, N. S., JOEL, A., FELLER, R. L. and INDICTOR, N., 'Indian Yellow', in *Artists' Pigments: a Handbook of*

their History and Character, Vol. I, Ed. R. L. Feller, Cambridge and Washington (1986), 17–36

23. DANIELS, V., 'Analysis of samples containing turmeric', *Dyes on Historical and Archaeological Textiles 4th Meeting* (1985), 10–12

24. AHMAD, S. A., RIGBY, W. and TAYLOR, R. B., 'Gamboge. Part II', *J. Chem. Soc. (C)* (1966), 772–9, and refs. cited therein

25. OGER, B., 'Chimie de la teinture en indigo', in *Sublime Indigo*, Paris and Marseille (1987), 142

26. SMITH, A., REEVE, A., POWELL, C. and BURNSTOCK, A., 'An alterpiece and its frame: Carlo Crivelli's "Madonna della Rondine" ', *National Gallery Technical Bulletin*, 13(1989), 29–43

27. RIOUX, J.-P., 'Usage de l'indigo en peinture de chevalet: *La Vierge de douleur* de Philippe de Champaigne', *Sublime Indigo*, Paris and Marseille (1987), 98

28. VIATTE, F., 'Lavis d'indigo et papiers bleus', *Sublime Indigo*, Paris and Marseille, (1987), 75–8

29. HOFENK-DE-GRAAFF, J. H., 'A simple method for the identification of indigo', *Stud. Conserv.*, 19(1974), 54–5

30. VAN OLPHEN, H., 'Maya blue: a clay-organic pigment?', *Science*, 154(1966), 645–6

31. LITTMANN, E. R., 'Maya blue – further perspectives and the possible use of indigo as the colorant', *American Antiquity*, 47(1982), 404–8

32. BAKER, J. T., 'Tyrian purple: an ancient dye, a modern problem', *Endeavour*, 33 (1974), No. 118, 11–17

33. MCGOVERN, P. E. and MICHEL, R. H., 'Royal purple dye: its identification by complementary physicochemical techniques', *MASCA Research Papers in Science and Archaeology*, 7(1990), 69–76

34. MICHEL, R. H. and MCGOVERN, P. E., 'The chemical processing of royal purple dye: ancient descriptions as elucidated by modern science', *Archaeomaterials*, 4(1990), 97–104

35. GERHARD, P., 'Emperor's dye of the Mixtecs', *Natural Hist.*, 73(1964), 26–31

36. MICHAELSEN, H., UNGER, A. and FISCHER, C.-H., 'Blaugrüne Färbung an Intarsienhölzern des 16. bis 18. Jahrhunderts', *Restauro*, No. 1(1992), 17–25

37. ROUX, D. G., FERREIRA, D., HUDT, H. K. L. and MALAN, E., 'Structure, stereochemistry, and reactivity of natural condensed tannins as basis for their extended industrial application', *Applied Polymer Symposium*, 28(1975), 335–53

38. FLIEDER, F., BARROSO, R. and ORUEZABAL, C., 'Analyse des tannins hydrolysables susceptibles d'entrer dans la composition des encres ferrogalliques', *ICOM Committee for Conservation Report 75/15/12*, 4th Triennial Meeting, Venice (1975)

39. ARPINO, P., MOREAU, J. P., ORUEZABAL, C. and FLIEDER, E., 'Gas chromatographic – mass spectrometric analysis of tannin hydrolysates from the ink of ancient manuscripts (XIth to XVth century)', *J. Chromatography*, 134(1977), 433–9

40. MASSCHELEIN-KLEINER, L., LEFEBVRE, J. and GEULETTE, M., 'The use of tannis in ancient textiles', *ICOM Committee for Conservation Report 81/9/7*, 6th Triennial Meeting, Ottawa (1981)

41. AIRAUDO, CH. B., CERRI, V., GAYTE-SORBIER, A. and ANDRIANJAFINIONY, J., 'Chromatographie sur couchemince de colorants naturels', *J. Chromatog.*, 261(1983), 272–85

42. TAYLOR, G. W., 'Ancient textile dyes', *Chemistry in Britain*, 26(1990), 1155–8

43. KHARBADE, B. V. and AGRAWAL, O. P., 'Analysis of natural dyes in Indian historic textiles', *Stud. Conserv.*, 33(1988), 1–8

44. ROELOFS, W. G. TH. and HOFENK-DE-GRAAF, J. H., 'Appendice 3: Analisi delle materie coloranti', in *Botticelli e il Ricamo del Museo Poldi Pezzoli: Storia di un Restauro*, Ed. M. T. Balboni Brizza, Associazone Amici del Museo Poldi Pezzoli (1989), 87–93

45. GOLIKOV, V. P. and VISHNEVSKAYA, I. I., 'A comparative study of dyeing technology in 16–17th century Persian and Turkish textiles from Moscow Kremlin collections', *ICOM Committee for Conservation, 9th Triennial Meeting, Dresden 1990: preprints* (1990), 294–8

46. SALTZMANN, M., 'The identification of dyes in archaeological and ethnographic textiles', *Archaeological Chemistry II*, ACS Advances in Chemistry Series no. 171, Washington D. C. (1978), 172–85

47. WALKER, C. and NEEDLES, H. L., 'Analysis of natural dyes on wool substrates using reverse-phase highperformance liquid chromatography', in *Historic Textiles and Paper Materials: Conservation and Characterization*, ACS Advances in Chemistry Series No. 212 (1986), 175–85

48. WHITING, M., 'Identification of flavones and flavonols on a microgram scale', *Dyes in History and Archaeology. 10th Meeting 1991* (1992), 7–10

49. GUINEAU, B., 'Non-destructive analysis of organic pigments and dyes using Raman microprobe, microfluorimeter and absorption microspectrophotometer', *Stud. Conserv.*, 34(1989), 38–44

50. GUINEAU, B., 'Experiments in the identification of colorants *in situ*: possibilities and limitations', *Dyes in History and Archaeology. 10th Meeting 1991* (1992), 55–9

51. SATO, M., MASHUHARA, H., ITAYA, A., YAMADA, T. and TAKEUCHI, T., 'Nondestructive analysis of fluorescent dyes contained in fabrics' (in Japanese), *Bulletin of the Apparel Science Research Centre (Kyoto Institute of Technology)*, 62(1987), 12–14

52. MIYOSHI, T. and MATSUDA, Y., 'Laser-induced fluorescence and reflection spectra of red and purple natural dyes on silk cloths' (in Japanese), *Kobunkazai no Kagaku*, No. 32(1987), 47–55

53. MIYOSHI, T. and MATSUDA, Y. 'Laser-induced fluorescence of natural dyes on silk cloths' (in Japanese), No. 17(1984, 1985), 51–60

54. SCHWEPPE, H., 'Nachweiss von Farbstoffen auf alten

Textilien', *Z für Analytische Chemie*, 276(1975), 291–6

55. SCHWEPPE, H., 'Nachweiss natürlicher organische Künstlerpigmente', *Mikrochimica Acta (Wien)*, (1977 II), 583–96

56. HOFENK-DE-GRAAFF, J. H. and ROELOFS, W. G. TH., 'On the occurrence of red dyestuffs in textile materials from the period 1450–1600. Origin, chemical constitution, identification', *ICOM Committee for Conservation Report 5/72/3*, 3rd Triennial Meeting, Madrid (1972).

57. HOFENK-DE-GRAAFF, J. H. and ROELOFS, W. G. TH., 'Occurrences of textile red dyes: 1450–1600 A. D.', *American Dyestuff Reporter*, 65 (1976), No. 3, 32–4

58. HOFENK-DE-GRAAFF, J. H. and ROELOFS, W. G. TH., 'Preliminary report on the identification of yellow dyestuffs in ancient textiles with thin-layer chromatography', *ICOM Committee for Conservation Report 69/17*, Amsterdam (1969), 9 pp

59. HOFENK-DE-GRAAFF, J. H. and ROELOFS, W. G. TH., 'The analysis of flavonoids in natural yellow dyestuffs occurring in ancient textiles', *ICOM Committee for Conservation Report 78/9/4*, 5th Triennial Meeting, Zagreb (1978)

60. HOFENK-DE-GRAAFF, J. H., '"Woven bouquet": dyestuff analysis on a group of northern Dutch flowered table-cloths and tapestries of the 17th century', *ICOM Committee for Conservation Report 75/10/3*, 4th Triennial Meeting, Venice (1975)

61. MASSCHELEIN-KLEINER, L. and MAES, L., 'Etude technique de la tapísserie des Pays-Bas méridionaux aux XVe et XVIe siècles, 2. Les colorants', *Institut Royal du Patrimoine Artistique, Bull.*, 14(1973–4), 193–5

62. MASSCHELEIN-KLEINER, L. and MAES, L., 'Etude technique de la tapísserie des Pays-Bas méridionaux. Les tapisseries anversoises des XVIe et XVIIe siècles. Les teintures', *Institut Royal du Patrimoine Artistique, Bull.*, 16(1976–7), 143–53

63. SALTZMANN, M., 'Analysis of dyes in museum textiles or, you can't tell a dye by its colour', in *Textile Conservation Symposium in Honor of Pat Reeves, 1 February 1986*, Eds. C. C. McLean and P. Connell, Los Angeles (1986), 27–39

64. TAYLOR, G. W., 'Detection and identification of dyes on Anglo-Scandinavian Textiles', *Stud. Conserv.*, 28(1983), 153–60. Errata corrected 29(1984), 208

65. WHITING, M., 'The dyes of Turkoman rugs', *Hali*, 1(1978), 281–3

66. WHITING, M., 'The identification of dyes in old oriental textiles', *ICOM Committee for Conservation Report 78/9/2*, 5th Triennial Meeting, Zagreb (1978)

67. SCHWEPPE, H., 'Wie kann man unterscheiden, ob ein Teppich mit Naturfarbstoffen oder synthetischen Farbstoffen gefarbt ist?', *Hali*, 2(1979), 24–7

68. WHITING, M., 'Progress in the analysis of dyes of old oriental carpets', *Hali*, 2(1979), 28–9

69. WHITING, M., 'The red dyes of some East Mediterranean carpets', *Hali*, 4(1981), 55–6

70. BÖHMER, H., 'Farbstoffanalysen, Färbedrogen und Färbungen nach Analysenergebnissen demonstriert an einem broschierten Flachgewebe aus Anatolien', *Hali*, 2(1979), 30–3

71. WHITING, M. C., 'Dyes in early Oriental rugs', *Chemie in Unserer Zeit*, 15 (1981), No 6, 179–89

72. WOUTERS, J., High performance liquid chromatography of anthraquinones: analysis of plant and insect extracts and dyed textiles', *Stud. Conserv.*, 30(1985), 119–28

73. MASSCHELEIN-KLEINER, L., 'Analyse des laques rouges anciennes', *Stud. Conserv.*, 13(1968), 87–97

74. KIRBY, J., 'A spectrophotometric method for the identification of lake pigment dyestuffs', *National Gallery Technical Bulletin*, 1(1977), 35–45

75. KIRBY, J. and WHITE, R., unpublished results

76. LOW, M. J. D. and BAER, N. S., 'Advances in the infrared spectroscopic examination of pigments', *ICOM Committee for Conservation Report 78/20/3*, 5th Triennial Meeting, Zagreb (1978)

77. FELLER, R. L., CURRAN, M. and BAILIE, C., 'Identification of traditional organic colorants employed in Japanese prints and determination of their rates of fading', in *Japanese Woodblock Prints: a Catalogue of the Mary A. Ainsworth Collection*, Allen Memorial Art Museum, Oberlin, Ohio. Distrib. by Indiana University Press (1984)

78. DE KEIJZER, M., 'Microchemical analysis of synthetic organic artists' pigments discovered in the 20th century', *ICOM Committee for Conservation 9th Triennial Meeting, Dresden, 1990: preprints* (1990), 220–5

79. PADFIELD, T. and LANDI, S., 'The fastness to light of the natural dyes', *Stud. Conserv.*, 11(1966), 181–96

80. DUFF, D. G., SINCLAIR, R. S. and STIRLING, D., 'Light-induced colour changes of the natural dyes', *Stud. Conserv.*, 22(1977), 161–9

81. CREWS, P. C., 'The influence of mordant on the lightfastness of yellow natural dyes', *J. Amer. Inst. for Conservation*, 21 (1982), No 2, 43–58

82. ARNEY, J. S., JACOBS, A. J. and NEWMAN, R., 'The influence of oxygen on the fading of organic colorants', *J. Amer. Inst. for Conservation*, 18 (1979), No2, 108–17

83. THOMSON, G., *The Museum Environment*, Butterworths, London (1978), 187

84. BAILIE, C. W., JOHNSTONE-FELLER, R. M. and FELLER, R. L., 'The fading of some traditional pigments as a function of relative humidity', *Materials Research Society Symposia Proceedings*, 123 (1988), 287–92

85. SAITO, M., MINEMURA, C., NANASHIMA, N. and KASHIWAGI, M., 'Color fading behavior of anthraquinone dyes due to environmental conditions', *Textile Research Journal*, 58(1988), 450–4

86. GROSJEAN, D., WHITMORE, P. M., DE MOOR, C. P., CAS, G. R. and DRUZIK, J. R., 'Ozone fading of organic colorants: products and mechanism of the reaction of

ozone with curcumin', *Environmental Science and Technology*, 22(1988), 1357–61

87. GROSJEAN, D., WHITMORE, P. M., CASS, G. R. and DRUZIK, J. R., 'Ozone fading of natural organic colorants – mechanism and products of the reaction of ozone with indigos', *Environmental Science and Technology*, 22(1988), 292–8

88. WITTMAN, C. L., WHITMORE, P. M. and CASS, G. R., 'The ozone fading of artists' pigments: an evaluation of the effects of binders and coatings', in *Protection of Works of Art from Photochemical Smog*, GCI Scientific Program report, Los Angeles (1988), 228–56

89. WHITMORE, P. M. and CASS, G. R., 'The ozone fading of traditional Japanese colorants', *Stud. Conserv.*, 33(1988), 29–40

90. WHITMORE, P. M. and CASS, G. R., 'The fading of artists' colorants by exposure to atmospheric nitrogen dioxide', *Stud. Conserv.*, 34(1989), 85–97

91. WILLIAMS, E. L., GROSJEAN, E. and GROSJEAN, D., 'Exposure of artists' colorants to airborne formaldehyde', *Stud. Conserv.*, 37(1992), 201–10

Bibliography

A series of annual meetings on subjects related to natural dyes started in the UK in 1982, the papers initially being printed only as summaries but subsequently assuming a more substantial form. These have appeared under the following two headings:

Dyes on Historical and Archaeological Textiles, 1–6(1982–87)

Dyes in History and Archaeology, 7–11(1988–92)

ABRAHART, E. N., *Dyes and their Intermediates*, 2nd edition, Edward Arnold, London (1977)

ANON, *Sublime Indigo: ouvrage realisée à l'occasion de l'exposition Sublime Indigo, Marseille, Centre de la Vielle Charité, 22 Mars–31 Mai 1987*, Editions Vilo, Paris and Musées de Marseilles, Marseilles (1987)

ANON, *The Colour Index*, 3rd edition, 5 vols, The Society of Dyers and Colourists (with acknowledgement to the American Association of Textile Chemists and Colorists), Bradford (1971). Supplements (2 vols) 1975 and 1982

CARDON, D., *Guide des Teintures Naturelles*, Delachaux et Niestlé, Paris (1990)

FARRIS, R. E., 'Natural Dyes', in *Kirk-Othmer Encyclopedia of Chemical Technology*, 3rd edition, vol. 8, John Wiley and Sons, New York, (1979) 351–73

HARBORNE, J. B., MABRY, T. J. and MABRY, H. (Editors), *The Flavonoids*, Chapman and Hall, London (1975)

HARLEY, R. D., *Artists' Pigments c. 1600–1835*, 2nd edition, Butterworths-Heinemann, Oxford (1982)

HASLAM, E., *Chemistry of Vegetable Tannins*, Academic Press, London and New York (1966)

HOFENK DE GRAAF, J. H., 'The chemistry of red dyestuffs in medieval and early modern Europe', *Cloth and Clothing in Medieval Europe*, edited by N. B. Harte and K. G. Ponting, Butterworth-Heinemann, Oxford (1983), 71–79

ISLER, O. (Editor), *Carotenoids*, Birkhäuser Verlag, Basel and Stuttgart (1971)

MCILROY, R. J., *The Plant Glycosides*, Edward Arnold and Co., London (1951)

THOMSON, R. H., *Naturally Occurring Quinones*, 2nd edition, Academic Press, London and New York (1971)

VENKATARAMAN, K. (Editor), *The Chemistry of Synthetic Dyes*, vols. I–VIII, Academic Press, New York (1952–78)

VENKATARAMAN, K., (Editor), *The Analytical Chemistry of Synthetic Dyes*, John Wiley and Sons, New York and London (1977)

Deterioration: causes and prevention

Deterioration and other changes in organic materials result from both free radical and ionic reactions. The first kind includes most autoxidation reactions, usually initiated by thermal or photochemical energy input, and rarer reactions brought about by ionizing radiation alone, without the intervention of oxygen. The ionic reactions are predominantly of a hydrolytic nature, mediated by acids or other catalysts. A third type of deterioration, lying largely outside the scope of this book, is that of bio-deterioration by moulds, bacteria, and even higher forms of life, often the result of enzymatic action or other biochemical processes.

Deterioration can only be prevented if the chemical reactions involved are understood so that ways can be devised to interrupt them or, better, prevent them from starting. This is easier said than done for most are complex and only understood in broad outline, if at all. Moreover, with such complicated substrates as the natural materials, several different processes are usually going on at once which it may be impossible to disentangle.

11.1 Radical reactions

The radical reactions involved in breaking down organic materials are related to those discussed already in connection with the drying of drying oils (3.4.1) or the polymerization of other monomers (9.2). The energy to initiate such reactions can come simply from the heat of the surroundings (i.e. the translational energy of molecules, transferred by collisions), or it may come from the absorption of light or other radiant energy. Thermal and photo-chemical reactions are not always different in kind;

very often the only difference lies in the way in which radicals are initially produced, the reactions then following similar paths. On the other hand, some photochemical reactions can produce products that are then susceptible to different thermal reactions, and *vice versa*. Most degradative reactions are autoxidations but there is one initially puzzling feature about these, namely the slowness of the normal oxidation of organic materials. To understand this it is necessary to explain activation energies.

11.1.1 Activation energies – the Arrhenius equation

Most organic materials can react vigorously with oxygen to be converted to carbon dioxide and water, i.e. *they burn*. Oxidation is thus an exothermic reaction. Why does it not take place spontaneously? We know that in practice it only occurs when the energy of the material is raised locally by heating, after which it is self-perpetuating. Less complete oxidations, such as those converting a hydroxyl group to an aldehyde or forming a hydroperoxide at an allylic position, may also be exothermic yet likewise need an initial 'push' of energy input.

The situation is summed up by *Figure 11.1* which indicates how the initial stage of a chemical reaction involves an increase in the energy content of the reactants. In the case of some reactions this initial energy absorption may represent the energy needed to break a bond in one of the reactants to form radicals (see next section), while in a bimolecular reaction between two compounds it corresponds to the energy needed to arrive at the half-way state of

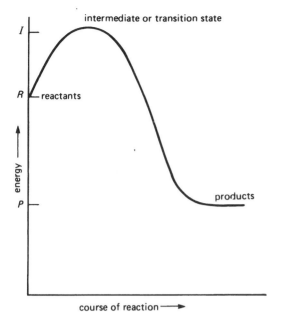

Figure 11.1 Generalized diagram of the energy changes during an exothermic chemical reaction. If *R, I* and *P* are the energies of the reactants, intermediates, and products then *I–R* is the activation energy and *R–P* the overall energy liberated by the reaction.

the reaction, with old bonds half-broken, new half-made. This energy 'hump' is known as the activation energy of the reaction.

The expression which relates the rate of a reaction to temperature, and which includes a term corresponding to the activation energy, is known as the Arrhenius equation (1889):

$$\frac{\mathrm{d}\log_e k}{\mathrm{d}T} = \frac{E_a}{RT^2} \qquad (1)$$

This says that the rate of change of the natural logarithm (i.e. the logarithm to the base e) of the reaction rate constant (k) with temperature equals the activation energy (E_a) divided by the product of the gas constant (R) and the square of the absolute temperature (T). If E_a is constant (not always strictly true) the expression can be integrated to

$$\log_e k = -\frac{E_a}{RT} + C$$

where C is an integration constant. This is turn can be converted to a form using logarithms to the base 10:

$$\log_{10} k = \frac{C}{2.303} - \left(\frac{E_a}{2.303R} \times \frac{1}{T}\right)$$

which means that if values of $\log_{10} k$ are plotted against $1/T$ a straight line is obtained with a slope equal to $-E_a/2.303R$. The validity of this expression has been confirmed for many single-step chemical reactions over a limited temperature range.

If equation (1) is integrated between limits k_1 and k_2 (the rate constants at temperatures T_1 and T_2), a second expression for the slope of an Arrhenius plot is obtained, namely:

$$\log_e \frac{k_2}{k_1} = \frac{E_a}{R}\left(\frac{T_2 - T_1}{T_1 T_2}\right)$$

This may be rearranged in turn for \log_{10}, inserting the value for the gas constant R, to give an expression for E_a which allows it to be calculated from experimentally determined rates of reaction at two different temperatures:

$$E_a = 2.303 \times 1.987 \times \frac{\log_{10} k_1/k_2}{(T_2 - T_1)/T_1 T_2}$$

Once the energy of activation, E_a, is known then reaction rates can be calculated for other temperatures.

The Arrhenius equation indicates that at any temperature there will always be *some* reaction, though it may be immeasurably slow if the temperature is low enough. This is easily understood if it is remembered that in a gas or liquid there is a *distribution* of molecular kinetic energies about a mean level. There is thus always a certain probability, the smaller the lower the temperature, of the reagent molecules having the requisite energy for reaction.

Figure 11.2 shows the plot of molecular energies against number of molecules at each particular energy level, at two different temperatures T_1 and T_2. It can be seen that there are more molecules having energy levels above E_a (the activation energy) at the higher temperature, T_2, than at T_1.

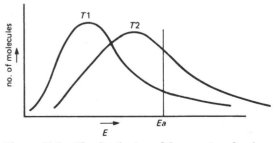

Figure 11.2 The distribution of the energies of molecules at two different temperatures. At the higher temperature, T_2 more molecules have energy at (or above) the level of the activation energy, E_a.

Clearly the Arrhenius equation does not necessarily apply to photochemical reactions, since here the energy initiating the reaction is unrelated to the temperature of the system. This is not to say, however, that photochemical reactions are necessarily unaffected by temperature (see below). Many of them consist overall of a *sequence* of reactions, some of which will be thermal (so-called 'dark') reactions. If these are the slowest part of the sequence (i.e. they are overall rate-determining) then the Arrhenius equation may apply.

Studies have been made to see whether degradation of natural materials (as measured by the change in some physical property) is related to temperature in ways which fit the Arrhenius equation[1,2]. This is only occasionally (and perhaps fortuitously) found to be true and some reasons for this have been put forward in connection with paper:

Several reactions can occur simultaneously;

Individual reactions proceed at different rates;

Reactions might not proceed independently of each other;

Additional reactions may occur as a result of intermediates formed;

Activation energies can vary with temperature;

All physical properties of paper do not respond in the same fashion to chemical changes occurring within the paper.

11.1.2 Bond dissociation energies

The fundamental factor which determines the stability of a molecule or − should it undergo pyrolysis, photolysis or rupture by reactive species − the way in which it breaks up, is the strengths of the different chemical bonds which hold its component atoms together.

The differing strengths of carbon–hydrogen bonds in different molecular environments were briefly mentioned in connection with the reactivities of saturated and unsaturated hydrocarbons (1.1). A selection of bond dissociation energies[3] is shown in *Table 11.1*. These figures are for the bonds in the particular small molecules indicated. They are not necessarily the same for such bonds in large polymer molecules but they do provide a guide to these.

The relationship between bond energies and the wavelength of light which would match this energy and be adequate to break them was mentioned in connection with the absorption of light in the ultraviolet region, i.e. the ultraviolet spectra (2.2.2). The majority of bonds in ordinary organic compounds with $C-H$, $C-C$, $C-O$ etc. linkages do not absorb in the near ultraviolet region yet in practice it is found that polymers such as polymethyl methacrylate, polyethylene etc., as well as natural materials like cellulose, can be quite severely

Table 11.1 Approximate bond dissociation energies

Compound type	Bond broken	Bond dissociation energy	
		(kcal/mol^{-1})	(kJ/mol^{-1})
Alkane	CH_3-H	102	427
	C_2H_5-H	99	415
	iso-C_3H_7-H	94	394
	t-C_4H_9-H	91	381
Alkene	$CH_2{=}CHCH_2-H$	82	344
Aromatic (benzyl H)	$C_6H_5CH_2-H$	83	348
Alcohol	CH_3-OH	89	373
	C_2H_5-OH	92	385
	CH_3O-H	100	419
	C_2H_5O-H	100	419
Alkyl halide	CH_3-F	110	461
	CH_3-Cl	82	344
	CH_3-Br	67	281
	CH_3-I	53	222
Ether	$C_2H_5O-C_2H_5$	79	331
Nitrate ester	$C_2H_5O-NO_2$	36	151
Hydroperoxide	*t*-C_4H_9O-OH	36	151
Peroxide	*t*-$C_4H_9O-OC_4H_9$	35	147
Alkoxy radical	$CH_3-CH_2O^{\cdot}$	13	54
	$C_2H_5-CHO^{\cdot}CH_3$	6	25

Figures from B. Rånby and J. F. Rabek, *Photodegradation, Photo-oxidation, and Photostabilization of Polymers*, Wiley (1975), Table 2.1. A factor of 4.19 has been used in converting kcal mol^{-1} to kJ mol^{-1}.

affected by light of such wavelengths and the possible reasons will be discussed further below.

It can be seen from *Table 11.1* that some bonds have markedly lower dissociation energies than those just mentioned. In general carbon–carbon bonds are slightly weaker than carbon–hydrogen ones. Carbon–oxygen bonds in alcohols are strong while the corresponding oxygen–hydrogen bonds are even stronger (always remembering that we are speaking here of homolysis to radicals, not ionization).

The carbon–halogen bonds form an instructive series. Carbon–fluorine bonds are exceptionally stable, carbon–chlorine and carbon–bromine progressively less so, and carbon–iodine bonds rather weak, and this is reflected in the frequent spontaneous decomposition of alkyl iodides at room temperature with liberation of free iodine.

The instability of nitrate esters (as in cellulose nitrate) is easily understood from the low dissociation energy of the $RO-NO_2$ bond. $RO-OR$ and $RO-OH$ bonds in peroxides and hydroperoxides can be seen to be weak and easily broken, hence their role in providing alkoxy radicals which initiate, or propagate radical chain reactions.

The very low bond dissociation energies of some carbon–carbon bonds in alkoxy radicals themselves is also informative, explaining why such radicals commonly break up instead of abstracting hydrogen, so resulting in the formation of some small molecules in the course of radical chain reactions such as the drying of oils.

11.1.3 Radical reactions and the diffusion of oxygen

The scheme usually given for the reaction of alkyl radicals with oxygen in the course of radical chain autoxidation reactions is as follows:

Initiation $\qquad RH + I^{\bullet} \longrightarrow R^{\bullet} + IH$
where I^{\bullet} is an initiator

Propagation $\qquad R^{\bullet} + O_2 \longrightarrow ROO^{\bullet}$
$\qquad\qquad ROO^{\bullet} + RH \longrightarrow ROOH + R^{\bullet}$

Chain branching $\quad ROOH \longrightarrow RO^{\bullet} + OH^{\bullet}$
$\qquad\qquad RO^{\bullet} + RH \longrightarrow ROH + R^{\bullet}$
$\qquad\qquad {}^{\bullet}OH + RH \longrightarrow H_2O + R^{\bullet}$

Termination $\qquad R^{\bullet} + R^{\bullet}$
$\qquad\qquad ROO^{\bullet} + ROO^{\bullet}$ $\Big\}$ end products
$\qquad\qquad R^{\bullet} + ROO^{\bullet}$
$\qquad\qquad$ etc.

The reaction of alkyl radicals with oxygen occurs very readily, and is preferred over other pathways, but evidently the scheme presupposes that there is no shortage of oxygen. Calculations have been made[4] to see whether this holds true for different rates of reaction in oil and varnish films of various kinds, given the rate of consumption of oxygen in the film for a range of possible reaction rates; the permeability to oxygen of the films; and thus the concentration of oxygen attained at particular depths (on the assumption of diffusion into the film according to Fick's Law).

A 'starvation depth' was defined as the depth into the film at which the oxygen concentration was reduced to 10% of that required to maintain the reaction rate under consideration. For a 1% per month oxidation rate for the dried oil of an oil paint film (an impossibly high rate given the survival of oil paintings) this depth was calculated as between 0.4 and 4 mm and consequently oxygen starvation in the film could not be the limiting factor to oxidation of the paint medium.

For even slower rates, namely 1% per year and 1% per 100 years the depths became 1.5–15 mm and 1.5–15 cm respectively. However, extrapolation to these limits (relevant to, say, objects made of modern synthetics) should be treated with caution. It would seem to call for experimental confirmation given such observations as the survival of readily oxidizable compounds in very old resin such as Baltic amber, under a quite thin 'skin' of oxidized material.

11.1.4 Photochemistry

Light has to be absorbed to be photochemically active. Thus it would seem that only materials with appropriate absorption spectra should be subject to photochemically induced reactions. Polymers such as polyethylene and polymethyl methacrylate have, in themselves, no chromophores to absorb light above about 200 nm yet, as stated in the preceding section, they can be severely affected by such light. In fact the latter material does in practice show weak absorption at around 254 nm, as does also polystyrene.

All three of these materials show photoluminescence on irradiation at this wavelength and the spectrum of this suggests that it arises from a low content of carbonyl groups, possibly at the ends of chains. It may be at these points that photochemical reactions start. Carbonyl groups undergo three types of primary reaction on excitation by absorption of

light, of which one, known as Norrish Type I, yields radicals which can then initiate other reactions.

$$RCOR^1 \left\langle \begin{array}{l} RCO^{\bullet} + {}^{\bullet}R^1 \longrightarrow R^{\bullet} + CO + {}^{\bullet}R^1 \\ \\ R^{\bullet} + R^1CO^{\bullet} \longrightarrow R^{\bullet} + CO + {}^{\bullet}R^1 \end{array} \right.$$

Because the absorption by carbonyl groups is so weak, light of this wavelength will penetrate quite deeply into bulk materials before it is all absorbed, to depths in fact at which possibly no oxygen can penetrate (though see previous section). This might lead to the formation of stable free radicals (detectable by electron spin resonance spectroscopy), or to radicals which simply recombine with loss of their energy as light or heat. Light of these wavelengths should not normally be present inside buildings since it will have partly been absorbed by glass and could be completely removed with suitable ultraviolet filters.

It has been noticed that the temperature at which polymers are photolysed greatly affects the course of the reactions. Above the glass, or second order, transition temperature (*Tg*) of the polymer or in solution, where greater mobility of radical species is possible, recombination of radicals is less and the *quantum yield* of the photochemical reaction increases.

Quantum yield is an empirical measure of the extent of photochemical reaction divided by the amount of light absorbed. More precisely this may be expressed as the ratio of the number of macromolecules undergoing chain scission divided by the number of quanta absorbed by the system.

Another measure is the quantum yield of evolution of low molecular weight products, notably gases (CO, CO_2, H_2 etc.). Some values which have been reported for the quantum yield of chain scission (at 253.7 nm) are: polymethyl methacrylate, 2–32; natural rubber, 0.4; cellulose, 0.7–1; cellulose acetate, 0.2; and cellulose nitrate, 10–20; all \times 10^{-3}.

The near ultraviolet (300–400 nm) is not absorbed by methacrylates, many of which are stable to it, at least as concerns chain scission. Of more importance from the viewpoint of varnish materials is the question of insolubilization from crosslinking, and light of these wavelengths can induce this in methacrylates with reactive tertiary hydrogen groups[5]. Apparently the ratio of cross-linking to chain scission was higher at higher, rather than lower, temperatures. This is a puzzling result since decomposition of radicals (leading to fragmentation)

is generally more pronounced at higher temperatures.

The photochemistry of the natural resins – long known from experience to be far less stable than the high molecular weight polymers – is of importance to those who wish to continue to use them as picture varnishes and so seek ways of stabilizing them. A careful study of the accelerated ageing of dammar, both photochemically and thermally, has been carried out and interesting results have emerged[6].

The progress of ageing was studied by means of ultraviolet/visible and infrared spectrometry, gel permeation chromatography, and change in solvent solubility. During ageing, absorption in the ultraviolet range increased and occurred at increasingly longer wavelengths, eventually moving into the visible region and showing itself as a yellowing of the films. Two quantitative measures of change were obtained from the resulting spectra: the change in absorbance at 300 nm per 10 μm film thickness, and a yellowness factor based on absorbance at 420 nm. Corrections for film thickness above 10 μm were found to be unnecessary for the fadeometer aged samples (though they were for the heat-aged) indicating that degradation products were forming only in the top 8 μm or so of the film.

This must be as a result of the failure of the ultraviolet radiation to penetrate the films significantly below this depth (because of the increasingly strong absorption in the near ultraviolet region), rather than to any deprivation of oxygen. Both measures of degradation were higher for heat (100°C)-aged films than for the fadeometer-aged films (for the same period of ageing) but were far higher again for fadeometer-aged films subsequently subjected to brief heat ageing. Such significantly yellowed films could be bleached again by exposure to visible light. This suggests photochemical formation of metastable oxidation products which then combine with one another during the heat-ageing phase to give coloured products. These are themselves capable of being once again photolysed to colourless compounds.

Infrared spectrometry indicated, as would be expected, an increase in the amount of functional groups typical for products of autoxidation reactions, such as carboxylic acids, and this was confirmed by determination of acid number.

Gel permeation chromatography showed changes in the molecular weight distribution. Under light, the peak at molecular weight *c.* 465, representing the original triterpenoids of the resin, largely

disappeared (more survived heat ageing) and was replaced by a peak at 555, probably representing highly oxidized triterpenoids. The tail of still higher molecular weight material maximized at *c.* 900, probably representing triterpenoid dimers.

These results were paralleled in the solubility studies which indicated an increase in oxidized, more polar materials, requiring more polar solvents to dissolve them, but no truly insoluble (cross-linked) polymer.

Overall, this study confirmed suggestions by earlier workers, that photochemical reactions (caused especially by ultraviolet) are the principal cause of degradation of dammar varnish films, and gave a firm basis for exploring ways to counter this, as discussed below.

11.1.5 Sensitized photochemical reactions; singlet oxygen

As already explained, polymers are commonly affected by light of considerably longer wavelength than that which can be absorbed by the material in question, and the presence of occasional chromophores attached to the polymer may be one reason for this.

Another is the possible presence of small amounts of compounds which can act as sensitizers, i.e. which are capable of absorbing the light, being raised to an activated state, and then transferring this energy to other molecules, themselves returning to the ground state. Most such photosensitizers are ketones, notably aromatic ketones such as acetophenone $(C_6H_5COCH_3)$ and benzophenone $(C_6H_5COC_6H_5)$. Such compounds can have a strongly promoting influence on the photo-oxidation of a variety of substrates though the extent to which such effects may occur naturally has been little studied.

Another, perhaps more significant, form of photosensitization is when the activated compound transfers its energy to oxygen to produce an activated state of this, known as singlet oxygen, which can then undergo reactions with an organic substrate.

Particularly efficient in the production of singlet oxygen, and hence in photosensitizing oxidations by it, are a number of dyestuffs such as Fluorescein, Rose Bengal, Methylene Blue, Eosin etc.[7]. Irradiation of solutions of different compounds in the presence of one of these and oxygen can lead to several types of compound. Compounds with single double bonds can yield allylic hydroperoxides:

Conjugated dienes can add oxygen:

Some oxidation of saturated hydrocarbons is also said to occur. The above hydroperoxides and cyclic peroxides can then decompose, and the resulting alkoxy radicals react, as in the usual free radical oxidation reactions. Unfortunately most investigations and writings on this subject neglect the question of which wavelengths of light are effective in these reactions and it is not clear whether visible light or perhaps the near ultraviolet is responsible.

The extent to which effects such as these play a part in the photo-oxidation of the natural materials has been rather little studied but their role in the degradation by light of dyed textiles (observable by the reduction of tensile strength etc.), well known under the name 'phototendering', has been recognized at least since 1948. Cotton is the fibre worst affected, while yellow and orange anthraquinone dyes have a particularly serious effect. No clear correlation has been found, however, between structure of the dyestuff and deleterious effect.

11.1.6 Effects of metal ions

Metal oxides and other salts can also have a strong effect on oxidation of organic substrates. This has already been touched on in connection with the drying of oil paint (3.4.2) but some other examples can also be given. Both zinc oxide and titanium dioxide (anatase form) promote a light induced reaction leading to the formation of hydrogen peroxide, and thence hydroxy radicals[7-11]. This is believed to be related to the intermediate formation of an oxygen radical ion:

$$ZnO + O_2 \rightarrow (ZnO)^+ + O_2^{\bullet -}$$
$$O_2^{\bullet -} + H_2O \rightarrow HO_2^{\bullet} + HO^-$$
$$2HO_2^{\bullet} \rightarrow H_2O_2 + O_2$$
$$H_2O_2 \rightarrow 2HO^{\bullet}$$

The similar sequence of reactions for titanium dioxide has been worked out in some detail. The

wavelength threshold for the reaction was between 375 and 395 nm, i.e. almost into the visible region. Water is, of course, needed for the reaction sequence and the permeability of most organic films to water vapour readily allows for this. These reactions and their products lead to the breakdown of the medium and the resulting 'chalking' of external paint using such pigments. Related effects have been noticed in artists' paints using these pigments while their effect on the progressive insolubilization of poly *n*-butylmethacrylate paints containing them has also been studied[10]. Initially both anatase titanium white and zinc oxide slowed down cross-linking, presumably on account of their absorbing ultraviolet. Thereafter there was substantial weight loss, due to degradation reactions, but progressive insolubilization due to cross-linking was still the predominant long-term effect.

Some pigments, such as ferrous oxide (Fe₂O₃) and carbon black can have a strongly protecting influence on a substrate, probably principally because they simply prevent light penetration. The carbon pigments also show a definite antioxidant effect as a result of the phenolic and quinonoid structures which, due to incomplete carbonization, many of them still retain to some extent.

11.2 Countering oxidation

11.2.1 Antioxidants

The effects of some organic compounds on the course or speed of the drying of oils have already been discussed (3.4.3). In the period since the first edition of this book some important work has appeared on the possibility of using oxidation inhibitors for stabilizing varnishes for paintings and so reducing the frequency of their removal and renewal.

Because of their industrial importance a vast range of antioxidants is available commercially. Many reviews have appeared, most relevantly to us one written with picture varnishes in mind[12]. The principal types of compound found to be of utility are as follows.

The hindered phenols are phenols with one or more bulky groups such as tertiary butyl in a position ortho to the phenolic hydroxyl group. A much used material is butylated hydroxytoluene (BHT), but more substituted, higher molecular weight materials are also common.

butylated hydroxytoluene (BHT)

These compounds act as radical scavengers, and hence chain stoppers, being themselves oxidized in the process in ways very similar to those outlined for phenol oxidation to form lignin (6.8.1). They are eventually used up and cease to play their role. They work best as stabilizers against thermal autoxidative reactions but perform poorly in the presence of light. Moreover they may give rise to coloured products which can render them useless for stabilizing clear colourless materials. Thus BHT can yield quinone methide, which is yellow:

Aromatic amines behave in ways very similar to the hindered phenols and have similar disadvantages, for example they are used up and have low photochemical stability. Many are derivatives of diphenylamine:

Hindered amine light stabilizers (HALS) are a new class of antioxidants which, as their name indicates, are effective against photochemical degradation. Their mode of action is complicated and only incompletely worked out but apparently they partly graft themselves on to resin substrates to form hydroxylamine ethers, >N−O−R, which continue to act as stabilizers by reacting with further peroxy radicals. The antioxidant is consequently not used up, which makes them the most effective light stabilizers currently available. Many HALS are derivatives of 2,2,6,6-tetramethylpiperidine:

Other structural types, which need not be further considered here, are organic sulphides ($R-S-R^1$, which can reduce hydroperoxides by an ionic reaction) and phosphites ($P(OR)_3$), which react similarly. Some agents enhance the effect of others (synergism) and this is taken advantage of in many products by using mixtures or by incorporating the different functional groups within the same molecule.

11.2.2 Stabilized varnishes

Some studies of the heat ageing of dammar resin varnish films[13-15] indicated that deterioration, as indicated by yellowing and insolubilization, could be significantly slowed down by incorporation of the antioxidant Irganox 565, a molecule which incorporates hindered phenol, amine, and sulphide groups:

A later paper[16], however, while confirming the powerful effect on heat ageing, showed that this antioxidant was not effective in preventing photochemical ageing since it was itself rapidly broken down in the fadeometer. Moreover its breakdown products could cause enhanced yellowing.

The two measures of deterioration mentioned in Section 11.1.4 (change in absorption at 300 and 420 nm), as well as change in solubility, were used as indicators. Loss of the antioxidant was followed by means of HPLC. It was found to be much slower during fadeometer ageing with an ultraviolet filter and in view of this, and the results just to be discussed, it might well be more effective under such conditions, but this was not determined in detail.

Further studies were made to see whether effective stabilization was possible using HALS[17]. This was found to be impossible in the presence of ultraviolet, typical stabilizers being virtually without effect even at high (6%) concentration. However, when ultraviolet filters were used in the fadeometer a very marked improvement in stability was achieved in the presence of, for example, Tinuvin 292. The effects of adding a second stabilizer of the benzotriazole type (Tinuvin 328) was also investigated. These are usually thought of as ultraviolet

absorbers but are known also to have a synergistic effect. In fact a further improvement was indeed obtained even in the absence of ultraviolet. Such stabilized films showed little change in both their infrared spectra and the gel permeation chromatograms after prolonged fadeometer ageing. Even more striking indicators of stabilization were the solubility tests and examination by GLC–MS. The films remained completely soluble in cyclohexane and all the original triterpenoid components of dammar were found to be still present in scarcely altered proportions.

The effectiveness of stabilization was dependent upon the ultraviolet filter used. For best results a filter with a cut-on wavelength of not less than 400 nm is required, i.e. one with a very slight yellowish tone.

The incorporation of ultraviolet absorbers into a varnish film gives rise to certain inconveniences and so further studies were made to see whether using higher concentrations of HALS was not just as effective[18]. This proved to be so. Mastic resin films could also be significantly stabilized in this way but not to the same degree as dammar. With a concentration of 3% of Tinuvin 292 it was estimated that a dammar varnish film could have a useful life in excess of 100 years in an ultraviolet-free environment.

11.3 Other agents of deterioration

Other atmospheric agents of deterioration include ozone, whose mechanism of attack on rubber has been described (8.5.1). It attacks other unsaturated compounds in a similar way. While commonly present in polluted air, particularly in cities, its concentration within buildings is usually very low because it is rapidly destroyed by contact with the organic materials in them, though this can, of course, include the art works themselves. None the less in a recent study in California it was found that ozone levels inside a gallery could be half as high as those outside[19]. As reported more fully in Section 10.4 ozone was found to be damaging to many natural dyestuffs and pigments, particularly alizarin-based red, and natural yellows.

Of the nitrogen oxides, nitrogen dioxide (NO_2, N_2O_4) is the most dangerous. Dissolved in water it gives rise to nitrous and nitric acids which are of course corrosive as well as being oxidizing agents. As acids these will have similar hydrolytic effects to those resulting from sulphur dioxide, the main

source of acidic contamination. Hydrolysis of cellulose and consequent reduction in average molecular weight, and possibly a similar effect on proteinaceous materials, is the principal type of damage to be expected of acids. This, together with the effect on inorganic materials, has been surveyed by Thomson[20].

References

1. GRAY, G. C., 'Determination and significance of activation energy in permanence tests', in *Preservation of Paper and Textiles of Historic and Artistic Value* edited by J. C. Williams, ACS Advances in Chemistry Series No. 164, Washington, D. C. (1977), 286–313

2. BAER, N. S. and INDICTOR, N., 'Use of the Arrhenius equation in multicomponent systems', *ibid*, 336–51

3. RÅNBY, B. and RABEK, J. F., *Photodegradation, Photo-oxidation and Photostabilization of Polymers*, Wiley, New York (1976), Table 2.4

4. THOMSON, G., 'Oxygen starvation in paint and other films', *National Gallery Tech. Bull.*, 2(1978), 66–70

5. FELLER, R. L., CURRAN, M. and BAILIE, C., 'Photochemical studies of methacrylate coatings for the conservation of museum objects', *Photodegradation and Photostabilization of Coatings*, ACS Symposium Series No. 151, Washington D. C. (1981), 183–96

6. RENÉ DE LA RIE, E., 'Photochemical and thermal degradation of films of dammar resin', *Stud. Conserv.*, 33(1988), 53–70

7. MEIR, H., 'The photochemistry of dyes', in *The Chemistry of Synthetic Dyes*, vol. VI, edited by K. Venkataraman, Academic Press, New York and London (1971), 389–515

8. VOLZ, H., KAEMPF, G., FITZKY, H. G. and KLAEREN, A., 'The chemical nature of chalking in the presence of titanium oxide pigments', *Photodegradation and Photostabilization of Coatings*, ACS Symposium Series No. 151, Washington D. C. (1981), 163–82

9. ALLEN, N. S., 'Effects of dyes and pigments', in *Comprehensive Polymer Science* vol. 6, Editors G. Allen and J. C. Bevington, Pergamon Press, Oxford (1989), 579–95

10. WHITMORE, P. M. and BAILIE, C., 'Studies on the photochemical stability of synthetic resin-based retouching paints: the effects of white pigments and extenders', *Cleaning, Retouching and Coatings. Preprints of the Brussels Congress, 3–7 September 1990*, IIC, London (1990), 144–9

11. MCKELLAR, J. F. and ALLEN, N. S., 'Photosensitized processes involving dyes and pigments', in *Photochemistry of Man-made Polymers*, Applied Science Publishers, London (1979), 199–215

12. RENÉ DE LA RIE, E., 'Polymer stabilizers. A survey with reference to possible applications in the conservation field', *Stud. Conserv.*, 33(1987), 9–22

13. LAFONTAINE, R. H., 'Decreasing the yellowing rate of dammar varnish using antioxidants', *Stud. Conserv.*, 24(1979), 14–22

14. LAFONTAINE, R. H., 'Effect of Irganox 565 on the removability of dammar films', *Stud. Conserv.*, 24(1979), 179–81

15. LAFONTAINE, R. H., 'Use of stabilizers in varnish formulations', *ICOM Committee for Conservation Report 81/16/5*, 6th Triennial Meeting, Ottawa (1981)

16. RENÉ DE LA RIE, E., 'An evaluation of Irganox 565 as a stabilizer for dammar picture varnishes', *Stud. Conserv.*, 33(1988), 109–14

17. RENÉ DE LA RIE, E., 'Stabilized dammar picture varnish', *Stud. Conserv.*, 34(1989), 137–46

18. RENÉ DE LA RIE, E., 'The effect of a hindered amine light stabilizer on the ageing of dammar and mastic varnish in an environment free of ultraviolet light', in *Cleaning, Retouching and Coatings. Preprints of the Brussels Congress, 3–7 September 1990*, IIC, London (1990), 160–64

19. SHAVER, C. L., CASS, G. R., GLEN, R. and DRUZIK, J. R., 'Ozone and the deterioration of works of art', *Environmental Science and Technology*, 17(1983), 748–52

20. THOMSON, G., *The Museum Environment*, 2nd edition, Butterworth-Heinemann, Oxford (1986), 138–53

Bibliography

ALLEN, N. S. and MCKELLAR, J. F. (Editors), *Photochemistry of Dyed and Pigmented Polymers*, Applied Science Publishers, London (1980)

BRILL, T. B., *Light: Its Interaction with Art and Antiquities*, Plenum Press, New York (1980)

CALVERT, J. G. and PITTS, J. N., *Photochemistry*, John Wiley and Sons, New York (1966)

CRANK, J. and PARK, G. S., *Diffusion in Polymers*, Academic Press, London and New York (1968)

LABANA, S. S. (Editor), *Ultraviolet Light Induced Reactions in Polymers*, ACS Symposium Series No. 25, Washington D. C. (1976)

MCKELLAR, N. S. and ALLEN, N. S., *Photochemistry of Man-made Polymers*, Applied Science Publishers, London (1979)

PAPPAS, S. P. and WINSLOW, F. H. (Editors), *Photodegradation and Photostabilization of Coatings*, ACS Symposium Series No. 151, Washington D. C. (1981)

RÅNBY, B. and RABEK, J. F., *Photodegradation, Photo-oxidation and Photostabilization of Polymers*, John Wiley and Sons, London, New York (1975)

REINISCH, R. F. (Editor), *Photochemistry of Macromolecules*, Plenum Press, New York and London (1970)

SCOTT, G., *Atmospheric Oxidation and Antioxidants*, Elsevier, Amsterdam (1965)

THOMSON, G., *The Museum Environment*, 2nd edition, Butterworth-Heinemann Oxford (1986)

Analysis in practice

Chapter 2 was devoted to analytical methods in general. They were discussed there so that it should be understood how the knowledge of the compositions of the various classes of materials covered in subsequent chapters had been arrived at.

The object of this final chapter is to give some account of how these analytical methods are applied to the identification of the organic materials of actual museum objects. The examples are generally taken from the authors' own results and so are concentrated largely on paint and varnishes, and on chromatographic methods.

12.1 Paint

12.1.1 Sample preparation

For examination by GLC or GLC-MS a paint sample has first to be saponified and methylated. Such samples are usually exceedingly small, less than the size of a full stop (period) at the end of this sentence, and they are conveniently treated in small teflon-stoppered centrifuge tubes or Pierce Reactivials, to which they are transferred immediately on sampling. These vessels must be carefully cleaned beforehand (see below).

For saponification a few drops of potassium hydroxide solution, either in methanol or 50% methanol-water, are added to the sample and the tube warmed up on the steam bath briefly. Usually, with oily or resinous media, or even rich egg tempera medium, yellow material can be seen to flow from the sample, which disintegrates. The tube is allowed to stand for 24 hours at room temperature or, if closely sealed, it may be heated to up to 90°C

for three or four hours. It is then acidified with a few drops of dilute hydrochloric acid, diluted with a little more distilled water and the freed fatty acids and any other compounds extracted by shaking with pure, recently redistilled ether.

If there is any tendency for emulsions to form it may be a help to centrifuge the tube and contents to aid complete separation of water and ether layers, the ether solution being then pipetted off into a small, clean disposable sample tube. This solution is then evaporated to dryness on the water bath and the (usually invisible) residue redissolved in a few drops of 12% methanol in ether and methylated with diazomethane (CH_2N_2). This is a poisonous yellow gas which can however be readily and safely generated on a small scale in a fume cupboard (US: hood) and, entrained in a stream of nitrogen, be bubbled through the sample solution[1]. An alternative and now preferred methylation procedure is to use a new reagent, (trimethyl)silydiazomethane, $CH_2NNSi(CH_3)_3$. At first sight the name can confuse. It does not give (trimethyl)silyl derivatives. What happens is that it reacts with the methanol in the sample solution to give (trimethyl)silyl methanol and diazomethane itself, which then reacts with the acids in the usual way. It is available as a 2.0 M solution in hexane (Aldrich Chemical Company Ltd., Catalogue number 36,283–2) and a convenient way of using it is to carry it over to the sample solution entrained in a stream of nitrogen in the same way as for diazomethane itself.

Methylation is complete in a few minutes, after which the solvent and excess reagent is gently evaporated off, down to a small volume. The solution is then best transferred to a 0.1 ml Pierce

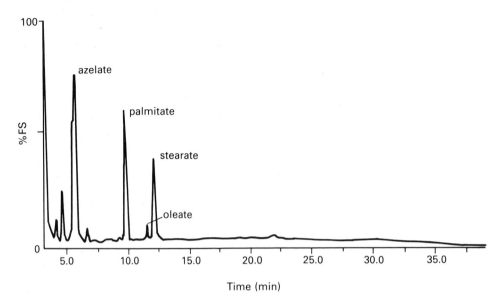

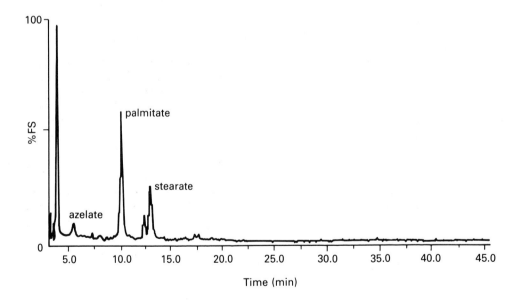

Figure 12.1 Total ion gas chromatograms yielded by artificially aged test samples of paint films of lead white with (*top*) linseed oil medium and (*bottom*) egg tempera medium, after saponification and methylation of the acids. The two media are clearly distinguished by the difference in the proportion of dimethyl azelate. The samples were saponified and the free fatty acids isolated as described in the text. Methylation was effected with (trimethylsilyl)diazomethane. The analysis was carried out on a VG Trio 2000 Research Grade GLC–MS system with Hewlett Packard 9800 gas chromatograph connected via a direct line. GLC–MS conditions: injection (1.5 μl) on to deactivated pre-column; 25 m (0.32 mm i.d.) quartz capillary column with SGE HT5 bonded phase; temperature programme 35°C (0.5 min) × 25°C min^{-1} to 120°C (1 min) × 7°C min^{-1} to 310°C (30 min). Helium carrier gas pressure-controlled to give MS source pressure of 1 × 10^{-5} Torr at the initial column temperature of 35°C. MS operated in positive EI (electron impact) mode at 70 eV; source temperature 300°C; scan mode, 600–40 amu (atomic mass units); 0.9 s scan time; 0.1 s reset time.

Reacti-vial, or similar pointed-end tube, and further concentrated down to a few microlitres by warming and gently puffing off the solvent vapour with a disposable pipette and teat. It is then ready for injection into the gas chromatograph using an appropriate syringe.

Some workers have recommended the use of other methylation methods, such as the boron trifluoride–methanol complex, but this is not convenient on a very small scale. Trimethylsilylation itself is also used as an alternative derivatization method and has some advantages in that in addition to forming esters with the carboxylic acid groups, any hydroxyl groups are converted to trimethylsilyl ethers.

12.1.2 Gas chromatograms of egg and oil

The chromatograms yielded by simple egg tempera medium and drying oil medium are shown in *Figure 12.1*. They have in common the peaks due to the methyl esters of the two saturated acids palmitic and stearic, plus a variable proportion of the mono-unsaturated C_{18} acid, oleic acid, the amount of which diminishes with time and is also dependent on the pigment present. The dried oil film shows high proportions of the dicarboxylic acid degradation products, particularly the C_9 compound azelaic acid.

The amounts of these dicarboxylic acid esters can be quite variable and it is hard to be sure about the reasons for this.

A peak of azelate about equal to that of palmitate would seem to be about the minimum to be expected of a pure oil film but sometimes it can be very much stronger. Egg fats contain small proportions of unsaturated acids and so formation of small amounts of azelate would be expected in tempera films. Sometimes none is observable while at other times amounts equivalent to about a quarter or even a third of the palmitate peak are present.

At this point an element of ambiguity creeps in and one may suspect the presence of a small proportion of drying oil. This may not be an original component of the medium. For various reasons tempera paint may be slightly porous, the medium not filling all the space between the pigment particles. Consequently old oil varnish or even oil itself, with which the surfaces of paintings were sometimes treated in the past, may have partially penetrated the paint and not been removed during cleaning. Alternatively, since egg fats do not dry they remain solvent-soluble and so could in theory have been partly extracted into

(and been replaced by) applied varnish layers. However the continued presence of saturated fats in tempera paint suggests that this does not occur to any great extent.

12.1.3 Contamination

The possible penetration of the paint film by coating materials raises the question of contamination of the sample generally. The quantity of organic material being studied in these small paint samples is so small that results can be greatly distorted by even traces of contaminants.

The work-up procedure for the samples involves the concentration down to a few microlitres of perhaps two or three millilitres of ether, which has therefore to be of the highest purity. Likewise the glassware used must be scrupulously cleaned and rinsed, for fats are ubiquitous contaminants.

It is a wise precaution, when results indicate very low lipid levels, to run a blank sequence without sample to check on background levels.

12.1.4 Palmitate/stearate ratios

An early study of dried drying oils[2] suggested that it might be possible to distinguish between the three main kinds used in western European painting, linseed, walnut and poppyseed, on the basis of the relative amounts of palmitate and stearate observed. Subsequent experience with many samples has confirmed that this can often be done with reasonable confidence, though inevitably there are sometimes ambiguous results.

A histogram of palmitate/stearate ratios obtained with samples from Italian paintings of between 1300 and 1800 (*Figure 12.2*) shows a bimodal distribution corresponding to use of linseed (most frequent ratio 1.7) and walnut (most frequent ratio 2.6) oils[3, 4]. Overlap between the two probably occurs in the 2.1 ratio region.

The results also suggest that walnut oil was the preferred one in Italy when oil-painting started in the fifteenth century while use of linseed oil, always commoner in Northern Europe, became more usual in Italy in the next century. Poppyseed oil, with a palmitate/stearate ratio usually well above 3.0, has been most commonly encountered in paintings of the French school, particularly of the nineteenth century[5–8]. The grounds of paintings of the seventeenth century French School are prepared with both linseed and nut oils, and more rarely with poppyseed[9].

P/S	NO. OF RESULTS	
.1	0	
.2	0	
.3	0	
.4	0	
.5	0	
.6	0	
.7	0	
.8	0	
.9	0	
1	0	
1.1	1	*
1.2	4	****
1.3	5	*****
1.4	10	**********
1.5	13	*************
1.6	10	**********
1.7	18	******************
1.8	15	***************
1.9	12	************
2	12	************
2.1	8	********
2.2	5	*****
2.3	4	****
2.4	9	*********
2.5	11	***********
2.6	13	*************
2.7	9	*********
2.8	10	**********
2.9	8	********
3	12	************
3.1	6	******
3.2	3	***
3.3	2	**
3.4	2	**
3.5	2	**
3.6	1	*
3.7	0	
3.8	0	
3.9	0	
4	0	

Figure 12.2 Histogram of palmitate/stearate ratios obtained from Italian paintings of the fifteenth to eighteenth centuries. The bimodal distribution corresponds to use of linseed oil (most frequent ratio 1.7) and walnut oil (most frequent ratio 2.6). The two overlap in the 2.2, 2.3 region.

A study of the compositions of linseed and poppyseed oil films, dried in the presence of octanoates of cobalt, manganese, lead, and zinc as driers, has provided valuable confirmation of the constancy of the palmitate/stearate ratios during the drying process[10]. Linseed oil (33 results) gave an average ratio of 1.6 with a spread of 1.4–1.9. Poppyseed oil gave an average ratio of 3.3 (39 results) with a spread of 2.9–3.7. The same sample of oil was involved in each case so the spread in results must represent imprecision resulting from the work-up and analytical method rather than a real variation in composition.

There is literary evidence that painters of various periods were aware of the different properties of different oils, notably the lesser tendency to yellow-ing of walnut and poppyseed as opposed to linseed, and analytical results have confirmed that this knowledge influenced their practice. Recommendations to use particular oils with particular pigments were made by the eighteenth century English artist Thomas Bardwell and analysis of his paintings has showed that to some extent he followed his own precepts[11].

12.1.5 Additional components in the paint film

In addition to the main ester components from oil or egg fat mentioned above, many minor peaks also commonly appear on the gas chromatogram. Some of those which are often present have been identified as minor fatty acids and are of no particular diagnostic significance, but occasionally unusual or less common peaks appear whose identification calls for mass spectrometry. This has proved of particular value in confirming the presence of resin components in paint samples even in cases where such small amounts survive as to produce scarcely perceptible peaks on the chromatogram.

The chromatogram of a sample of green paint from a painting by Raphael (*Saint John the Baptist Preaching*, National Gallery, London) was typical of oil and showed a palmitate/stearate ratio of 2.7 (walnut). *Figure 12.3* shows the later part of this chromatogram together with a scan for mass 314 (the molecular ion of methyl dehydroabietate) which shows this to be mostly present in the position of the small peak centred at scan 375, and the spectrum of this peak is indeed that of this compound (*Figure 12.4*). A mass scan at 328, the molecular ion of methyl 7-oxodehydroabietate, showed this compound also present at scan 442.

These two compounds are the only remaining indicators surviving from pine resin in the medium. Two other samples from this painting (blue sky and black) were found to be in egg tempera medium and the use of oil and resin for the green suggests that this colour was of the transparent 'copper resinate' type made by heating verdigris with an acidic resin. The survival of the resin components may be due to two factors. Firstly green copper pigments are known to slow down oxidation processes, and the presence of a fairly large proportion of oleic acid in this sample is a further instance of this. Secondly the green paint had been partly covered for some time by restorers' putty which would have protected it from the action of light. This cannot however have

been operative over a very long proportion of the painting's five hundred year life.

Small quantities of dehydroabietate have likewise been detected in green paint samples from works by Altdorfer, Veronese and Rubens[12]. In the last instance it was also found in paint of other colours.

Another type of component which may, in certain rare instances, be present admixed with oil medium is wax. The paintings of George Stubbs (1724–1806) are well known, even notorious, among restorers for their frequent vulnerability to solvents (such as might be used for varnish removal) and heat (as might be used in relining or blister-laying operations). Examination of samples from several of his late paintings has indicated that he used varied combinations of oil, non-drying fat, resin and wax as his medium[13, 14].

The detection of beeswax as such is discussed elsewhere (4.4) but when it is present in a paint sample which is saponified and methylated its composition is changed (wax esters are converted to methyl esters) and one needs to be able to recognize the different pattern. *Figure 12.5* shows the chroma-togram obtained from a sample from a late Stubbs painting, *Hambletonian*.

In addition to oil components a number of minor peaks are to be seen emerging after stearate. Some were suspected of being resin components and were indeed identified as methyl dehydroabietate and methyl 7-oxodehydroabietate as indicated. A scan for mass 74, the base peak for long chain saturated fatty acids, picks out the pattern of these in the post-stearate section (*Figure 12.6*) which were identified as those characteristic for saponified beeswax (*Figure 12.7*). As can be seen from this latter chromatogram, beeswax contributes a large amount of palmitic acid which would vitiate any attempt to identify the oil from the palmitate/stearate ratio.

Another class of ingredient whose presence may be suspected in dark-coloured paint samples is that of asphalts or tars, though here more in use for their pigmentary properties rather than as part of the medium. An interesting example was provided by the brown-black background in a painting by Van Dyck, *The Lord John Stuart and Lord Bernard Stuart* (National Gallery, London, no. 6518). *Figure 12.8* shows the total ion current chromatogram given by

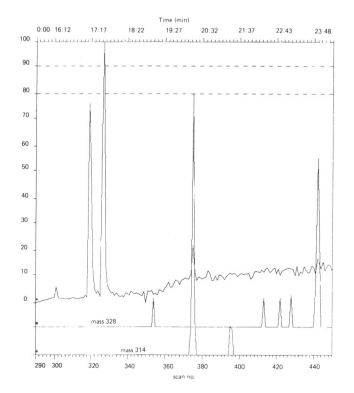

Figure 12.3 Later section of a gas chromatogram of a green paint sample (after saponification and methylation) from Raphael's *St. John the Baptist Preaching* (National Gallery, London) together with scans for masses 314 and 328, the molecular ions of methyl dehydroabietate and methyl 7-oxodehydroabietate respectively, which permit their localization on the chromatogram. The small size of the sample and the need for high sensitivity settings on the mass spectrometer result in a rather 'noisy' chromatogram. The spectra of the two resin components are shown in *Figure 12.4*.

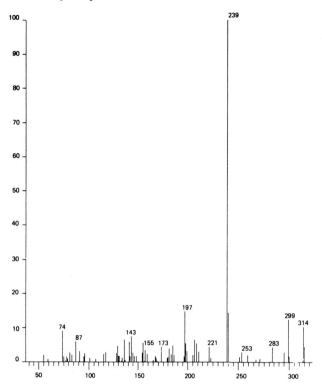

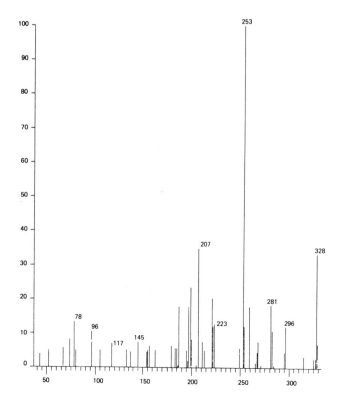

Figure 12.4 Mass spectra of scans 375 and 442 of the chromatogram shown in *Figure 12.3*. While less than perfect, the spectra are quite adequate to identify the compounds as the methyl esters of dehydroabietic acid and 7-oxodehydroabietic acid, formed by oxidation of original abietadiene acids of pine resin in the green Raphael paint, which was probably of the 'copper resinate' type.

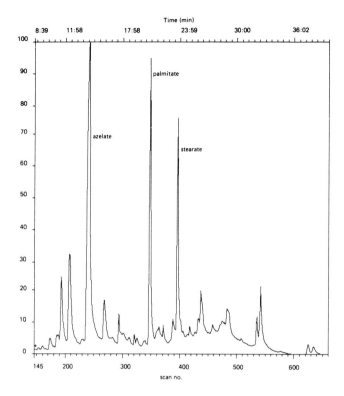

Figure 12.5 Capillary gas chromatogram of a sample of paint from George Stubbs's *Hambletonian* (The National Trust) after saponification and methylation. It shows azelate, palmitate and stearate peaks suggestive of drying oil but also a number of post-stearate peaks from other components. That section is shown enlarged in *Figure 12.6*.

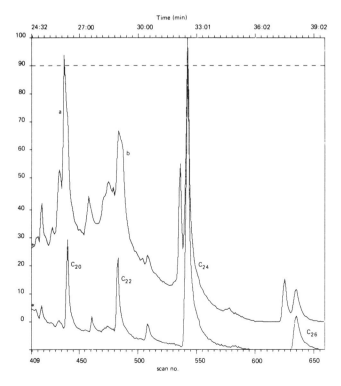

Figure 12.6 Post-stearate section of the chromatogram shown in *Figure 12.5*. A scan for mass 74, a major peak in the mass spectra of fatty acid esters, shows up the chromatographic peaks for these. They proved to be the methyl esters of the C_{20}, C_{22}, C_{24} and C_{26} acids, maximizing at C_{24} as in beeswax (see *Figure 12.7*). Also detected were (a) methyl dehydroabietate and (b) methyl 7-oxodehydroabietate from pine resin, which overlapped the peaks of the C_{20} and C_{22} esters.

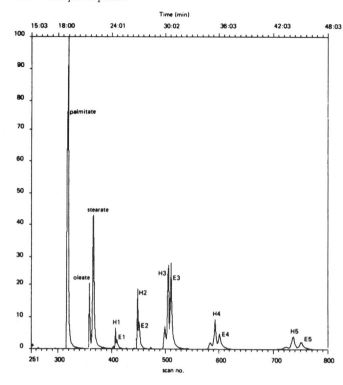

Figure 12.7 Capillary gas chromatogram of beeswax after saponification and methylation. In addition to the peaks of palmitate and stearate, the peaks labelled E1 to E5 correspond to esters of the even, saturated, straight chain C_{20} to C_{28} acids (maximum at C_{24}). The peaks labelled H1 to H5 correspond to the odd, straight chain hydrocarbons from C_{23} to C_{31}.

a sample of it after the usual saponification and methylation treatment. The early peaks, and the palmitate/stearate ratio correspond to linseed oil, while the broad, partly unresolved group of peaks bounded by scans 1200–1600 is in the region to be expected for triterpenoids. Scans around 1494, after background subtraction, gave a mass spectrum, with molecular ion at 470, M−18 (loss of H_2O) at 452, and base peak at 189, which agreed well with that of an authentic sample of the methyl ester of betulinic acid (for structure see *Figure 8.5*). This compound is not well known as a component of triterpenoid resins but its corresponding diol, betulin (*Figure 8.5*), is abundant in the bark of the silver birch (*Betula alba*). As already explained (5.2.1), this compound is to be found in tar made by destructive distillation of birch bark and it is also present in the tarry soot collected from burning birch wood, known as bistre. In the present case betulin itself could not be detected but it could well be that the betulinic acid arose by natural autoxidation of betulin originally present in birch tar or bistre in the paint. It must be remembered that oxidation conditions are much more severe in a thin paint film exposed to light and air than in a relatively thick and protected lump of birch tar adhesive, sealant or

coating associated with an object buried for much of its life. If this does indeed identify the presence of birch tar or bistre, this is so far the only identification of such material in a painting.

12.1.6 Proteinaceous media

It will have been noticed that in the foregoing nothing has been said regarding the detection of proteins, such as egg albumin or animal glue, by the above procedures. These are in fact transparent to the presence of protein which is not isolated by the work-up method but stays in the aqueous phase, whether hydrolysed to amino acids or unchanged. If a protein medium is suspected then acid hydrolysis, derivatization and chromatographic determination of the amino acid composition is called for (7.3).

The derivatization methods utilized in the authors' laboratory involve methylation of the carboxylic acid groups (dry HCl/methanol) followed by trifluoroacetylation of the amino groups (trifluoroacetic anhydride). The procedure for this has been described in detail elsewhere[15] as have a number of identifications of particular proteins on a basis of relative amounts of particular amino acids.

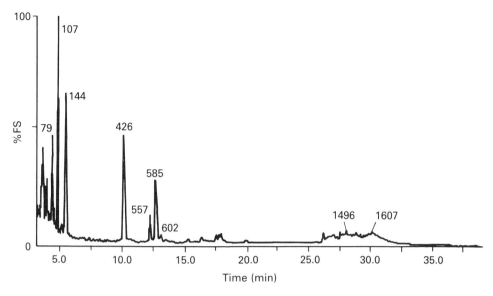

Figure 12.8 Total ion chromatogram of brown–black paint from Van Dyck, *The Lord John Stuart and Lord Bernard Stuart* (National Gallery, London). Sample treatment and GLC–MS parameters as for *Figure 12.1*. The usual peaks for oil (linseed) are seen at scans 107, 426, 557, and 585, namely azelate, palmitate, oleate and stearate. The group of low peaks bounded by scans 1200–1600 (time 27 to *c.* 30 min.) is in the triterpenoid region and one, at c. scan 1494, was identified as methyl betulinate, its background-subtracted mass spectrum (molecular ion at 470; base peak at 189) closely resembling that of an authentic sample. The most likely explanation for the presence of this compound is that it results from autoxidation of betulin, present in birch tar or bistre used as pigment.

Another instance which may be cited is that of the medium used by the French painter Edouard Vuillard (1868–1940). This artist sometimes used a curious technique involving powder colours tempered with an aqueous medium[16]. Examination of samples from one such painting (private collection) indicated the presence of egg fats but subsequent amino acid analysis showed the presence of hydroxyproline, which could only come from animal glue. It was found possible to separate the proteins from the two sources by gentle extraction with slightly acidic water. Amino acid analysis of the soluble and insoluble fractions showed a clear separation into collagen and albumin respectively. How exactly this combination of materials was used as a medium remained unclear however.

12.1.7 Staining and other micro techniques.

A drawback of instrumental methods of analysis of paint samples is the impossibility of effecting them *in situ* on multilayered samples. The technique of differential staining of cross-sections, to show up oil or protein layers, and possibly also to distinguish between different types of the latter, has therefore

long seemed an attractive one and some account of its development must be given.

The first attempts at this approach were published[17] as early as 1905 but they were not widely known about until this article reappeared in English translation[18] in 1936. Occasional use of such techniques was then made[19,20] but it was not until the studies of M.-C. Gay that they began to be systematically used[21].

As well as a number of chemical reactions on thick sections mounted in a polyester resin, Gay used staining with Sudan Black B and Oil Red O for the detection of oil and egg fat components. They were found unreliable, however, as they could give falsely positive results through absorption by some pigments (particularly chalk), and also falsely negative results since thoroughly dried oil does not adequately absorb them unless it is heated to about 60°C. For protein staining, Acid Fuchsine and also Light Green in solutions of different pH were used. Roughly summarized, her results showed that it was easy to detect gelatine but less easy to detect egg albumin using these stains.

Shortly thereafter Johnson and Packard[22] described an extensive study of samples from fifteenth and

sixteenth century Italian paintings using Sudan Black B as an oil stain and Ponceau S as the principal stain for proteins. They interpreted their results on the basis of the following simple scheme:

Stain for oil but not for protein: oil layer;
Stain for protein but no stain for oil: glue;
Stain for protein and moderately positive stain for oil in the same layer: egg tempera.

They also claimed to be able to detect artificial emulsions of oil with egg yolk or glue. An interesting result was the use of oil medium for copper resinate-type greens in fourteenth and fifteenth century paintings which were otherwise entirely in tempera technique (cf. the result for the Raphael painting described above). Unfortunately reserve must be felt concerning some of the more specific findings (such as the identification of the oil as walnut oil) since they were based on thin-layer chromatography of the non-saponifiable components of the sample, a method later shown to be incapable of such specificity[23].

Gay followed up her first article with a second detailing further results obtained with similar methods[24]. She rejected the use of thick sections for staining as they often gave falsely positive results because of porous layers or infiltration of the stain into cracks or between layers. An interesting finding was that in mainly tempera paintings oil was also sometimes used to coat the gesso (to render it impermeable) and also in lead white underlayers.

A sequence of four papers by Martin[25–28], also working at the Laboratoire de Recherche des Musées de France, succeeded those of Gay. She developed new staining reagents based on amido black (*noir amide*) in solutions of varying pH. These three dye solutions reacted differently with gelatine and albumen and to some extent allowed their distinction. One of these reagents was particularly sensitive and was claimed to make detection of protein in artificial emulsions more certain. Such emulsions were said to have been detected in certain areas of many paintings later than the sixteenth century.

These tests were all carried out on thin sections or sometimes simply flakes of paint. Emulsions are also claimed to have been detected frequently as the medium of certain highlights, particularly yellow highlights using the pigment lead–tin yellow, in Flemish primitives of the fifteenth and sixteenth centuries[29].

Considerable interest has been shown in reactive, and sometimes fluorescent, dyes as a means of visualizing and distinguishing between media in paint cross-sections[30,31]. Unfortunately it cannot be said that adequate control experiments on known test samples, checking for the effects of mixtures and different pigments, have always been carried out. In the more thorough study[31] many different dyes were surveyed and five of the best selected for more intensive work. Use of aqueous solutions of the dyes were found to have disadvantages in that many inorganic materials absorbed them, giving misleading results. Best and clearest detection of protein binders was afforded by use of solutions of the dyes in 10% aqueous dimethylformamide, adjusted to a pH of 5.6.

Specific identifications of different media by these methods must be considered uncertain in the absence of confirmation by other means. Probably, as with other staining methods, they are most valuable in showing up thin layers otherwise difficult to see and in showing differences in the medium of different layers in a section, rather than as an absolute method of identification. In a study of a discoloured and insoluble surface coating on a painting by Van Gogh[32], positive protein staining was found with two dyes (Lissamine Rhodamine sulphonyl chloride and Texas Red isothiocyanate) and identification as egg white was in this case confirmed by means of an FTIR spectrum of a sample. With some staining studies on the medium of painting by Whistler and some later overpaint[33], interpretation of the results of staining with certain oil stains as indicating possible use of an early alkyd resin medium seems more speculative.

A very interesting study of media, both by staining of cross-sections and by gas chromatography (though without full details of the experimental results being given) was carried out on the particularly well-documented series of paintings by different artists for the *Studiolo* of Isabella d'Este in Mantua, executed in the late fifteenth and early sixteenth centuries[34].

12.1.8 Paint and other coatings on external stone

The analysis of polychromy and coatings which have been subjected to all the weathering and contamination of the outside world, and also perhaps to sundry protective treatments, presents very great difficulties. An attempt was made to identify the medium of the painted sculptures on the facade of the cathedral in Ferrara[35]. Both casein and oil were found by gas chromatographic exam-

ination but it seemed likely that all of the latter came from a coating of linseed oil applied as a protective measure in 1843. Examination of organic coatings on sculpture and columns on the facade of the church of San Petronio, in Bologna, suggested the use of a casein coating as a probably non-original protective layer while a layer in direct contact with the sculptures of Jacopo della Quercia contained beeswax among other components and could represent an original coating[36].

12.2 Varnishes and lacquers

The identification of varnishes on paintings is not often undertaken. Unlike the paint, the existing varnish is very rarely original, having in most instances been removed and replaced, or simply 'refreshed' with an additional layer, many times in the lifetime of the painting. This latter factor makes analysis difficult and, even if it is successful, the result's significance for the history of the painting may be hard to interpret. Very occasionally traces of what seems to be an original varnish are found and an example of one, consisting of boiled oil and sandarac resin, has already been mentioned (8.3.6).

Varnishes of other kinds however, such as those on furniture and other woodwork (including musical instruments), on globes, and on metalwork (including scientific instruments) may well be original, and the subject of great and even passionate interest. Much can be achieved in the way of identifying varnish ingredients but there are limitations, particularly to the detection of the hard copal resins or amber[37].

The sample is usually saponified and methylated in the same way as for paint. Oil is then readily detected by gas chromatography as are surviving diterpenoid and triterpenoid resin components if the oven is programmed up to a sufficiently high temperature. Higher fatty acid esters from waxes, can also be detected though not always positively identifiable unless GLC–MS is being used.

12.2.1 Varnishes

Figure 12.9 shows the chromatogram yielded by a varnish removed from Pieter Bruegel's *Adoration of the Kings* (National Gallery, London)[38]. This was a varnish remaining on the painting after removal of upper, more soluble varnish layers and presumably represented an early varnish remaining after an incomplete cleaning though of quite uncertain date.

In this instance the presence of oil had been indicated in the usual way and a second sample was then extracted overnight with cold ether/methanol (9:1) and the extract then diluted with further methanol to precipitate less polar polymeric material. Methylation with diazomethane was followed by injection of 0.5 μl of the concentrated solution under cold trapping conditions using a Grob splitless injection system at 260°C with solvent tail cutting after 20 seconds. A 6 m flexible quartz capillary column coated with SE30 silicone gum was used. The carrier gas was helium at 0.6 bar pressure and the column oven was programmed from 120°C to 260°C at 5 per minute. The Kratos MS-25 mass spectrometer was set up for electron impact ionization at 70 eV with a source temperature of 220°C. Scanning was at a rate of 1 second per decade.

The earlier section of the chromatogram shows diterpenoid resin components, the later peaks are the triterpenoid resin components. The largest peak (centred at around scan 311) is composite but contains methyl 7-oxodehydroabietate as the main component. The second largest peak (at around scan 242) is methyl dehydroabietate. More significant is the detection of the labdane diterpenoid larixol (8.2.2) at scan 222, indicating the presence of Venice turpentine, the resin of *Larix decidua*, in the varnish.

The peak at around scan 201 is methyl $\Delta 8$-isopimarate whose presence in this amount is unusual and not readily interpretable though it may have been formed by isomerization of methyl isopimarate, a major component of Venice turpentine. In the later triterpenoid section a scan for mass 426 picked out a possible triterpene alcohol which was identified from its mass spectrum (*Figure 12.10*) as tirucallol, a component of mastic resin.

Most of the other peaks were not identified but the largest one at scan 923 contained several triterpenoid keto esters of molecular weight 426 including methyl ursonate with base peak at mass 203. Venice turpentine was commonly included in eighteenth century mastic varnish recipes, supposedly for its plasticizing properties.

Varnishes from three eighteenth century musical instruments, all made in Italy, were analysed by gas chromatography alone[39]. While not identified with the degree of assurance possible with GLC–MS, large samples and use of standards gave fairly clear results. All three contained walnut oil and pine resin (presence of dehydroabietate and 7-oxodehydroa-

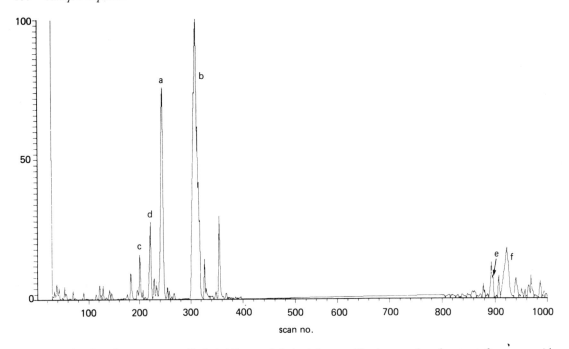

Figure 12.9 Gas chromatogram afforded (after methylation) by a cold ether–methanol extract from a varnish removed from Pieter Bruegel's *Adoration of the Kings* (National Gallery, London). A flexible quartz capillary column coated with SE30 silicone was used, programmed from 120°C to 260°C at 5°C min^{-1} with helium at 0.6 bar pressure as carrier gas. The mass spectrometer was set up for electron impact ionization at 70 eV with scanning at 1 second per decade. Two main groups of peaks are seen, corresponding to diterpenoids and triterpenoids.

As well as the usual esters (a) dehydroabietate and (b) 7-oxodehydroabietate (in a composite peak) and the less usual (c) Δ8-isopimarate, a neutral compound (d) larixol was identified, indicating the presence of Venice turpentine. Among the triterpenoids were (e) tirucallol (MW 426) and methyl ursonate (MW 468) in (f), a composite peak.

bietate), but a Serafin violin appeared to have additional sandarac and possibly an unidentified leguminous copal.

The varnish of a Tononi 'cello also yielded some beeswax on extraction with benzene while the methanol-soluble portion of the same extract showed some triterpenoids attributable to the presence of mastic or dammar. The rich red–brown colour of this last varnish seemed to be attributable to a lake pigment rather than to dragon's blood resin or discolouration due to strong heating.

The insect resin shellac is rather problematic as concerns its identification by gas chromatography. Examination by GLC–MS serves only to pinpoint some simple fatty acids among the peaks produced, none of the various reported components (8.6.1) being definitely identifiable. It is none the less possible to distinguish shellac varnish by chromatography of the saponified and methylated material since certain (unidentified) compounds with distinctive mass spectra are fairly consistently present.

There are some variations between the different types of shellac, perhaps due to different treatments applied to the raw material. For some reason (perhaps from the fact that it is itself oxidized by the treatment) bleached shellac gives results which are closest to those found with old films of shellac and so it is considered here.

Figure 12.11 shows the chromatogram yielded by saponified and methylated bleached shellac. *Figure 12.12* shows the same total ion trace together with specific ion chromatograms (m/z 74, 155, 276 and 308) which show up compounds characteristic for shellac. Mass 74 indicates the saturated fatty acids, present (in small amounts in this sample) at scans 273, 430, and under the scan 474 composite peak. Mass 155 indicates, *inter alia*, compounds within the composite scan 474 peak and on the leading edge of the scan 703 peak that have this ion as the base peak. The two masses 276 and 308 (molecular ion?) pinpoint two characteristic compounds peaking at *c.* scans 662 and 748. *Figure 12.13* shows the mass

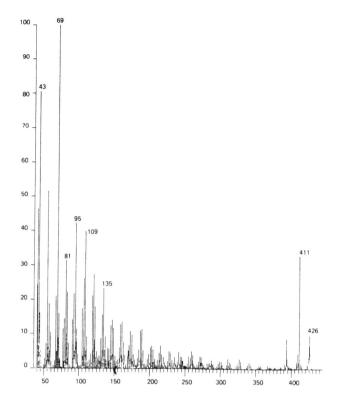

Figure 12.10 Mass spectrum of scan 896 of the chromatogram of *Figure 12.9*, identifying it as the triterpene alcohol tirucallol, probably from mastic resin.

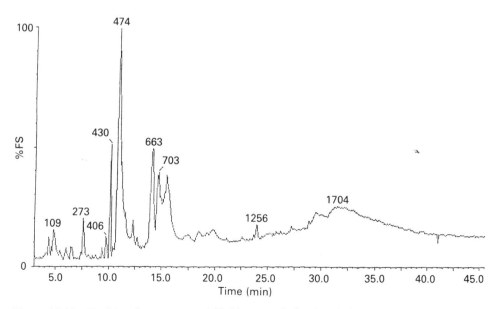

Figure 12.11 Total ion chromatogram yielded by saponified and methylated bleached shellac. Procedures and GLC–MS parameters as given for *Figure 12.1*. Peak characterization by specific ion monitoring and mass spectra is shown in *Figures 12.12* and *12.13*.

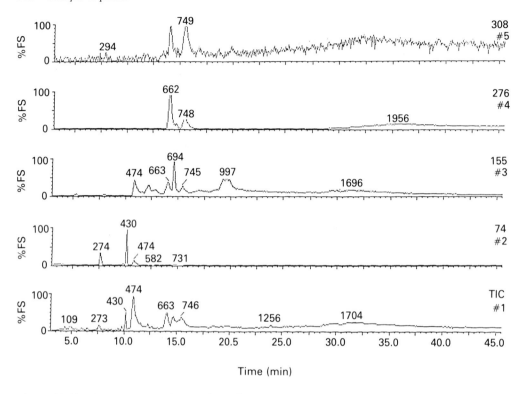

Figure 12.12 Comparative total ion and specific ion chromatograms of saponified and methylated bleached shellac (*Figure 12.11*). From bottom to top: total ions; specific ions (m/z) 74, 155, 276, and 308. m/z 74 shows up the methyl esters of saturated fatty acids (C_{14}, C_{16} and C_{18} at *c.* scans 274, 430, and 474); m/z 155, and 276 and 308 together show up unidentified compounds diagnostic for shellac (see *Figure 12.13*).

spectra of these two compounds which have, of course, yet to be identified.

Figure 12.14 shows the chromatogram yielded by the varnish covering a metal backplate of about 1820. Two such backplates (to a handle on a piece of furniture) had accidentally been used instead of one and consequently the original varnish or lacquer on the lower one had been protected from erosion and oxidation. The pattern is similar to that of shellac and the composite peaks after stearate showed the characteristic compounds with masses 276 and 308. Though there are differences (for example the fatty acid peaks are much stronger), its identification as shellac seems fairly certain. There are no detectable di- or triterpenoids and it is clearly not simply a drying oil.

A modern varnish removed from a painting by Rubens, the '*Gerbier Family*' in The National Gallery of Art, Washington D. C. , was thought to be shellac on the basis of its infrared and visual spectra[40].

12.2.2 European lacquers

European lacquers were made in imitation of Japanese lacquering in the late seventeenth and the eighteenth centuries and they were, in practice, pigmented spirit varnishes. The materials of two such lacquers, both copper green-pigmented, have been identified. One, covering a commode by Chippendale dated 1770, consisted solely of pine resin and still showed (*Figure 12.15*) all the original diterpenoid components though with the proportion of dehydroabietic acid much increased. Surprisingly, even monoterpenoid oil of turpentine components were still observable[38].

Another green lacquer covered the woodwork of an Irish harp and this showed a different composition[41]. A high proportion of sandaracopimaric acid, in addition to dehydroabietic acid, indicated use of a mixture of sandarac and pine resin. In both these cases the green pigment undoubtedly contributed to the preservation of the resin components.

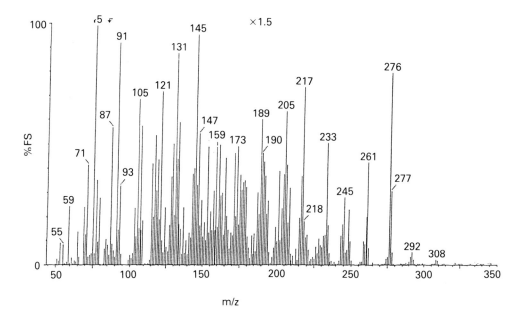

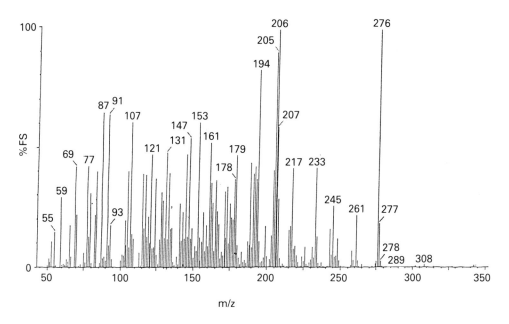

Figure 12.13 The mass spectra of two unidentified but characteristic compounds from the chromatogram of saponified bleached shellac, as shown in *Figures 12.11* and *12.12*. Scan 663 (*below*) and scan 746 (*above*), both after background subtraction.

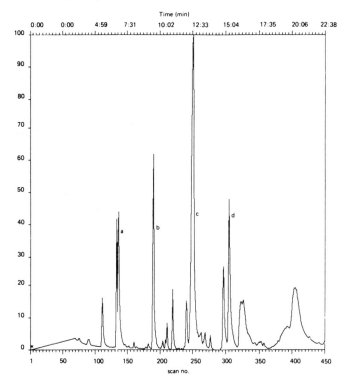

Figure 12.14 Chromatogram yielded, after saponification and methylation, by the varnish on a metal backplate from a piece of English furniture dating from about 1820. Identified peaks include methyl esters of (a) laurate, (b) myristate, (c) palmitate, and (d) stearate. The broad post-stearate peaks include the unidentified compounds with masses at 276 and 308 referred to in the two preceding figures. The two chromatograms were run on different GLC–MS instruments under different conditions and are not directly comparable.

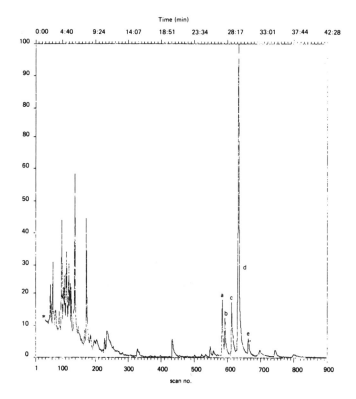

Figure 12.15 Chromatogram yielded by a green lacquer from a Chippendale commode of 1770. The early peaks are of residual monoterpenoids from oil of turpentine, the later are common pine resin components, here unusually well preserved. Methyl esters of (a) pimaric, (b) sandaracopimaric, (c) isopimaric, (d) dehydroabietic, and (e) abietic acids.

12.3 Resins in bulk

Resins preserved in bulk rather than as thin films of varnish are naturally less susceptible to oxidation, except superficially. The most striking demonstration of this is the case of Baltic amber (8.4.1) which after many millions of years still yields a recognizable chromatogram of diterpenoid and other components, and this is naturally also true of any artefacts made from it.

Other hard resins are also carved to make small sculptures. A sample from a carved head of resin, initially thought to be Romano-British, yielded the chromatogram shown in *Figure 12.16*. It is readily recognized as that of kauri resin from *Agathis australis*, a tree occurring naturally only in New Zealand (8.2.4), and the carving is probably nineteenth century Maori work.

Resins survive well when submerged in water. *Figure 12.17* shows comparison chromatograms, and *Figure 12.18* comparison mass spectra of one peak (Kratos MS-25 GLC-MS instrument) yielded by the resin samples from a Bronze Age shipwreck at Ulu Burun, Kaş (Turkey). Large quantities of resins were recovered from the amphorae in which they were being transported and all those examined proved to be the same material[42]. The triterpenoid components identified were those found in the *Pistacia* resins mastic and Chios turpentine (8.3.3), and the present samples were certainly the latter material. The shipwreck samples showed some variations in proportions of components, particularly in the relative amounts of the parent and the dihydromasticadienonic acids, but this variation is also found in samples of the fresh resin from different trees.

In this case the resin is so well preserved that a tentative identification of it would have been feasible even by infrared spectrometry. To demonstrate this, and also to show the power of Fourier-transform instruments coupled with the use of the infrared microscope, *Figure 12.19* shows some comparison spectra obtained by these means.

A sample of the Ulu Burun resin was deposited from solvent solution on to powdered potassium bromide. A spectrum was obtained from a single crystal, coated in this way with the resin, using a Nicolet FTIR (model 710 bench) coupled to a

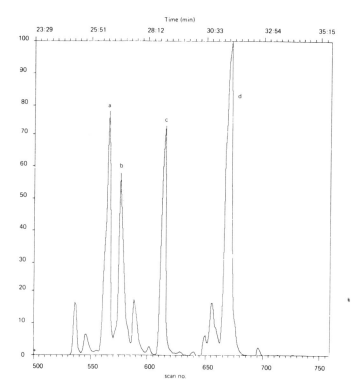

Figure 12.16 Chromatogram of sample from a carved head made of resin, after methylation of the acidic components. The main peaks are (a) methyl sandaracopimarate, (b) sandaracopimarol, (c) methyl abietate, and (d) dimethyl agathate. The pattern corresponds well with kauri resin from New Zealand and the head was probably of nineteenth century Maori manufacture. The object had, by chance, been found on a Romano-British site in England and before analysis was thought to be of that period and place.

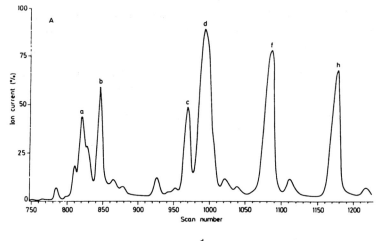

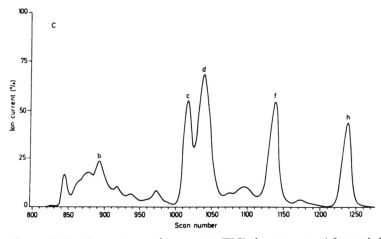

Figure 12.17 Comparison total ion current (TIC) chromatograms (after methylation of acids with diazomethane) of (A and B) resin samples from the Ulu Burun (Kaş) Bronze Age shipwreck, nos. KW169 and KW957, and (C) *Pistacia altlantica* resin collected at Mesoyi, near Paphos, Cyprus. Identified peaks are: (a) tirucallol; (b) β-amyrin; and methyl esters (c) moronate; (d) oleanonate; (e) dihydroisomasticadienonate; (f) isomasticadienonate; (g) dihydromasticadieno-nate; (h) masticadienonate. Mass spectral identification of one of the peaks is shown in *Figure 12.18*.

Nicolet Nic-Plan infrared microscope fitted with a Spectra-Tech Reflachromat ×32 lens (transmittance mode). The detector was an MCT 'A' type (128 scans, 4 cm⁻¹ resolution). Comparison spectra, obtained in the same way, are shown for *Pistacia lentiscus* resin (mastic; the composition and spectra of mastic and Chios turpentine are virtually identical) and for the resin of *Boswellia carteri*, a source of olibanum or frankincense. It may be seen that the

Ulu Burun and *Pistacia* spectra are almost superimposable; the *Boswellia* resin readily distinguishable.

Another example is provided by resin from a sixteenth century Ottoman shipwreck at Yassiada, near Bodrun, Turkey. GLC–MS of this showed the usual diterpenoid resin acids of pine resin, fairly well preserved. An FTIR spectrum of this, prepared in the same way as above, is shown in *Figure 12.20*

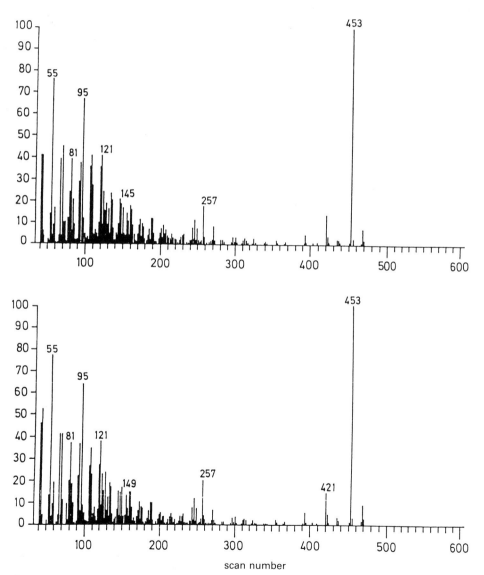

Figure 12.18 Comparison mass spectra of the chromatograms of *Figure 12.17*. Scan 1054 of sample KW957 (above) and scan 1136 of the *P. atlantica* resin (*below*) show the presence of methyl isomasticadienonate with molecular ion at 468 and base peak at 453.

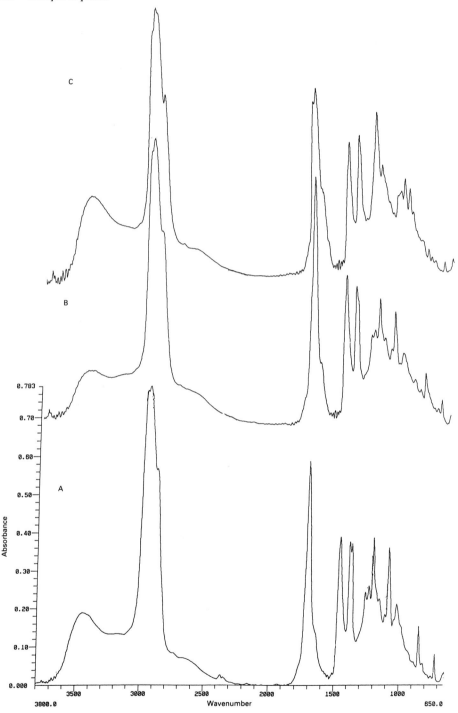

Figure 12.19 Fourier-transform infrared spectra of (A) resin from the Ulu Burun Bronze Age shipwreck; (B) a *Pistacia* resin; (C) *Boswellia carteri* resin (olibanum). The samples were deposited on potassium bromide crystals and a single crystal examined using an infrared microscope, as described in the text. On account of the well preserved state of the shipwreck sample an infrared spectrum is adequate here to make a convincing identification and rule out an alternative possibility.

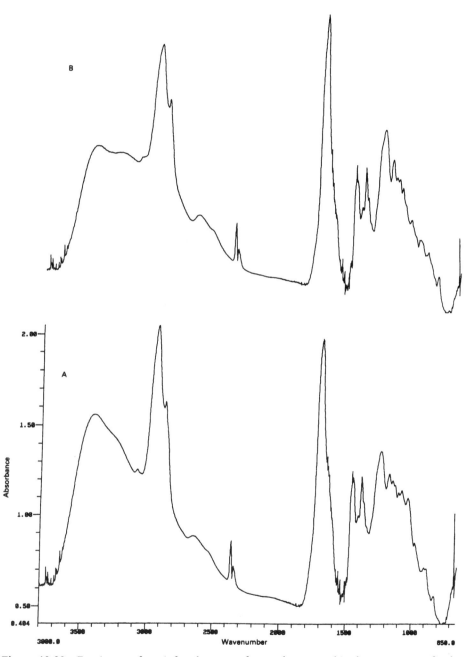

Figure 12.20 Fourier-transform infrared spectra of a sample, prepared in the same way as for the preceding figure, of a resin from a sixteenth century Ottoman shipwreck (A) in comparison with that for a commercial pine rosin (B). Again, a reasonably convincing identification is possible and in this case was confirmed by detection of the usual pine resin diterperoids by GLC-MS.

compared with that from a commercial pine rosin. Generally good qualitative coincidence of absorption bands is observable, with some variation in absorbance. The small differences may be due to real differences in original diterpenoid composition (tree source) or differences in the way the material has been processed. More important is that the spectrum would certainly point to a pine origin and exclude, for example, a *Pistacia* source.

12.4 Wax objects and coatings

As explained in Chapter 4, waxes are commonly stable materials containing hydrocarbons and esters. Old samples are therefore often of similar composition to fresh materials and, because of the absence (or insignificance) of highly polar groups, they may be examined directly by gas chromatography without derivatization.

However some of the components are of high molecular weight and high temperatures are needed to elute them from the chromatography column. With packed columns a number of possible stationary phases (stripped, by heating, of more volatile material) permitted use up to 380°C. OV-1 silicone was reasonably successful used as a 1% coating on acid-washed Diatomite, but better still was 1% Dexsil 300 on non-silanized acid-washed Chromosorb W as this had lower bleed levels and allowed use of higher sensitivity settings. More recently capillary columns have been used with greater success. *Figure 12.21* shows the chromatogram yielded by an unmethylated sample taken from the bust of Flora (Berlin Museums), variously attributed to Leonardo da Vinci and a nineteenth century imitator. It shows the presence of spermaceti wax, beeswax, and stearin wax (free saturated fatty acids). *Figure 12.22* shows a section of the chromatogram yielded by a methylated methanol extract of the sample, showing additionally the presence of pine resin components, as well as palmitate and stearate from the stearin wax, and a small proportion of the original wax esters from the spermaceti.

12.5 Bituminous adhesives and coatings

Figure 12.23 shows a capillary gas chromatogram of the hexane–benzene extract of a black coating which was found on a fracture of a sarcophagus (British Museum), from the El-Amarna royal tomb (1362 BC), which had been broken in antiquity. It shows, as the major components, triterpanes together with minor polyaromatic hydrocarbons, both characteristic for bitumen (5.1).

Figure 12.24 shows the so-called 'hopanogram' for a section of the chromatogram, i.e the scan for mass 191, a major, and usually the base, peak for hopanoid compounds which are invariable components of bitumens and serve as their most characteristic identifier. The mass spectrum of the main

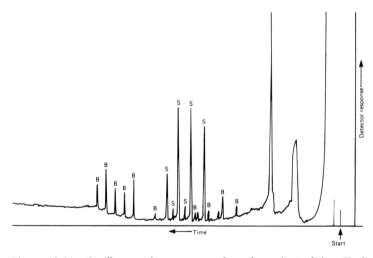

Figure 12.21 Capillary gas chromatogram of wax from a bust of Flora (Berlin Museums). The chromatogram shows beeswax components (marked B) and spermaceti wax ester components (marked S). Further components were identified by GLC–MS (see *Figure 12.22*).

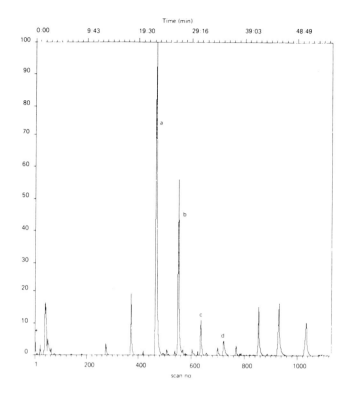

Figure 12.22 Gas chromatogram of a methanol extract of the wax from Flora, after methylation of acids: (a) and (b) are methyl palmitate and stearate from stearin wax (and to a small extent from the other waxes); between scans 600 and 740 are pine resin components including (c) methyl dehydroabietate and (d) methyl 7-oxodehydroabietate; following scan 800 are spermaceti esters partially extracted into the methanol.

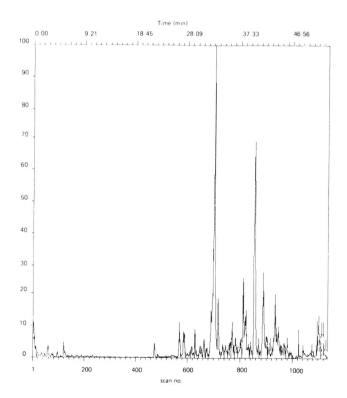

Figure 12.23 Capillary gas chromatogram yielded by the benzene-soluble fraction of bitumen from a sarcophagus from the El Amarna Royal Tomb, 1362 BC. Most peaks are of triterpanes but the major one is due to contamination (see text).

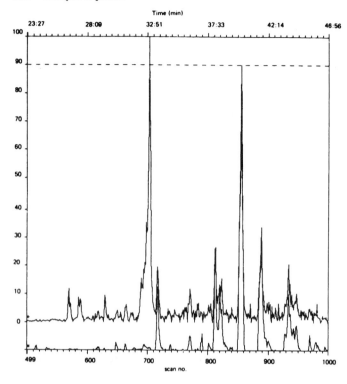

Figure 12.24 Section of the preceding chromatogram with scan for mass 191 (*lower curve*), which picks out hopanoid triterpanes.

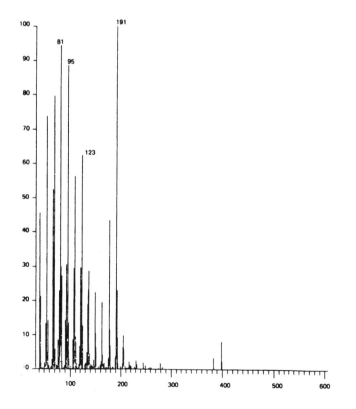

Figure 12.25 Mass spectrum of the main hopanoid component of the preceding chromatogram identifies it as 29-nor-hopane.

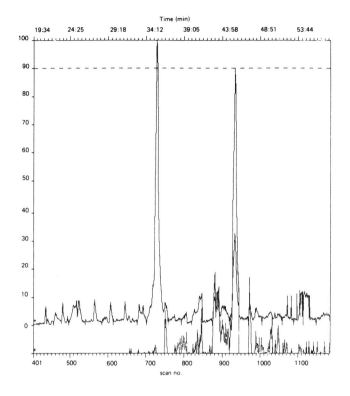

Figure 12.26 Section of the gas chromatogram of bituminous material used to attach the pupil of an eye on a sculpture from Abuabed (c. 3000 BC). A scan for mass 191 (lower curve) picks out the hopane components.

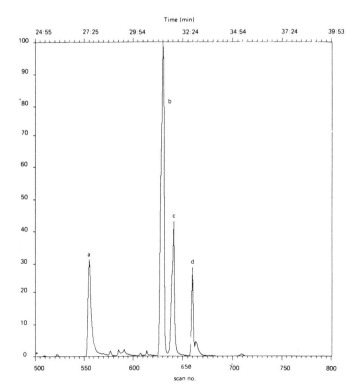

Figure 12.27 Chromatogram yielded (after methylation) by the impregnant/adhesive from a fourth century BC Greek vessel, excavated from off Kyrenia, Cyprus. The components are: (a) 1,2,3,4-tetrahydroretene; (b) a mixture of methyl isopimarate and dihydroabietate; (c) methyl dehydroabietate; and (d) methyl abietate. The pattern is puzzling but may represent a mixture of both pine resin and softwood tar.

hopanoid peak (*Figure 12.25*) identifies it as 29-norhopane.

Figure 12.26 shows another chromatogram of a hexane–benzene extract of a bituminous material, this time used as the adhesive for attaching the pupil of an eye on a statuette found at a pre-pottery, Jericho site at Abuabed (Jordan), of around 3000 BC. The hopanogram again shows up characteristic hopane components, though here the small sample, and need to use a high sensitivity setting on the mass spectrometer, leads to a 'noisy' mass scan owing to the scattered presence of mass 191 throughout the triterpane section from other components or even background. Such a result is representative of what may be expected from typical small samples of an archaeological nature. It is quite adequate, none the less, for a positive identification of the material as bitumen. The mass spectrum of the largest hopanoid peak showed it to be again norhopane.

A cautionary note is provided by the identity of the largest peak on both this chromatogram and that of the Amarna sample. This in fact is due to bisoctyl phthalate, a common plasticizer for polythene as used for bags, sample tubes and their stoppers. This and other phthalate esters are, unfortunately, frequent contaminants of samples which have been stored in containers of this kind and obviously their presence can give very misleading results if gas chromatography alone is being used without the certain identification provided by mass spectrometry.

An interesting, not completely explained, result was yielded by the material impregnating plant material (*Agave* sp.) lying between lead and the wooden hull of a Greek vessel of the fourth century BC[43]. The chromatogram (*Figure 12.27*) shows the presence of 1,2,3,4-tetrahydroretene, a decarboxylated and dehydrogenated product found in softwood tar (5.2), but also the unchanged diterpene acids, abietic and isopimaric, as well as disproportionation products from abietic acid, dihydro- and dehydroabietic acids. It is not clear how this pattern could have resulted. It may represent an initial mixture of resin and tar, further altered under the anaerobic conditions of long submersion on the sea bed.

References

1. SCHLENK, H. and GELLERMAN, J. L., 'Esterification of fatty acids with diazomethane on a small scale', *Anal. Chem.*, 32(1960), 1412–14
2. MILLS, J. S., 'The gas chromatographic examination of paint media Part I. Fatty acid composition and identification of dried oil films', *Stud. Conserv.*, 11(1966), 92–108
3. MILLS, J. S. and WHITE, R., 'Analyses of paint media', *National Gallery Tech. Bull.*, 4(1980), 65–7
4. MILLS, J. S. and WHITE, R., 'Organic analysis in the examination of museum objects', in *Application of Science in the Examination of Works of Art*, (Ed. P. A. England and L. van Zelst), Museum of Fine Arts, Boston (1983), 29–34
5. MILLS, J. S. and WHITE, R., 'The gas chromatographic examination of paint media. Some examples of medium identification in paintings by fatty acid analysis', in *Conservation and Restoration of Pictorial Art*, edited by N. Brommelle and P. Smith, Butterworths, London (1976), 72–6
6. DELBOURGO, S. and RIOUX, J.-P., 'Manière et matière des impressionistes. Contribution à l'étude de la matière picturale', *Laboratoire de Recherche des Musées de France – Annales*, (1974), 35–43
7. WHITE, R., 'Impressionist paint media', in BOMFORD, D., KIRBY, J., LEIGHTON, J. and ROY, A., *Art in the Making: Impressionism*, National Gallery, London (1990), 72–5
8. WHITE, R. and PILC, J., 'Analyses of paint media', *National Gallery Tech. Bull.*, 14(1993), 86–94
9. RIOUX, J.-P., 'Note sur l'analyse de quelques enduits provenant de peintures francaises des XVII et XVIII siècles', *Laboratoire de Recherche des Musées de France – Annales*, (1973), 35–43
10. NACHTIGAL, M., ŠIMŮNKOVÁ, E. and ZELINGER, J., 'Influence of metal octoates on polymerization and degradation of linseed and poppyseed oils', *Sborník Vysoké školy chemicko-technologické v Praze (Scientific Papers of the Prague Institute of Chemical Technology)*, S10(1983), 11–32
11. WHITE, R., 'The examination of Thomas Bardwell's Portraits – the media', *Stud. Conserv.*, 20(1975), 109–13
12. MILLS, J. S. and WHITE, R., 'Analyses of paint media', *National Gallery Tech. Bull.*, 7(1983), 65–7
13. WHITE, R., ROY, A., MILLS, J. and PLESTERS, J., 'George Stubbs's "Lady and Gentleman in a Carriage": a preliminary note on the technique', *National Gallery Tech. Bull.*, 4(1980), 64
14. MILLS, J. and WHITE, R., 'The mediums used by George Stubbs: some further studies', *National Gallery Tech. Bull.*, 9(1985), 60–4
15. WHITE, R., 'The characterization of proteinaceous binders in art objects', *National Gallery Tech. Bull.*, 8(1984), 5–14
16. DUNSTAN, B., *Painting Methods of the Impressionists*, Watson-Guptill, New York and Pitman, London (1976), 157–63
17. OSTWALD, W., 'Iconoscopische Studien, I. Mikroskopische Nachweis der einfachen Bindemittel', *Sitsungsber. der Königlich Preussischen Akad. der Wissenschaften*, 5(1905), 167–74

18. OSTWALD, W., 'Iconoscopic studies. I. Microscopic identification of homogeneous binding mediums', *Technical Studies in the Field of the Fine Arts*, 4(1936), 135–44

19. COREMANS, P., GETTENS, R. J. and THISSEN, J., 'La technique des "Primitifs Flamands"', *Stud. Conserv.*, 1(1952), 1–29

20. PLESTERS, J., 'Cross-sections and chemical analysis of paint samples', *Stud. Conserv.*, 2(1956), 110–57

21. GAY, M.-C., 'Essais d'identification et de localisation des liants picturaux par des colorations spécifiques sur coupes minces', *Laboratoire de Recherche des Musées de France – Annales*, (1970), 8–24

22. JOHNSON, M. and PACKARD, E., 'Methods used for the identification of binding media in Italian paintings of the 15th and 16th centuries', *Stud. Conserv.*, 16(1971), 145–64

23. MILLS, J. S. and WHITE, R., 'The identification of paint media from their sterol composition – a critical view', *Stud. Conserv.*, 20(1975), 176–82

24. GAY, M.-C., 'Application of the staining method to cross-sections in the study of the media of various Italian paintings of the 14th and 15th centuries', in *Conservation and Restoration of Pictorial Art*, edited by N. Brommelle and P. Smith, Butterworths, London (1976), 78–83

25. MARTIN, E., 'Note sur l'identification des protéines dans les liants de peinture', *Laboratoire de Recherche des Musées de France – Annales*, (1975), 57–60

26. MARTIN, E., 'Application des tests sur coupes mince à l'identification des émulsions dans les liants de peinture', *Laboratoire de Recherche des Musées de France – Annales*, (1977), 21–9

27. MARTIN, E., 'Some improvements in techniques of analysis of paint media', *Stud. Conserv.*, 22(1977), 63–7

28. MARTIN, E., 'Contribution à l'analyse des liants mixtes', *ICOM Committee for Conservation Report 78/20/8*, 5th Triennial Meeting, Zagreb (1978)

29. KOCKAERT, L., 'Note sur les émulsions des primitifs flamands', *Institut Royal du Patrimoine Artistique, Bull.*, 14(1973/4), 133–9

30. WOLBERS, R. and LANDREY, G., 'The use of direct reactive fluorescent dyes for the characterization of binding media in cross sectional examinations', *Preprints of the 15th Annual Meeting of the American Institute for Conservation*, Vancouver, BC (1987), 168–202

31. GOLIKOV, V. P. and KIREYEVA, V. N., 'Study of spatial distribution of protein bindings in situ by means of reactive dyes', *ICOM Committee for Conservation, 9th Triennial Meeting, Dresden 1990*, Ed. K. Grimstad (1990), 24–8

32. STRINGARI, C., 'Vincent van Gogh's triptych of trees in blossom, Arles (1888) Part I. Examination and treatment of the altered surface coatings', *Cleaning, Retouching and Coatings. Preprints of the Brussels Congress, 1990*, IIC London (1990), 126–30

33. SAMET, W., STONER, J.H. and WOLBERS, R., 'Approaching the cleaning of Whistler's "Peacock Room": retrieving surface interrelationships in "Harmony in Blue and Gold"', *Cleaning, Retouching and Coatings. Preprints of the Brussels Congress, 1990*, IIC, London (1990), 6–12

34. DELBOURGO, S., RIOUX, J.-P. and MARTIN, E., 'L'analyse des peintures de Studiolo d'Isabelle d'Este au Laboratoire de Recherche des Musées de France. II. Etude analytique de la matière picturale', *Laboratoire de Recherche des Musées de France – Annales*, (1975), 21–8

35. ROSSI-MANARESI, R., 'The polychromy of the 13th century stone sculptures in the facade of Ferrara cathedral', *ICOM Committee for Conservation Report 81/5/3*, 6th Triennial Meeting, Ottawa, (1981)

36. ROSSI-MANARESI, R., 'Scientific and technical research', in *Jacopo della Quercia e la Facciata di San Petronio*, Centro per la Conservazione delle Sculture all'Aperto, Edizione Alfa, Bologna, (1981), 225–52

37. WHITE, R., 'A review, with illustrations, of methods applicable to the analysis of resin/oil varnish mixtures', *ICOM Committee for Conservation Report 81/16/2*, 6th Triennial Meeting, Ottawa, (1981)

38. MILLS, J. S. and WHITE, R., 'Organic mass-spectrometry of art materials: work in progress', *National Gallery Tech. Bull.*, 6(1982), 3–18

39. WHITE, R., 'An examination of varnish from three 18th century musical instruments', *ICOM Committee for Conservation Report 78/16/1*, 5th Triennial Meeting, Zagreb (1978)

40. FELLER, R. L., 'Rubens's *The Gerbier Family*: technical examination of the pigments and paint layers', *Studies in the History of Art*, National Gallery of Art, Washington D.C. (1973), 54–74

41. MILLS, J. S. and WHITE, R., 'Natural resins of art and archaeology. Their sources, chemistry and identification', *Stud. Conserv.*, 22(1977), 12–31

42. MILLS, J. S. and WHITE, R., 'The identity of the resins from the late Bronze Age shipwreck at Ulu Burun (Kaş)', *Archaeometry*, 31(1989), 37–44

43. KATZEV, M. L., 'Cyprus underwater archaeological search, 1969', *National Geographic Society Research Reports, 1969 Projects*, (1978), 289–305

Index